EYE OF THE CAMERA
A LIFE OF CHRISTOPHER ISHERWOOD

EYE OF THE CAMERA

A LIFE OF CHRISTOPHER ISHERWOOD

Jonathan Fryer

ALLISON & BUSBY

This edition
first published in Great Britain in 1993 by
Allison & Busby
an imprint of Wilson & Day Ltd
5 The Lodge
Richmond Way
London W12 8LW

A catalogue record for this book is available from the British Library

ISBN 085031 9382

Typeset by TW Typesetting, Plymouth, Devon
Printed and bound in Great Britain by
Biddles Ltd, Guildford and King's Lynn

For
A. B. S.
with love

Contents

Foreword

I first learned of Christopher Isherwood's existence in a dusty second-hand bookshop in Knysna, South Africa, around Christmas 1969. Then a student of Chinese civilisation, I was scouring even that unpromising territory for anything Oriental, and discovered a copy of *Journey to a War*, the 1939 China travel diary he had written with W. H. Auden. Christopher later said this was a good omen, as he had at that very time been researching his father, Frank Bradshaw Isherwood, who had been in Knysna during the Boer War. Isherwood was then in the process of rehabilitating his parents, in an exercise that resulted in the affectionate portrait, *Kathleen and Frank*, published in 1971.

By the time *Kathleen and Frank* came out, I had settled down at Oxford with a pile of Isherwood's novels and decided – in the way that quite a few male undergraduates of the period did – that Christopher Isherwood was my favourite contemporary novelist. He in turn relished that instant power of communication he had with Youth, on both sides of the Atlantic, and replied promptly and fully to an initial fan letter. A short correspondence ensued about our shared interest in Oriental philosophy and the Quakers, and our common backgrounds in the outlying areas of Manchester. Then I disappeared off to the Far East for a year, and the link was broken.

In the autumn of 1973, though, I took a job at Reuters news agency in London and was put on the euphemistically named Profile Desk, which prepared obituaries of people of note. When Auden died in Austria on the night of 28–29 September, there was an awful realisation in the office that Reuters had no 'profile' of Isherwood, which I was promptly detailed to do. Meanwhile, in a routine journalistic action that left me feeling physically sick, a colleague rang Isherwood in California for an instant reaction to Auden's death. As this was the first he had heard about it, Christopher was too shaken to respond.

I restarted the correspondence and determined to write Isherwood's life. In the summers of 1975 and 1976, I spent countless hours interviewing him

at the lovely little house in Santa Monica where he lived with Don Bachardy. His patience and generosity during those sessions were extraordinary, though the beginning of the first was a little fraught. He sat in an armchair a good ten feet away, frowned slightly, and asked: 'Are you gay?' He said he believed only another homosexual could ever really understand the life of a gay author like himself. I didn't agree then and I don't agree now; one only has to think of Humphrey Carpenter's admirable life of W. H. Auden. Despite the spirited little argument that ensued, I had satisfied his conditions, and got his full co-operation in the project. Yet my still youthful excitement at those long summer interviews was tinged with a degree of frustration. For increasingly I became aware that all the wonderful stories and memories that came tripping off his tongue sounded remarkably familiar, as indeed they were. For Isherwood had spent years analysing his own life, writing it down, and then – having established a kind of authorised version – consciously or unconsciously he had learnt it off by heart.

What's more, even some of his closest friends had become so familiar with the Isherwood 'official' version of events, as set out in his various autobiographical writings, that they also often parroted the same line, sometimes using the very words of Isherwood's books. At least Edward Upward was conscious of this fact. He confessed charmingly, at his home on the Isle of Wight, that he really couldn't remember exactly what had happened on various occasions fifty years before, as his own recollections had been obliterated by the striking portrayal of events in Isherwood's *Lions and Shadows*.

None the less, I produced a first, necessarily incomplete, book on Isherwood in 1977. It has been a rare privilege to go back now to the theme and re-do the whole thing. I have added not only coverage of the last decade of Christopher Isherwood's life, but also new things that have come to light, as well as some material which for various reasons was best left unsaid when Isherwood and various other people were still alive.

My own perspective has also inevitably changed. I'm no longer the young man who slightly idolised his subject. And these days there are other writers who I would cite as having made a far greater contribution to modern literature than Isherwood did. Shortly before John Lehmann's death in 1987, he and I agreed that Isherwood was a 'major minor' writer of the twentieth century. None the less, Isherwood's work, at its best, is of exceptional quality. As we Quakers say, it continues to 'speak to the condition' of many people, not just the young and the gay. Above all, Christopher Isherwood was a person of remarkable strength of character, for all his foibles. His friendship is something I will treasure for the rest of my days.

Acknowledgments

I would like to express sincere thanks to all those who, over the past twenty years, have shared their memories of Christopher Isherwood or of the places associated with him, either in interviews or in answering queries by letter, notably:

Don Bachardy, Sybille Bedford, Alec and Dodie Beesley (Dodie Smith), James Bridges, Edwin Bronner, Mrs Ivo Bulley (née Rosamira Morgan-Brown), Michael di Capua, Bill Caskey, Alan Clodd, Claud Cockburn, Henry Davidson, Michael Davie, Brian Finney, John Gammel, Jim Gates, Felix Greene, Raymond Greene, Peter Grose, D. J. Hall, Carolyn Heilbrun, Jack Hewit, David Hockney, Evelyn Hooker, Richard Isherwood, Clive Johnson, Francis King, Lincoln Kirstein, Margaret (Peggy) Kiskadden, Gavin Lambert, Jack Larson, John Lehmann, Marguerite (Lamkin) Littman, David Machin, Sylvain Mangeot, Robert Medley, Ed Mendelson, Jessica Mitford, Stathis Orphanos, Roger Pemberton and Alice Prochaska, Marie Rambert, John Rechy, Gottfried and Sylvia Reinhardt, Catherine Rodriguez-Nieto, Peter Schlesinger, Bill Scobie, Charles Smyth, Natasha and Stephen Spender, Douglas Steere, James and Tania Stern, Edward and Hilda Upward, Rex Warner, Peter Weeks and Geoffrey Woodhead.

1

1904–1914

Christopher William Bradshaw Isherwood was born shortly before midnight on Friday, August 26, 1904, at his parents' home of Wyberslegh Hall near the village of High Lane in Cheshire, about twelve miles south-east of Manchester. His mother, Kathleen, was experiencing her first childbirth at the age of nearly 37, and found it neither enjoyable nor exhilarating. She had to be given chloroform to get through the final stages. But later, as she wrote in her diary, she sensed the pride in her husband Frank's eyes and rejoiced in their new bond of parenthood. She smiled at the thought that the baby looked positively Japanese, with his broad slit-eyes. Then she handed the screaming bundle over to a nurse hired for the period of her confinement.

Before breakfast the following morning, Frank went over to convey the news of the successful birth to his parents, who lived in some style at Marple Hall, three miles away. His father, John, was celebrating his own birthday that day and ordered the staff to raise a flag above the house, so the news of a grandson and heir would be broadcast to the neighbourhood. Until John Isherwood's death twenty years later, Christopher shared an 'official' joint birthday of August 27 with his grandfather.

Frank and Kathleen had failed to decide in advance what the child would be called. John, William and Henry were all well-established Bradshaw Isherwood family names, but Frank rather fancied Louis, after one of his favourite authors, Robert Louis Stevenson. After a few days, Frank's elder brother Henry, who had agreed to be the boy's godfather, pressed the couple to make up their minds. Kathleen opted for Christopher, mainly because she liked the sound of the name. Frank added the William, not just for its family connections, but also in memory of a very close friend, Captain William Bradshaw (no relation), who had been killed in the Boer War. Frank often called the child William too.

Christopher was born into the world of provincial upper-middle-class respectability that was to be the bedrock of his early literary output. There was little ostentatious display of wealth by the Bradshaw Isherwoods, but correct behaviour and form were considered important, not least by Kathleen. She was acutely conscious of the gentility of the family into which she had married and made considerable researches into its past. This was not just for her own amusement. From the beginning, she was determined to instil a sense of responsibility and history into young Christopher.

Uncle Henry, being the eldest male of his generation, had been groomed as heir to the not inconsiderable family property and he enjoyed his position to the full. He ate well, drank well, travelled widely and liked to frequent fashionable society in London. By the time Christopher was born, however, everyone had come to the conclusion that Henry was a confirmed bachelor, set in his ways. Possibly some members of the family suspected that his sexual interests were directed more at men than at women, though it is unlikely anyone would have said so out loud. Certainly Kathleen assumed that Christopher would eventually inherit the Bradshaw Isherwood property and family tradition. So from a tender age he was made thoroughly conversant with his background.

Both Wyberslegh and Marple Halls dated back to the end of the fifteenth century. But it was in 1606 (exactly three hundred years before Kathleen started to write down an illustrated family history for Christopher) that the boy's Bradshaw ancestors bought the two houses from their previous owners. The Bradshaws had already been tenants there for several years. Judge John Bradshaw, notorious for signing the death warrant of King Charles I, after others had refused to have anything to do with the King's trial, was almost certainly born in what was subsequently known as the Bradshaw Room at Marple Hall, in 1602. John Bradshaw was christened at Stockport, the nearest sizeable town, and opposite his name in the parish register someone later added the single word 'traitor'. However, at the time, Parliament rewarded John Bradshaw for his treachery with a generous income. Later, he came into conflict with Oliver Cromwell and history has been less generous to him, generally viewing the trial of King Charles as perfidious and Bradshaw's role in it as ignoble. But he was an awfully exciting ancestor to have.

Kathleen was not the only relative by marriage of the Bradshaw Isherwoods to have paid an intense interest in the family's past. Christopher's great-great-grandmother Elizabeth had gone so far as to construct a weird *tableau vivant* in a small upstairs room at Marple Hall which she dubbed King Charles's Closet. Inside was a kneeling wooden figure, purporting to be the sovereign,

clothed in armour taken from the Hall's ample supply. This figure was bewigged with locks from Elizabeth's hair, was shod in leather boots and positioned as though reading his own death warrant, which was propped up on a small table in front of him.

Although Wyberslegh Hall was Christopher's home, Marple Hall was very much the centre of the Bradshaw Isherwoods' family life. So as a child he spent a great deal of time there, and could hardly fail to be impressed by the atmosphere of the place. It was a large and striking red sandstone building, one of the grandest houses in the area, with its own park and a small lake. The Hall was romantically covered in climbing ivy and was a good example of eclectic English country-house architecture. The original E-shaped Elizabethan mansion had frequently been added to and altered. Some of the old mullioned windows had been replaced by larger ones, while others had been bricked up in the eighteenth century to avoid window taxes. A well-stocked garden provided colour for most of the year, though the Hall's sheltered location among wooded hills on the edge of the Peak District meant that its interior was gloomy through lack of direct sunlight.

The richly coloured stained-glass windows in the flagstoned entrance hall only heightened the house's subdued air, as did the heavy dark furniture, the suits of armour and the lines of formal portraits of the Bradshaw and Isherwood families. These had been united in marriage in the eighteenth century, when Mary Bradshaw, a sister of the last male Bradshaw heir, had wed a felt-maker named Isherwood from Bolton in Lancashire, adding her surname to his. Their descendants sometimes hyphenated the two names, and sometimes didn't; a few, like Christopher, called themselves plain Isherwood. The coats of arms of the Bradshaws and Isherwoods were painted on the oak-panelled walls of Marple Hall and were embroidered on the chairs in the library, which in Christopher's childhood were lined with morocco-bound tomes that nobody read. Flemish tapestries graced the dining-room, while over the sideboard hung a forbidding portrait of Queen Elizabeth I. Christopher's paternal grandmother, also called Elizabeth, would glance up at this picture and mutter under her breath 'Justice without mercy!', like some ritualistic incantation. In such surroundings it was impossible to ignore the weight of English history.

To the young Christopher, John and Elizabeth Isherwood were themselves relics of a bygone age. John Isherwood's air of benign decrepitude pervaded Marple Hall. The victim of an early stroke, he had had to retire from the Army after only four years of service, at the age of twenty-one. After that, he did little except administer the family estates and occasionally officiate as a local Justice of the Peace in cases of petty criminality.

John Isherwood was already well into his sixties when Christopher was born, and with old age had lost any embarrassment he might once have had about his infirmity. He had a peculiar custom at meal-times of leaving all his wine and liqueurs till he had finished eating, when he would drink them all up in rapid succession. Then he would mount the great staircase, with some difficulty, and fall asleep in an armchair, sometimes relieving himself in the seat. To lessen the problem of his incontinence, he attached himself to a concealed urine bottle, which had a tendency to detach itself, filling the air with a warm, musty smell. Far from disgusting Christopher, this appealed to him, reminding him of wet hay in a stable.

As time went by, John Isherwood's speech became more and more slurred, until he was practically unintelligible to the unattuned listener. He would also sit smiling to himself as if amused at some private joke. He enjoyed smoking, scattering ash wherever he went, and had a passion for detective novels, which he bought with his tobacco at the stationer's in the village. Every morning he would be driven down to Marple by horse and carriage, to make his modest purchases, or just to chat to the shopkeepers. To Kathleen's delight, some of these would refer to John Isherwood as 'The Squire'. With such a status she was prepared to overlook the fact that his soiled dentures had the unfortunate habit of falling onto the table when he laughed out loud during meals.

Elizabeth, 'Granny Isherwood', was a more obviously pitiful creature in Christopher's eyes. She was a shrivelled, deathly pale old lady, who struggled against a failing memory. She fussed continually over the trivialities of everyday life and the comfort of her guests. She had the particularly irritating trait of dithering around people while they were trying to read, being full of concern that they were ruining their eyes by sitting in poor light. She also made a strange buzzing noise as she wandered round the big old house, preoccupied with myriad small anxieties.

Like many grandchildren, Christopher was too young to establish a profound relationship with John and Elizabeth Isherwood. Kathleen had tried, but felt excluded. Having an unusually close bond with her own mother, who lived down south, she found it particularly hard to accept that Elizabeth Isherwood seemed so distant. Indeed, at times she felt that the whole Isherwood family was incapable of deep personal affection.

Kathleen and Frank had been living at Wyberslegh Hall for only eighteen months when Christopher was born. For the preceding eighty years, Frank's family had rented the Hall out to farmers, as they did not need it for themselves. When Frank and Kathleen were planning to get married, though, John Isherwood had the house converted into two sections. Frank and

Kathleen lived in the grander front half, while the farmers were consigned to the back. Relations between the two households were not good.

Wyberslegh Hall (which, unlike Marple Hall, is still standing) is on hilly ground, though hidden from the road, above the small village of High Lane, between Disley and Marple. The main road from Manchester to Buxton runs through High Lane and, even in the early 1900s, a few enterprising suburban commuters had moved into the parish from the rapidly growing industrial conurbation of Manchester. Kathleen and Frank viewed this invasion with displeasure. Though Kathleen in particular regarded Stockport as 'quaint', with its beshawled working girls walking up the hilly streets, neither she nor Frank made much attempt to get to know the better side of industrial Manchester, apart from a few visits to concerts or to look at paintings and drawings in the Whitworth Art Gallery. While deeply fond of her adopted northern country homes, Kathleen tended to look south for cultural inspiration. As Christopher grew up he too quickly got to know London far better than he ever knew Manchester.

Wyberslegh stands between the city and the still-empty hills of Derbyshire, observing both worlds. Many years later, in his book about his parents, *Kathleen and Frank*, Isherwood described the atmosphere of the area vividly:

> The sense of weather is overwhelming. Every view is a watercolour, dripping with melancholy. The desolation of the nearby city seems to relate naturally to the desolation of the moorland. One may call this a suburb, implying that it has been tamed, but the dominant impression is of wildness. These bleak hills may be much less than mountains, but how hugely they impose their presence! (p 179)

Wyberslegh Hall is considerably smaller than Marple Hall was. Almost symmetrical from the front, it is like a miniature castle, topped with ornamental crenellations resembling battlements. The front door with its formal, straight lines is flanked by windows set curiously high in the wall. Grassy banks run away from the doorway. Like many stone houses in the area, it tends to be damp and bleak in winter, yet Christopher found it homely and cheerful.

Kathleen had fallen in love with Wyberslegh at first sight, and claimed to believe she had been there in some previous existence. She lived in constant apprehension of the day when Frank and she might have to relinquish the house, when he received another posting. Since the late summer of 1902, Frank had been Adjutant to the Fourth Volunteer Battalion of the Cheshire Regiment, based at Stockport. He had left his regiment in order to take up

this local posting, where he could offer Kathleen a decent home, despite his meagre salary. Frank's financial position was eased by a modest allowance from his father but, under the terms of the family settlement, John Isherwood had only a life interest in the estate. As eldest son and heir, Henry had to approve any further settlement that John might make on other members of the family, including the loan of Wyberslegh to Frank and Kathleen.

Frank did not like his Stockport job and would happily have resigned, had this not meant an inevitable move from Wyberslegh. His training and experience qualified him for a much more demanding task. He had been to Sandhurst before joining his father's old regiment, the York and Lancaster, in 1892. When he met Kathleen three years later, he was already a Lieutenant and, by the time Christopher was born, had been made a Captain. Yet Frank was no stereotyped turn-of-the-century military man. Compact and attractive, with fairish hair, a fine moustache and light-blue eyes, he was a highly competent self-taught watercolourist. He loved music and played the piano with enthusiasm, seizing any opportunity for duets. Above all, he adored acting, often taking on comic female roles in amateur revues and family entertainments, where his uninhibited clowning won warm applause.

Off-stage, though, Frank tended to be shy and punctilious. He always behaved with the utmost decorum towards Kathleen's father, Frederick Machell-Smith, even during the latter's most infuriating moments. In letters to Kathleen, however, Frank was more open about his true feelings, especially his irritation with her 'D.O.D.' (Dear Old Dad).

Frank read quite widely. Though his taste in novels was conservative, his non-fiction diet included a number of works on Oriental customs, philosophy and religion, including Buddhism and theosophy. This may have been prompted partly by his brother Henry's travels to Japan and other far-off lands. But Frank was attracted to Eastern religions because of their emphasis on self-effort and silent meditation. He had very little patience with formal Christianity, as represented by the Church of England. Kathleen foolishly attempted to make him share her reverence for all that the established Church stood for, which sometimes led to family rows. For Kathleen, the Church meant stability and tradition and she defended it loyally against what to her were its mortal enemies, Roman Catholics. She had a particular dislike for Catholic converts (who included both Frank's brother Henry and, later, their sister Mary), referring to them contemptuously as 'perverts'.

Frank was a keen athlete and kept his body in trim. Christopher later wrote that his first erotic image was of his father stripped half naked, doing vigorous physical exercises. Frank's energy seemed boundless. He hiked across the countryside in all weathers, and cycled to work even when it was pouring

with rain. He was always ready for a game of tennis or a round of golf. And yet he had no qualms about spending a quiet evening at home knitting. He obviously rather enjoyed teasing people by pretending to be in the wrong profession, claiming on a number of occasions that he hated guns because of the noise they made. But before his marriage, Frank had served two tours of duty in South Africa with distinction. The experience of the Boer War only confirmed his innate Toryism. He was made uncomfortable by radical or genuinely Bohemian attitudes, as well as by some of the rougher manners of the working class.

Kathleen came from a more conventionally bourgeois background than Frank's. Until the age of sixteen, she had lived in Bury St Edmunds in Suffolk, where her father Frederick Machell-Smith ran a wine business. In later life, he behaved with all the gravity of a hardened businessman, being suspicious of everyone's motives, especially anyone interested in his only daughter. Although he doubtless loved Kathleen, Frederick caused great misery to her as well as to Frank by his protracted opposition to their marriage, on tenuous material grounds. Like many fathers when dealing with marriageable daughters, he seems to have forgotten the passions and aspirations of his own youth.

For at seventeen, Fred Machell-Smith had run away from home, getting as far as Australia, where he worked on a sheep farm and as a policeman. On his return to a settled life in England, he took up the then rather unusual hobby of photography. But he also became irritable, pompous, dogmatic and selfish, partly in reaction to the discomfort he suffered from a bladder problem. None the less, he could at times display open affection to Kathleen and she remained loyal to him, despite all the obstacles he put in her path. Christopher never knew Fred Machell-Smith, as Kathleen's father refused to have anything to do with the baby, and died in 1905.

Kathleen's relationship with her mother Emily was happier and much more intense. Emily's letters show her to have been a woman of considerable character and determination, who managed to bridge the generation gap with her daughter, so that at times they seemed almost like sisters. Emily remained elegant and beautiful right up to her death at the age of eighty-four. This was despite being what Christopher later described as a 'great psychosomatic virtuoso', who expected Kathleen to be in attendance whenever she was indisposed. Her illnesses were spectacular in their timing, as well as in their mysterious nature, and often enabled her to achieve things which her husband, and even Kathleen, might have wanted to frustrate. Emily's greatest victory was to get her husband to move the family to London, on health grounds. There she could indulge her passion for the theatre. Sarah Bernhardt was her idol.

Kathleen was devoted to her 'Dearest Mama' and one of her greatest concerns about getting married had been that this might come between her and Emily. It is quite easy to picture Kathleen as a middle-aged spinster, acting as a sort of unpaid live-in nurse to her mother. But Frank reassured Kathleen during their courtship that he would respect the claims her mother had over her. This was quickly put to the test, as Emily, typically, arrived to stay with the newly-weds on the second day of their honeymoon, in Cambridge.

Emily herself came from a large and remarkable family, the Greenes, thus making Christopher a close cousin of the novelist Graham Greene. Emily's brother, Walter Greene, had a brewery, which meant he was in the same line of business as Fred Machell-Smith. The brewery prospered and Walter Greene made a considerable success of his life, launching himself into politics and later on receiving a baronetcy. When Kathleen was a girl, he had already acquired a country house with substantial grounds called Nether Hall. There he entertained generously. The Machell-Smiths were frequent guests, and Kathleen developed a taste for country-house life, with its endless cavalcade of balls, parties, picnics, shoots and other genteel amusements.

Otherwise, Kathleen's early life had followed the more usual middle-class pattern of parlour-games, walks, German lessons, watercolouring, mind-improving lectures and occasional good works for the deserving poor. Less typically, she helped her mother prepare a light guide to walks for gentlefolk in the City of London, published in 1893 under the title *Our Rambles in Old London*. Emily also took Kathleen with her on several visits to the Continent. Despite Kathleen's rather leaden outpourings of appreciation of continental works of art in her diaries, one gets the impression that she did not really approve of abroad – particularly not of the Germans.

In London, the Machell-Smiths lived in South Kensington, then as now a bastion of comfortable middle-class respectability. There was a full social life in the neighbourhood, of which Kathleen took good advantage before her marriage. She also shared her mother's enthusiasm for the cultural riches of London and, while being courted by Frank, spent many afternoons with him in the National Gallery in Trafalgar Square, copying paintings or just discussing their merits and deficiencies. Rather to her irritation, Frank soon became a better amateur artist than herself.

Kathleen's diaries of the period present a rather distorted self-portrait of an unrepentant snob, immature in her appreciation of the world, spoilt, apron-clinging and blighted by what seems to us now a patronising attitude to humanity at large, more typical of the nineteenth than the twentieth century. She certainly had a blind affection for the Royal Family and a reverence for

a bygone social order which must have struck even some of her contemporaries as archaic. Her diary for 1904 is full of pretentious portent concerning Christopher's birth, as she notes the propitious arrival of two other babies: the heirs to the thrones of Russia and Italy! However, people who knew Kathleen well have testified to her great dignity, sincere attentiveness and measured charm. However blatant her weaknesses, she also possessed sterling qualities, not least of which was a deep family loyalty.

With great pride, Kathleen charted the course of the infant Christopher's life in an illustrated handwritten manuscript entitled 'The Baby's Progress'. This was carried on right through Christopher's school-days, the final entry being in 1928, when his first novel, *All the Conspirators*, was published. Kathleen's drawings and photographs show Christopher attired in the conventional frilly baby-dresses of the period, with large hats to keep off the sun, graduating later to plush velvet outfits with lace collars and mock sailor-suits.

After some initial difficulty, Kathleen found a nurse to look after Christopher, a young woman from Suffolk called Annie Avis, who stayed with the family, in a variety of roles, for over forty years. Christopher became very fond of 'Nanny', who relieved Kathleen of all the tiresome everyday chores of raising a child, thereby gaining his affection and trust. As he got older, Christopher also teased Nanny unmercifully and in truculent moods would boss her around. Yet it was to Nanny, and not Kathleen, that he confided most of his childhood secrets. When he had nightmares, or just felt scared of the dark, as quite often happened, it was for Nanny that he screamed. She told him stories, spoke of the doings of her family and friends and taught him nursery songs.

Frank Isherwood was an even better story-teller, who charmed his son with imaginative tales and drew cartoons for him on the backs of duplicate army receipts. Largely thanks to his father, from a very early age, Christopher saw cultural pursuits like drawing and music as fun, and something that one could take part in oneself. He particularly loved it when the youngest of the three Isherwood brothers, Jack, came over and played rowdy piano duets with Frank.

Christopher relished the days spent over at Marple Hall, where he would follow the housemaids round while they were doing the cleaning. He clambered over the furniture and the stairways, poking into every corner, fingering the books and the antiques, smelling the odours of the house. Each spring, he would watch the great tapestries being thrashed with a carpet-beater on the lawns. And when he tired of watching the servants at work, he could climb up to the Hall's attics, a fantastic world which he imagined to be

9

populated with mysterious presences. He half expected Beatrix Potter's animal characters to materialise there at any moment. Most scaring of all the dark corners was the Glory Hole, a narrow shaft that plunged all the way down from the attics into the cellars. The family called it the *oubliette*, pretending that in past ages prisoners were thrown down it and then left to rot.

Not surprisingly, given Marple Hall's connection with the regicide Judge Bradshaw, the house was reputed to be haunted by the ghost of King Charles I. He was said to wander round with his head under his arm, though no one in recent time had actually claimed to have seen him. But, in later life, Christopher Isherwood stood by a story of another alleged encounter with the Other Side. While Frank and Kathleen were visiting Oxford with Emily on one occasion in 1907, Nanny took Christopher to stay at Marple. He slept in a large north-eastern room, full of heavy Victorian furniture, which had been designated as the nursery. Each night that he was there, Christopher awoke to confront a sour-faced, muzzy old woman he described in detail to his credulous Nanny. She herself saw nothing, but did feel a peculiar presence in the room, and sometimes woke up there in a sweat. Back at Wyberslegh, on Frank and Kathleen's return, the story was duly recounted, but was dismissed by Christopher's parents as fanciful nonsense.

A few weeks later, when Frank and Kathleen went travelling again, this time to Spain, Christopher was once more taken over to Marple and put in the same room. On the evening of October 29, the adults downstairs were alarmed by a shuffling noise and deep sighing out on the terrace. A moment later, Christopher's voice was heard from the anteroom of the servant's hall, calling for Nanny. When she ran to fetch him, he told her that Frank (who was of course hundreds of miles away) had come into the room, switched on the light and carried him downstairs. When Nanny took the boy back upstairs, she found the door of the nursery would not open. A light shone through the crack under the door and she thought she could make out a shadow moving about inside the room. Jack Isherwood, who happened to be visiting, was summoned from downstairs. When he tried to force the door, he found it blocked by a chair jammed between it and a chest of drawers. Yet when they did finally manage to get inside they found no trace of anyone.

These strange doings were also later reported back to Kathleen and Frank, who this time took them seriously. Most of the Isherwood family was convinced that it all had something to do with an eighteenth-century ancestor of theirs, Moll of Brabyns, who was dispossessed of Marple Hall when the husband of her childless marriage died and the property passed to her brother-in-law. She was said to have resented the loss of Marple so bitterly

that she came back to haunt it. The last people who reportedly saw her were aunts of John Isherwood's, in the early nineteenth century. Brushing aside any more human explanation for Christopher's strange sightings, the Isherwoods decided that Kathleen must have reactivated the ghost when she had a portrait of Moll of Brabyns which hung over the staircase taken down so she could copy it. Oddly, the family's acceptance of the reality of Christopher's ghostly experience did not stop them putting him back in the same room to sleep at Marple that Christmas. However, when several years later Christopher's younger brother Richard reported seeing the same old woman in the room, Kathleen hastily removed him. Unhappily for the continuity of the story, Richard later confessed to Christopher that it wasn't Moll of Brabyns that he had seen at all, but a headless dummy.

One frequent terrestrial visitor to Cheshire at that time was Emily Machell-Smith, who had in fact been at Wyberslegh Hall for Christopher's birth. The family saw more of her after Frederick Machell-Smith's death. Posthumously, he had added even more bitterness to his tally with Frank. For at the height of Mr Machell-Smith's opposition to Kathleen's marriage he had cut her out of his will, and never had this reversed, despite intimations that he would. After his death, Emily soon moved out of the South Kensington flat and installed herself in one in Buckingham Street just off the Strand, near Charing Cross Station, on the doorstep of London's theatreland. There she received her numerous callers stretched out grandly on a chaise longue.

In October 1907, between Christopher's two encounters with the Marple apparition, came some unexpected and most unwelcome news. Uncle Henry announced he was getting married. The young lady in question, Muriel Bagshawe, turned out to be a delightful creature, sympathetic in manner and with an assured private income of £5,000 a year – then a very useful sum. After her initial shock, Kathleen – who had every reason to resent the intrusion of this agent of Christopher's likely disinheritance – took a great liking to Muriel. Besides, she asked herself, how could everyone have been so silly as not to realise that Henry, like all men, needed a woman in his life? Henry had last seen his bride-to-be three years previously while on a tour of Egypt, where he had proposed unsuccessfully (a fact he had not confided to his family). Miss Bagshawe subsequently had a change of heart and, in 1907, proposed back. The wedding was in London at the end of November, while Kathleen and Frank were away in Spain. Christopher attended the ceremony with Nanny and his grandfather. Henry, perhaps in recognition of Muriel's money, added her surname to his own, finding nothing ridiculous in his new triple-barrelled signature Bradshaw-Isherwood-Bagshawe.

Henry and Muriel gave a large dinner at Marple Hall on their return from

11

a continental honeymoon in January 1908. Christopher, then aged three and a half, amused some of the guests in a side-room by giving a precocious little speech beginning: 'Ladies and Gentlemen, I rise on this auspicious occasion . . .' In contrast, Frank and Kathleen caused immense offence by not being present at the dinner, preferring to stay over at a friend's house-party near Macclesfield. They then added insult to injury by arriving at Marple the morning after.

However, Frank was preoccupied with more serious considerations than trying to smooth his brother's ruffled feathers. His Stockport adjutancy was coming to an end, and he was required to rejoin his old regiment in York. He spent some time house-hunting on the other side of the Pennines before settling on a cottage in the village of Strensall, a few miles north of York. Kathleen looked on the move with as much enthusiasm as she would have had for a funeral, commenting melodramatically in her diary: 'It seems like the passing away of Romance and Youth!'

Kathleen never took to Strensall during the family's brief stay there. And Christopher was too young for it to make much impression. But he did later recall being taken to York Minster one day by John Isherwood, when the old man was over on a visit and showed Christopher the regimental flag there that he had carried when a raw young officer.

Shortly afterwards, Christopher was taken to stay at Nether Hall with Great-Uncle Walter Greene, who amused the young child with his practical jokes. The most sophisticated of these was a stuffed rabbit, which a concealed gamekeeper would drag across the lawn on a wire. This stunt was usually timed for the hour when the house-guests assembled for tea, whereupon Walter Greene would cry: 'There's that confounded rabbit again!', race into the gunroom to grab a firearm, and then blaze away from the window. Christopher liked his great-uncle enormously and himself retained a taste for practical jokes and pranks into later life, to the intense embarrassment and annoyance of some of his friends.

In November 1908, Frank, Kathleen and Christopher were on the move again, this time to Aldershot in Hampshire, England's largest military base. But at Christmas they were back at Marple Hall. Christopher was taken to see Uncle Henry and Aunt Muriel, who were living nearby. To Frank and Kathleen's dismay, Henry had had the family settlement on the estate altered, so that now a daughter of his union with Muriel could inherit, and not just a son as was the case before. As it turned out, though, such precautions were unnecessary, as Henry's marriage, which was in many ways a failure, was without issue, thus guaranteeing Christopher his inheritance.

By the time Christopher was four and a half, he had become a keen director

of toy theatricals of a rudimentary kind. Christopher's 'actors' were china animals and other handy ornaments, and his earliest 'theatre' was a shoe box artfully converted by Frank. Over the next few years, the boy spent countless hours engrossed in his toy theatricals, in a series of ever-more sophisticated settings. What his earliest productions lacked in subtlety, they made up for in enthusiasm. In fact, he became so over-excited by some of his own toy dramas that Kathleen sometimes had to send him to bed to calm him down. For Christopher, this burgeoning world of the imagination was far more interesting than the prospect of playing with other children.

He also loved dressing up. Like many little boys, he found his mother's wardrobe more exciting than his father's, and Kathleen did nothing to stop him kitting himself out in her finery. On the contrary, she obviously enjoyed the game, wrapping him with her silk petticoats and furs, and showing him how to clasp on her 'switch' – a hair-piece made from her own hair – which could be used to give more body to fashionably elaborate coiffures.

Kathleen's diary records that Christopher dictated his first story to her in November 1909, when the family was up at Marple yet again, this time for Bonfire Night. The story – long since lost – was called 'The Adventures of Mummy and Daddy', but seems to have been mainly about himself. To Frank's growing disapproval, the lad was becoming something of a show-off, who liked to be the centre of attention.

Back at Aldershot, there was great excitement when Christopher saw his first aeroplane in May 1910; nearby Farnborough was a pioneering base for flying. Another welcome novelty was the arrival of Frank's younger brother Jack Isherwood, who settled nearby after leading a moderately Bohemian life in London amongst writers, artists and musicians. Jack Isherwood was an extremely competent amateur musician himself and was a close friend of the composer Cyril Scott. In his autobiography *My Years of Indiscretion* Scott recounts delving with Jack Isherwood into various esoteric philosophical and health practices, such as hatha yoga, spiritualism, vegetarianism and cold-water cures. In Hampshire, Jack still kept himself healthy by sluicing his system out once a week with a stomach-pump. He undoubtedly talked about such matters with his brother Frank, given Frank's own penchant for things Oriental. And even if Christopher was presumably usually confined to the nursery on such occasions, and would have been too young to really understand what the two men were talking about anyway, it is hard to escape the conclusion that his own later searching for enlightenment in Eastern traditions must have been given some impetus by his father and his Uncle Jack. Christopher developed a deep admiration, verging on hero-worship, for this handsome, reckless uncle, with his rich sense of humour and zest for

life – all carried on, incidentally, while earning a living as a perfectly competent government lawyer.

Frank, meanwhile, had started teaching Christopher elementary French. In common with many upper-middle-class households, Kathleen and Frank had the rather nasty habit of conversing in French at the dining table when the servants were in the room, so the servants could not understand what they were talking about. This was despite the fact that Kathleen's French was sadly wanting. As a language, it was only just beginning to come back into fashion in Britain, replacing the German that had been the favourite foreign tongue of the Victorians. Frank also aided his son's reading progress by producing a daily, illustrated journal for him called 'The Toy-Drawer Times'. This gradually evolved into a comic strip, eagerly awaited by Christopher. Time spent with his father thus became something to be looked forward to, even though Christopher sometimes found himself the victim of Frank's pent-up rage, when he had been particularly slow or stupid in learning something Frank was trying to teach. On such occasions, Frank would shake the boy until his teeth rattled, a sensation Christopher later claimed to have enjoyed.

Kathleen, meanwhile, concentrated her efforts on instruction in written composition, having realised that young Christopher shared her natural instinct to note things down. During the winter of 1910–1911, they produced together a tiny handmade book – not surprisingly more Kathleen's work than her son's – entitled 'The History of My Friends'.

It was while the family was living in Aldershot that Christopher had his first experience of erotic fantasy. He later recalled playing with himself while dreaming of lying wounded on a battlefield, his clothes half torn off, as a woman gently administered to him. His homoerotic fantasies developed later.

In May 1911, Christopher was sent to school for the first time, to a one-hour-a-day institution of the kind usually referred to as a dame-school – except that this one was run by a man, a Mr Penrose. In it, five little boys were taught the three R's. According to Kathleen, Christopher already wrote very nicely, but was behind in reading, despite Frank's noble efforts. Both parents continued their at-home instruction, though; at this time, Kathleen initiated Christopher into the delights of classical theatre by reading to him from that hugely popular book for children, Charles and Mary Lamb's *Tales from Shakespeare*. At Mr Penrose's school, Christopher began to make friends of his own for the first time, and Kathleen was happy for him to invite them home.

Frank was aware, however, that Aldershot and the life of an army wife really did not suit Kathleen. On several occasions he tried to find some appropriate employment in civilian life which would enable him to resign

his commission. Hoping to get settled nearer his old home – perhaps even returning to Kathleen's beloved Wyberslegh – he tried for a position with the Cheshire Constabulary, but was turned down. Whatever qualities Frank had, he was not adept at impressing prospective employers. Although he joked about the possibility of scraping a living as a professional artist, having sold one of his watercolours for ten shillings (50p), he knew that he could not support a family with such a life, especially now that Kathleen was pregnant again.

Kathleen viewed the prospect of another child with some misgivings. She was nearly forty-four years old, and Christopher's delivery had not been easy. To make matters worse, Frank's regiment was due to be transferred to Limerick in Ireland in late September, just when the new baby was due. Frank's efforts to delay this posting were initially fruitless. He had just been promoted to the rank of major, and his commanding officer insisted on having a major with him in Limerick from the beginning. No stand-by or replacement for Frank seemed feasible.

Frank consulted his mother-in-law about his dilemma, and Emily advised him to retire from the Army while he was still young enough to find decent civilian employment. Accordingly, he sent in his papers. But in August 1911 a transport strike led to widespread civil unrest in England and confrontation between workers and the Army. Frank's loyalty was firmly to the cause of authority, as it resisted the clamouring demands of the rising working class. After all, he reasoned, if one gave the agitators an inch, they would take a mile.

The War Office then refused to accept Frank's request for retirement unless he agreed to enter the Militia for five years. That was clearly impossible if he were to adopt a new full-time civilian profession. None the less, another major was found to stand in for him during the first few weeks of his regiment's posting to Ireland, so at least he was able to be around for Kathleen's safe delivery of his second son, Richard, who was born on October 1, 1911. Christopher was delighted with the appearance of this strange little creature, and took advantage of Richard's first airing in the garden to decorate him with flowers. Frank then joined his regiment in Limerick, leaving Kathleen and the two boys behind.

That December, Kathleen took Christopher down to London to stay with Emily, who gave him his first outing to a theatre. This was a variety show at the Coliseum, a spectacular production during which a real motor-car and a coach with live horses appeared on stage. He also relished the Christmas displays in the big department stores along Oxford Street – a child's wonderland of ingenious models and miniature historic tableaux, depicting

such scenes as the frozen Thames criss-crossed by runners bearing sedan chairs.

Christmas itself was once again spent at Marple, where Christopher received his most sophisticated toy theatre yet: a German or Swiss model, complete with cardboard figures representing the romantic heroes and villains of great Teutonic dramas. There were just two standard sets: a banqueting hall, and a clearing in a pine forest. Their gloom and Christopher's temperament led to a series of positively Wagnerian productions, eerily lighted by candles placed in the wings. When Kathleen and the boys joined Frank in Ireland in the first week of January 1912, Frank taught Christopher how to simulate lightning by blowing resin through a tube into a candle-flame. Henceforth there were thunder-storms in every play.

In Limerick, Kathleen started a weary house-hunt. But the seventeenth place she visited, Roden House, was just what she was looking for. It was a sizeable dwelling protected from the bustle of the town by high walls. A long glass veranda ran along its length, while upstairs there was a maze of little passages and doorways. Some of the windows looked over to the barracks where Frank's regiment was stationed. Fine ornamental urns topped the crumbling pillars that supported the house's iron gate.

Christopher started school in Limerick almost immediately, being one of several little boys registered at the local girls' high school. He did well at this school, and enjoyed it. Saturdays and Sundays were both free to accompany his mother on her explorations of the town. On Sundays, after church, they would often go to the old-fashioned market-hall, with its Doric pillars, where they could look at the traders and the farmers' wives in their colourful head-scarves leading donkey carts. Pleasant walks took them quickly out to meadows, where they could look back to the cathedral towers dominating the little city.

Far from being overshadowed by this contact with a new world, Christopher's passion for toy dramatics began to take on truly epic proportions. In July 1912, he announced a Shakespeare Week, reading extracts from the Bard's works, liberally edited, in which various china animals took on the roles. A rabbit was cast as Lady Macbeth. Notices announcing the current production were pinned to the nursery door, and his parents, as well as Nanny, were expected to attend every performance. Fortunately, in Christopher's truncated version, even *Macbeth* only took a quarter of an hour, including all the blood-curdling sound effects. Christopher took these shows extremely seriously and was deeply offended if anyone laughed in the wrong place. His parents indulged him up to a point, but sometimes Frank lost his temper at Christopher's showing off.

Even so, Frank was pleased that his son seemed in some way to be taking after him. Until the move to Limerick, Christopher had not been allowed to stay up to see Frank in one of his amateur dramatic roles. But once he had seen some, he wanted to be an actor, like his father. He even wrote his first 'play', which took the form of a melodramatic scene in which a woman reads a letter telling her of her son's death, after which she falls into a swoon. As Christopher had learnt from his grandmother to idolise Sarah Bernhardt, this playlet was written in French, and was entitled *La Lettre*. It was banned one memorable morning when he marched into a room full of guests and gave an impromptu performance without permission.

Sometimes Kathleen would take Christopher over to the barracks to watch the soldiers drilling on the parade ground. This served as a reminder that life was not all fun and games at Limerick. In the eyes of the Irish Republicans, the British Army was an occupying force, denying them their right of self-determination. Tension could be felt in the town beneath the surface calm. Even the children seemed infected by it. Kathleen complained in her diary: 'The Irish seem *hopelessly* lawless, and murders are overlooked in a way to make an Englishwoman's blood boil.' She called in the police to see about local ragamuffins who ran up and banged on the front door of Roden House, or who sneaked into the garden to steal fruit and flowers. In keeping with the practice of other Army families, she had to vet which children she considered it safe for Christopher to play with. He was anyway rather wary of the Catholic children in the neighbourhood, who tended to shout 'Dirty Protestant!' at him as he walked down the street.

In the autumn of 1912, rioting in Limerick led to the smashing of shop-windows and other damage. The Protestant Archdeacon was chased out of his house by a mob and cut about the face. Peace was only restored by the intervention of Catholic priests. Until the Easter Rising of 1916, though, such open violence was relatively uncommon, and the insecurity in Limerick seems not to have bothered Christopher one jot. As he recalled more than half a century later, with more than a touch of romantic hindsight, in *Kathleen and Frank*, he:

> took the hostility of the street boys for granted, as part of daily life, along with the caressing foreign charm of their eyes and voices, the music of their accent, the filth of the picturesque lane and the stink of sewage in the puddles and the gutters. (p 269)

In late September 1912, Christopher was taken to the cinema for the first time, so beginning a love which was to surpass that of the theatre and become

one of the most important aspects of his life. The silent-film-makers had already learnt the art of winning faithful young audiences by producing adventure serials in weekly episodes that ran for months and months. Often, out of economy, bits of footage would reappear at various stages of these marathons, whose plots relied more on brash excitement than imagination. None the less, Christopher was captivated. Apart from the serials, there were newsreels, the more patriotic ones eliciting howls and whistles from the Limerick audience. And then there were the full-length feature films, which introduced Christopher to the Keystone Kops, and silent movie stars like Dorothy and Lillian Gish and Mabel Normand.

The family went on leave to England at the end of November and stayed there till February 1913. Frank and Kathleen travelled round the country, visiting friends and relatives, while Christopher and Richard were installed with Nanny at Marple Hall. Frank's sister Mary (Auntey Moey) was also there. She wrote children's books of high moral tone, which were published by the Society for the Promotion of Christian Knowledge. She was by then a sick woman, with a melancholy temperament, and was rather masculine in appearance, so she offered little of attraction as a companion for a young boy. Moreover, Richard was still too much of a baby to be a playmate; in fact, the two brothers didn't really get to know one another until much later on in life.

Back in Limerick, Christopher changed schools, ostensibly to give him the chance of getting to know more boys. This is a bit puzzling as there were only seven pupils at the school *in toto* and two of those were girls. Anyway, if Frank's idea was that Christopher should get into a few character-building scuffles with fellow pupils, the boy duly obliged. But 1913 was a restless year for Christopher's family. Kathleen was twice called over to England to tend to Emily and, in early August, when Frank had to go on manoeuvres, she went again, taking the boys over to Marple Hall.

Kathleen felt a growing political tension when they got back to Limerick that autumn. Probably the unease this caused was one reason why his parents decided to send Christopher away to school in England, though that was anyway common practice among army families. It was believed that that way the children would get a better education than was considered available in Ireland. And they would be better prepared for the inevitable day when their fathers would be posted back home.

So, when the Isherwoods made their usual pilgrimage to Marple at Christmas 1913, they took time off to look over a few preparatory schools. They settled on St Edmund's School in Hindhead, Surrey, which was run by relatives of theirs, Cyril Morgan-Brown and his sister Monica (Mona). With

the prospect of life at a boarding school looming, Christopher declared that he no longer needed Nanny to sleep in his room at night, and decamped into Frank's dressing-room armed with a torch, a supply of books and a clock.

Christmas 1913 was exactly as tradition dictated. Thick snow around Marple enabled Christopher to go out tobogganing. On Christmas Day itself, the midday family dinner, after church, consisted of roast turkey, a blazing plum-pudding and champagne. Christopher played happily with his presents, which included an electric dynamo, a Meccano set and a box of conjuring tricks. But whatever uneasy feelings Kathleen and Frank may have had about what the New Year would hold for them in Ireland, nobody present could have realised the scale of the tragedy that would sweep across Europe, shattering their own family life.

2

1914–1923

C hristopher left Ireland with Kathleen on April 23, 1914, travelling via Marple to London, where they stayed a week at Emily's flat. This took on a role it was to have throughout Christopher's schooldays, as a holiday base-camp from which to make forays into the world of cinemas, theatres and bookshops. Christopher loved the flat, with its feminine decor of pale marble, alabaster, gilt frames and fabrics in pink and sky-blue. The walls were almost obscured by Emily's collection of etchings and water-colours, many depicting foreign scenes which aroused wanderlust in her grandson. Emily herself would usually be stretched out in an alcove, protected from draughts by a series of screens, swathed in furs and strongly perfumed. In front of her, on a table, would be a bottle of champagne or vials of homeopathic medicine, in which she was a staunch believer.

On May Day, Cyril Morgan-Brown was waiting at Waterloo Station to escort a group of boys to St Edmund's. He struck Kathleen as being dazed and incapable and indeed his dreamy disposition made him the subject of considerable ribaldry behind his back at school. Three days later, his sister Mona wrote to Kathleen to reassure her that Christopher was settling in well and that she was keeping an eye on him. This didn't stop Kathleen going to the school herself a few days after, just to make sure.

St Edmund's was a late-Victorian country house, near the village of Hindhead, on the London to Portsmouth road. It was set in nearly thirty acres of hilly grounds that were a wilderness of trees, gorse bushes and long grass. In *Exhumations* Isherwood later described it, with characteristic subjectivity, as:

an aggressive gabled building in the early Edwardian style, about the size of a private hotel. The brickwork is varied here and there with sham frontings of criss-crossed stucco. In the foreground is a plantation

21

of dwarf conifers, such as are almost always to be seen in the grounds
of better-class lunatic asylums. (p 194)

George Bernard Shaw had lived in the house for a few months in 1899, just
prior to its conversion into a school. St Edmund's School had in fact been
founded a generation earlier, in Norfolk, by Cyril and Mona's father, the
Reverend John Morgan-Brown. Divinity continued to have an important place
in the curriculum and after showing a desultory interest in the subject at first,
Christopher surprisingly went on to win several of the school Divinity prizes.
There was compulsory chapel twice a day, as well as private prayers. Latin
and Greek were stressed in the teaching, as were French and maths. But
English literature was meant to be picked up in passing as an adjunct to
history and geography. Music of a traditional kind was prominent and a grand
piano dominated the school's spacious drawing-room. The music mistress
was a young woman who was going deaf and who rapped pupils' knuckles
with a large red pencil when they made mistakes. The boys wondered how
she could tell.

The headmaster, Cyril Morgan-Brown - nicknamed 'Ciddy' by the boys
- was a shambling man with grey hair and a large floppy moustache. He
had once been handsome, but had distinctly gone to seed. Visitors to the
school who did not know him tended to assume he was the odd-job man.
None the less, he was an accomplished classical scholar who tried to impart
to his wards the values of a Victorian gentleman. Honesty, forthrightness,
thoroughness and perseverance were all endlessly lauded.

Christopher got on well with Cyril's sister Mona, who unfortunately left
at the end of his first term, after war had been declared, to run a soup-kitchen
in London's East End. But he did not appreciate 'Ciddy' at all. The dislike
was mutual, as the headmaster found Christopher a bit of a know-all,
supercilious, lazy and a chatterbox. Christopher would be sure to be among
any boys tearing round the corridors noisily, yet he demonstrated what to
Cyril Morgan-Brown was a lamentable contempt for team sports.

Cyril's unmarried daughter Rosamira ('Miss Rosa') also taught at St
Edmund's. She was an attractive, energetic young woman who once lost her
temper at Christopher's insolence and gave him a resounding slap. From this
he deduced that she too did not like him. When she read this judgment more
than fifty years later, in a piece in *The Times Saturday Review*, she wrote
Isherwood a gentle letter of reproach, saying that had been far from the case.

It was probably not a good idea to send Christopher to a school run by
relatives, as this puts undue strains on the normal teacher–pupil relationship.
In such situations the teacher may be frightened of being accused of showing

favouritism and may therefore over-compensate by emphasising a sense of distance, while the boy himself may be regarded with distrust by his schoolmates, who suspect him of being in league with authority. Kathleen came to regret sending Christopher to St Edmund's and was quite scathing in her later appraisal of both Cyril and Rosa Morgan-Brown.

The school had ample sports facilities, including an outdoor swimming-pool where the boys bathed naked. Isherwood later claimed that he loved the physical excitement of wrestling at the school, and particularly enjoyed being knocked about in boxing. But to the despair of the master in charge of games, Ivor Sant, young Christopher was a complete dud at cricket, in which he found no sensual satisfaction.

Though Isherwood's adult recollections of St Edmund's were almost entirely negative, at the time Christopher gave the impression of coping well. His letters home, written under supervision at a Sunday ritual at which suggestions of news were written up on the blackboard, show no undue strains. His clowning helped avoid the unpopularity among the other boys that might have resulted from his affectations and his lack of physical prowess, and he began to make friends. Most of these came from a similar background to his own, and he took great delight in recounting to them the more sensational parts of his family history and the more ridiculous foibles of his poor old Isherwood grandparents.

Though the educational goal at St Edmund's was to produce disciplined, upright, God-fearing youths, there was plenty of time for fun. After all, the property had been especially selected because of the wildness and accessibility of the local countryside, which offered countless thrilling walks. Returning from these without soiling the school uniform of dark trousers, jacket and Eton collar was a serious challenge. Once the local newspaper recorded proudly that St Edmund's boys had put out a bush-fire in the nearby Devil's Punch-bowl while out on one of their walks. But it neglected to mention that the boys had also started it.

Kathleen was back in England again in July 1914, to fetch Christopher home for the summer holidays. No sooner had they arrived in Limerick than mobilisation began. The following day, August 4, war was declared. The Anglican Church proclaimed that God was on England's side and the Dean of Limerick cheerily informed his congregation of soldiers that their widows would be well looked after. He called at Roden House the next day and expressed his sorrow that perhaps half of the men who had attended that service would never return. Sadly he was to be proved right.

Frank left for England on August 14. Christopher was not yet of an age to understand fully the momentous nature of what was happening, so while

Kathleen fretted, he went off to the cinema or played with friends. Everything was very confused in those early days of the war. But soon Frank, who was stationed comfortably at Cambridge, realised it was unlikely he would be sent immediately to the Continent, so he wrote asking Kathleen to join him. Nanny and the boys travelled with her as far as Crewe, and then headed for Marple. Kathleen followed them there when Frank finally received his orders to leave for France, on September 7.

Empty cottages in Marple village were being prepared for the first consignment of Belgian refugees. John Isherwood told Kathleen that she was welcome to use Marple Hall as her home for the duration, as there was clearly no point in returning to Ireland. When Christopher went back to St Edmund's soon after, he found war preparations were well underway around Hindhead too. The common was already occupied by tents and soldiers, most of them kitted out in old-fashioned scarlet as the supply of khaki had run out.

The war was a permanent presence during Christopher's time at St Edmund's, though at first not a tragic one. Frank wrote cheerful letters to him from France, saying how pretty the guns looked when they fired at the German planes flying overhead. Not as yet under any undue pressure, Frank sat back in his trench knitting.

As the war progressed, the army camp on the common near St Edmund's grew immense. Many of the soldiers who came there were Canadians, who became favourites with the boys because they handed out cigarette-cards. Like his fellows, Christopher succumbed to cigarette-card mania and abided by the boys' own rules of only building up sets of cards through receiving individual ones or swapping duplicates with their mates. Sending a shilling or two off to the cigarette company for a complete set, as was possible, was considered unacceptable cheating. Completing a set became an obsession that could dominate a boy's thoughts for weeks. Isherwood captures the mood brilliantly in a short story entitled 'Gems of Belgian Architecture', written in 1927 and reproduced in *Exhumations*. The story also gives a good idea of the peculiar schoolboy slang of the time.

Frank's regiment had its first taste of real war in mid-October, suffering heavy casualties in an attack on Radinghem. Frank began to experience the common battlefront sensation of hardly being affected by the horrors around him, as a means of psychological self-defence. As the nights grew colder, he wrapped his head in old socks, and covered himself with the greatcoats of fallen men.

At St Edmund's, Cyril Morgan-Brown gave rousing speeches to the school assembly about the glorious action going on in Europe in defence of Decency. A few black armbands began to appear, as some pupils' fathers were killed.

Boys wearing them were treated with great respect by the others, but if they wanted to join in rowdy games, all they had to do was to take the armbands off, whereupon they became like everyone else. One poor child, suffering from loneliness, pretended his father had been killed, to gain sympathy and attention. When his lie was uncovered, he was pitched into the gorse bushes – the usual punishment by the boys for serious offenders against their rigid private code of conduct.

On December 21, Kathleen met Christopher at Waterloo and took him back to Marple, where John and Elizabeth Isherwood were celebrating their golden wedding anniversary. The family had to try to make Christmas as joyous as they could in Frank's absence. Meanwhile, at the Front, Allied and German soldiers fraternised with each other in no man's land, taking group photos and making a mockery of the war.

Frank was made a Lieutenant-Colonel in the King's List of February 1915. A few days later he was back in England on leave and Kathleen and he visited Christopher, who had started limping badly. He had suffered chronically for several years from a mysterious leg ailment – worthy of Emily – which seemed to flare up in changeable weather conditions. It may have been a form of rheumatism, or cramp, or simply growing pains; anyway, Kathleen had discovered that the most effective cure was to wrap his leg tightly with a woollen scarf.

Frank had to return to France on March 1 and, on the same day, Christopher went down with measles. The disease ran through the school like wildfire, and Kathleen was warned to stay away. When she heard he had developed a touch of pneumonia, she went to the school and at the end of the month had him transferred to Ventnor on the Isle of Wight, to convalesce. The sea air did indeed prove beneficial and he quickly began to improve. But on April 9 Kathleen herself broke out in a measles rash; fortunately it was a very mild dose.

Christopher was meant to return to St Edmund's on May 3, but by then he was laid low with new ailments; both his legs were now stiff and he had lumbago in his back. The pain moved to his big toe and the doctor ordered him back to bed.

Kathleen's anxiety was heightened by her fears for Frank, now at Ypres, where casualty figures were mounting by the thousands. On May 8, the York and Lancaster Regiment was ordered to retake some trenches lost during the previous night. In the subsequent attack, practically every officer present was put out of action. Frank was posted as missing.

A few days later, Kathleen received a telegram from the War Office telling her her husband was believed wounded. This initiated a long and agonising

search on her part for more information. Conflicting reports from soldiers on leave or in hospital only increased her concern, as each new story proved to be false. For six weeks, she followed up every possible line of enquiry in London, while Christopher and Richard were happily ensconced at Marple, oblivious to her growing despair. At the end of June, the British Red Cross wrote to say that Frank's identity disc had been found, after which all real hope for his survival evaporated.

John Isherwood offered Kathleen the chance of moving back into Wyberslegh Hall, whose tenant had recently died. But she felt she could not bear living there without Frank, and made Emily's London flat her new base. Throughout the summer, though, she journeyed back and forth between London and Marple with Christopher. Her diary records that she found his sweet disposition a great consolation.

In mid-September, after nearly six months away, Christopher returned to St Edmund's to find his status dramatically changed. He was now the son of a dead hero. From the boys came half-comprehending sympathy, while the teaching staff were full of extravagant condolences, mixed with lectures about the pride he should be feeling at his father's noble end. But quickly the sympathy from the masters was transformed into reprimands, as they reduced the boy to tears by accusing him of not living up to Frank's example. Every slight misdemeanour was pounced on as evidence that he wanted treacherously to aid the 'Huns'.

Frank's posthumous role in Christopher's consciousness grew like a cancer in the boy's teenage years, becoming a source of great mental conflict. He had only happy personal memories of his father, so it disturbed him greatly that Frank was now being used as an instrument of reproach by people who he was beginning to despise. Gradually Christopher developed an acute adolescent disrespect for the Establishment, as represented not only by the school authorities and the Church, but by adults in general. This was however a far slower process than is suggested in some of Isherwood's later writings. There was no blinding flash of realisation about the perfidy of the older generation, or about the hollowness of accepted British values. Such perceptions came in stages, and largely through the intermediary of a number of crucial figures who influenced Christopher's development.

The first, and therefore in many ways the most significant, was a grubby little boy at St Edmund's called Wystan Auden. Auden arrived at the school aged eight in 1915, though Christopher didn't get to know him properly until 1917. By that time Auden – over two years younger – had caught him up. Even in a comparatively small school like St Edmund's, with only about fifty boys, there was no reason for Christopher to have paid much attention

to such new small fry, but Wystan Auden was no ordinary boy. His precocity quickly became a legend. He was called Dodo Minor, for no better reason than that Dodo was the nickname of his bespectacled older brother John, who was also at the school. Their father, George Auden, was Schools' Medical Officer in Birmingham, where he lectured at the University and pursued his leisure interests as a classicist and antiquarian. The family had Icelandic ancestry and the young Wystan showed a temperament that seemed imbued with the epic darkness and symbolism of the sagas. He had also learnt how to command attention. On arrival at St Edmund's, he is said to have announced to the school matron that he was looking forward to the experience because it would give him the opportunity of studying the different psychological types represented there.

Wystan had the good fortune to come from a home where intellectual pursuits were actively encouraged. There were plentiful books in the house and music was a common pastime. He had the even greater advantage of landing firmly on his feet at his prep school. Rosa Morgan-Brown took an immediate liking to him, whilst among the boys he made friends easily. Sharing Christopher's dislike for organised sport, Wystan made up for this defect by his ability to entertain and shock. He played the piano with great gusto. And he dazzled people with the extent of his esoteric knowledge. Even at this tender age, he delivered his pronouncements with terrifying finality.

In his early autobiographical work, *Lions and Shadows*, Isherwood recalled the 1917 Auden – 'Hugh Weston' – as:

a sturdy, podgy little boy, whose normal expression was the mislead-ingly ferocious frown common to people with very short sight. Both the brothers had hair like bleached straw and thick, coarse-looking, curiously white flesh, as though every drop of blood had been pumped out of their bodies. (p 181)

Auden returned the compliment by remembering that his first image of Isherwood was of a small boy with an enormous head and large eyes, who was busy copying the work of the classmate sitting next to him. Yet Wystan saw that there was more to Christopher than a barefaced cheat. While the two boys were out on a school walk one day, Christopher made a deep impression on him by making what Auden later said was the first genuinely witty remark he had ever heard, commenting gravely: 'I think God must have been tired when He made this country.'

At this time, Wystan wanted to become a mining engineer. His play-box was full of fat geology handbooks borrowed from his father's library, and

his conversation reflected half-assimilated scientific knowledge culled both from these and from his brother John, who went on to become a distinguished geologist. Wystan would suddenly come out with long Latin names, horribly mispronounced but none the less very impressive. Even more appealing to his contemporaries' adolescent hunger for worldliness were his hints of biological secrets of breathtaking import. For Wystan had found the key to the locked bookcase in which Dr Auden kept his German illustrated anatomical manuals, enabling Wystan, in the garden of innocence that was St Edmund's, to initiate the other boys into the mechanics of sex. He would draw explicit diagrams on the blackboard, extemporising those details he did not know for sure, while pointing out the most important organs with his ink-stained, nail-bitten hands.

Meanwhile, it was Christopher, rather than Wystan, who was starting to make a mark as a schoolboy poet. To encourage a healthy war spirit, boys at St Edmund's were asked to write poems in a suitably jingoistic vein. In April 1917, Christopher produced a sturdy piece, with apologies to Lewis Carroll. The first two verses ran:

'You are old, Father William,' the Crown Prince said,
'And your hair has become very white,
And yet you incessantly can't go to bed,
Do you think that at your age it is right?'

'In my youth,' Kaiser William replied to his son,
'I slept every night without pain,
But now that I think of the crimes we've done
I shall never slumber again.'

But Christopher's mind was also starting to turn towards fiction, even if nothing came of it as yet. Out on the cricket field, while the others were busy with the game, Christopher collaborated with Wystan's best school chum Harold Llewellyn Smith in planning a long historical novel which was set in a barely disguised Marple Hall. Sixty years later, Harold Llewellyn Smith still recalled Christopher's 'luscious' descriptions of tapestried galleries, where suits of armour alternated with shelves of leather-bound books, 'inlaid with great lozenges of velvet'.

According to Rosa Morgan-Brown, Christopher left St Edmund's in a blaze of glory, having managed to win the form prize in both his final years. She for one expected great things of him. It was a natural progression for him now to go to a reputable public school and, on the advice of Jack Isherwood,

who had studied at Repton, Kathleen sent Christopher there. Had she wanted to keep her son's education in family hands, she could have put him in the care of cousin Charles Henry Greene, headmaster of Berkhamsted, where he would have been a contemporary of Charles Henry's son Graham Greene. And, in fact, she did send Richard to Berkhamsted in the autumn of 1919. By keeping the brothers apart, however, Kathleen probably did Christopher an enormous favour.

He arrived at Repton in January 1919, to discover a much grander institution than St Edmund's. The school was founded in the reign of Mary Tudor and still dominates the Derbyshire village of the same name. Repton's main street leads through an archway into the school grounds, where a variety of dark stone buildings reflect the different architectural styles employed in its gradual construction. The oldest building is The Priory, built in 1172, and the school itself has a long ecclesiastical tradition. Geoffrey Fisher, the headmaster in 1919, went on to become Archbishop of Canterbury, as did his predecessor William Temple and one of the boys who entered the school in the same year as Christopher, Michael Ramsay.

Geoffrey Fisher was also Head of Hall, the largest of the school's houses, into which the boys were divided. Hall was Christopher's house, which meant he was under Dr Fisher's watchful eye. Although the headmaster was a strict disciplinarian, he was also a kindly man, with a well-developed sense of humour, and a down-to-earth manner. He did, however, have rather traditional views. About eighteen months before Christopher arrived at the school, there had been a show-down between Dr Fisher and a radical young master called Victor Gollancz, who had been posted there as a form of wartime service. Gollancz and a colleague unwisely produced a publication called *A Public School Looks at the World*, which outraged other more conservative members of staff. The two offenders were dismissed and Gollancz was sent out to Singapore, before embarking on a successful career in publishing, including that 1930s literary landmark, the Left Book Club.

Although his stay at Repton was brief, Victor Gollancz left one significant legacy: a debating society for sixth-formers, called the Civics Class, to which distinguished visiting speakers were invited. The Civics Class had been disbanded on Gollancz's demise, but was resuscitated in the Michaelmas term of 1920. One speaker that year, for example, was Gilbert Murray, on the League of Nations. The older boys were thus encouraged to widen their horizons beyond the introspective worlds of school and family.

Christopher was already fourteen by the time he got to Repton, so he missed out on the trials that many smaller boys face when trying to come to terms with life in such a community. He was even spared the worst

torments of 'fagging', the practice whereby young boys at public school are obliged to run errands or do chores for older ones, forever running the risk of physical punishment or humiliation for real or imagined deficiencies. Christopher's 'fag-master' was a happy-go-lucky chap, who was head of the house but did not abuse his position. Thus Christopher, unusually, escaped being beaten.

Equally unusually, considering how rampant homosexuality was – and is – in so many boys' public schools, Christopher had no sexual experience while at Repton. This is despite the fact that his contemporary in Hall, the future poet Vernon Watkins (whom Christopher did not really get to know until university), told his own biographer Roland Mathias fifty years later that he had only survived sexual assault at Repton by the strength of his stomach muscles. Only too aware of the temptations facing four hundred boys at various stages of puberty, the school authorities tried to prevent what tended to be known as 'unhealthy relationships' by forbidding contact between boys from different houses until they reached the sixth form. Each housemaster was expected to keep an eye on any unduly close friendship evolving within his domain. The idea that this should be part of the training of future Archbishops of Canterbury appealed to the adult Isherwood's sense of the ridiculous.

Such control by the school authorities did not prevent Christopher developing a series of romantic crushes on boys. These were often those who showed talent on the playing-fields he otherwise so despised. Nor were such passions limited to school terms. One youth who made a particular impression was a long-legged, blond hockey-player in Cheshire, whom Christopher incorporated into a suitably literary fantasy based on *Wuthering Heights*, in which Christopher was Heathcliffe and the hockey-player Catherine Linton. As Isherwood recorded in *Kathleen and Frank*, he would ride his bike over the hills around Marple – not far distant from the real Brontë country – dreaming of death and despair and hopeless love.

However, it is doubtful that Christopher confided such feelings to the tough young Liverpudlian youth called Pepper whom he paired up with at Repton. Christopher provided the Salt in this unlikely duo, as his by now caustic wit was the ideal counterpart to Pepper's brawn. He demolished one particularly unctuous lad by giving him the nickname 'Lubricant', which he was stuck with till the end of his schooldays.

Christopher's early academic performance at Repton was unremarkable. He ploughed in both maths and science, but continued to show an aptitude for Divinity. Dr Fisher prepared him for confirmation into the Anglican Church, and although Christopher was already having doubts about his faith,

he went through with it. He later saw this as a terrible indictment of his own weakness of character.

Christopher's real forte at Repton, though, was English. Three times he won distinctions in English in the years 1919 and 1920. His first original composition to appear in print was a frivolous parody of a Sax Rohmer mystery, published in the school's humorous magazine *The Phoenix* in July 1921, in which the plucky English hero goes in search of a tribe called the Obi Gum.

Christopher was also writing poetry, believing, like so many adolescents, that this was the highest art form. Bored stiff by field exercises in the school's OTC (Officers' Training Corps), he would stand around making up verses in his head. After he had learned them off by heart, he would race back to Hall at the end of the field exercise and write them down, even before taking a shower. One such poem was 'Mapperley Plains', a romantic piece in three stanzas, which was considered good enough to appear in an anthology of public school verse published in 1923. Christopher chose the title because he thought the name sounded so appealing, and was rather miffed years later to discover that Mapperley Plains is in fact a singularly undistinguished suburb of Nottingham.

Life at Repton took on a welcome new dimension in Christopher's first year in the sixth form, 1920-1921. This was largely thanks to his history teacher, G. B. Smith ('Mr Holmes' in Isherwood's early book of reminiscences, *Lions and Shadows*). Graham Smith was in many ways an ideal schoolmaster. He started teaching at Repton in 1919 and stayed there seven years, before going on to become headmaster at another fairly distinguished public school, Sedbergh. He was small in stature, with receding, reddish hair, and suffered from a slight but not unattractive speech defect. He was a keen musician and held musical evenings in the house he had had built at Repton. Unmarried and theatrical, in the literal sense of the world, Mr Smith devoted himself whole-heartedly to opening boys' eyes to their own and the world's potential. Christopher fell completely under his spell, and left an affectionate portrait of him in *Lions and Shadows*, which is untypically devoid of any waspishness:

Almost everything Mr Holmes [Smith] did or said contributed to a deliberate effect: he had the technique of a first-class clergyman or actor. But unlike most clergymen, he was entirely open and shameless about his methods. Having achieved his object – which was always, in one way or another, to startle, shock, flatter, lure or scare us for a few moments out of our schoolboy conservatism or prejudice – he would

explain to us gleefully just how this particular trap, bomb or bait had been prepared. (p 10)

G. B. Smith's teaching methods were wildly unconventional for the period. He would make outrageous generalisations about history, to provoke a boy into shooting them down, and to know why they should be shot down. He got to know each pupil's special likes and interests, foibles and weaknesses, and then played on them, to shake the boys out of the state of boredom which is at the root of so much apathetic adolescent behaviour. Not all the boys responded as positively to Mr Smith as Christopher did, however. Some found the man's sense of humour, with its curious dry mixture of academic wit and ruthless cut-and-thrust, disconcerting. Besides, to those who showed no obvious response to his efforts to teach them a love of history, he could exhibit a devastating coldness.

From early 1921, when Christopher was assigned to the History Sixth, G. B. Smith directed all his studies except Divinity and some Classics. As Christopher was by now considered potentially good Oxbridge material, it was decided to enter him for a Cambridge History Award, the examinations for which would be held in the Michaelmas term of 1921. Repton had much closer links with Cambridge than it did with Oxford, and G. B. Smith himself was a Cambridge (King's College) man.

The most striking of Christopher's classmates in the History Sixth was a boy from another house, Latham, called Edward Upward ('Allen Chalmers' in *Lions and Shadows*). Upward was born in Essex, but his family had been connected with the Isle of Wight since the time of Charles I. He was a year older than Christopher, who immediately took a liking to his romantic attractiveness and idealism. From the start, Christopher determined to get to know him well. Normally quiet and broodingly contemplative, Edward would sometimes launch into a tirade against some particularly unjust aspect of the school, which he invariably referred to as Hell. Christopher found Edward's attitude of defiance excitingly challenging and was impressed that he had avoided confirmation by declaring uncompromisingly that he was an agnostic. Slowly, under Upward's influence, Christopher reappraised his own outlook on life and started to adopt many of his friend's damning judgments. To the end of his life, Isherwood considered Upward to be the ultimate arbiter of his actions and his literary output. G. B. Smith became aware of the unusual closeness of the two boys' friendship – which seems to have had no sexual overtones – and dubbed them 'The Mutual Admiration Society'.

The friendship was crucial for the development of both parties. Edward was often shaken out of his disillusionment with life by Christopher's

boisterous enthusiasm for things and people. He loved the way Christopher built up his friends and acquaintances, exaggerating their traits to the verge of caricature, which the people concerned would then sometimes try to live up to. Upward, now known mainly for his trilogy of novels *The Spiral Ascent*, was writing poetry at Repton. He won the Howes Verse Prize for 1920-1921 with a quasi-mystical poem entitled 'The Surrender of the German Fleet at Scapa Flow', which was full of intimations of doom. G. B. Smith can hardly have approved of Edward's essentially anarchic attitude to the school, yet he encouraged him to develop his imagination, and to write down his thoughts. He accepted without sarcasm even the most vertiginous flights of fancy in Upward's history essays.

Most of the boys' writing went on in the library, a haven for sixth-formers at Repton, where silence and privacy were otherwise hard to come by. It was a large, comfortable room, thickly carpeted and furnished with inviting armchairs, like a gentlemen's club. There it was possible to work at leisure with minimal interference from masters, though sometimes a boy who dozed off inadvertently might find himself rudely awakened by a sharp nudge from Dr Fisher, who happened to be passing through. Both Christopher and Edward spent countless hours in the library, dipping into books, studying and writing.

The star writer in the library, though, was a boy called Hector Wintle ('Philip Linsley' in *Lions and Shadows*). Like Christopher, Hector had lost his father; his uncle, the distinguished Harley Street specialist Mackenzie Wintle, acted as his guardian. Chubby and amiable, Hector Wintle willingly shared his considerable literary output with other library users, though it was nothing like as accomplished as the novels he published in later life. During 1921, Hector Wintle was working on a long and tortuous novel called *Donald Stanton*, which Christopher and others would dissect with glee, pouncing on every unintended double entendre or descriptive absurdity. Wintle never shrank from such criticism; on the contrary, it only spurred him on to improve.

The year 1921 brought two important changes to Christopher's family life. In March, his grandmother Elizabeth Isherwood died. And, in the autumn, Kathleen took a lease on a house in London, near Olympia: no. 36 St Mary Abbots Terrace. As Emily had been told by her doctor that the tall stone staircase leading to her flat in Buckingham Street was bad for her heart, she moved in with Kathleen. Nurse Avis (Nanny) completed the female triumvirate of the household that was to be Christopher's home base for several years.

In December, Christopher and Edward travelled to Cambridge together for the scholarship examinations. By now they were talking a private language. This derived most of its earliest inspiration from Edward - with borrowings

from Arthur Conan Doyle and Beatrix Potter. Edward had persuaded Christopher to identify himself completely with his opposition to The Others, The Enemy, Them. The journey to Cambridge was seen as an adventure into The Enemy's territory; the gloom of the Fenland in winter suited their mood perfectly. As the train pulled into Cambridge station, Edward declared solemnly: 'Arrival at the country of the Dead'.

The city itself reinforced their sense of fantasy. They revelled in the dark mystery of the icy fog, the blurred street lamps which greeted them as they emerged after days in the examination halls, the formless shadows of Gothic buildings and the sudden brief appearances of gowned students on bicycles. To confound Christopher and Edward's expectation that people would be out to attack them, everyone in the university was as welcoming and helpful as possible. They were comfortably housed in rooms belonging to undergraduates away on vacation and were woken in the mornings by a college servant bringing tea. The food was considerably better than the rather spartan fare at school and good wine was freely available. Superb libraries full of valuable tomes were placed at their disposal. However, they were determined that their fiction of The Enemy's conspiracy should not be thwarted by this show of generosity. They sternly declared that it must all be an extravagant bribe, which they had to resist. They swore eternal fidelity to their cause. Entirely wrapped up in their imaginations and the business of taking exams, they had very little to do with anyone else there.

When the results came out, they found that they had both done well. Edward had won a scholarship, while Christopher had obtained an exhibition (financially a less valuable award). But as Christopher was only seventeen, he was advised to stay on another year at Repton, at the end of which he could always sit the examinations again to try to upgrade his award. He was not happy with the prospect, especially as Edward would be going up to Cambridge – Corpus Christi College – in October 1922. Edward left Repton at Christmas and spent much of the intervening months in lodgings in Rouen, France, learning French. Life in the History Sixth at Repton was not the same without Edward. Yet Christopher was not such an alien in his final year at school as he later made out.

In the summer, he seized the opportunity of joining a small school walking-party to the French Alps, led by G. B. Smith. The fact that a stop had been scheduled at Rouen added to the appeal of this first foray onto the Continent. Edward was at Rouen station to join the group, calm and diffident, while Christopher buzzed around in childlike excitement. Edward had grown a moustache and was smoking a pipe, which became an essential prop for his successful image as the wistful poet. He was in his element in Rouen,

liberated from the oppressive conventions of England, and was revelling in the literary worlds of Flaubert and Maupassant.

If Edward had succeeded in turning himself into Christopher's idea of a Montmartre poet, G. B. Smith had become a parody of an Englishman abroad, his tubby little form squeezed into loud pepper-and-salt tweeds and topped with a cloth cap. The motley band went on to Paris, making a whistle-stop tour of the main tourist sights, during which Edward denounced Les Invalides as a shrine to war. Christopher was actually rather impressed by it, but was not about to admit it. He had not as yet achieved Edward's total rejection of the Establishment, but felt proudly that he was well on the way.

From Paris they caught an overnight train to Aix-les-Bains, travelling third class on wooden seats, surrounded by Frenchmen who made themselves completely at home in the carriage in a way that was a revelation to Christopher. The following day the party moved on to Annecy, taking a trip on the lake. Edward spoke enthusiastically of Baudelaire, whose *Fleurs du Mal* he had just read. Ever the willing disciple, Christopher rushed to the nearest bookshop to buy a copy. As both boys were still virgins, it offered them a vicarious experience of depravity.

Christopher found the Alpine scenery of the walking tour stunning, but again kept this quiet. For Edward had declared irrefutably that mountains should be consigned to the great rubbish-heap of objects and ideas admired by their adversaries. G. B. Smith, meanwhile, was anxious that the trip should be amusing as well as instructive, so allowed the party of boys to drink, even to excess. Christopher also tried a pipe, in imitation of Edward, and was promptly sick. But it was probably the French food which made his digestion give way completely. This made him feel so ill that he remembered little of the three days spent in Paris on the way back other than falling asleep during a performance of Wagner's *Die Walküre* at the Opera.

Back in London Christopher was laid up for several weeks, while Kathleen coped with the stoicism of someone who had been living with a professional invalid most of her life. Kathleen's experiences with Emily had made her efficient as a home nurse, but had killed her capacity for effusive sympathy. This failing infuriated Christopher, who would have preferred a more dramatic reaction. This was one of the earliest grievances against his mother that began to gnaw away at Christopher's insides.

Separated from Edward's anarchic influence, Christopher went on to have a successful Michaelmas term at Repton. He became the literary editor of the school magazine, wrote a number of poems and produced a paper for the Repton Literary Society on 'Chivalry in English Literature'. He now had a study of his own in which to conduct all this activity, and two young fags to

keep it clean. One of these was a pretty young boy appropriately named Austin Darling, who had the misfortune one day to mislay Christopher's football boots. Seemingly forgetting his own good fortune in the care of a kind-hearted fag-master, Isherwood thrashed the young Darling for this supposed offence, perhaps thereby sublimating the strong desire he felt for the boy. The incident was something Isherwood felt ashamed of until the end of his days.

Edward wrote regularly from Cambridge, describing it as even more hellish than school – a 'blood-supping blasé monster', no less. He was now thoroughly disgusted with his chosen subject, history, which was no longer the fun it had been with G. B. Smith at school. Edward felt the lecturers were submerged in their quest for precise detail, and thus had lost any overall view of events. Unforgivably, they almost never made the students laugh. In other students' eyes, though, the Cambridge history faculty in the early 1920s had much to recommend it, and Corpus Christi, Edward's College, had the advantage of having a first-rate historian in Kenneth Pickthorn. But this did not stop Edward condemning him out of hand. Unfortunately, many of the best lectures were held in the mornings, and he could not be bothered to get up in time. Besides, in the Oxbridge of the 1920s, it was rather smart not to do any work.

Christopher duly travelled to Cambridge to resit the scholarship exams in December 1922. He heard a few days later that he had won the best scholarship of his year at Corpus Christi. To celebrate, G. B. Smith invited him to his house on the last day of term and managed to get him slightly drunk on claret. Suitably relaxed, Christopher then confided that he did not want to study history at university at all, but English. Mr Smith reacted sensibly, suggesting that Christopher read History until Part One of the Tripos examinations, and then switch to English if he still felt the same way. That is in fact what Edward Upward did.

Alarmed by Edward's reports of history at Cambridge, however, Christopher decided to attempt to effect the change as soon as possible. He wrote to the college tutor, William Spens, explaining why he wished to change courses. But he received a polite rebuff, explaining that Kenneth Pickthorn could not sanction such a move, though the matter could be raised again after Part One of the Tripos. Spens was unhappy at the prospect of losing what ought to have been his best history student of that year and possibly he thought Christopher's cold feet were just an adolescent whim which would disappear when he got to university and buckled down to the course. But Spens weakened any influence he might have had on Christopher by mentioning the duty the young man had to the tradition of the college in taking a responsible attitude to his studies and his position as a Scholar.

With several months spare before going up to Cambridge, Christopher followed in Edward's footsteps by studying French in Rouen. He even stayed in the same lodgings as Edward had done, Le Vert Logis, in the resonantly named Impasse des Arquebusiers. He was woken in the morning by the sound of horse-drawn wine-drays clattering by delivering merchandise to the nearby wine-shops. The *pension* was run by a small, precise schoolmaster called Mr Morel, whose peasant wife was assisted by two slavish maids. It was there that Christopher got sufficient grounding in French to feel confident enough later – not altogether justifiably – to translate Baudelaire.

Meanwhile, he was in constant touch with Edward. A letter which survives from this period gives a good idea of the stage of development their private language and obsessive imagery had reached. Like most of Isherwood's early letters it is undated, but Upward placed it in June 1923. Isherwood's writing has already become tiny and precise, but there still is a recognisable beginning and end; in time, the pair would dispense with such bourgeois conventions.

> The time is passing more and more rapidly and the Vert Logis is always a house of shadows. Only green remains, colour of Lust and of the thievish worms who steal down marvellous stairways through our bowels . . . I am glad you have abandoned women. There is no really pure love like the passion for a child. The flame still burns brightly before Darling's altar . . . I am in high favour with my family for the moment, not having seen them for three months. The epitaphs on Laily are superb . . . These are the best I can manage on the spur of the moment:
>
> > Laily is dead – and many a don might weep
> > That so much ordure should be put to sleep
> > Did not the jolly worm cry from his bed
> > The teeming Laily – 'Laily is not dead!' . . .

'Laily', also known as the Worm, was a rather confused imaginary being in Christopher and Edward's canon, being a don who was their special enemy, or a swot – a bookworm who was none the less eager to be accepted by the body of students, and so professed a fake enthusiasm for sports. The name is derived from a couplet in an old ballad ('and she has made me the laily worm/That lies at the fit o' the tree') and means 'loathly'. In *Lions and Shadows*, for literary tidiness, Isherwood records that the construction of the

37

elaborate joint Isherwood–Upward fantasies, centred on Cambridge, was begun after he went up to the university. But that was not true.

Christopher returned to England in July 1923 and did a couple of weeks' library duty at Repton. Edward joined him there for the second week, during which they produced doggerel as well as more serious creations. Christopher had in fact already started the first of many drafts of an abortive novel, while Upward was still concentrating on poetry. This seemed to confirm a premonition Christopher had had on his first visit to France, that Upward would become the greatest poet of their generation. It was a prospect that made his eyes fill with tears of excitement and pride.

3

1923–1925

For most aspirant writers of the 1920s who had the good fortune to go to Oxford or Cambridge, the university years were their most formative. But Christopher was a notable exception. His most important friendships had been, or were to be, made elsewhere and he never truly profited from the Oxbridge environment. It is tempting to point out that creativity was at a low ebb among the Cambridge undergraduates of the time; the brilliant days of Lytton Strachey, Maynard Keynes and other budding Bloomsburyites had passed. Without a doubt, it was Oxford that was the centre of literary and social brilliance at the time, featuring such luminaries as Harold Acton, Claud Cockburn, Brian Howard, Peter Quennell and Evelyn Waugh. But that cannot explain Christopher's Cambridge débâcle, which arose from purely personal problems.

Corpus Christi was perhaps not the best choice of college for Christopher. It is one of the smallest at Cambridge, and was founded in the fourteenth century exclusively for priests. It remained a strongly religious college for most of its history. But great changes took place in 1906–1907, when the range of subjects offered was considerably widened, and some talented new dons joined the teaching staff. Yet it retained an aura of political conservatism, while its religious leanings moved from the evangelical towards the Anglo-Catholic. Typical of this new mood were the Master (Principal), Dr Pearce, who later became Bishop of Derby, and Christopher's history tutor Kenneth Pickthorn.

Corpus Christi was small enough for everyone to know each other, and for no one to escape the eagle eye of the community. Christopher had second-floor rooms on the same staircase as Edward's, and as he thought his own sitting-room had all the charm of a dentist's waiting-room, he preferred to spend most of his time at his friend's. There he perused Edward's copies of Katherine Mansfield, Walt Whitman, Edgar Allan Poe and Flaubert. The

usual state of cosy muddle in Edward's rooms was in stark contrast to Christopher's, in which every tiny thing had its proper place. When Edward visited he would tease Christopher by moving things around, and would scatter ash from his cigarette into the grate, knowing that Christopher would invariably whisk out a pan and brush and start cleaning up after him, like some neurotic housewife.

Christopher's early tutorials with Kenneth Pickthorn were not a success. A brilliant man still in his twenties, Pickthorn had little patience with sham. Confronted with Christopher's first eloquent but shallow essay (which was by tradition read aloud), he became increasingly fidgety, finally strumming on the mantelpiece with his fingers. As Isherwood recalled in *Lions and Shadows*, when the reading was finished, Pickthorn pronounced crushingly: 'I'll say this for you – it's not the work of an entirely uneducated fool. Look here, Isherwood, don't you yourself agree that it's all tripe?'

Pickthorn tried to be a sympathetic tutor. Aware that Edward Upward had become totally disenchanted with the subject, Pickthorn once asked him if studying history seemed worse than working in a bank. But he was less effective when lecturing, and it was in the lecture halls that Christopher realised that he would never be able to cope with the Cambridge history course unless he was prepared to get down to a great deal of detailed study. He could not concentrate on what was being said and instead daydreamed. Later, he would borrow other people's notes to copy, but after a while stopped doing even that, returning to his rooms dejectedly for some more obsessive tidying-up.

Edward had evolved a new and even more persuasive objection to lectures. In his view, the dons showed no humanity in their approach to history, no passion for lost causes, no anger at the brutality and futility of men's actions. Though he had still not embraced any precise political doctrine, Edward had acquired a strong social consciousness. This was one reason why he developed a violent dislike for the sort of people Christopher had started to get friendly with at college, dubbed by Edward 'The Poshocracy'. Like Christopher, these youths were mainly from well-to-do families, and spent most of their time having tea in each other's rooms, playing squash or simply fooling around. Christopher had been spotted by the Poshocrats as a likely recruit, and Edward was quick to voice his disgust.

Similarly Christopher strongly disapproved of the back-slapping, football-playing 'hearties' who congregated round Edward, drinking beer and talking loudly about sport and girls. This situation could easily have broken up their friendship, but they decided to enjoy their own social circles separately, while keeping enough time free to be together. For despite their disparate interests, they did continue to share the bond of their ever-growing fantasy world.

Walking through the streets of Cambridge, they kept up their conspiratorial game against The Enemy, discerning spies among waiters and shop-assistants. One evening, they happened to turn into a unfamiliar alley, at the end of which was a small old door that let into a high stone wall. Edward announced that this was 'The Other Town'. The Other Town became a new dimension of escape from their mundane college life. Over the following months, they worked together to describe this mythical alternative reality and to define its vocabulary. The Other Town was stacked with Gothic imagery, peopled by benevolent eccentric beings and fantastic creatures, some inspired by the writings of Poe and Conan Doyle and the drawings of Albrecht Dürer.

Christopher and Edward kept a joint diary of their imaginary lives, calling themselves 'Hynd' (Upward) and 'Starn' (Isherwood). They wrote humorous and lewd verses about Laily and other favourite characters, such as Edward's 'About the middle of the night a thing with fins/Came to reprove the Tutor for his sins . . .' Edward often inserted homosexual references, for Christopher's benefit.

Christopher was also working on a novel, entitled *Lions and Shadows*, begun in July 1923 and finished eighteen months later. The title was taken from C. E. Montague's *Fiery Particles* ('arrant lovers of living, mighty hunter of lions and shadows'). In the novel, the hero is at a public school called Rugtonstead (a clumsy compound of Rugby, Repton and Berkhamsted) when he is struck down in 1919 by rheumatic fever – a dramatic detail borrowed from the real life of Hector Wintle. Otherwise, much of the novel is a romanticised version of Christopher's own time at Repton, in which the central figure is a considerably enhanced Christopher who is called upon unexpectedly to captain a 'bad' house, fighting slackness and moral rottenness, while repressing his own romantic feelings for a younger boy. Finally, the hero emerges triumphant over all the obstacles, as a Man. He has passed the test.

'The Test' became one of Christopher's main preoccupations at Cambridge. The need to prove himself obviously indicated a deep inner insecurity. Subsequently, Isherwood tried to explain this by diagnosing a sense of guilt felt by his own generation for being too young to take part in the Great War. Thus, they had missed out on the supreme Test. George Orwell noted the same phenomenon in his essay 'My Country Right or Wrong', claiming that his generation had become conscious of the vastness of the experience they had missed and felt less manly because of it.

The 'War Test' also implied a need to prove one's masculinity – to show one was not impotent, or homosexual. Even Christopher was not immune. Conscious of his small stature and homosexual desires, Christopher exercised

in secret with a chest-expander. He was a virgin when he arrived at Cambridge, and although he could not have had any doubts about his sexual inclinations, he made no attempt to satisfy them. When he did finally have his first sexual experience, with another student at Corpus, it was the other young man who took the initiative, locking the door and sitting himself down firmly on Christopher's lap, so there was no chance of escape. But it was not a very fulfilling encounter.

Christopher and Edward saw several other Old Reptonians who were at Cambridge, especially Christopher Orpen, who went up to Corpus Christi at the same time as Christopher. Orpen was the son of a senior clergyman, but turned completely wild. A favourite trick of his, which thrilled Christopher, was to swing out of the window of his rooms in a gown, terrifying passers-by. But it was Geoffrey Kingsford – who had been with Christopher and Edward in G. B. Smith's walking party in the French Alps – who helped Christopher choose a motor-bike in the spring of 1924. This was a powerful model, AJS, which Christopher saw as the 'Test on Wheels'. And it was a Test he failed. Frightened of driving it through Cambridge's narrow, crowded streets, he tended to wheel it around, peering at it occasionally as if it had broken down. After a couple of minor accidents, he got rid of it.

One new friendship which did blossom at university was with Roger Burford, who had recently founded the Cambridge Film Club. Christopher soon became a most enthusiastic member. Edward made fun of his indiscriminate love of films, which Christopher pompously put down to a fascination with the outward appearances of people. In fact, from this time on, the making of movies, and the mythology of the film world, were as much a fascination for Christopher as the finished products.

One of the first guest speakers at the Cambridge Film Club was the producer George Pearson, who invited the club's members to visit his studios in Islington. Christopher followed up this invitation during the Easter holidays, in the company of a handsome fellow student called Pembroke Stephens. A scene representing London's Savoy Hotel on Armistice Night was being shot, and the two young men found themselves being coerced into being extras. Christopher was dressed up as a midshipman, and spent the day dancing round and round, while other extras pelted his group with balloons and streamers. Take after take was shot, during which the studios were filled with a cacophony of shouted directions and the band played an interminable fox-trot. Christopher was paid one pound four shillings for the day's work, which ended at ten o'clock in the evening. And he was not even visible in the finished film. The experience did not encourage him to try to pursue an acting career. But Pembroke Stephens was seized upon by the

casting director, and a few months later was given the part of an undergraduate hero of a film set in the West Indies.

Subsequently, Pembroke Stephens crossed Christopher's path on a number of occasions. He was an aggressive and successful foreign correspondent in Germany during the 1930s, and was expelled by the Nazis for tracking down and reporting on concentration camps. Later, he was in China during the Sino-Japanese War, like Isherwood. He was killed by Japanese machine-gun fire while covering a battle from a watch-tower in the neutral international settlement of Shanghai. Isherwood admired such men of action, who took risks not in the name of glory but in the search for truth, and he recognised that he could never have that brand of courage himself.

During that same Easter vacation, 1924, Christopher wrote to Edward, informing him that he had let his mother and his brother Richard into some of the secrets of their fantasy world. Writting from the family's home in Kensington on April 7, he revealed:

Here I am in the midst of dreams and magical faint ecstasies. . . . The symbols of the Hostel surround me, but I was unprepared for my brother's exclamation, on looking out at the street from the sitting-room window: 'There's a light blue horse!'

I have introduced Mr Gunball to the family, under a decent veil of piety, and his saga is a constant source of amusement to Wintle, who made the shrewd comment that we are indebted to Alice in Wonderland. . . . The Slug's Jesus is crucified on Crouch End, and the hot-gospeller bittern bears witness at Balham. I see a two-decker tram, full of pianos, heading for Java; sixteen cormorants praying at St Paul's for pardons for the Pekinese Pope and an enormous cortege of rabbits bearing tailor's dummies interminably towards a mausoleum of pumice-stone. . . .

Yours, till we meet in Pintu's Spinkey,

Christopher.

'Ronald Gunball' was one of the key characters of Christopher and Edward's fantasies: a drunken fisherman subject to the DTs, whose existence enabled Edward's imagination to run riot in conjuring up hideous monsters. 'The Hostel' mentioned in the letter is the 'Rat's Hostel', another important element of their mythical world, being typical of a certain atmosphere, a genre, a special brand of mediaeval surrealism which they had made their own. It is interesting to note that neither of them were aware of the existence of the Surrealists then active on the Continent; had they been, one suspects they would have dismissed them as being too arty for words.

On May 9, 1924, old John Isherwood died. Uncle Henry had in fact already moved back into Marple Hall, as he and Muriel had separated. The building was revitalised by Henry's presence, as he filled the air with incense and converted the dreary library into a sitting-room filled with dainty knick-knacks and framed photographs of society ladies. Before long, though, Henry tired of life at Marple and took a flat down in London. There he became a frequenter of the guardsmen who had for many years been the staple diet of English gentlemen who sought rough trade.

During the summer term of 1924, Christopher saw much less of Edward, who was working hard not only for Part One of his Tripos exams, but also on composing a lengthy poem (on Buddha) for the Chancellor's Medal – the University's most prestigious literary prize. In the examinations, Edward gained a miserable Third, and was granted his wish to change faculties. But he did win the Chancellor's Medal. Christopher was also working for exams that June (perversely called 'Mays'), which were of no importance for his final degree. Rather to his surprise he managed a IIi (the equivalent of an upper Second), but his college was disappointed, believing their prize history scholar ought to have been capable of better things.

In the long vacation, Christopher saw a great deal of Hector Wintle in London. Hector lived in a gloomy basement in North Kensington, decorated with photos of film stars. Of all the portraits in *Lions and Shadows*, that of Hector Wintle is probably the most accurate. He had not gone to university from Repton, but had instead attended a crammer, in the hope of getting into a London medical school and eventually becoming a doctor. His heart was not truly in the work, however, as he believed his real vocation was to be a successful novelist, fêted by society and, in particular, by beautiful women. He had abandoned his schoolboy epic *Donald Stanton*, but was progressing well with a new novel. Hector's friends were amused by his soulful exploits and monitored closely his carefully planned but usually futile advances to various girls. Hector was short and stout, but always immaculately groomed. He had cultivated a suavity which co-existed uneasily with his morbid pessimism about the state of the world and his own future in particular. Christopher found Hector's worries about his own health endearing, though the young man had every reason to be concerned, having twice been seriously ill with rheumatic fever. It was difficult not to be charmed by Hector's compulsive generosity – despite living on a very small allowance – and the pleasure this obviously gave him.

In comparison, Christopher was quite well-off. His £80 scholarship at Cambridge went quite a long way in those days, and at home in London he had free board and lodging. Not that his taste in entertainments was

extravagant. He was often happiest walking the streets of London with Hector, especially in the shabbier districts. Christopher found this contact with working-class life sexually stimulating, in a way that the privileged environment at university was not. Having initiated Hector into his fantasy world, Christopher was able to have the same sort of imaginative but ridiculous conversations with him that he had so enjoyed with Edward in Cambridge. Hector's taste for the absurd and the grotesque was almost as well developed as theirs. And he was happy to accompany Christopher to the 1924 Wembley Exhibition, where they rode the Big Dipper while reading from a newspaper at the top of their voices.

Around this time, Christopher started to write a journal of his life, largely inspired by the *Diary of a Disappointed Man*, a then popular book by Barbellion (Bruce Cummings), who had died of disseminated sclerosis the year the book had come out. Christopher's own journal was full of despair and self-pity. Through this medium he was able to describe and develop the personality of a sensitive young man of letters, alienated from the world by his unique perception of its sordid fatuity. Illness seemed to be an essential prerequisite for the successful maintenance of such a pose, and as there was now very little physically wrong with Christopher, apart from some dental trouble, he gave full vent to his latent hypochondria.

Back at Corpus, Edward was full of enthusiasm to continue the Hynd and Starn stories. A fresh element to his fantasies had been added by his new college rooms, which were said to be haunted, though he never saw any evidence of this. During the long vacation, Edward had clarified the rather muddled and inconsistent concept of their fantasy world by deciding that The Other Town was not an alternative existence in Cambridge but a village, far away, lost among rolling downs, by the Atlantic Ocean. To emphasise its deathly dankness, they named the village Mortmere.

Several of the stories the two friends wrote about Mortmere in the 1920s are still in existence, as Upward kept the manuscripts written out in Isherwood's precise hand. But Upward resisted Isherwood's attempts later to have some of them published. Paradoxically, the longest and most complex of all, *The Railway Accident*, was eventually published by Upward in 1969. It was written entirely by him in 1927, Isherwood having lost interest by then.

Mortmere was a convenient vessel into which they could pour their own peculiar brand of political and sexual anarchy. The Church was a natural target for satire, given the ecclesiastical traditions of both their public school and college. Much space was given over to vicars, choirboys and vergers in a decadent marriage of Church ritual and homosexuality *à la* Ronald Firbank.

Mortmere's vicar, the Reverend Welken, had pushed ritual into the realm of magic. A widower who had been charged with indecent offences against a choirboy, he compounded his crimes by indulging in 'angel manufacture' in the belfry where, surrounded by the paraphernalia of alchemy, he regularly repeated the original offence with the exquisite Boy Radnor. Welken was also a devilishly skilful amateur conjuror. Gunball, who has been mentioned earlier, was his best friend. It does not require too great a stretch of the imagination to identify Welken as a grotesque extension of Christopher's own character, and Gunball as that of Edward's.

As well as containing liberal doses of the supernatural and the perverse, the Mortmere stories were steeped in mystery and suspense. One, *The Javanese Sapphires*, is a surreal parody of Sherlock Holmes. In it, a seemingly impossible crime is committed with the aid of a trained snake which enters Gunball's house by way of the plumbing and then swallows some valuable sapphires before making its escape. Unfortunately, the scheme fails when the snake is unable to regurgitate the gems and slowly digests them instead.

Encouraged by their mutual enjoyment of the Mortmere stories, Christopher and Edward often talked of writing a full-length book in the genre, but never did. The project simply got lost in flights of imagination when they tried to discuss definite plans. As Isherwood recalled in *Lions and Shadows*, the book:

> was to be illustrated . . . with real oil paintings, brasses, carvings in ivory or wood; fireworks would explode to emphasize important points in the narrative; a tiny gramophone sewn into the cover would accompany the descriptive passages with emotional airs; all the dialogue would be actually spoken; the different pages would smell appropriately, according to the subject matter, of grave-clothes, manure, delicious food, burning hair, chloroform or expensive scent. All copies would be distributed free. Our friends would find, attached to the last page, a pocket containing banknotes and jewels; our enemies, on reaching the end of the book, would be shot dead by a revolver concealed in the binding. (p 114)

Nothing less would do.

Such was Christopher's excitement about the Mortmere world that he was unable to keep it a secret. Telling his family was a bad enough risk, but he rashly also let Vernon Watkins into his confidence. Watkins duly shared the stories with a Cambridge don, who pronounced them childish, as undoubtedly they were. Edward was appalled at Christopher's treachery. In retrospect, the

Mortmere stories none the less served the valuable purpose of enabling their creators to write out their discontent and to rebel against the prevailing prudery and conventions of their times. Stylistically, they are far more flamboyant than anything else that Isherwood wrote; indeed, his stylistic maturity was in deliberate opposition to the extravagance of these early prose writings.

On November 10, 1924, Emily died of pneumonia. Christopher travelled to London for the funeral and the cremation at Golders Green. The ceremony struck him as dismal and untheatrical, in contrast to his grandmother's personality. He remembered with affection how, towards the end of the Great War, she had sat in a deckchair on the roof of her old flat in Buckingham Street, watching the spectacle of German daylight air-raids over London through a pair of opera-glasses.

Christopher finished the novel *Lions and Shadows* during the Christmas holidays and took the completed manuscript along to the Irish novelist and translator Ethel Mayne, who had been a great friend of Frank Isherwood's before his marriage. Frank had met her in the late 1890s, while on an early posting to Ireland, and had given her the nickname 'Venus'. Venus was witty, self-assured and occasionally coarse, and became well known in the literary circles of London when she moved there. Christopher was enchanted by her conversation and was excited that she had promised to take his manuscript to her publishers if she liked it. However, she did not like it. In fact, she recommended to Christopher that he put the novel away in a drawer and forget all about it. To soften the blow, she also told him that if he really wanted to write then he would go on writing, no matter what anyone said.

Back at University, Christopher read *Lions and Shadows* out loud to Edward. It was well over a hundred thousand words long, so although he started it in the early evening, he did not finish till the following morning. Edward, exhausted, enthused politely. But a couple of days later he admitted that he too did not think it was much good. Christopher himself had also come to recognise that it was in many ways a poor imitation of Compton Mackenzie and Hugh Walpole, expressed in tortuously emotional language.

Edward, meanwhile, was already disillusioned with his change to reading English at Cambridge. He felt that all too often literary texts were treated like corpses on the dissecting table. All passion and romanticism were lost in the dons' technique of nit-picking textual analysis. The one exception was the young I. A. Richards, who was giving a series of lectures on modern poetry, which both Edward and Christopher attended. Despite his funny little voice, Ivor Richards held their attention as no other lecturer had managed to do. He opened their eyes to what was going on outside their limited field of

vision, revealing in a sequence of lightning flashes the nature and expanse of the Modern World. Richards persuaded them that they should heed Katherine Mansfield's injunction to be a part of life. Accordingly, Christopher and Edward began to see the Mortmere stories for what they were: a private indulgence. Edward reacted by losing his faith in himself as a poet, and subsequently turned to prose. He was often troubled and irritable during this period and the two friends began to get on each other's nerves.

Richards' particular enthusiasm was for T. S. Eliot, whom he saw as a crucial voice of the post-War scene. He even had hopes of luring Eliot away from the bank where he worked in London and installing him in Cambridge. According to Richards, *The Waste Land* was a major testament of the times. Christopher and Edward, who had until then deliberately ignored Eliot because of his popularity among the 'in' crowd at Cambridge, now fell upon his work voraciously.

Richards did far more than just introduce them to new poets. He annihilated their innocent, arrogant rejection of work being done in other fields, notably in psychology. When they were encouraged to read Sigmund Freud (whose *Introduction to Psycho-analysis* was published in English in 1922), it was as if the floodgates of understanding had been opened. Thanks to Freud, Christopher and his peers acquired the belief that their parents were responsible for everything. As Isherwood declared in a lecture at Berkeley, California, nearly forty years later: 'It was all their fault, and we would *never* forgive!' The parents' crime was exacerbated by their failure to recognise that a psychological revolution had taken place. With Frank dead, it was therefore Kathleen's inescapable fate to be viewed by Christopher as a thoroughly menacing and destructive presence.

In February 1925, undeterred by the experience with the novel *Lions and Shadows*, Christopher began a new work of fiction, entitled *Christopher Garland*. Flagrantly autobiographical, the book centres on a Cambridge undergraduate who finds the University utterly stultifying. In the vacations, the young hero becomes involved in a dismal struggle with the domineering personality of an aunt with whom he lives. He starts a love affair with the fiancée of a friend, but only in renouncing that does he begin to feel any confidence about the future. In *Lions and Shadows*, Isherwood says he was trying to come to terms with his own role as an artist in society, but 'as I still imagined that "being an artist" was a kind of neurotic alternative to being an ordinary human man, it is hardly surprising that my ideas got a little mixed'.

This new literary endeavour did nothing to relieve Christopher's own dejection at being at the University. The thought of over another year to go

was almost too much to contemplate. However, his new history tutor was less demanding than Kenneth Pickthorn had been, so Christopher was able to get by with a minimum of work, often just copying out Edward's essays from the year before.

The approach of the Tripos examinations was an insufficient incentive to study. Guilty panic made Christopher work hard for a couple of days, then he sank back into apathy, convinced that it was too late for him to do enough work to put on an acceptable performance anyway. Then one evening in April, while on a walk with Edward, he decided quite suddenly that the only proper course of action was to get sent down: to end Cambridge not with a whimper of academic mediocrity but with a bang of defiance. Plotting his own academic demise became the ultimate Test of the Mortmere consciousness, a gesture against The Enemy, which was no mere fantasy but very much part of life. Indeed, it could affect Christopher's whole future. Together they devised the most effective course of action which would lead to certain banishment from the University: a wounding thrust at the system itself by mocking its sacred symbol, the examinations. Accordingly, Christopher sold all his history textbooks to second-hand bookshops, with the exception of Bishop Stubb's *The Constitutional History of England*, which he dropped ceremonially into the River Cam.

As spring turned into summer, Christopher and Edward spent their time punting along the Backs, listening to Beethoven and Schubert on Edward's portable gramophone, or telling each other funny stories. Christopher threw himself into the pleasures of Cambridge in the sun, walking and talking and visiting friends. But he let no one except Edward into his secret. As the exams approached, Edward became increasingly excited, while Christopher, whatever sick feeling he had in the pit of his stomach, knew that now it really *was* too late to do anything about it.

Oxbridge examinations tend to be swift and intensive, with three or four days of papers, morning and afternoon. While Christopher's fellow history students busily wrote down everything they knew about the death of King Charles I, he composed whatever came into his head. What he produced was not much of a testimony to his literary abilities. Unable or unwilling to write anything at all interesting, or even genuinely funny, he filled his papers with short satirical passages, third-rate verse and a few mild jabs aimed at the supposed imbecility of some of the questions. He left himself plenty of time to make a copy of his answers for Edward's benefit. Between the examinations, he read out these answers to Edward, who pranced about with glee. Christopher gave no sign either to the other students or to the invigilators that he was doing anything other than answering the exam questions

normally. At the end, without fuss, he packed his bags at Corpus and returned to London to await the explosion.

A week later, a telegram arrived from his tutor, recalling him immediately to Cambridge. In a manner that was both kindly and pained, he asked Christopher if there were any extenuating circumstances for his extraordinary behaviour. Christopher had no excuse or apology, and sat in silence, feeling rather stupid. The tutor shrugged his shoulders, shook Christopher's hand and wished him luck. The college authorities were furious, and Kenneth Pickthorn never forgave him. To save him the ugly process of being sent down, however, his tutor suggested that he take the more dignified course of removing his name from the college books, which he did. His two wasted years at one of the world's most prestigious universities were officially wiped out.

4

1925–1928

In later life, Christopher felt heartily ashamed of the way he had thrown up Cambridge, and Edward Upward went through pangs of remorse for encouraging his folly. Edward wondered whether Christopher would have gone on to become a don had he stayed on at university and been allowed to switch to the English faculty. Or would he have become a schoolmaster, as Edward did? The prospect terrified Christopher at the time.

But it was Kathleen who felt the effects of Christopher's action most cruelly. She really did want him to become a don, ideally at Oxford. So his uncompromising rejection of the academic world was quite a shock. The blow was made worse by the fact that she had had no inkling of the degree of his dissatisfaction. However, she was not the sort of woman to slam the door in his face for such irresponsibility. He was welcomed into the fold at St Mary Abbots Terrace. Kathleen, toughened by the deaths of her husband, parents and in-laws, and without brothers or sisters, was determined to stand by her sons, whatever they did. Richard proved a trial at school, and refused to study any further, or, later, to earn a living. And Christopher drifted through life – albeit less passively – in a way that must have made his mother despair.

However, it was largely Kathleen's strength of personality that made Christopher want to escape from the house at every available opportunity, sometimes slamming the door behind him. He came to look on the Isle of Wight as a bolt hole, and in July 1925 wrote cheerily to Edward from Freshwater Bay, where he was staying at a guest house called Marine Villa, whose landlady had the great advantage of leaving him to his own devices:

> . . . this is pure heaven. I am sitting on a veranda whose roof is curiously curved with wooden struts like the bottom of a rowing boat. . . . One can walk down to the beach and back in two minutes debating the next

paragraph – equivalent, in fact, to those journeys to the Corpus rears.
. . . Last night I hired a canoe, and went right out to sea. It was utterly
calm. . . .

They are all here. I met Gunball stalking under the cliffs with a gun
over his shoulder, a curious three-pronged spike projecting from the
barrel. We embraced with tears. . . . No writing done, thank God.

Your bemused friend, Christopher.

The handwriting of this letter is almost illegible without a magnifying glass,
having shrunk to minute proportions. A psychiatrist later told Christopher
that this indicated his subconscious desire to disappear completely.

Back in London that August, he applied with Roger Burford for a job in
films both with the Stoll Studios and with George Pearson's smaller company.
Nothing was immediately forthcoming, but George Pearson thought there
might be an opening the following spring. Accordingly Christopher persuaded
himself that he did not need to do any more serious job-hunting, as he would
only have a few months to fill in.

At the end of the month he celebrated his twenty-first birthday and blew
the £150 he had in his Post Office savings account on an extravagant present
to himself: an impressive but impractical large second-hand Renault. All he
needed now to take on the pose of a dashing young man about town was a
more substantial income than the allowance he got from his family, so he
decided to persuade his Uncle Henry that it would be a good idea to let him
enjoy now some of the money he was due to inherit later. Henry seems to
have appreciated this cheeky approach, knowing full well that he had been
equally calculating in his own relationship with his father, and agreed to give
him a quarterly allowance. Encouraged by his uncle's positive response,
Christopher determined to foster relations with him, choosing to overlook
some of Henry's more patronising attitudes to the world at large.

Henry's view of things was so selfish and outdated that Christopher felt
able to laugh off most of his prejudices. Henry even spoke like a caricature
of an English gentleman buffoon, dropping the final 'g' from words like
'hunting' and 'shooting', being unable to roll his 'r's', so that he always said
'fwightfully', and punctuating his conversation with expletives like 'don't
you know!'. By this time he was in his late fifties, but he still considered
himself dashing. He played the role of the wealthy uncle with great panache,
illustrating his talk with sweeping gestures and showing off his *objets d'art*
and fine wines with pride, while a smiling Italian valet noiselessly served
delicious meals.

Henry and Christopher's intimate dinners became considerably more lively

later on when Christopher confessed his own homosexuality, as Henry loved to hear about his nephew's adventures. In return, Henry would describe his own encounters with guardsmen, waiters and others. Like so many homosexual gentlemen in those days, Henry was only sexually interested in the sort of working-class young men whose social origins he simultaneously despised. He was a shameless snob, and rather foppish, but he was physically attracted to brute masculinity to such an extent that he once paid a man not to wash for a week. After satisfying his carnal desires, Henry would then trot off to a priest to confess.

It was thanks to the car, though, and not Uncle Henry's connections, that Christopher got an *entrée* into an exiciting new world. He was generous in taking friends out for rides, and therefore was not particularly surprised when an old school chum, Eric Falk, asked him one day if he could take out a young friend of his, Sylvain Mangeot, for a run in Richmond Park. Eric had met the eleven-year-old Sylvain and his family on a recent holiday in Brittany, where Sylvain had had a bad bicycle accident, cutting his knee to the bone. The Mangeots lived in a mews house in Creswell Place, Chelsea, where, after the drive, Christopher was invited for tea.

André Mangeot, Sylvain's father, was a French violinist, and his English wife Olive had chosen the house so he could practise without disturbing the neighbours. The fourth member of the family was another boy, Fowke, who was just a year older than Sylvain. Christopher instantly fell in love with the family, who seemed to have arranged the sort of intimate artistic life that he would like to emulate. In contrast to St Mary Abbots Terrace, the Mangeots' home was in a cheerful state of disorder and struck Christopher as being a warm household of individuals living in mutual respect, while remaining intent upon their work.

André Mangeot, slim, sunburnt and forty, won Christopher's immediate approval by accepting without question his motives for leaving Cambridge. He inquired about Christopher's future plans and, by the end of the afternoon, had hired the young man as his secretary, at a salary of one pound a week. Kathleen was not very impressed by the wages, but Christopher was thrilled with the job, which struck Hector Wintle and his other close friends as being wildly romantic. Christopher flushed with pride when he saw his own name printed at the top of new stationery ordered for the string quartet of which André Mangeot was the leader. This operated variously under the names of the Music Society Quartet, the International Quartet or simply the Mangeot Quartet. The other members were Boris Pecker (second violin), a very sociable and amusing man of Russo-Jewish origin, whose family were furriers in the East End of London; Henry Berly (viola), who liked fast cars and

penny dreadfuls, and was a first-rate jazz-player; and a very serious-minded young cellist, John Barbirolli, who learnt musical scores off by heart and dreamed of becoming a conductor, as indeed he did, finding fame as the resident conductor of Manchester's Hallé Orchestra.

André Mangeot's self-declared aim was to present to the British public a wide range of worthy chamber music, old and new, domestic and foreign. The quartet gave a series of subscription concerts – at two guineas for a season of six – in a peculiar vault-like room in a narrow street at the back of Westminster Abbey. This was difficult to find and the only seating when you got there was provided by deck chairs, but the concerts attracted a devoted following of connoisseurs, some of whom would turn up early to have tea with the players.

Olive Mangeot was dark and elegant, eminently cultivated, understanding and charming. At first Christopher was shy of her, but later she became his confidante – the first of several such women in his life. She was a calming influence in an otherwise frantically active environment. André Mangeot and the other musicians were totally bound up in their work, and were also keen on sports, while Olive was only too happy to sit down and put her feet up. She became a sort of honorary mother to Christopher, who wrote to her as 'My darling Mop', signing himself 'your loving eldest'.

Of the two boys, Sylvain became the closer to Christopher. An intelligent, artistic child, then at preparatory school, he worked with Christopher on a little book of twenty-nine nonsense poems that are portraits of humanised animals called *People You Ought to Know*. This was published in a charming edition in 1982. It was not originally intended for public consumption, but displays an unusually high degree of originality and wit, both in Christopher's text and Sylvain Mangeot's colourful drawings. Considering that Christopher apparently rattled off all the poems in a couple of days, it was quite an achievement.

As the year went by, Christopher's relationship with the Mangeot family became very possessive. He was jealous of their friends and later recalled looking enviously at their old photograph albums, thinking of all the years of their lives he had not shared. He invented work, in order to have an excuse to stay at their house far longer than his official hours. On Sundays, when he had to stay at home, he felt lonely and bored. But often he would go off to see Edward Upward, who was then back living with his family in Romford in Essex, after graduating from Cambridge with an unimpressive Second in English.

The two friends were still thinking a great deal about the Mortmere stories, and they had decided that Hynd and Starn, their alter egos of earlier fantasies,

should be introduced into the Mortmere tales as external observers or, rather, as one observer, 'Hearn'. The nature of Hearn posed numerous problems, however. Initially, they conceived of him as a neurotic young man who arrives in Mortmere to recover from a nervous breakdown. But they soon realised that too much of the reader's attention would be focused on Hearn, because he was interesting, thereby stealing the limelight from the fantastic characters of the village. The obvious way to overcome this was to tone down the observer character, so he becomes almost insipid, as Isherwood most successfully managed in his later Berlin stories.

A few days before Christmas, Christopher rang a casual friend, Stanley Fisher, to invite him over for tea. Fisher asked if he could bring a young fellow undergraduate from Christ Church, Oxford, who was currently staying with him. The friend turned out to be Wystan Auden, who arrived with Stanley Fisher looking like a much larger version of the gawky child Christopher remembered from prep school. Auden was expensively but untidily dressed in a crumpled, chocolate-brown suit, and his stumpy fingers were now stained with nicotine as well as ink. While Christopher talked to Stanley Fisher, Auden scowled, smoking his pipe, and occasionally pulling a book from Christopher's shelves. Having flicked through several books, he then dropped them, open, face-down on the floor, oblivious to Christopher's silent outrage. It was only when Stanley Fisher excused himself to keep another engagement that Wystan unwound and he and Christopher started to reminisce about St Edmund's. Auden acted out a wicked parody of Ciddy giving a sermon in the school chapel, which had Christopher virtually rolling on the floor.

Just as Wystan was about to leave, he mentioned casually that he had started to write poetry. Christopher was dumbfounded, as there had been no such intimation at school. Wystan promised to send him some examples of his work. Sure enough, a few days later, a packet of poems arrived, showing the clear influence of Thomas Hardy, Edward Thomas and Robert Frost. The handwriting was so atrocious that whole lines were indecipherable. Wystan's accompanying note requested Christopher's comments, which have not survived, as Auden tended to throw all incoming correspondence away. But Christopher was not the only person whose literary judgment was being solicited at this time. Robert Medley, the artist and stage-designer, who had been at Gresham's School with Wystan, remembers being sent some of the same poems Auden had shown to Christopher.

In January 1926, Edward Upward took a job as a private tutor near St Ives in Cornwall. He sent long letters to Christopher, evoking the doom of shipwrecks and dissecting every particle of the loathsomeness of the local

inhabitants. Having been persuaded by Christopher that he ought to seek a new destiny as a prose-writer rather than as a poet, Edward had started writing a novel called *The Market Town*.

Christopher took a break from his work with the Mangeots that Easter, to go to visit Edward. In his suitcase he carried the first six chapters of a new novel, entitled *The Summer at the House*. After Cambridge, he had abandoned writing entirely for a few months, and he was not happy with the way things were going with his new literary awakening. Fortunately, he was able to abandon the work in progress with a clear conscience, because Edward had exciting news that changed their whole attitude to writing, making *The Summer at the House* redundant.

Edward had been reading E. M. Forster's *Howard's End*, and had been struck by the massive realisation that Christopher and he had made a terrible error in believing in tragedy. Instead, they should aim at being comic writers, and should learn from Forster's technique of 'tea-tabling' events. Rather than screwing all his scenes up to the highest possible pitch, Edward told Christopher excitedly, Forster toned them down until they sounded like mothers'-meeting gossip. Forster laid less emphasis on the really big scenes than on the superficially trivial ones. It was a completely new kind of accentuation, like someone talking in a different language. Forster henceforth became their mentor, and was to remain Isherwood's literary guru for the rest of his life.

From Cornwall, the two friends went by boat to the Scilly Isles, where Christopher prepared the ground for a new novel, which was to be entitled *Seascape with Figures*. The title was often the first thing that he settled on, and he would preserve titles he liked from abandoned projects for use later, the classic examples being *Lions and Shadows*. On walks through island flower-gardens, or in pubs over pints of beer, Christopher and Edward discussed the plot of *Seascape with Figures* at length. The two principal characters were to be a would-be writer and a medical student; Hector Wintle seemed fated to appear in Christopher's first published novel, whatever it was going to be. The artist persuades the medical student to leave home. They go to stay in the Scilly Isles, where both form an attachment to a fourteen-year-old girl. A posh Cambridge hearty, who is also visiting the island, takes the girl climbing and she falls to her death. Complex circumstances in London lead to the murder of the hearty by the medical student brandishing a poker. All this was to be 'tea-tabled' *à la* Forster and subtly comic, though the ending would be pure farce.

Christopher was back in London in May when the General Strike happened. Kathleen, looking brighter than ever at the breakfast-table that morning, briskly

declared her opposition. Even Olive Mangeot (the future Secretary of the Chelsea branch of the Communist Party!) wondered aloud how the workers could do anything so 'uncosy'. Hector Wintle signed up on the first day as a conductor on the London Underground, one of an army of mainly middle-class volunteers who kept public transport functioning, after a fashion. Undergraduates arrived from Oxford and Cambridge to do their bit, treating the whole thing rather as a romp, though several ugly confrontations with strikers did occur. Christopher, typically, did not know what to do. He could not write to Edward for advice, as the postal services were disrupted. He did not know whether to support the strikers, or to do something for the Country, as Kathleen's friends put it. Finally, he volunteered for service, asking for the most unpleasant task available. He was assigned to the sewage department, but before he could start work the strike was over.

Having utterly failed that political test, Christopher went off to the Isle of Wight again in July, this time taking Wystan Auden with him. Wystan marched around dressed in dirty grey flannels, with a black bow-tie and a large black felt hat, drawing immediate attention to himself. Christopher was profoundly embarrassed by the sniggers this attire drew from the locals, but Wystan brushed aside his objections, declaring: 'Laughter is the first sign of sexual attraction.'

The effect the two young men had on each other was crucial to their development. Wystan, then only nineteen, was undergoing a constant intellectual ferment, and used Christopher as a sounding-board for some of his new ideas. He had cast out his previous literary role models and now loudly proclaimed the brilliance of T. S. Eliot, who was, like all Auden's enthusiasms, 'the only *possible* thing, my dear'. He had recently devoured Freud and Jung and the writings of various anthropologists, and littered his talk with esoteric words and jargon, sometimes chosen as much for their sound as their meaning. Christopher often had the impression that Wystan was experimenting as he talked, seemingly oblivious to the startling effect that his loud and pretentious monologues were having on passers-by. He was none the less well aware of his power to shock, particularly a comparative innocent like Christopher. Astounded and fascinated, Christopher listened to his friend's diatribes, blushing scarlet with shame when Wystan nearly had them thrown out of a local pub for giving a recitation of some of the juicier examples of English verse.

Sex was the ultimate topic for unsettling Christopher. Despite his romantic yearnings for younger boys, and the one rather unsatisfactory sexual experience at university, Christopher was still in a state of considerable confusion about his sexual needs. In contrast, Wystan spoke of his own

animal desires with the straightforwardness of someone describing what they had had for breakfast. Indeed, Wystan tended to treat sex as something to be enjoyed naturally if it was presented to him on a plate. According to Robert Medley, Wystan had happily come to terms with his sexual preferences while still at school. He had had a show-down with his father about homosexuality after Dr Auden had discovered some poems Wystan had written in appreciation of Medley's body in the school swimming-pool. Dr Auden had suggested that such emotions, while common in adolescence, were not a very good idea in adult life, not just because homosexuality was then illegal in England. But Wystan had been unimpressed. His frankness on the subject took Christopher's breath away. He would lie awake at night, in his single bed at Marine Villa in Freshwater Bay, unable to get Wystan's sexual anecdotes out of his mind.

Although Wystan frequently complained of the cold, he had an aversion to natural sunlight. He would draw the curtains of his room at the guest-house during the day, preferring to work by the light of a table-lamp. At night he would pile overcoats, rugs and anything else available on to the bed, as he liked to be weighed down while he slept. He smoked his pipe incessantly, announcing in self-justification: 'Insufficient weaning, my dear; I must have something to *suck*.' He thumped hymn-tunes out on the piano and drank endless cups of tea.

The objects of Wystan's enthusiasms and criticism changed with bewildering frequency, as reflected in his university studies. He abandoned Science at Christ Church, spent a brief transition period reading Politics, Philosophy and Economics, and finally settled in the English faculty, where he was fortunate to have as his tutor the young Nevill Coghill, who became a valued friend.

Christopher was surprised and flattered to see how much influence he was having on Wystan's writing. In *Lions and Shadows*, Isherwood recounts – with undoubted exaggeration – how Wystan would cut out any word or line in a poem which Christopher disliked:

If, on the other hand, I had praised a line in a poem otherwise condemned then that line would reappear in a new poem. And if I didn't like this poem either, but admired a second line, then both the lines would appear in a third poem, and so on – until a poem had been evolved which was a little anthology of my favourite lines, strung together without even an attempt to make connected sense. For this reason, most of Weston's [Auden's] work at that period was extraordinarily obscure. (pp 190–191)

58

Christopher began to see Wystan as The Poet of their generation; the Mutual Admiration Society started with Edward Upward had grown.

Wystan introduced Christopher to the world of Icelandic sagas, getting him to read the copies of *Grettir* and *Burnt Njal* that he had brought to the island. The heroic warriors' behaviour and language struck Christopher as being reminiscent of those of the boys at St Edmund's. This led to the composition of 'school sagas' with Wystan, who fell in with the spirit of the game. Out of this grew Christopher's story 'Gems of Belgian Architecture', and a short verse play by Wystan, *Paid on Both Sides*, in which the two worlds of Norse legends and preparatory school life are interwoven.

In August, Christopher and Edward Upward went back to the Haute Savoie region of France, to try to do justice to the Alpine scenery they had scoffed at on their school trip four years earlier. The tour was plagued by small misfortunes and Edward moaned that he wanted to go home. They had a tiff when Christopher hit a sore spot by exclaiming: 'You'll only write one slim book of verse. You're far too fastidious!' However, it was the sight of a sexy boy on a train who caught his fancy which prompted Christopher to abandon Edward at Bourg-Saint-Maurice and go off in vain pursuit.

These two trips, with Wystan and Edward respectively, deeply disturbed Christopher. Even being with the Mangeots in London left him feeling unfulfilled. Not yet ready for another dose of Wystan's brutal analysis, he went away to a cottage in Wales to sort out his attitude to his own homosexuality and his plans for the future. He took some volumes of Proust with him, which was a most counter-productive exercise, as he was horrified by the portrait of the ageing Baron de Charlus. Far from lifting, Christopher's depression deepened so that, after only four days, he headed back for London, intent on killing himself.

He bought a Browning automatic pistol and went to consult Hector Wintle about the best part of his anatomy to aim at to ensure a successful suicide. If Christopher's subconscious had been hoping Hector would react by trying to dissuade him, it was disappointed. Ever the master of melodrama, Hector clinically told him exactly what to do. He recommended sticking the gun into his mouth, and pointing it upwards towards the brain to inflict maximum damage. But in the end, Christopher did not have the nerve to go through with it, though he did get as far as making a will, leaving everything to Edward Upward, apart from his diaries and papers, which he asked to be destroyed.

A more acceptable alternative to death, Christopher decided, was to leave home. However, this break was not quite the theatrical coup he had hoped for. Far from creating a scene, Kathleen agreed it would be rather nice for

him to rent a little place of his own, not too far away, where he could get on with his writing in peace, and enjoy the sort of independence that a young man needs at the age of twenty-two. This caused Christopher to flirt briefly with the idea of going off to Java, but he settled on a room in Redcliffe Road, Chelsea, instead. He moved in September 1926, and got a little work doing private tutoring, to help with the expense.

The room's previous tenant had been Roger Burford, who had abandoned his hopes of getting into films for the time being and had gone into freelance journalism. He had also acquired a girlfriend, Stella Wilkinson, and gone off with her to Milan. Christopher liked Stella enormously, with her bubbling, artistic ways. She called him 'Bisherwood' (a contraction of Bradshaw Isherwood), which Wystan Auden acidly shortened further to 'Bish', pronounced like *biche*, the French slang word for 'lesbian'. Christopher wrote mournfully to Roger and Stella when he was ready to move into Redcliffe Road: 'By the time you return I shall have gone mad. . . . Everything here is vile, vile, *vile*, vile, vile, VILE, *VILE*.'

During 1926, despite his black despair, Christopher managed to complete his novel *Seascape with Figures*. He showed it to Ethel Mayne (Venus), who thought it was a distinct improvement on *Christopher Garland*. She recommended a couple of publishers, but both of them turned it down. Edward Upward did not think much of it either, so Christopher decided to put it away for possible further revision the following year.

Meanwhile, the idea for a different novel had been born in his head. This was to have been a gigantic survey of the post-War generation, set in London, North Wales and the French Alps. Not only Hector Wintle, but also Edward Upward, Wystan Auden, the Mangeots and other friends were scheduled to appear in it, thinly disguised, alongside Christopher himself. The plot was a little vague, but the theme was clear from the beginning, as was the title: *The North-West Passage*. This theme was intimately connected with the Test in Christopher's mind, as he had been reading the psychological writings of Bleuler. One of Bleuler's case histories, of a homocidal paranoiac, speaks of his concept of the Truly Strong Man. Christopher adopted and adapted this concept – and its antithesis, the Truly Weak Man – to describe two distinct sorts of people. It was not just a matter of separating the sheep from the goats, as the Truly Strong Man might not necessarily be identified by mere heroics, which could actually be symptomatic of the opposite extreme. T. E. Lawrence, for example, was considered by Christopher to be a Truly Weak Man, who needed a dramatic show in Arabia to hide his inherent weakness. Frank Isherwood, on the other hand, had been a Truly Strong Man, brave but disdainful of heroics. According to Christopher's new philosophy,

the Test exists only for the Truly Weak Man, who, he later wrote in *Lions and Shadows*, is ready to expend huge amounts of energy, money, time, and physical and mental resources in an attempt to navigate the laborious, terrible North-West Passage rather than confront Life head-on. The book was never written. But the concept of the Truly Weak Man pervades many of Isherwood's published novels, in which neurotic characters are clearly adrift on the North-West Passage.

Early in December 1926, Christopher went to Oxford to visit Wystan Auden, who had comfortable oak-panelled rooms in Peck Quad at Christ Church. Although Wystan disdained the college social climbers who courted the 'in' group of Harold Acton, Bryan Guinness and Christopher Sykes, he did have an impressive circle of friends at Oxford, including the budding poets John Betjeman, Cecil Day Lewis, Louis MacNeice and Rex Warner, as well as the future politicians Richard Crossman and Gabriel (Bill) Carritt. Wystan also had a piano, located in a closet that was startlingly decorated with a red-and-black cubist mural representing a railway accident. There he would play Bach and selections from *Hymns Ancient and Modern*, to illustrate points in his conversation.

Christopher was treated to a torrent of Wystan's latest fads, including the German lyric poet Christian Morgenstern, Gertrude Stein and Sophie Tucker. Ballet, he said, ought to banned by an Act of Parliament, while the only possible form of evening entertainment was a visit to a greyhound track. Reeling from Wystan's monologue, Christopher was taken to the George Restaurant for a splendid dinner. Wystan was not normally a member of the 'Georgeoisie', who dined there every night to the strains of a string band, but presumably he wanted to make a good impression. From there they went to the Christ Church Essay Club, where Christopher barely understood an abstruse paper presented by one of its members and entitled 'The Concept of Duty'.

By this time, Christopher and Wystan had become lovers, rather on Auden's terms. Isherwood later said that they made love unromantically, but with great pleasure. This situation lasted several years, though in no way preventing either of them from pursuing other people. And, although they were deeply fond of each other, they were never strictly 'in love'.

The day after he returned from this visit to Oxford, Christopher developed influenza, and in future usually managed to catch a cold when he met up with Wystan. Not that he could count on any sympathy from Wystan, who had no time for people who moaned about their ailments. Besides, he insisted that Christopher's illnesses were psychosomatic, referring to his friend's frequent sore throats as 'liar's quinsy'.

Installed in his room in Redcliffe Road, Christopher received numerous visits from Hector Wintle, the Mangeots, Roger and Stella Burford – now back and married – and other friends. He had little contact with Edward Upward, though, as witnessed by a postcard Edward sent him on March 27 bearing the simple query: 'Are you, perhaps, dead?' Christopher thrived on company at this period, and fretted when left alone in his room. But he settled into a weekly routine of travelling round London giving lessons arranged by the well-known agency Gabbitas and Thring, which Christopher rechristened 'Rabbitarse and String'. To his surprise, he derived particular pleasure from teaching Divinity.

Early that summer he returned once more to the Isle of Wight, where he worked consistently on the revision of *Seascape with Figures*. He adopted a new routine which became a pattern he was to follow for years to come: rising early and writing from breakfast until eleven, and then breaking off for a walk around Freshwater Bay. There he would chat with the vicar or the coastguard or the fishermen, gaining snippets of information or turns of phrase which he filed away for future use. He made notes of conversations overheard on the beach, and sent them in long letters to Edward. But he affected to despise the noisy middle-class holiday-makers, who were all too clearly enjoying themselves, and he cast himself in the role of a permanent outsider, looking in on their world with contempt.

In contrast, Christopher went to great pains to get on friendly terms with the local fishermen. In order to hide his upper-middle-class Oxbridge accent, which he thought would be a barrier to friendship with them, he adopted a fake Cockney accent which, once started, could hardly be abandoned. He spent a lot of time with one particular ruggedly attractive seventeen-year-old fisherman, partly as an exercise in inverted social-climbing, but also because of the boy's animal appeal. He went drinking with the youth and the two of them took girls to the local cinema where, after a few gins-and-tonics, Christopher discovered that he quite liked cuddling in the back row. When some of these dates seemed to be leading all too fast towards more serious petting on the Downs, he nobly passed on his girl to the ever-willing fisher-boy, who was too pleased at Christopher's generosity to question it.

Christopher finished *Seascape with Figures* in July. He had cut out the murder scene and pared the whole novel down to its bare essentials. He had worked from the basic idea that the form of the novel should be highly contrived; while respecting the mood he had taken from Forster, he derived much of the book's construction from detective stories and the plays of Henrik Ibsen. Every word was meant to be a clue leading towards some great discovery.

Edward Upward was shown the manuscript and liked it, but thought the title was wrong. After much thought, Christopher chose another: *All the Conspirators*, taken from Antony's speech over Brutus's body in the last scene of Shakespeare's *Julius Caesar*. This had little, if any, direct relevance to the content of the book, though some critics have seen it as referring to the attitude of Isherwood, Auden and Upward towards the Establishment.

All the Conspirators is a claustrophobic domestic drama, set largely in North Kensington. The subject, if not the style, owes much to Hector Wintle. The novel opens with Edward Upward and Hector Wintle sitting in a small hotel by the sea. They are thinly disguised as the characters of Allen Chalmers and Philip Lindsay (both of whom also have an element of Christopher in them). Their professional roles have been reversed, for, in the novel, it is Allen Chalmers who is the medical student. As Alan Wilde has correctly stated in his study of Isherwood's fiction, *All the Conspirators* is the angriest of his novels. Isherwood himself described its style as 'trembling with aggression'; a reflection of what Shelley calls the great war between the old and the young. In this war, Philip Lindsay's revolt against his mother is a failure – just a small incident on a distant frontier, where some shots are fired without much obvious result. The main battle is going on somewhere else.

In *All the Conspirators*, Isherwood and several of his main characters are shown to be angry young men, but they differ from their 1950s counterparts in that they have no clear political consciousness. Their vision of injustice is blurred, confused and totally self-centred. The novel is an intensely private work, too. Only Christopher's closest friends can possibly have understood all of the book's allusions, with its clipped language, phrases from their own jargon and incidents taken from their own lives. As such, it provided a special entertainment for those friends, almost as if it were an extravagant present. For Christopher himself, it was an opportunity to vent his dissatisfaction with the world of Kathleen and her friends. The Mrs Lindsay in the novel is the first of a series of diabolical mature women in Isherwood's work, with enough similarities to Kathleen to make it clear who provided the character's main inspiration. Yet Mrs Lindsay is a rather two-dimensional figure, something which Christopher's mother most certainly was not.

Christopher sent the finished manuscript of *All the Conspirators* to two publishers, both of whom rejected it. However, he did appear in print, anonymously, soon after. While he had been putting the finishing touches to the novel, Wystan Auden and Cecil Day Lewis had been editing the 1927 volume of *Oxford Poetry*, and had decided to include one of Christopher's poems in it, called 'Souvenir des Vacances'. As he had not studied at Oxford, though, his identity could not be revealed.

At the end of the summer of 1927, Christopher moved out of his room in Redcliffe Road and went back home. His landlady had proved impossibly incompetent, screaming babies had kept him from work and sleep, and Irish neighbours had stolen his gramophone. But his return was not exactly sheepish. It was around this time that he made his sexual preferences clear to Kathleen and he spent a great deal of time out of the house, drinking and carousing with friends. Gin was Christopher's favourite tipple, though he was introduced to a more lethal concoction by a good friend of the Mangeots, the young painter Bill Lichtenberg. Lichtenberg came from the family that made the cigarette-papers, His job and his character were as intoxicating as his cocktails. He played upon Christopher's fascination with the supernatural by staging séances for him. One night, on a wild impulse, they just took off in Bill's car and got as far as Cape Wrath in Scotland, where Christopher wrestled with imaginary enemies on a beach, after downing three-quarters of a bottle of Highland whisky.

Despite such bursts of escapism, Christopher did consider the possibilities open to him, and decided that medicine was worth a try. Hector Wintle warned him against it, but Edward Upward liked the idea, as it would give Christopher the chance to observe at close-quarters eccentrics and invalids who could then be characters in future great novels. Kathleen was a little startled by this change of direction, but arranged for Christopher to go see her young relative Raymond Greene (Graham Greene's elder brother), who was then an intern at Westminster Hospital. His account of the rigours of hospital life did not put Christopher off, but there were practical reasons why it would not be possible for him to start at medical school until the autumn of 1928. This left almost a year to be filled with other amusements.

In January 1928, the stroke of good fortune Christopher had been waiting for finally arrived. Jonathan Cape, the publisher, wrote to him asking him to go to see him about *All the Conspirators*. He said he would like to publish the book in May, if Christopher could make a few minor alterations. Christopher received advance copies of the book while on yet another short holiday at Freshwater Bay, in the company of Edward Upward. Whenever Edward went out of the room, he would peek surreptitiously at his name on the fly leaf, to reassure himself that he really was now a published author. To commemorate this momentous transformation, Edward took a photograph of Christopher holding a copy of the book, and looking very serious indeed.

5

1928–1932

Early on in *All the Conspirators*, the Edward Upward character 'Allen Chalmers' speaks of boredom as belonging to the group of cancerous diseases. Isherwood could equally well have been writing about himself. For in his twenties, Christopher regarded boredom with terror. It could lay him so low that he was unable to move, yet often he lacked the power to keep it at bay. Instead, he would depend on some friend or acquaintance shaking him out of his inertia with a proposal that managed to rekindle his imagination or interest in life.

In the spring of 1928, just such an angel of mercy appeared in the unlikely form of a distant relative of Kathleen's, Basil Fry, who was the British Vice-Consul in the German port of Bremen. While over on a visit to London, Basil Fry wrote to Kathleen suggesting that he pay a call. At first, Christopher found the man loathsome, with his patronising air and pedantically delivered classical allusions. But when Mr Fry casually invited Christopher to visit him in Germany, he rose immediately to the bait. Thus it was that in May he set off for Bremen in a 'tramp' steamer. Basil Fry had predicted that he would be violently sick on the voyage, but that the journey might help make a man of him. Determined to prove Fry wrong, Christopher armed himself with sea-sickness tablets and successfully weathered the ride.

Installed in Fry's apartment at 42 Elsassestrasse, Christopher wrote to Edward that the city was mild:

> . . . with moist fernlike trees. The houses are covered with vines and have sliding doors. Yes, after all, our later days must be spent in travel. The pleasure of sauntering along streets of ratsly [*sic*] lettered shops, soon to be left behind. Never to remain more than a week in any country. Conrad was wrong – but the tramp steamer had a Chinese cook and a Welsh cabin-boy. The captain appeared drunk on the bridge as soon as

we entered the Weser. His barely credible insults to important German officials on the quay. 'Now then Tirpitz - show a leg.' They merely smiled. I know now which side started the War.

Proust, also, would have rewritten a volume if he'd attended the consular dinner. The ices had coloured lights inside them. There is a kind of brandy liqueur which you drink out of a beer-mug. It makes you speak French better than English. My cousin is a prig, a fool, a neuter. Hatefully tall. His Oxford titter.

The whole town is full of boys . . .

Christopher was offended by Basil Fry's appearance, with his small, feminine head, large ears, soggy moustache and peevish mouth. In the amusing but unflattering portrait he left of his unfortunate relative in the 'Mr Lancaster' section of *Down There on a Visit,* Isherwood later wrote that Fry's long red nose, with a suggestion of moisture on the end, reminded him of one of Wystan Auden's dicta: 'All ugly people are wicked.' Accordingly, he shifted his interest to the office-boy at the consulate, a cute but reserved youth with whom he made little progress. As the letter to Edward suggests, Christopher felt an instantaneous sexual attraction to Germany as the home of so many desirable boys.

Klaus Mann, Thomas Mann's homosexual eldest son, described in his autobiography *The Turning Point* the extraordinary dynamism and self-glorification of German youth during the Weimar Republic (1918-1933). It was a period of economic, social and political turmoil, in which even poor boys could none the less get a suntan in summer, don shorts and a rucksack and march off into the countryside in search of adventure. As Mann wrote: 'To proclaim "I am young!" meant a war-cry and a programme. Youth was a conspiracy and a challenge.' As the mature middle classes worried about survival, having seen their savings obliterated by the rampant inflation of the early 1920s, the young could seize and savour what Nature offered for free - while at the same time keeping an eye open for any opportunity to improve their own precarious position. Even in this first brief encounter with Germany, Christopher picked up a sense of the creative tension of the place. And when one day Basil Fry gave him a long lecture about how the corruption and moral degeneracy of Germany had reached such a state that the capital, Berlin, was now unspeakably vile, Christopher made up his mind to get there as soon as possible, and to stay there for a considerable time.

The first reviews of *All the Conspirators* were waiting for Christopher when he got back to London. The book was not widely noticed and some of the critics were merciless. The *Times Literary Supplement* declared sternly:

'Mr Isherwood has collected various parts of a machine, but he has not succeeded in putting them together', while *Punch* opined: 'Mr Christopher Isherwood is either badly troubled with that kind of portentous solemnity which so often accompanies the mental growing pains of the very young, or else he has written his novel with his tongue in his cheek. . . . Altogether, the book leaves behind it a faintly nasty taste.' *All the Conspirators* sold poorly – about three hundred copies – before being remaindered and, for the time being, forgotten. However, in 1933 Hugh Walpole described it as one of the half-dozen most unjustly neglected novels since the First World War. It did not find an American publisher until 1958, by which time Cyril Connolly was generously commending it as a key to Isherwood and the Twenties.

Christopher went to Oxford to see Wystan Auden shortly after returning from Bremen. Wystan was then in his final term at Oxford, and was to astound his tutors by graduating with only a Third-Class degree. According to Stephen Spender's early autobiography *World within World*, it was in Auden's rooms on that sunny afternoon that he first met Christopher. Stephen Spender had been eager for this encounter for some time, as Wystan had been singing Christopher's praises:

> Auden had spoken of Isherwood in a way which made me think of him as The Novelist, who applying himself with an iron will to the study of material for his work was determined to live the life of The Ordinary Man, going to the office in the train, dancing in dance halls at seaside resorts, dressing with a studied avoidance of every kind of distinctiveness, and so on. Isherwood, according to Auden, held no opinions whatever about anything. He was wholly and simply interested in people. (p 101)

Christopher had in fact asked to meet Stephen Spender after Wystan had shown him a short story based on Spender's intimate friendship with another English boy at a pension in Switzerland. Spender recalled the actual meeting in *World within World* in terms that reflect the rather stylised role-playing that was to become the public projection of their triangular relationship:

> Auden wore a green shade over his eyes, and looked like an amateur chemist. Isherwood looked like a schoolboy playing charades. . . . Auden looked up abruptly when I came in and said: 'You're early. Sit down.' Isherwood giggled, and while I sat down he turned to Auden and said: 'But really I don't see the image of a "frozen gull flipped down the

weir''; it sounds like cold storage.' Auden flushed and struck out the lines with a thick lead pencil.

When they had finished, Isherwood made a quite formal little speech saying he had read my manuscript and that he regarded it as one of the most striking things he had read by a young writer for a long time. (p 102)

That judgment from a Christopher who was all of twenty-three at the time! It is interesting to note, though, that Isherwood himself, in *Lions and Shadows*, situates his first encounter with Stephen Spender in London several weeks later, and in completely different terms:

He [Spender] burst in upon us, blushing, sniggering loudly, contriving to trip over the edge of the carpet – an immensely tall, shambling boy of nineteen, with a great scarlet poppy-face, wild frizzy hair, and eyes the violent colour of bluebells. . . . In an instant, without introductions, we were all laughing and talking at the top of our voices. (p 281)

The inconsistency of the two accounts, both carefully constructed to be amusing, is a useful warning about taking such autobiographical writing at face value. What is certain, though, is that Christopher and Stephen saw each other several times in London in the summer of 1928 and became close friends.

Stephen came from an intellectual, middle-class family, partly Jewish, and entirely German on his mother's side. He had lost both of his parents by the time he went up to University College, Oxford, in 1927, to read history. Like Edward Upward at Cambridge, he soon became disillusioned with it and switched, not to English (as he later knew he should) but to Politics, Philosophy and Economics. His late father Harold – best known for his journalism – had himself been something of a politician, having stood unsuccessfully as a Liberal candidate in Bath in the 1923 General Election. Harold Spender had also been at University College, and Stephen's elder brother Michael was at Oxford too. Michael had been at school with Wystan Auden, whom Stephen had longed for months to meet until they eventually ran into each other at a lunch-party at University College, given by a mutual friend, Archie Campbell.

By the time Christopher met Stephen, Spender had studiously turned himself into something of an undergraduate 'character'. He accentuated his already impressive, towering presence by wearing brilliant scarlet ties and other unconventional clothes. As Isherwood recalled in *Lions and Shadows*, Stephen:

. . . inhabited a world of self-created and absorbing drama, into which each new acquaintance was immediately conscripted to play a part. [Spender] illuminated you like an expressionist producer, with the crudest and most eccentric of spot-lights: you were transfigured, became grandiose, sinister, brilliantly ridiculous or impossibly beautiful, in accordance with his arbitrary, prearranged conception of your role. And soon – such is the hypnotic mastery of the born *régisseur* – you begin to live up to his expectations. (p 281)

In that way, Stephen and Christopher were remarkably similar, which led to an instant rapport, but also sometimes proved a source of friction.

Stephen became Wystan's first publisher that summer, by running off a booklet of his poems on a hand-press at home. Wystan meanwhile secretly and mysteriously got engaged to be married to a nurse in Birmingham. He then left for Germany in August, intending to spend a year in Berlin learning German. At first he stayed as a paying guest in a comfortable house in the middle-class suburb of Nikolassee, but his hosts there were too keen to practise their English on him, so he moved to a working-class district. By then he had already discovered the 'wickedness' for which Berlin was so famed and had jumped in with both feet. Christopher and other friends in England started to receive ecstatic and explicit letters from Wystan describing a world that could have been a million miles from strait-laced London.

In stark contrast, Christopher began his medical studies at King's College, London, that October. He had the singular disadvantage of approaching the subject without any previous intensive study of science. Most of his fellow students were several years younger than himself, being fresh from school, and were familiar with physics, chemistry and biology. Very quickly Christopher realised that he had made yet another mistake, and that he did not have the sort of true vocation to become a doctor that would have enabled him to handle the enormous amount of rote-learning required to pass his medical examinations. Fortunately, he was able to befriend a willing lad of eighteen, who steered him through the most difficult experiments and lent him his notes to copy.

However, Christopher did successfully clear a hurdle that many better-prepared medical students fail: watching his first operation without feeling faint. Hector Wintle was then working as a dresser in an operating theatre at St Thomas's Hospital and Christopher arranged to go and watch. The operation was a leg amputation, and struck Christopher as so unreal that it was not in the least nauseating. Afterwards, he had tea with Hector in the hospital canteen, where Hector spoke with such authority about the operation that

Christopher realised his friend had overcome his earlier hesitations about the medical profession and was well on the way to becoming a good doctor. Hector went on to be a ship's doctor – his first boat auspiciously being called the *Hector* – before settling down in England as a medical officer. He managed to publish a number of novels, though none enjoyed great success.

Christopher meanwhile channelled the energy he ought to have been putting into his medical studies into a new novel of his own. Already entitled *The Memorial*, this was to be a survey of the effect of the Great War on his generation. The theme was epic, but the treatment would be in 'tea-tabled' style. Every afternoon, when classes were over, he rushed home and began writing. By the end of his first term at King's, he had finished an initial draft of the novel. In the College chemistry exams, though, he came bottom of the list.

At Christmas, Wystan came back to England to see his parents and called on Christopher. His latest enthusiasm was for the teachings of the American psychologist Homer Lane, whose British disciple, John Layard, he had met in Berlin. In fact, after initial hesitation on Wystan's part, Layard and he had started to go to bed together, which was Layard's first foray into gay sex. The crux of the Lane–Layard doctrine was that there was only one sin: disobedience to the inner law of one's own nature. Layard preached that many human problems were caused by the unhealthy education given to children, which tried to suppress their natural urges in order to turn them into miniature adults. He saw disease as an outward manifestation of inner sickness, which meant that successful cures depended on purifying the soul. Layard could hardly have found a more receptive pupil than Wystan, who had come to rather similar conclusions on his own, which is probably one reason why Layard fell so heavily in love with him.

Wystan was particularly attracted by Layard's contempt for obsessive hygiene, and looked even shabbier than usual when he called on Christopher. He immediately made Christopher a guinea-pig for a bit of Layard-style treatment, telling him bluntly that the sore throat Christopher was complaining of merely proved that he was wicked and had been telling lies. Christopher scorned Wystan's instant diagnosis, but was none the less impressed by what he was hearing about John Layard. He was pleased to discover that Wystan had talked about him to Layard, who had judged that he could not be a completely hopeless case of a neurotic artist if he had had the gumption to leave Cambridge in the way he did. This intrigued Christopher enough to want to get to know Layard personally.

But the thing which really determined him to follow Wystan to Berlin was his friend's description of life among the boys there. Wystan had reported

gleefully that there were 170 male brothels in Berlin, and that he had found a bar where he could turn his fantasies into reality. This was the 'Cosy Corner', at 7 Zossenerstrasse, in the working-class area of Hallesches Tor, where juvenile delinquents – as Wystan described them – offered themselves for sex in return for a little cash or a present. He had himself found a regular sex-partner, a boy called Pieps, whom he described in a letter to another friend in England as a cross between a rugger-hearty and Josephine Baker. Somewhat to Layard's concern, Wystan would emerge from sessions with Pieps covered in bruises, having provoked the boy with pillow-fights into beating him up. Nostalgic for the rough-and-tumble of wrestling and boxing at school, Christopher could hardly wait to join in.

Wystan's stories about Berlin led Christopher to the inescapable conclusion that he would have to abandon medical school. He informed Kathleen of his decision, but she implored him at least to stay on till the end of the academic year, as all the fees had been paid in advance. Besides, he might change his mind. He compromised by agreeing to hold out until Easter. During January and February 1929, though, he did little more than mark time.

On March 14, Christopher boarded the Dover to Ostend ferry for the beginning of his great journey of liberation. The idea was to go for just ten days or so – Berlin on approval – but he was already sure he would love it.

Wystan used Christopher's arrival as a pretext for starting a diary. This is on occasions quite obscene and remains unpublished. One of the more printable entries (for March 19) is the rather petulant comment that Christopher seemed so babyish with his notebook and sulks. The notebook accompanied Christopher everywhere, for jotting down overheard conversations – insofar as he could understand them – as well as recording his own thoughts and impressions. In this respect, he rather resembled a journalist, in wanting to have an accurate record of what people said. But the novelist side to his nature none the less ensured that he felt no qualms about improving upon reality with a little fictionalisation.

Wystan was living on Furbingerstrasse, near a brothel at the Hallesches Tor. This was conveniently located for the Cosy Corner, which Christopher was quick to get to know. The decor there was tatty, with a few photographs of boxers and cyclists pinned up on the wall over the bar, and the only heating was provided by an old stove. But it was the ideal environment for an upper-middle-class British adventurer intent on slumming. The boys were seated at tables, and would weigh up each new arrival as he came in. Potential customers could inspect the merchandise in the loo, or by discreetly slipping their hands under the tables into trouser pockets that had been conveniently ripped inside. Many of the boys in the bar were unselfconsciously vain, and

knew that the upkeep of their bodies was their key to success. Only a few of them would have considered themselves homosexual, however. Indeed, most vaunted their concurrent affairs with women, often prostitutes themselves. In the boys' minds, the fact that they were sexually desirable to gay men only emphasised their masculinity.

As Christopher's German was still rudimentary, the triviality of most of the conversation in the Cosy Corner did not bother him. Trying to make himself understood in a new language with rugged and often humorous boys provided sexual thrills of its own. Having nurtured the ideal of the Blond German Youth during the months since his short visit to Bremen, Christopher now had a feast for his eyes. The irony was not lost on Wystan, though, when Christopher plumped very early on in his first stay in Berlin for a boy of Czech, not German, origin. Berthold Szczesny, universally known in the gay milieu as 'Bubi' (Baby), was an independently minded lad who had had a brief spell as a boxer. Blond and dreamy, there was a gentle side to his nature, as well as the cunning more usually associated with his present profession. Christopher saw Bubi every day; they made love and toured the city together. Wystan, who had himself been enjoying quite a stream of boys, was amused by Christopher's fidelity to Bubi, and wrote a poem in their honour, which begins cynically:

Before this loved one
Was that one and that one,
A family
And history
And ghost's adversity
Whose pleasing name
Was neighbourly shame . . .

Christopher went several times to the cinema in Berlin, reacting enthusiastically to silent films such as Georg Pabst's *Pandora's Box* and Vsevelod Pudovkin's *Storm over Asia*. He also met John Layard, though they did not become close friends until later in London. Christopher returned there in the last week of March, romantically clutching a cheap gold bracelet that Bubi had given him. Six days later, John Layard – having gone to bed with Wystan's latest boyfriend, Gerhardt, partly out of spite for Wystan's rejecting his love – tried to kill himself by shooting himself in the mouth. The bullet lodged in his skull, having missed the brain, so he got into a taxi to Wystan's and begged him to finish him off. Instead, Wystan sent him in another taxi to hospital. This bizarre sequence of events was duly incorporated by

Christopher into *The Memorial*. He was working on the second draft of the novel in London during April and May and started giving himself a crash course in German.

Christopher thus missed the great May Day clash in Berlin between the Communists and the police. The winter of 1928 and 1929 had been particularly harsh, and discontent with the Weimar regime grew alongside mounting unemployment. Berlin was a hotbed of left-wing activism, but the authorities tried to suppress it with continual harassment and bans on public demonstrations. Defiantly, the Communists took over whole streets in the capital, especially in the Neukoln district. They erected barricades using commandeered trams, and the five days of fighting with the police that ensued left over twenty people dead and 150 wounded. Auden composed a poem that included the line 'All this time was anxiety at night', and he later attributed his political awakening to this period.

By the time Christopher returned to Germany in early July, Wystan had left Berlin and was travelling round the country with yet another new boyfriend, Otto. Christopher caught up with them in the attractive village of Rotehütte in the Harz mountains, where Wystan scandalised the locals by wrestling naked with Otto in the fields. Bubi was meant to join them, and when he didn't, Christopher rushed to Berlin to find out what was wrong. On Wystan's recommendation, he went to see a regular client of the Cosy Corner, the British archaeologist Francis Turville-Petre. From him Christopher learnt that Bubi was wanted by the police and had slipped over the frontier into Holland, in the hope of shipping out to South America. Christopher left his Rotehütte address with Francis Turville-Petre, in case Bubi got in touch. Alerted by Christopher's enquiries, the police then followed him back to Rotehütte, where they arrested Otto, who turned out to have absconded from a reformatory.

In due course, a letter did arrive from Bubi in Amsterdam, asking Christopher to send some money. Undeterred by this brush with the underworld, Christopher persuaded the now companionless Wystan to travel with him to Holland to try to track Bubi down. By an amazing fluke, they bumped into him in the main post-office almost as soon as they arrived in Amsterdam. Christopher failed to persuade Bubi not to leave for South America, but saw him off at the quayside.

Back in England that autumn, Christopher set about earning some money. Through Wystan, he met a rather bitter but wealthy man, Colonel Solomon, whose Russian wife - reputedly Kerensky's former mistress - had founded the Blackamoor Press. Wystan had told the Solomons that Christopher was absolutely brilliant at French, which is how he got the commission to translate

Baudelaire's *Journaux Intimes*. This appeared in 1930, with a complimentary introduction by T. S. Eliot. Isherwood's most vivid memory of the Solomons was of driving round Piccadilly Circus with the Colonel, who was paralysed from the waist downwards, gleefully pointing out the homosexuals who loitered by the entrance to the Underground Station, exclaiming: 'Look! There's another one!'

By this time, Kathleen had moved her household out of St Mary Abbot's Terrace because of increased traffic noise, and installed them in a smaller house at 19 Pembroke Gardens in Earl's Court. It was there that Christopher and Wystan began writing a play together, entitled 'The Enemies of a Bishop', dedicated jointly to Bubi and Otto. The play is redolent of prep school, with characters in the Mortmere vein. There's a reformatory, cross-dressing, white slavery and much implied buggery. At frequent intervals the action just stops while rather good poems by Auden are declaimed. No attempt to get the play performed seems to have been made, yet it cannot be dismissed merely as a private indulgence, as Christopher and Wystan continued to tinker with it over the next couple of years and even went to the expense of having it professionally typed.

Meanwhile, Christopher had been sent off to a remote Scottish village, in Sutherland, to be private tutor to an attractive young boy. He kept his hands off the child, but ended up in bed with the mother – an experience he described later as quite workable, but not as good as the real thing. Probably he needed to prove to himself that he could function sexually with a woman, but he realised that his romantic, as well as sexual, inclinations, were overwhelmingly directed at boys, preferably in the seventeen to eighteen-year-old range.

Berlin beckoned, and he was back there by November, this time looking for somewhere to live. Wystan had gone to take up a tutoring job in London, so the English contact he had in Berlin was Francis Turville-Petre. He went round to see him at his flat in In Den Zelten, overlooking the Zoo Park. When Christopher rang Francis's bell, however, Francis opened the door only to slam it again in his face, screaming insults in German from inside. Christopher shouted his name and encouragements in English through the door, convinced that Francis must have mistaken him for somebody else. This was indeed the case, as Francis, much the worse for wear after a heavy night out, had thought Christopher was the local boy he had brought back with him and who had slipped out early with some of his belongings. Once that misunderstanding was out of the way, Francis invited Christopher in, apologised for his rudeness and asked him to stay for lunch.

Francis rented a couple of rooms in the flat from the sister of Dr Magnus

Hirschfeld, who ran the Hirschfeld Institute of Sexual Science next door. This now legendary institution was a centre for the academic study of sexual deviancy. Perversions of every imaginable kind were treated as interesting cases and discussed with all the eminent respectability of German scientific terminology. The building itself was a most imposing mansion, having been the former residence of the famous violinist Joseph Joachim. It was furnished with heavy period pieces, including busts of Goethe and other heroes of Teutonic civilisation.

Magnus Hirschfeld himself, then already sixty-one, was a Baltic Jew whose father had been a well-known doctor and philanthropist. By middle age, Magnus Hirschfeld had already acquired a formidable reputation, and was able to purchase the mansion at no. 10, In Den Zelten in 1919, where he founded what was the world's first serious centre of sexology. He was the author of such seminal works as *Transvestites* and *The Homosexuality of Men and Women*. A homosexual himself, Hirschfeld had for a number of years been having a relationship with a much younger man, Karl Geise, who acted as his lover and secretary. Karl Geise adored Magnus Hirschfeld and called him 'Papa'.

The institute also housed a marriage guidance centre and a VD clinic, the latter patronised by Francis Turville-Petre. But it was its dealings with the outer fringes of homosexual practice which won it its popular notoriety. Attacks from puritans and queer-bashers were a constant threat. But during the early years of the Weimar Republic, Magnus Hirschfeld did have powerful friends who supported his struggle for the better treatment of homosexuals. He was even able to plead his cause in parliament, and for a while it looked as though his crusade to get Germany's anti-homosexual laws liberalised might succeed. In the end, though, the economic crisis and political unrest meant that the government shelved related draft legislation in favour of more pressing concerns.

None the less, Hirschfeld had succeeded in winning a precarious special status for the Institute, so that it was accepted as an asylum for sex-offenders who would be left alone by the authorities until their cases came before the courts. When Christopher moved into the same flat as Francis Turville-Petre in the building next door, he was thus able to meet an extraordinary diversity of marginalised people. He was quickly dubbed the 'house-child' by fellow residents, because of his comparative youth and small size. He ate with them, though Hirschfeld himself was rarely at table. Initially Christopher was rather sniffy about Hirschfeld, being distrustful of the Doctor's attitude to the residents there. But all his doubts evaporated one memorable day when the French novelist André Gide came on a visit to the Institute. Christopher

happened to observe Gide being taken on a tour of some of the building's more noteworthy freaks, including a youth with perfect female breasts. Gide's consciously romantic cape and his supercilious air aroused all of Christopher's latent hatred for intellectual 'Frogs'. Suddenly he saw Hirschfeld himself in a new and more favourable light; his shambling, professorial air, which Christopher had been the first to lampoon, became noble in contrast to Gide.

One great advantage of having a room in the Hirschfeld establishment was that there was no problem about bringing boys home. But as a novelist collecting material, Christopher spent more of his time observing Francis Turville-Petre, who was the first of the truly exotic personalities of Christopher's Berlin experience whom he would eventually put into his books.

Francis had noble looks, much worn by years of debauchery. He was being treated for syphilis at the Institute's clinic, but he was already beyond the infectious stage, so was himself able to bring boys back to the flat. Often, in the mornings, Christopher would come across more than one unknown youth wandering around – the gleanings of Francis's night out. Despite his aura of decay, Francis was an extremely resilient person who survived by letting life's worries pass over him. None the less, he could be vitriolic in condemning humanity, and in particular anyone who did *not* have syphilis. He frequented a number of Berlin's boy-bars, and Christopher often accompanied him. But whereas Francis might spend half the night out, haggling over the price of a boy he fancied, Christopher would get home by ten or eleven, having been careful not to have too much to drink, so he could be up early and fresh to get on with his writing.

By this stage Isherwood had developed what was to remain a lifelong habit of reworking complete drafts of his books several times. He was currently revising *The Memorial*, writing it out painstakingly in longhand, with obsessive neatness, assiduously scratching out mistakes with a razor-blade. He established the routine, during this period in Berlin, of installing himself at a table in a café in In Den Zelten, drinking beer and smoking Turkish cigarettes while he worked.

In February 1930, though, he had to return to London, as Uncle Henry had perversely withheld his quarterly allowance. There he found himself caught in the middle of a dreadful family row. Richard had pretended he had found a job so he would not have to study with a private tutor hired in the hope of getting him into Oxford. Richard had no wish to further his education; indeed, he struck Christopher's friends as being like a shy but intelligent child for the rest of his life. Kathleen was furious, but Christopher sided with his brother – and then rubbed salt into Kathleen's wounds by describing in detail the sort of life he was living in Berlin. This sent his mother into fits

of tears, which only heightened his resentment against her. At Christopher's suggestion, John Layard – who had now settled back in London – came over to see Kathleen and persuaded her to submit to some of his psychological analysis. Though his own life was something of a mess, Layard was an acknowledged expert at helping other people overcome their problems. Kathleen admitted to him that she had made mistakes in bringing up her sons, but pleaded that she had tried seriously to come to terms with their difficult natures. Layard's counselling does seem to have done some good, though, as gradually her anger at Christopher's behaviour subsided, and she began to take on a new role as his unpaid London literary agent. Richard, in turn, seems to have gained great satisfaction from becoming an equally compliant amateur secretary, to whom Christopher would dictate some of his work in progress.

Christopher saw a lot of Stephen Spender at this time. Stephen had used some of his university vacation to go to Germany in 1929, though to Hamburg, not Berlin. Like Christopher and Wystan, he had fallen under the spell of German youth. As he wrote in *World Within World*:

> The sun – symbol of the great wealth of nature within the poverty of man – was a primary social force in this Germany. Thousands of people went to the open-air swimming baths or lay down on the shores of the rivers or lakes, almost nude, and sometimes quite nude, and the boys who had turned the deepest mahogany walked amongst these people with paler skins, like kings among their courtiers. (p 107)

So the two friends had a great deal to talk about.

Less happily, the Mangeots' home had broken up, largely thanks to André Mangeot's peccadilloes with attractive female musicians. Olive Mangeot sued him successfully for divorce, though the separation was gradual. First, André moved out of Cresswell Place, while Olive and the two boys continued living upstairs. Then she found a house in Gunter Grove, Chelsea, where she took in lodgers to help make ends meet. Fowke, her elder son, moved there with her, while Sylvain – shortly to go up to Oxford – continued to use Cresswell Place as his base.

Once again feeling stifled by the atmosphere in his mother's house, but reassured that his allowance from Uncle Henry would be forthcoming, Christopher returned to Berlin in May. Germany had a new Chancellor, Dr Brüning, who had tried to get a hold of the country's economic problems by a package of austere measures which included cutting wages and social security. Public resentment was mounting. Another foreign resident of 1930s

Berlin was Claud Cockburn. He wrote in his memoirs, *I Claud*, that in that city 'you felt that the deluge was always just around the corner'.

For those who were after sensual enjoyment, however, there now seemed to be even more boys about 'on the game'. Christopher quickly found himself a new companion, a lively sixteen-year-old working-class youth, 'Otto', who was to be the basis for the Otto Nowak character in *Goodbye to Berlin*. Otto was cheeky and full of charm, and never tried to hide his bisexual promiscuity. Christopher later wondered whether getting himself so entangled with the boy, with all the fraught possessiveness of devotion that this entailed, was motivated by some subconscious artistic need for a psychologically masochistic relationship.

The summer of 1930 brought visits from both Wystan Auden and Edward Upward. Wystan had started teaching at a small private school near Glasgow, though he had had to go into hospital before taking up his duties for an operation on a painful anal fissure – 'the stigmata of Sodom', as he described it to his friends. He brought with him a copy of his first book of poems, which was dedicated to Christopher.

Edward had also become a schoolmaster, and a Marxist sympathiser as well. Though not yet a member of the Communist Party, he displayed a new-found austerity and a political seriousness which impressed Christopher who, however, was in daily contact with Communists at the Hirschfeld Institute. Many gay men, including Hirschfeld himself, had been wooed by Marxist theories of social justice, and by the early Soviet Union's liberal attitude to sex – a position that was being totally eroded under Stalin. Christopher was in broad sympathy with leftist ideas, yet was never seriously tempted to join the Party. He was too much of a liberal individualist. Moreover, his lack of deep concern with matters political is shown by the fact that in a letter home at this time, he mis-spelt Hitler's name.

Stephen Spender returned to Hamburg when he left Oxford that summer and took a room in a boarding-hourse. He discovered the Hamburg equivalent of the Berlin boy-bars and, in the middle of August, Christopher and Otto came up to visit for a couple of days. Afterwards, Christopher wrote to Stephen saying how nice it would be if he moved to Berlin, which Stephen not unnaturally interpreted as an indication that Christopher would like to see much more of him.

In the elections of September 1930, the Nazis increased their representation in the Reichstag from 12 to 107 seats, garnering six and a half million votes. The streets of Berlin were the scene of clashes between armed groups of opposing political factions. The authorities tried to impose a ban on Nazis wearing their distinctive uniform in public, but their decrees were futile.

Prevented from wearing brown, the Nazis turned out in white. Violence was in the air and, however much Christopher deplored it in principle, he found the tense atmosphere highly stimulating.

When Otto suggested that it would be fun if Christopher moved in with him and his family in their flat in a slum tenement at 4, Simeonstrasse, Christopher readily agreed. Not only would this arrangement be cheaper than living at the Hirschfelds', but it would give him the opportunity of more contact with Otto and first-hand experience of German working-class life. In fact, he only stayed at Otto's for a month, sharing a room with the boy, but it was sufficient time to gather the material for the 'Nowaks' section of *Goodbye to Berlin*. Otto's father was an amiable enough man when sober, but unpredictable when drunk. In compensation, Otto's mother, who looked on Christopher as a kind of saviour because of the extra money he brought in, tried to make him feel welcome. Unfortunately, though, she was a very sick woman and had to be moved into a TB sanatorium in November, which prompted Christopher's departure for new lodgings at 38 Admiralstrasse, where he had a room to himself. He was delighted when the police, with whom all foreigners had to register, told him he was the only Englishman in the district.

Within a month, he was on the move again, this time to a more comfortable neighbourhood, just south of the Nollendorfplatz, near the city's main entertainments area. The landlady of his new lodgings at 17 Nollendorfstrasse, Fräulein Meta Thurau, reminded Christopher of a character straight out of Beatrix Potter – Mrs Tiggywinkle, the hedgehog lady who takes in people's washing. Fräulein Thurau became very fond of Christopher, whom she invariably called Herr Issyvoo. She is the model for Fräulein Schroeder in *Goodbye to Berlin*, who has been forced by the times to let out almost every square-metre space in her flat to a motley collection of people in an effort to survive:

All day long she goes padding about the large dingy flat. Shapeless but alert, she waddles from room to room, in carpet slippers and a flowered dressing-gown pinned ingeniously together, so that not an inch of petticoat or bodice is to be seen, flicking with her duster, peeping, spying, poking her short pointed nose into the cupboards and luggage of her lodgers. She has dark, bright, inquisitive eyes and pretty waved brown hair, of which she is proud. She must be about fifty-five years old.

Although she was not as portly as this portrait may suggest, it fits Fräulein Thurau well. But Stephen Spender, who was a frequent visitor to the flat

after he had moved from Hamburg to Berlin at the beginning of 1931, occupying a bed-sitter in the slightly more up-market Motzstrasse, left a less affectionate description of her in *World within World*, calling her the watch-dog of the Herr Issyvoo world, with pendulous jaws and hanging breasts. She was, Spender recalled, always polite to him, because she recognised that he was one of those friends of Christopher's who was neither a blackmailer nor a wastrel, perhaps, even, that he was good influence. Quite what that good influence might be remains unstated, unless it was Stephen's attempts to make Christopher eat something more wholesome than the execrable fare that he favoured in the very cheap cafés where they often ended up for lunch.

Christopher's fellow lodgers at Fräulein Thurau's flat provided him with an endless source of amusing tales with which to regale his friends, as well as the material for what many people consider to be his two best books. Foremost among them was Jean Ross (the model for 'Sally Bowles'), who was the daughter of a wealthy cotton merchant, and had spent much of her childhood in Egypt. About nineteen when she moved into Nollendorfstrasse, in early 1931, she was a pale, aristocratic-looking girl, with a long beautiful face. She had been used to being waited on hand and foot, and never really became adjusted to life without servants. Fräulein Thurau grumbled endlessly about the extra work Jean caused her. However, she was intrigued by Jean's promiscuity. Though Jean was not as depraved as she herself enjoyed making out, none the less she did tend to end up in bed with the men she met, of all ages and nationalities. Jean's moods were dramatic, and her clothes frequently outrageous; in short, she loved to make an impact. Having turned her back on her family, she earned a sort of living by singing, rather badly, in a run-down bar – nothing whatsoever like the decadent but glamorous cabaret of Bob Fosse's film *Cabaret*. Paul Bowles, the young American composer and novelist-to-be, who was in Berlin with Aaron Copland, recalls her most characteristic pose as being stretched out on her bed at Fräulein Thurau's, smoking Murattis and eating chocolates, while playfully addressing her latest German admirer as 'Du Schwein!' Bowles thought that Christopher himself was chilly and distant, and was rather astonished when Isherwood purloined his surname for Jean Ross's fictional representation. However, years later, he and Christopher did become friends.

Jean performed a sisterly function for Christopher, in which there was not even a hint of sex, though they did share a bed on at least one occasion. She knew about his boys, whom he sometimes brought to the flat, with Fräulein Thurau's implicit connivance. Jean listened sympathetically to the ups and downs of his relationship with Otto. But she and Christopher did also have

frequent rows. They were both strong but sensitive personalities, with an easily wounded pride, and they knew each other's weaknesses all too well. She would sometimes aim mercilessly at Christopher's Achilles' heel: his writing. *The Memorial* was still in the process of final revision, and she could be quite cruel in her criticism of it. Christopher was furious once when she informed him off-handedly that perhaps some day he would write something really great, 'like Noël Coward'.

Uncle Henry's allowance was not quite enough to support Christopher, Otto and occasional boys on the side, but Stephen Spender rather romanticised Christopher's poverty at this time in his portrait in *World within World*, in which he suggests that Christopher was surviving on horseflesh and lung-soup. In fact he was still going out at night quite often, and spent money on coffee, beer, cigarettes and toffees, and little presents for his protégés. This was possible partly because both Stephen himself and Edward Upward gave or lent him money, without caring too much about how it was spent. More importantly, Christopher earned extra cash by teaching English to private pupils, whom he would quiz about the state of Germany.

Among these pupils was a young Jewish girl from a wealthy family, Gisa Soloweitschik. She was introduced to Christopher by Stephen, who had met her on a skiing holiday in Switzerland. Of Lithuanian origin, Gisa studied history of art, and had cultured, generous parents who gave both Stephen and Christopher a standing invitation to Sunday lunch at their elegant home in Wilmersdorf. The Soloweitschiks called Christopher 'Shakespeare' and Stephen 'Byron', but sometimes the studied intellectualism of the household irritated Christopher, who had a number of arguments with Gisa. He also spoke at length to her about Otto and the trials and tribulations Otto's family were going through, without making the nature of their relationship specific. These details would bring tears to her eyes, and then she would talk sadly of the growing storm clouds over the country. Happily, she left Germany in the autumn of 1933 and married a Frenchman, André Gides nephew, thus escaping the Holocaust.

Another, unrelated, Jewish friend of Christopher's was Wilfrid Israel, who worked for his family's large Berlin department store. Five years Christopher's senior, Wilfrid was a British subject, born of an English mother and a German father. A stylish young man, who looked younger than his years, he decided not to take the easy way to safety when the Nazi net started closing in by seeking refuge in England, but stayed on in Germany right up until 1939, helping others in difficulty. He escaped deportation to a concentration camp, and managed to reach Portugal, but was killed when the aeroplane he was flying in from Lisbon to London was shot down. The rather heroic side to

Wilfrid Israel's character is not reflected in the portrait of him as 'Bernard Landauer' in *Goodbye to Berlin*, and Isherwood later felt guilty about this.

In complete contrast to Wilfrid Israel was Gerald Hamilton, the model for 'Mr Norris', whom Christopher met in the winter of 1930-1931, when Hamilton was working as the Berlin sales representative for *The Times*. Born in Shanghai in 1890, of Irish origins, Hamilton had already travelled the world and had been involved in underhand dealings of many kinds. The self-proclaimed intimate friend of both royalty and Communists, he was a walking paradox. He was a Catholic convert with ties to the Vatican, but he campaigned for legalised abortion, along with prison reform and the abolition of the death penalty. He was a friend of the homosexual Irish patriot Roger Casement and, as a homosexual himself, had a taste for rough working-class men. His complete lack of political or moral scruples was counter-balanced by his brilliant conversation, urbanity and grace - no mean achievement for an overweight, middle-aged gentleman who wore an ill-fitting wig.

Claud Cockburn, who worked for *The Times* in Berlin until his left-wing views became unsuitable, frequently had to tell Gerald Hamilton that *this* time he really had overstepped the mark, but on each occasion within fifteen minutes Hamilton had him laughing. Cockburn dared not introduce new people to Hamilton, even those who had heard of his notoriety, since he knew that within a matter of days they would be stung for cash, lured by some attractive-sounding bogus business proposition, or find themselves summoned in the middle of the night to a police station to stand bail for their new friend. Hamilton thrived on his wicked reputation, particularly after the publication of Isherwood's *Mr Norris Changes Trains*, and wrote several volumes of autobiography, which should be read with a healthily sceptical eye. His ultimate coup was to sit as a model for part of a memorial statue to Winston Churchill, who was of similar bulk.

It was not only Christopher who was fascinated by 'Mr Norris' and turned a blind eye to his more sinister side. Hamilton was a great success with Fräulein Thurau, whom he referred to as *La Divine Thurau*. He knew how to flatter and cajole, as well as flirt with women. He also had an expert's eye for spotting a sucker, or a 'client' who had every reason not to go to the police when he realised Hamilton's duplicity. Even so, Hamilton kept barely one step ahead of the law at times, and spent several spells in prison.

Early in 1931, Christopher decided there was nothing more he could usefully do to the manuscript of *The Memorial*, and sent it off to Jonathan Cape. In March he travelled over to England to see what was happening to it. To his disbelief, Cape rejected it. Christopher was aware that it was a distinct improvement on *All the Conspirators*, and the rebuttal hurt him.

However, Jonathan Cape, mindful of the very poor sales of Isherwood's first book, was working on the principle of 'once bitten, twice shy'. He wished Christopher the best of luck in finding a new publisher and added cheerily that one day he might live to regret his decision. Meanwhile, Stephen Spender suggested Christopher contact the literary agents Curtis Brown, whose client he subsequently remained. While Christopher was in London, though, Otto got in trouble with the police and was rescued by Stephen Spender, thus establishing a new bond between the two of them which was going to be a cause of considerable jealousy.

Christopher travelled back to Berlin on March 21, in the company of Archie Campbell, the young man who had first introduced Wystan and Stephen. Archie now introduced Christopher to an American artist friend, John Blomshield ('Clive' in *Goodbye to Berlin*), who had married a wealthy woman and was enjoying spending her money prior to getting a divorce. He had a suite at the plush Adlon Hotel, where he seemed to live off champagne. Although Blomshield was accompanied by a young Norwegian boyfriend, Stephen Spender got it into his head that he was just the sort of person Jean Ross should meet. Sure enough, they had a brief passionate affair, before his sudden departure for America. As described in *Sally Bowles*, they did watch Hermann Müller's funeral from the balcony of Blomshield's hotel, while he threw coins down to boys in the street below.

That summer, Christopher, Stephen and Otto went off to Ruegen Island on the Baltic for a holiday, and Wystan came over to join them. Typically, he shut himself away in his room, with the blinds drawn, and wrote, while the others enjoyed nude sunbathing on the beach and romping about. Stephen had become addicted to taking snapshots of his friends, sometimes to Christopher's exasperation. He had an automatic exposure fitting on his camera, which meant that if he ran fast enough, he could be in the picture too. It was from this holiday that the famous photograph of Christopher, Stephen and Wystan standing together dates. Wystan looks like an overgrown schoolboy, Christopher is grinning broadly, and Stephen towers over them both. But behind the surface bonhomie there was tension, as Christopher fought unsuccessfully to get Otto to commit himself to him alone. Irritated by so much pressure and attention, Otto would go off dancing with girls and deliberately stay out late.

Stephen went on to Salzburg in Austria, and wrote from there suggesting that he move in to Fräulein Thurau's. Christopher was horrified by the idea and replied, fending him off, suggesting rather ungraciously that he was sure Stephen could find something cheaper nearby. He added: 'I think it is better if we don't all live right on top of each other, don't you? I believe that was

partly the trouble at Ruegen. Anyhow, I'm resolved not to live with Otto again for a long time.' The plain truth was that Christopher had begun to feel threatened and oppressed by Stephen. Many years later, in his autobiographical volume *Christopher and His Kind*, he wondered whether there was also an element of fear that Stephen might invade his literary territory. Christopher had, after all, found himself in an amazing little world, which he already knew he was going to write about.

Stung by the rebuff, Stephen decided to go back to England, generously taking with him a copy of the manuscript of *The Memorial*, which he showed to his friend John Lehmann. Lehmann was then working at Leonard and Virginia Woolf's Hogarth Press. Aged twenty-four, he was the son of Rudolph Lehmann who was an affluent one-time Liberal MP and editor of the *Daily News*, where Stephen Spender's father had been his deputy. An old Etonian of the famous generation that produced Harold Acton, George Orwell (Eric Blair), Cyril Connolly, Anthony Powell and Henry Green (Henry Yorke), Lehmann had graduated from Trinity College, Cambridge, before joining the Hogarth Press, which published his book of poems *A Garden Revisited* in 1931. He had met Stephen Spender a few months previously through his novelist sister Rosamond Lehmann. Stephen had spoken at length in his enthusiastic way about his friends Wystan Auden and Christopher Isherwood, so the manuscript of *The Memorial* was planted in well-tilled ground.

Meanwhile, in Berlin, things were going from bad to worse. In July, the Darmstädter und Nationalbank collapsed and Christopher wrote to Curtis Brown saying he thought a revolution was imminent. His own position was made more difficult in September when Britain went off the gold standard, causing the pound to fall against the mark. He moved into a smaller room at the back of Fräulein Thurau's flat, to economise on the rent. To his immense relief, just when things were starting to get him down, and Kathleen was beginning to despair after three more publishers rejected *The Memorial*, the news came through that the Hogarth Press had accepted the book. As Christopher wrote to Edward Upward, in response to his friend's letter of congratulations:

Phew, that was a close one. Mater's hand was on the pen, in fact she'd already begun a pretty nasty letter inside there last week when the telephone bell rang and Stephen blurted out the news of the reprieve. Richard was sent out to the grocer's for purple rockets and Nanny hurriedly rummaged out soiled Christmas festoons from the cellar.

On October 1, he returned to London to celebrate.

6

1932–1935

The Memorial opens in a Chelsea mews, where Mary Scriven (largely based on Olive Mangeot) leads an active musical life. Also in London is a morose, artistic widow, Lily Vernon (Kathleen), obsessed with memories of her heroic husband Richard (Frank), who was killed in the war. Richard had been a keen watercolourist and had lived in a large house in Cheshire (Marple Hall). Lily has a son Eric (who is only partly Christopher, as Eric is handicapped by poor eyesight and a stammer), whom she oppresses. Eric helps Mary Scriven run little concerts, having thrown up Cambridge at the time of the General Strike. But he 'certainly wasn't interested in politics any more. From something he'd once said, he seemed to lump Communists and Fascists and everyone together in one heap.'

The reader is shown life at the big hall, Lily's elderly father-in-law (John Isherwood) and his wife (more Emily Machell-Smith than Elizabeth Isherwood). Lily writes a diary and is preparing a book of sketches of the house. Her attitude towards her environment and the local villagers is exactly that of Kathleen's passion for the past. The thrust of the novel – whose style owes something to Virginia Woolf – is that Youth must condemn Lily's cult of her dead husband. Yet she is justified in mourning him, as he was a Truly Strong Man. His opposite, the Truly Weak Man, is represented by Edward, a great friend of Richard's. He is a homosexual who had performed heroic feats in the war, but whose bravado is a sham behind which lies an insecure man chasing after worthless boys. After the war, Edward goes to live in Berlin, were he attempts to commit suicide by shooting himself in the mouth. Eric's own sexuality is ambiguous. Angrily he warns Edward to stay from an attractive male cousin, yet inwardly he realises his only motive for that can be jealousy.

Confusingly, the novel is not presented in chronological order, but the Hogarth Press did persuade Isherwood to date the four different sections, to

give the reader a clue as to what was going on. The only other change they asked for was that the phrase 'he can lick his arse' be expunged. *The Memorial* still reads well, even if its main fascination now is how much autobiographical material Isherwood crammed into it. Kathleen seems to have accepted her own psychological demolition in the book with a remarkable degree of equanimity. But some of Christopher's other relatives were furious about what they saw as the unnecessarily cruel portrayal of poor old John Isherwood's infirmities.

When *The Memorial* was published in February 1932, it got several favourable reviews. However, one critic did note sadly that there seemed to be rather a lot of queer characters in the book, but added that that sort of thing seemed to becoming more common these days. However, even that little hint of titillation did not help the book sell.

Meanwhile, Christopher was already at work on a new book, an autobiography, which was rather a brave concept for an as yet unsuccessful novelist of twenty-eight. He wrote to John Lehmann at the Hogarth Press:

> Stephen tells me that you want me to write and let you know what I am working on and what I mean to do in the near future. At present I'm writing an autobiographical book, not a novel, about my education – preparatory school, public school and University. After this I shall start a book about Berlin, which will probably be a novel written in diary form and semi-political. Then I have another autobiographical book in mind. And possibly a travel book. So you see, I have no lack of raw material! It is only a question of time and energy.

Therein lay the foundations of both *Lions and Shadows* and the Berlin books, as well as other projects never realised. One hindrance to getting all this done, however, was that the 'raw material', as he called it, was still coming in thick and fast. As Christopher wrote to Olive Mangeot, being in Berlin by this stage was rather like living in Hell:

> Everyone is absolutely at the last gasp, hanging on with their eyelids. We are under Martial Law, and to all intents and purposes living in a Communist regime without any of the benefits of Communism. Nobody in England can have the remotest idea of what it is like. There are wagon-loads of police at every street corner to sit on any attempt at a demonstration. You can scarcely get along the street for beggars. Hitler and the Communists openly discuss plans for Civil War and nobody can do anything.

That winter was indeed grim in Germany. Unemployment had passed the five million mark, and President Hindenburg had been forced to sign new emergency decrees cutting wages, prices and interest rates, while increasing taxation. Membership of the Nazi Party had more than doubled during 1931 to over 800,000. More and more people in authority were beginning to accept the 'advisability' of compromising with the Nazis, giving Hitler some share of power. In February, Hitler himself was in Berlin, wondering if he ought to risk competing openly with Hindenburg in the forthcoming presidential elections. In the event he did, forcing Hindenburg to a second ballot, and winning over thirteen million votes.

Apart from conversations with his pupils and gossip in Fräulein Thurau's flat, Christopher was now keeping abreast of political developments through friends in the foreign press corps. Violence was on the increase, which made him feel uneasy. Yet he felt more immediate concern over the fact that Otto had announced he had met a very nice girl and that his sexual relationship with Christopher would have to stop. Christopher resigned himself to the inevitable, though he still saw Otto for several more weeks.

At this stage, Francis Turville-Petre arrived back providentially in Berlin after a long spell in the Mediterranean. When Christopher heard he was coming, he had visions of the two of them going off to the Orient, which is an interesting indication of how much he suddenly wanted to get out of Berlin. But Francis wanted to go and stay quietly in the German countryside instead. When he offered to take Christopher with him, Christopher readily agreed. Their destination was Mohrin (Moryn), in a flat, bleak area not far from the sea, now in Poland. Francis engaged Erwin Hansen – a friend of Karl Geise's – as cook and housekeeper. Hansen, a big, muscular man with short-cropped blond hair, had been working as an odd-job man at the Hirschfeld Institute, and before that was an army PT instructor. He was an active Communist as well as a practising homosexual. When he was asked to find someone to help him with the heavier work, he produced a teenager named Heinz Neddermayer.

Heinz was a very un-Teutonic-looking boy, with tight curly hair, protruding lips, a broken nose and large brown eyes. In certain lights he looked almost African and he was highly amused when Christopher dubbed him 'the Nigger boy'. Francis did not take to Heinz at all. But Christopher was quickly won over by his straightforward charm, and took him as his lover. Heinz proved to be a conscientious worker around the house, and was particularly fond of outdoor tasks like gardening. As Francis and Erwin Hansen both soon got bored with being stuck in the country, they started going back to Berlin for long weekends, leaving Christopher and Heinz to construct a rural idyll.

Christopher left Mohrin in June, and the following month went back to Ruegen Island for a holiday, taking Heinz with him. Stephen was there with his brother Humphrey, as were Wilfrid Israel and William Robson-Scott, an English lecturer whom Christopher had met in Berlin. The news from the city was not good. The Nazis had won 230 seats in parliamentary elections that month, to become the largest party in the Reichstag. When Hindenburg refused to make Hitler Chancellor, more violence flared. Wilfrid Israel outlined to his friends a plan of action for the Jews in Germany if Hitler were to come to power. He believed they should go out into the streets, as a protest, and refuse to go home, even if they were fired on. He reasoned that only by such a unified public sacrifice would the conscience of the world be aroused.

Certainly, Christopher was disturbed when he went over to London for August and September and discovered how few people there had the slightest inkling of what was happening in Germany. He spent the first few days with Jean Ross, who soon afterwards moved into Olive Mangeot's lodging-house, which became a hotbed of Communist sympathisers. Jean later married Claud Cockburn. Edward Upward, who had been on a visit to the Soviet Union earlier in the year, had himself now joined the Communist Party. Christopher remained unconvinced.

It was on this visit to London that Christopher met John Lehmann in person for the first time. They did not immediately warm to each other. Christopher was rather suspicious of Lehmann's formal manner, handsome profile and quizzing eyes. Although they appreciated each other's talents, it was some time before they became intimate friends. Through John, though, Christopher got to know the Lehmann sisters, Rosamond, Beatrix and Helen. Beatrix was a fine actress, a madcap personality and a lesbian, which meant that when she moved to Berlin later that year, it was almost inevitable that she and Christopher should become close. As Beatrix would have been the first to acknowledge, she replaced Jean Ross as his honorary sister.

Wystan Auden was also in London, between jobs, and introduced Christopher to two friends of his who were destined to play an important role in Christopher's American existence: Gerald Heard and Christopher Wood, who lived together in a comfortable flat off Oxford Street. Gerald Heard was a man of prodigious erudition and intellectual curiosity. He was also blessed with the gift of being able to discuss scientific and philosophical topics in layman's terms, even if sometimes his arguments seemed to be at a complete tangent to the matter in question. When Christopher met him, he was doing a series of radio talks for the BBC.

The rather dry tone of Gerald Heard's books, which now seem frightfully

dated, did not do justice to his personality. He was a brilliant talker, witty and playful – a true exotic, if at times a little over-theatrical in an Irish way. He was more than ten years older than both Christopher Isherwood and Christopher Wood. The latter was rich and handsome but, far from vaunting this, he was rather a shy man. He was a good amateur musician and wrote short stories, as well as flying a small aeroplane in his spare time.

While Auden and Heard got together in an intellectual huddle, the two Christophers settled down to more light-hearted conversation. Christopher Isherwood was intrigued to learn that Christopher Wood had visited the Hirschfeld Institute while he had been living there, and had got a fleeting glance of a great beauty. After further discussion, they decided that this could only have been Isherwood himself, and they both thought it hilarious that Christopher Wood did not think that the person now before him lived up to that initial impression.

Through Stephen Spender, Christopher also met the South African novelist William Plomer at this time and the two became regular correspondents. Indeed, Plomer considered Christopher to be a letter-writer of exceptional brilliance. In his *Autobiography*, William Plomer wrote of Christopher:

> 'Amazing' was one of his favourite words, and his capacity to be amazed by the behaviour of the human species, so recklessly displayed every-where, made him a most extraordinary talker. . . . Christopher Isherwood, compactly built, with his commanding nose, Hitlerian lock of straight hair falling over one bright eye, and the other looking equally bright under a bristly eyebrow already inclined to beetle, an expression of amusement in a photo-finish with an expression of amazement as he came to the conclusion of a story, and almost choking at the climax . . .

William Plomer, in turn, reminded Christopher of a benevolent owl, largely because of his big, round spectacles. Plomer took Christopher to meet E. M. Forster, which was how Christopher's literary hero became his friend. Forster was then fifty-three, but for once in his life looked younger. Christopher was deeply moved by their first encounter and on subsequent occasions often found himself on the verge of tears in Forster's presence. Normally contemptuous of the older generation, Christopher was content to sit at Forster's feet, metaphorically and literally. Forster's approval of *The Memorial* meant more to Christopher than anything else. As Christopher told friends, once Forster had praised him, he felt the summit of his literary career had been reached.

It was while visiting William Plomer and his artist lover Anthony Butts one

day that Christopher had a show-down with Stephen Spender. Spender was still one of Christopher's most ardent fans and, despite earlier rows, he kept coming back to Christopher's side with all the devotion of a faithful dog. As Spender recalled in *World within World*, on that day at William Plomer's:

> Christopher showed so clearly his irritation with me that I decided I must lead a life which was far more independent of his. So the next day I called on him at his mother's house in Kensington, where he was staying. I explained that I had noticed that I was getting on his nerves, and that when we returned to Berlin we should see nothing, or very little, of each other. He said he was quite unaware of any strain, and that of course we should meet, exactly as before. I went away not at all relieved, because I thought he was refusing, more out of pride than friendship, to face a situation which he himself had made obvious. Moreover, he had expressed his views in the accents of ironic correctitude with which Auden, [Upward] and he could sometimes be insulting. Next day I received a letter from him saying that if I returned to Berlin he would not do so, that my life was poison to him, that I lived on publicity, that I was intolerably indiscreet, etc.
>
> The result of this letter was that I decided not to return to Berlin.
> (p 174)

Certainly Christopher was upset that Stephen had told a number of people in London a lot about his lifestyle in Berlin. But despite this supposed break, the two men remained in close contact for most of the rest of their lives.

Meanwhile, things at Pembroke Gardens were on an unusually even keel. Christopher kept Richard happily occupied by dictating the first draft of his new 'Berlin novel' to him, and Kathleen and Nanny were obviously delighted to have this activity going on under their roof. The original idea for the novel had been a vast canvas depicting the crumbling state of Germany and the weird people living there. As usual, Christopher had settled on a title long before the outline of the book itself was clear: *The Lost*. True, this did sound better in German, *Die Verloren*, which is how he had first thought of it, but even so it was full of possibilities. As he noted in his diary: 'The link which binds all the chief characters together is that in some way or other each of them is conscious of the mental, economic and ideological bankruptcy of the world in which they live. And all this must echo and re-echo the refrain: It can't go on like this. I'm the Lost, we're the Lost.'

Most of the characters of Isherwood's later Berlin stories were already in *The Lost*. However, the chief character is 'Peter Wilkinson' (basically

Christopher, hiding behind some of the mannerisms of William Robson-Scott), a young Englishman who is picked up by 'Otto Nowak' (Otto) while taking a walk along the shores of a lake, and then has sex with him in a wood. The relationship with Otto is a stormy one, and Peter returns to England after a particularly serious row. The book ends with Otto lying dead in the snow beneath the girders of an overhead railway.

Christopher returned to Berlin at the end of September. That month, the Nazis voted with the Communists in the Reichstag to bring the government down. New elections were announced for November. A few days before they were held, there was a transport strike against further wage-cuts. The Communists were the main backers of the strike but, to many people's surprise, the Nazis also gave it their support, to try to win the goodwill of the working class. Through Gerald Hamilton, Christopher was asked to do some translations for the Communist Party and agreed.

In the elections, the Nazis lost nearly two million votes, though they remained the largest party in the Reichstag. The Communists, however, made significant advances, taking Berlin with a majority of over a hundred thousand votes. Franz von Papen – who had taken over as Chancellor from Brüning in May – suggested a coalition government, but Hitler refused. Papen resigned and, on November 18, Hitler was summoned to visit President Hindenburg. The two men failed to reach agreement on terms for forming a government, and General Kurt von Schleicher was made Chancellor on December 2. He was destined to enjoy that position for less than two months.

It was impossible to avoid the growing sense of political menace. Christopher took Heinz to an air display one afternoon, where little pieces of paper were dropped onto the spectators' heads, bearing the message: 'This might have been a bomb, therefore Germany must arm!' Typically, Christopher retorted: 'This might have been a bun, therefore eat it!'

About this time, he received a letter from Michael Roberts, who had brought out a landmark anthology of poetry earlier in 1932 entitled *New Signatures*. This included work by Wystan Auden, Cecil Day Lewis, William Empson, John Lehmann, William Plomer, Stephen Spender and A. S. J. Tessimond – a collection which more than anything else created the concept of a new wave in English literature, later christened the Auden Generation. Roberts was soliciting material for a new volume, and Christopher considered sending part of *The Lost*. He was uneasy about the concept of the project, though, as he wrote to William Plomer:

I rather loathe the idea. It seems so idiotic to be dressed up in a sky-blue uniform as Youth, Knock, Knock, Knocking at the door. And when

Roberts writes in his letter about wishing to represent the 'new spirit in literature, politics and education', I just feel frankly scared. What is the new spirit? How could I manage to inject some of it into a description of a sanatorium for consumptive paupers? Or have I, perhaps, got it all the time and don't know it? It's like being asked to a party where one doesn't know if one's supposed to dress.

Eventually, Christopher sent Michael Roberts a piece entitled 'An Evening at the Bay', an essentially autobiographical story, set in Freshwater Bay. Its main interest retrospectively is that for the first time in Isherwood's work, the character 'Christopher Isherwood' is present, alongside the already familiar 'Allen Chalmers' and 'Philip Lindsay'. The piece duly appeared in Roberts's 1933 anthology *New Country*.

Christopher spent New Year's Eve in the company of Beatrix Lehmann, who had got far more deeply involved in left-wing causes. They were fearful of what 1933 might have in store. In fact, they were so engrossed in their conversation on the subject that they missed saluting New Year at midnight, which their German friends thought ominous.

A few days later, Beatrix's brother John came on a visit. He had left the Hogarth Press the previous autumn and had moved to Vienna with the aim of becoming a full-time poet. He was on his way back there after spending Christmas in England. He spoke of his hopes of launching a literary magazine, to which he wanted Christopher to contribute. Christopher gave him a tour of the icy city, where Hitler's picture seemed to be leering from half the shop-windows. He also initiated John into the pleasures of the 'Cosy Corner'. John Lehmann was another afficionado of brawny youth, which helped bind him to the growing Auden-Isherwood circle.

On Sunday, January 22, Christopher went to watch a Nazi demonstration at the Bülowplatz, involving ten thousand SA troopers. The SA had been unbanned the previous summer, despite the protests from Communist leaders like Ernst Thälmann, who said it was an open invitation to murder. In order to enable the Nazis to hold the demonstration, the police had to cordon off the square, post sentries on roof-tops, make a house search for weapons and stop the Underground railway. Christopher's diary entry for the day is incorporated into the final section of *Goodbye to Berlin*. Eight days later, Hitler was summoned to the President's palace once again, and this time emerged Chancellor of Germany.

At the end of February, the Reichstag was burned down and a general sense of despair pervaded the city. Many of Christopher's Jewish and Communist friends had already left Germany and others were preparing to

go. Gerald Hamilton had discreetly slipped away, following a police warning. Christopher's friends came from all political persuasions, but the story they told was the same: sudden arrests, disappearances, exile, violence and death. 'The Mad Tsar', as Christopher sometimes styled himself oddly during this period, could no longer sleep calmly in his bed.

On April 1, he went to a large Jewish department store to see the effect of Nazi boycotting. Young men with swastika armbands were posted on the doors, informing everyone going in that they were about to patronise a Jewish store. With a start, Christopher recognised one of the young Nazis as a boy he knew from his night prowls. None the less, unlike some of the prospective shoppers who were intimidated into walking away, Christopher entered the shop and made a token purchase.

On April 5, aware that his time in Berlin was probably coming to an end, Christopher went over to England with most of his belongings, storing them at Kathleen's. He dictated some more of *The Lost* to Richard, and received a stream of visitors, including E. M. Forster, Gerald Hamilton and Bubi, who was now working on a Dutch freighter smuggling Jewish refugees into Britain.

Morgan Forster showed Chistropher the manuscript of his then unpublished homosexual novel *Maurice*, which he had written twenty years before. Forster had always been eminently discreet about his own homosexuality, largely for his mother's sake, but he believed passionately in the worth of this novel and wanted Christopher's opinion. Christopher was profoundly moved by the Master coming to him for approval and, though he wriggled with embarrassment over some of the passages – especially Forster's use of the word 'sharing' for homosexual intercourse – he thought *Maurice* a noble work, superior to Forster's other books in its passion, though inferior as a work of art. Forster nervously asked if the book had dated, to which Christopher replied: 'Why shouldn't it?' Forster was touched by Christopher's enthusiastic reaction to the novel and leant over and gently kissed him on the cheek. In his will, Forster stipulated that any royalties from *Maurice*, which was finally published after his death in 1971, should go to Christopher, who used them to set up a travel fund for young British writers wanting to visit the United States.

Having just inherited a small legacy from his great-aunt Agatha, Christopher now toyed with the idea of going off to the other side of the world. But he realised that he had fallen totally in love with Heinz and needed to arrange his life so that he could be with the boy. Staying in Germany was obviously unwise. When he got back to Berlin, Fräulein Thurau informed him that the police had called round making enquiries about him while he

was in England. And, in the new climate of fear and intolerance, even the boy-bars were being closed down. So Christopher leapt at a suggestion from Francis Turville-Petre that he join him on a small Greek island which he had acquired.

Heinz would go with him to Greece, along with Erwin Hansen who, for the past few months, had been bravely guarding the Hirschfeld Institute against possible rioters. Hirschfeld himself had left Germany in 1930 and settled in the South of France. He died in May 1933 and thus was spared the sadness of knowing that a mob sacked the Institute a few days later. Fortunately the most valuable research material had already been taken out of the country. Books by Hirschfeld and a bust of him were publicly burned in front of the Opera House. Christopher was there to witness this act of righteous vandalism, and cried 'Shame!' – very softly.

On May 13, Christopher, Heinz and Erwin left Germany, bound for Athens. They travelled via Prague to Vienna, where they visited John Lehmann and the League for Sexual Reform. From there they continued to Budapest and caught a Danube steamer to Belgrade. The last stage of the journey was by train and Francis was at the station to meet them.

Francis had leased the island of St Nicholas from the villagers of Chalia on the Greek mainland. It was small and uninhabited, though it did have a church, and Francis was having a house built for himself by masons who came over to the island every day. Francis had assembled a small male harem, consisting of his driver, Mitso, his favourite boy Tasso and two others. Everyone had to live under canvas, and water was brought over from the mainland in kerosene cans, which gave it a nasty taste. As Christopher was there from the end of May to early September, he experienced the heat of a Greek high summer – and hated it.

In fact, he soon felt he had exchanged the hell of Berlin for another, even worse. As he complained in a letter to Olive Mangeot, the atmosphere was hardly conducive to work, being a 'series of shrieks and yells and stinks and pricks'. The Greek boys got on his nerves, with their noise, their lack of hygiene, their cruelty to animals and their obsessive appetite for sex. Fishermen from the locality would sometimes tie up their boats at the island for the afternoon, to eat and carouse and then get stuck into an orgy. Christopher felt the nadir was reached when he found one of the boys screwing a duck they were due to have for dinner.

To Christopher's intense irritation, Heinz got on famously with these local lads, even though he could not speak a word of Greek. This prompted jealous scenes, exacerbated by the return of Christopher's old enemy, boredom. As he wrote to John Lehmann, 'the heat obliterates all will, all plans, all

decisions'. An earlier idea of writing a travel book, something along the lines of Joe Ackerley's *Hindoo Holiday* was abandoned. Yet Christopher did manage to get on with some more of *The Lost*, notably the section dealing with Jean Ross. This only made him feel the lack of female company all the more acutely. Francis and his boys may have relished what to them was a buggers' paradise, but Christopher and Heinz missed the sort of conversations they had with women. Every so often they would recharge their batteries by escaping the island to the relatively more normal environment of Athens.

By the end of July, Christopher was desperate to get away, but the question was: where? He quite fancied France, but had heard it was expensive. He also toyed with the notion of joining John Lehmann in Vienna. The idea was to find a safe place where Heinz and he could stay together. Yet, perversely, during the latter half of August, Christopher allowed the tension between the two of them to develop to such a stage that Heinz was provoked into saying he wanted them to split up. Barely reconciled, they left the island on September 6 and sailed to Marseilles. There Heinz sat on a wall and, as usually happened when he was unhappy, sulked. Christopher wrote in his diary: 'He's sitting about with a face like death and won't speak. I shall have to get rid of him as soon as I'm in Paris.' In fact, they had patched things up by the time they got to Paris, and spent a couple of weeks in the suburb of Meudon, which was the home of a skilful Communist propagandist, Rolf Katz, whom Christopher had known in Berlin, and who was one of about half-a-dozen characters who kept popping up in Christopher's wanderings round the globe.

The next stop was London, where they arrived at the end of the month. Christopher stupidly lied to Kathleen, telling her he had met Heinz in Paris. This falsehood was glaringly exposed when Heinz guilelessly spoke of things that had happened to them in Germany and Greece. Christopher was angered by what he felt was Kathleen's supercilious treatment of someone she viewed as her social inferior – and who was a hateful German to boot. But what is even more likely is that she was upset that Heinz was the cause of her son's deceitfulness. Christopher's friends, generally tolerant of the fact that Heinz did not have much conversation, even in German, rallied round. But soon his tourist visa expired and there was nothing for it but for him to go back to Germany.

Meanwhile, something had cropped up which would keep Christopher in London for some time. Jean Ross telephoned him to say that she had just met the most *marvellous* man, who was a positive genius, and who was making some sort of film. The woman who was writing the script (Margaret Kennedy) couldn't go through with it, Jean said, so she had told this new

friend that she knew the *perfect* person to help him out. Jaded by so many experiences of Jean's temporary enthusiasm for new admirers, Christopher listened to her sceptically, and only agreed to provide a copy of *The Memorial* to give to the man if Jean herself paid for it. She concurred, so long as Christopher gave her a cut of his first week's earnings if he got the job. He expected to hear no more of it. However, a few days later, Jean rang again and told him with breathless amazement: 'Darling, he thinks it's *good!*'

The man in question was Berthold Viertel, an Austrian poet, man of letters and film director, who was at that time employed by Gaumont-British. He was working on a film called *Little Friend*, based on a novel of the same name by Ernst Lothar. Berthold Viertel was a rather eccentric man of considerable sensitivity and talent. Unfortunately he spread himself too widely, in various creative fields, so never truly excelled in any of them. He was particularly proud of his poetry, which remained almost unknown outside Austria. Before coming to England, he had worked in films in Vienna and in Hollywood. He was married to the distinguished Polish actress Salka Steuermann, who had worked with Max Reinhardt in Berlin, but who was now installed in southern California. Viertel had not in fact read all of *The Memorial*, but fortuitously opened the book at the scene of Edward's attempted suicide. On the strength of that, he hired Christopher within a week.

Berthold Viertel had many of the stock characteristics of a highly intelligent, central European Jew, including a curious blend of practicality and wild romanticism. He took a great liking to Christopher, and was relieved to have someone to talk German to from time to time, even though his English was perfectly adequate for his work. He once told Christopher that he felt no shame before him, as though they were two men meeting in a brothel. Viertel had the comforting knowledge that his own family was safe in California, but he followed events in Germany and Austria with growing distress. He lapped up everything that Christopher could tell him about the situation in Berlin.

In turn, Christopher and the Pembroke Gardens household thought that working for the film industry was immensely glamorous. Then and later, Christopher retained an almost childlike reverence for the movies and their stars. He was wildly excited that the Viertels were intimate friends with their California neighbour, Greta Garbo, who was then at the height of her silver-screen fame. He thoroughly enjoyed going into a London shop shortly before Christmas with Berthold Viertel, who bought a present for Garbo there, giving her name and address to an incredulous assistant.

Quickly, Christopher and Berthold Viertel established a sort of uncle-and-

nephew relationship. Yet Christopher did not yet feel able to tell Viertel about his own private life. In fact, Viertel had made a number of anti-gay remarks which seemed to close off any opening for such confessions. Viertel meanwhile waxed lyrical about heterosexual love, assuming Christopher shared his tastes.

The story of the film (whose making forms the main plot of Isherwood's novella *Prater Violet*) is intensely melodramatic, and had been transposed to a British setting, to be of greater appeal to an English-speaking audience. Little Felicity Hughes is the child of affluent parents, whose marriage is falling apart. Although she has everything money can buy, Felicity is disturbed by her realisation that an actor (her mother's lover) seems to be intent on breaking up the household. Finding her mother and the actor together in Richmond Park one day, the little girl rushes away on her scooter and only just misses being run over. Her father walks out in disgust at the situation, but hopes to get custody of the child. Divorce proceedings are instigated, but Felicity, called as a witness, breaks down in the courtroom and attempts suicide. Horrified by the extent to which their selfishness has harmed their child, her parents reunite.

The plot of the film had all the markings of a real tear-jerker, but Berthold Viertel and Christopher were determined to keep it as saccharine-free as possible. Far from being disdainful at having to write dialogue for such a film, Isherwood found it an amusing challenge, and was proud to discover that he could produce realistic conversation quite easily. Undoubtedly this work helped his smooth-flowing style – what Cyril Connolly once called his fatal readability. Moreover, working on *Little Friend* seems to have shown Isherwood that he *needed* to work on a truly vulgar project from time to time, to be forced to extend his talent. Most of his literary friends did not share this sentiment and thought he was crazy, or else doing it for the money.

For the first couple of months that he was working on the film, Christopher was beset with the worry of how he was going to arrange a reunion with Heinz. In letters to the boy, he outlined in plan which he hoped would ensure Heinz's safe passage through British immigration and his obtaining a long-term visitor's permit to stay in England. Heinz was to say that Kathleen had invited him to stay; he would carry money Christopher had sent him, but claim it was his own.

Christopher duly went to Harwich on January 5, 1934, to meet Heinz's ferry, accompanied by Wystan Auden. They waved to the boy as he came off the boat, but when all the other passengers had emerged from the terminal building, there was still no sign of him. Christopher and Wystan went into the Customs House to find Heinz sitting dejectedly with some very stern

immigration officers. On the table was the letter Christopher had sent to Heinz, outlining the way he should present his case to the immigration officials and which the boy had foolishly brought with him. The officials had become suspicious because Heinz's passport showed his profession as 'domestic servant'. Christopher was responsible for that, as he had not wanted Heinz to put down anything as bourgeois as 'student' or 'of independent means'. The officials probably thought at first that Heinz was trying to enter Britain not as a guest of Mrs Isherwood's, but rather as a prospective employee. But once they had read Christopher's letter, with its unmistakably intimate manner, they smilingly made it understood that they knew the score and that there was no alternative but to send Heinz back to Germany on the next boat. On the train back to London, Christopher cursed everybody's stupidity, including his own, while Wystan declared that he was sure the senior immigration officer was gay and had rejected Heinz out of spite.

Christopher spent the next fortnight revising the screenplay of *Little Friend*, but as soon as it was delivered, he left for Berlin. He packed up Heinz and their remaining belongings and accompanied him to Amsterdam, where Christopher found them a flat. He spent ten days there, enjoying the boy's company and helping him settle in, then returned to England for the shooting of the film.

Christopher's professional commitments ended at the end of March, when he returned to Amsterdam. His idea was to get as far away as possible and his first choice was Tahiti in the Pacific. But there were delays with the French colonial formalities, so he and Heinz got on a boat that was going to the Canary Islands instead, via Vigo, Lisbon and Funchal. Christopher had been looking forward to Lisbon, but it turned out to be a wash-out. In the pouring rain, he and Heinz tried to find a decent café, before stumbling on a medical relief station where milk was handed out to the poor. There was some talk of Gerald Hamilton joining the boat but, not for the first time, he failed to show up. The two friends amused themselves on board playing ping-pong and watching films. When they got to Las Palmas in Grand Canary, they found hotel accommodation fully booked, so they ended up staying on the roof of the Towers Strand Hotel by the beach, in a hut which normally was used by hotel staff. At the beginning of June, they went on a trip to the hills in the interior of the Island. They climbed up El Nublo, a bleak rock-face which had been miraculously scaled by Nazi sympathisers, who had planted a swastika on top. Heinz was in his element, gleeful and singing, so Christopher was able to enjoy the climb vicariously through his young lover's pleasure, while himself trying to fend off vertigo.

On June 6 they moved to the nearby island of Tenerife, where they lodged

in a pension in Oratava called Pavillon Troika. From there, Christopher wrote to John Lehmann, describing their new existence:

> Here, amidst the flowers, our Rousseau life goes on. Heinz has just got me to cut off all his hair. He now looks like one of the boys in a Russian film. Every day we return to our tables in the banana grove. He writes letters, making at least two copies of each. Indeed, calligraphy is dignified by him to the position of an art. One is reminded of the monks in the Middle Ages. This place is a sort of monastery, anyhow. It is run by a German of the Göring-Roman Emperor type and an Englishman who dyes his hair. The Englishman loathes women so much he has put a barbed-wire entanglement across an opening in the garden wall, to keep them out.
>
> My novel is exactly three quarters done. I hope to finish on the day War was declared in 1914 [i.e. August 4]. It is a sort of glorified shocker; not unlike the productions of my cousin Graham Greene. When it is done and sent off I think we shall leave at once for another island in this group, La Palma.

The 'glorified shocker' was *Mr Norris Changes Trains*, which Christopher had pruned from the overgrown *The Lost*. He had realised that his original concept was far too complicated and that it was better to try to concentrate on one strong personality: Mr Norris. As was also shown in the strength of the dialogue in *Mr Norris Changes Trains*, Christopher's short experience in writing for films had not been in vain. Unusually, though, he did not decide on a title for the book until shortly before its publication the following year. The manuscript was actually finished on August 12.

The Arthur Norris of the novel is a small-time con man and political operator, temporarily in Berlin, where he plays a dangerous game of profiteering from the stormy unrest of the closing years of the Weimar Republic. He is not particularly successful in his dealings and is supervised by a harsh, unpleasant German male secretary. Arthur partakes in the masochistic pleasures offered by stern young ladies in leather boots, and accepts other people's perversions, eccentricities and dishonesty without qualm, so long as they do not offend *his* sense of decency. Christopher deliberately did not portray Norris as a homosexual, because he felt that would have given an unhelpfully provocative slant to the book. Like his real-life model Gerald Hamilton, Arthur Norris is an epicurean, a leaden butterfly tasting the nectar of flowers across the world. Despite his awful wig and his rotten teeth, he is essentially a lovable rogue.

The love of boys is represented in the novel by the Baron Kuno von Pregnitz, an avid reader of boys' adventure stories, which fire his fantasy life of wholesome Boy-Scout-cum-Hitler-Youth camaraderie. Mr Norris, in soliciting the Baron's help in one of his nefarious enterprises, is not above dangling a handsome young friend of his before him: the narrator William Bradshaw. These were, of course, Christopher Isherwood's middle names. 'William Bradshaw' is however a very different creature from the Christopher Isherwood who lived in Berlin; he is a wet fish, sexless, gullible and terribly English. Isherwood felt that this rather faceless alter ego was dramatically necessary if the narrator was not to divert too much of the reader's attention away from the main character. None the less, like *Goodbye to Berlin*, which followed it, *Mr Norris Changes Trains* draws heavily on Christopher's diaries of his Berlin period – which he subsequently destroyed, lest they fall into the wrong hands.

Bradshaw's feelings for Norris are characterised by grudging respect and affection. Even though he knows that Norris has harmed some of his own friends financially, William cannot condemn him. In fact, he is forgiving and protective towards Norris and often feels sorry for him. When Norris comes to a sticky end, William Bradshaw does not judge him harshly. 'Remorse is not for the elderly,' he declares. 'When it comes to them, it is not purging or uplifting, but merely degrading and wretched, like a bladder disease. Arthur must never repent. And indeed, it didn't seem possible that he ever would.'

Mr Norris Changes Trains was a considerable advance on Isherwood's two previous novels. Like some of Graham Greene's fiction, it is a good adventure story, raised to a higher level by an appreciation of the inner nature of the people involved. The background of the Nazi rise to power is succinctly and effectively evoked, without ever intruding directly on the private drama in the foreground. The style is radically different from that of both *All the Conspirators* and *The Memorial*, free of experimental pretensions, naturalistic and witty. In a very few words, Isherwood manages to convey a very precise impression of his characters.

For many people, *Mr Norris Changes Trains* is Isherwood's best novel. Yet he himself later condemned it because of the artificiality of the narrator figure. He felt he had lied about himself and had not been sufficiently conscious of the degree of suffering of those tragic years in German history. As he wrote in his introduction to Gerald Hamilton's autobiographical volume *Mr Norris and I*, published in 1956:

What repels me now about *Mr Norris* is its heartlessness. It is a heartless fairy-story about a real city in which human beings were suffering the miseries of political violence and near-starvation. The 'wickedness' of

Berlin's night-life was of the most pitiful kind; the kisses and embraces, as always, had price-tags attached to them, but here the prices were drastically reduced in the cut-throat competition of an overcrowded market. . . . As for the 'monsters' [like Arthur Norris], they were quite ordinary human beings, prosaically engaged in getting their living by illegal methods. The only genuine monster was the young foreigner who passed gaily through these scenes of desolation, misinterpreting them to suit his childish fantasy. This I later began to understand. (p 11)

In August 1934, however, the 'genuine monster' travelled as planned with Heinz around the smaller Canary Islands. On their journeyings, they came across two extraordinary beggars, who wandered from island to island with ingenious visiting cards, soliciting donations. Christopher wrote a short story about them entitled 'The Turn around the World', which Joe Ackerley published in *The Listener* twelve months later.

Another product of his stay in the Canary Islands was the short story 'A Day in Paradise', which was published in the April–May 1935 issue of *Ploughshare*, the organ of the Teachers' Anti-War Movement. It is the first piece of Isherwood's fiction which demonstrates a consciousness of social injustice, as the predominantly socialist readership of the magazine would understand the term. In a rambling concluding sentence to the story, Isherwood admits that the exotic attractiveness of the island in question may well obliterate images of human suffering.

In September, Christopher and Heinz began a long and complicated journey via Spanish Morocco and Spain up to Copenhagen, which Christopher had selected as their next refuge. Heinz's father had written to them asking Heinz to stay out of Germany, both because of the situation there and to avoid military service. Copenhagen was near enough, though, to make contact with Germany easy, and it had the advantage of relatively liberal immigration laws. Moreover, in Copenhagen they would not be entirely friendless. They had an introduction to Stephen Spender's Danish friend Paul Kryger, and Stephen's elder brother Michael was living there with his German wife Erica as well. Michael and Erica helped them find a tiny flat in the same block they lived in, at 65 Classengade. Later she confessed to Christopher that every time she saw him with Heinz she thought how much they must bore each other. And it was true that when Heinz dragged Christopher off to sporting events, he was bored to distraction.

Copenhagen in late summer and early autumn was an attractive city, with its cafés and flowers, good cinemas and emigré newspapers. But as the winter set in, Christopher began to get depressed. According to Danish

regulations, they would have to stay four or five months before even applying for permanent residence, with no guarantee of success. Continuing developments in Germany worried him, not only in themselves, but also because he feared they would make *Mr Norris Changes Trains* seem out of date. He tried in vain to persuade Leonard Woolf – who had readily agreed to take the book – to publish it earlier than the spring of 1935, but Woolf had a strong prejudice against publishing in between seasons. To try to stop fretting, Christopher engaged himself in a number of minor literary activities, including acting as honorary agent for several of his friends, including Klaus Mann, whom he had met in Berlin, and whose *Flight to the North* had been published by Querido Verlag in the Netherlands. Christopher went up to Sweden briefly to lecture about his time working on the film *Little Friend*, and he did some small translations for Rolf Katz.

His spirits rose over Christmas when he heard that Wystan Auden would be visiting soon. Wystan flew in on January 10, 1935, courtesy of his publishers Faber & Faber, for whom he was writing a verse play, provisionally entitled 'The Chase', drafts of which Wystan had already sent Christopher through the post. The idea was that Christopher would give Wystan some helpful criticism. But during the four days they were together in Copenhagen, the whole shape of the play changed drastically, and it became a joint effort. While Heinz cooked for the three of them, Christopher talked and Wystan feverishly attacked the manuscript with a violet-coloured pencil, covering himself with so many marks at the same time that he had to have a bath each night to wash them off.

The verse format appealed to both of them, as well as to Faber's editor T. S. Eliot, whose own *Murder in the Cathedral* was published that year. In Copenhagen, Wystan and Christopher decided to call the revised play *Where is Fronny?*, 'Fronny' being the nickname of Francis Turville-Petre. But Rupert Doone of the Group Theatre in London, who was to stage it, persuaded them to change this to *The Dog Beneath the Skin*.

Years later, when Auden was asked by a journalist how he and Isherwood had collaborated on this and other plays in the 1930s, he replied gravely: 'With the utmost politeness'. But it was not like that at all. Their communal work sessions were a riot of ribald banter, criticism and insult. Yet they worked extremely fast, as both had a remarkable facility with words. Isherwood later modestly declared that he had written little of value in *Dogskin*, as the play quickly became known in their circle, and Faber & Faber seem to have agreed. When the script was ready for publication, they tried to persuade Auden to publish it in his name only, but he refused.

The play is very much a child of its time, urgent in its anti-fascism and

aggressive in its overt suggestion that such things could also happen in England. The core element of the plot is a quest. The young hero, Alan Norman (described cruelly but perceptively by Stephen Spender as 'Candide with the mental age of Peter Pan') takes on the challenge of finding a missing heir, Sir Francis Crewe, who has fled the constricting environment of a decent English village. Sir Francis's sister has pledged herself to Alan if he is successful, in the true spirit of English folk-tales. The story has obvious links with traditional British myths of chivalry, as well as drawing heavily on pantomime (notably *Dick Whittington*), Noël Coward and the scouting ideals of Lord Baden-Powell. The hybrid result is a sort of politicised Mortmere. Many elements of the old Isherwood–Upward stories, with their bent vicars, ravished boys and absurd disguises are present, but now with the added element of a definite social message.

While antedating the Spanish Civil War, *The Dog Beneath the Skin* seems to be a clarion call to line up against Fascism. Yet its political position is not entirely clear-cut; its ardour for the left-wing cause is ambiguous. One senses an understanding of, and to some extent a pity for, some of the characters who are ideologically unsound. The Enemy is often laughed at, rather than hated. It has been suggested that there is a dichotomy in the play which reflects a difference in approach by Auden and Isherwood; the former being more deeply involved in making propaganda, while the latter was more fascinated by the comic and satirical possibilities of the characters them-selves. But this is an over-simplification. By this time, Christopher was quite sure of his own position *vis-à-vis* Fascism, but his artistic priorities would always prevent him from becoming a political mouthpiece.

Mr Norris Changes Trains was published in London in March and the reviews were generally good. The *Daily Telegraph* hailed Mr Norris as a true original: 'a flabby rogue without . . . a single redeeming quality, who is nevertheless one of the most delightful persons one has met in fiction for a long time'. *The Spectator* called the book a 'feast of sustained irony'. However, the joy that this cheering news should have brought to Christopher was overshadowed by worries about Heinz's position. Military conscription was about to be introduced in Germany, and Christopher feared that if the boy went back, then he would become part of a military machine and would not be allowed out again for five years or more. As Heinz's passport would expire in 1938, and there was no way that any German Embassy would renew it if he avoided conscription, the only way out seemed to be to try to change Heinz's nationality. Had he been a girl, it would have been easy; Christopher could have married him. But, once more, conventional society had stacked the cards against outsiders like them.

It had also become obvious that Christopher and Heinz would not be able to stay in Denmark much longer. The police had told Christopher that they considered him a 'politcal' writer, which worried him, and he also discovered that he was liable for Danish income tax. He wondered if they ought not to try to get to South Africa; Stephen Spender suggested the United States instead. In the end, though, Christopher decided that Gerald Hamilton, for all his faults, was the best man to help them out with their problem. As Hamilton was by now living in Brussels, they made their way to Belgium in the middle of April.

7

1935–1938

Christopher and Heinz stayed at 44, Avenue Longchamps during this visit to Brussels. On April 19 Christopher wrote to Stephen Spender enthusiastically:

> Brussels seems lively after Copenhagen. It is raffish and shabby, with dark monkeyish errand boys and great slow Flamands with faces like bits of raw meat. And there are kiosks and queer dives and the Host is carried to the dying through the streets, with people kneeling as it goes by. . . . I feel delivered from all kinds of vague suffocating apprehension.

Heinz was given only a one-month visitor's visa on arrival in Belgium, as Germans were not popular in many countries of Western Europe at the time. Gerald Hamilton promised to use his influence to improve this situation, but it seemed as if his influence was slight, or at least, very slow.

Once he had installed Heinz in their Brussels lodgings, Christopher went over to London, for the first time in more than a year. By this time, Wystan Auden had already decided to do a play about mountain-climbing – yet another Test. This was to be in collaboration with Christopher again, though work on what was to become *The Ascent of F6* was not begun until the following year. Wystan was currently in his third and final year of teaching at the Downs School in Cornwall.

Christopher was back in Brussels by May 12, but when Heinz tried to get his visa extended, it was refused. There seemed some hope, however, of obtaining another one from a Belgian embassy abroad. The two friends therefore went over into the Netherlands, where the Belgian Consul said it would be difficult but not impossible. Meanwhile, they moved into the same lodgings in Emmastraat where Heinz had spent part of the previous year.

At this time, Christopher became a regular contributor to *The Listener*,

thanks to Joe Ackerley, who had been appointed literary editor in April. Widely acknowledged to be one of the most handsome men in London, Ackerley was a promiscuous homosexual who later famously transferred his affections to an Alsatian bitch. More important, he was a significant figure in what Wystan dubbed 'The Homintern', a loose international fraternity of gay men in literature and the arts between the wars who befriended each other, collaborated and commissioned work from each other when possible. Not that people's sexuality was the key to getting a commission from Joe Ackerley to write for *The Listener*. Despite offering fees considerably lower than those provided by the Sunday newspapers, the magazine managed to get top-rank contributors thanks to Ackerley's professionalism, charm and wide network of literary friendships. These included E. M. Forster, Edwin Muir and Maynard Keynes.

Usually Isherwood's reviews in *The Listener* were unsigned. They cover the period 1935 to 1937, and are catholic in their range of subjects, though Christopher did specifically ask to be sent autobiographies by non-celebrities. One of his first reviews was of Eliot's *Murder in the Cathedral*, and one of the last was of the hilariously naughty travel book *Letters from Iceland*, which Wystan Auden and (the heterosexual) Louis MacNeice wrote about pony-trekking in Iceland with a party of school boys (who are transformed into girls in the finished work), under the watchful eye of a totally fictitious persona, 'Miss Greenhalge'. This link with *The Listener* kept Christopher more intimately involved professionally and socially with the new literary establishment in London, some of whom – like Auden and Spender – were master publicists. E. M. Forster and John Lehmann also did a great deal to boost Isherwood's reputation. However, he was not above doing a little self-promotion himself, going to great lengths to ensure that Hugh Walpole received an advance copy of *Mr Norris Changes Trains*.

For the time being, though, Christopher was physically out of the swim of things, living in the Netherlands. A pleasant new arrival there was Thomas Mann's eldest daughter Erika, who had been running a highly successful satirical cabaret in Munich called 'The Peppermill', until it was no longer safe. The rest of the Mann family were already in exile. Thomas and his wife Katia had left Germany in February 1933 on a lecture tour and decided it was better not to return. Despite winning the Nobel Prize for literature in 1929, Mann was vilified by the Nazis, who considered him dangerously unreliable. After a brief stay in the south of France, Thomas and Katia Mann settled in Zurich. Erika was later to reopen her cabaret in Switzerland, but for the moment had come to Holland. She had heard a great deal about the country from her brother Klaus, with whom she had unusually close sisterly

ties. Klaus had lived in the Netherlands, writing novels and editing an important literary magazine called *Der Sammlung* (founded with his uncle Heinrich Mann, André Gide and Aldous Huxley).

Erika astonished Christopher by proposing marriage. She knew that her German nationality was about to be taken away from her and needed to find someone, preferably British, who would be able to get her a decent passport to travel on. Erika was a strikingly attractive woman who had already had one disastrous marriage, to the actor Gustaf Gründgens. He had started out as a left-wing sympathiser, but was converted to the doctrine of National Socialism and was later made Director of the Berlin State Theatre. After divorcing Gründgens, Erika had given freer rein to the lesbian side of her make-up. Christopher felt honoured, excited and amused by her request for this marriage of convenience, but declined, mainly on the grounds that it could compromise Heinz if Christopher were publicly linked to so celebrated an anti-Nazi. But there was also a strong element of disgust at the whole idea of marriage, even for the purest of reasons. Christopher could not countenance any suggestion that he might be trying to pass as a heterosexual, and felt that even a token arrangement was more of an intrusion into his private life than he could accept. However, he contacted Wystan Auden on Erika's behalf, to ask if he could provide the service instead. Wystan (whose engagement to the nurse had ended as mysteriously as it had started) cabled back the single word 'Delighted!' - adding later, 'What are buggers for?' The wedding took place on June 15 at a registry office in Ledbury, Hertfordshire, after which the bride and groom went their separate ways.

Though Christopher had been considering writing a second Berlin book, he was currently working on a more convoluted novel called *Paul Is Alone*. A detailed synopsis of the projected work, which was to be in four parts, drawing on his experiences from the time he moved to Berlin, can be found in his later autobiographical book *Christopher and His Kind*. Like *The Lost*, *Paul Is Alone* is overpacked with material. It did, however, produce the germ of substantial parts of *Prater Violet* and *Down There on a Visit*, as well as a little bit of *The World in the Evening*.

During the first week of July, John Lehmann came to Amsterdam on a visit. His ideas for a literary magazine had progressed considerably since they had last talked about the subject back in Berlin. On a long walk around a sports field in Amsterdam, John outlined his plans for a publication that would be a vehicle not only for the names that had come into prominence through *New Signatures* and *New Country*, but also for foreign writers who took an anti-Fascist stance. He even dreamed, unrealistically, of getting Soviet authors to contribute. One section of the magazine would be reserved

for pieces which were too long to go into the mainstream short-story magazines, and yet which were too short to be published as separate books in Britain, given the lack of a British market for novellas. As Christopher was thinking of breaking up *The Lost* into more manageable chunks, the possibilities for him in the new publication would be enormous. Christopher was definitely interested, but recalled later that his mind kept wandering away from John's conversation as his eyes latched on to the blond Dutch boys and their more exotic colonial classmates boxing in one corner of the sports field.

Lehmann started discussions with a number of publishers when he returned to London, though for a while it was not certain whether the magazine would be a quarterly, or a half-yearly hardback volume similar in format to *The Yellow Book*. Eventually, the latter course was chosen and the new review was given the title *New Writing*. John saw his own role as that of editor, strongly supported by an advisory committee, of which he wanted Christopher to be a prominent member. Christopher replied to this suggestion by urging John to run the review autocratically and dispense with the idea of a formal committee entirely. This is exactly what Lehmann did, making *New Writing* one of the most important periodicals of the age.

Kathleen went out to Amsterdam to visit Christopher at the beginning of August, taking the red-light district there in her stride. But more eagerly anticipated by Christopher was the English lover of a German boy, Anton Altmann, 'Toni', who was living in the same house as Christopher and Heinz. The man in question was Brian Howard, to whom the epithet 'mad, bad and dangerous to know' seems to have stuck permanently. Christopher had never met Brian Howard before, though they had several mutual friends. He rather took to him, despite his being a snob and a drunkard and possessing a singularly vicious tongue. At Oxford, Brian had shown enormous potential as a poet, but never lived up to it. He was a hedonist, yet one who contrived to make most pleasure seem sinister. He and Christopher could never have become really close friends, but they had enough in common to get along. Brian was then trying to find a country where he could live with Toni, as the boy had been declared *persona non grata* in England because of his association with known drug addicts. The parallels with Christopher's own perplexing situation with Heinz forged a bond between the two Englishmen. But Christopher found it much more difficult to stomach Toni, whose mannerisms and affectations got on his nerves.

Less demanding companionship was provided simultaneously by E. M. Forster, who arrived on a visit, also in August, along with his beloved policeman Bob Buckingham. They were joined by Stephen Spender, and all

went to The Hague for Christopher's official birthday on August 27, along with Klaus Mann and Gerald Hamilton. Birthday parties were important milestones in Isherwood's life, to be celebrated with a group of intimate friends. But this one was quite unlike any other. Gerald Hamilton had made arrangements for them to eat at a nice restaurant, but a sudden downpour forced them to seek shelter among the torture instruments of the Gevangenpoort Prison Museum, while Gerald tried to keep them amused with outrageous anecdotes. Christopher was seeing a lot of Gerald then, as he was helping with the preparations of Gerald's early volume of autobiography *As Young as Sophocles*, as part of the deal for Gerald's assistance in getting Heinz a new nationality.

Brian Howard came up with the idea of going to Portugal, where life was cheap, and where he fancied buying an old house and raising animals. Toni disapproved. However, Christopher thought that he and Heinz could join them there, if the plan came off, but only if Gerald Hamilton and Stephen Spender went along too. Brian and Toni did indeed go to Portugal that October, but by then Christopher and Heinz had made alternative arrangements.

As nothing had materialised from the Belgian consulate in Rotterdam, where they had been trying to get Heinz a new visa, they decided to take up a friend's suggestion and go to Luxembourg, which did not require entry visas, and then double back to Belgium from there. Sure enough, Heinz was given a thirty-day Belgian permit without problem when they got to Luxembourg. They took a bus trip through the duchy's Petite Suisse region while they were there. The bus had to make a detour across the German frontier, but Christopher and Heinz recklessly decided to take the risk for the fun of it, as the bus-driver assured them passports would not be checked. They spent a quarter of an hour in a café on the German side of the border, drinking beer and writing postcards to send to astonish friends, before returning safely back to Luxembourg.

Once in Brussels, they rented a flat downtown, above Delvaux's leather goods shop in the Boulevard Adolphe Max. In October, Wystan came over for a weekend, bringing with him fragments which he had written in his new job as a member of the GPO Film Unit. Working from Soho Square in London, the Unit produced, under John Grierson's inspired direction, a series of remarkable documentaries on a surprisingly low budget. Auden had been working on verse for a film on mining, called *Coal Face*, directed by Basil Wright. The experience was not an entirely happy one, as some of the professionals in the Unit clearly thought Auden was too young and green, though Basil Wright himself was kinder. Perhaps the most valuable thing to

come out of the experience, though, was Wystan's friendship with a budding young composer introduced by Basil Wright, Benjamin Britten. Six years Auden's junior, 'Benjy' was then still trying to come to terms with his homosexuality, and Wystan was only too happy to help his awakening with the same sort of brutal analysis he had practised on Christopher.

Christopher himself was working on a piece for *New Writing*. It was directly inspired by the month he had spent living in Otto's family's tenement flat in Berlin. The story was originally called 'The Kulaks', until Christopher realised that this could lead to some misunderstanding. So, after discussion with Heinz, he changed it to 'The Nowaks', which was reissued later as one of the six sections of the novel *Goodbye to Berlin*.

The story is fairly faithful to real-life happenings, except that the time sequence is changed. In the story, Christopher moves in with 'Otto' after the holiday in Ruegen, not before. The most striking aspect of the story so far as the evolution of his technique is concerned is the change in the role of the narrator. 'Christopher Isherwood' in 'The Nowaks' is far more actively a party to events than his predecessor 'William Bradshaw' in *Mr Norris Changes Trains*. Though he observes and reports on the other characters, it is his own arrival which forms the dramatic point of departure. Some of the descriptions, notably that of Herr Nowak recounting his wartime experiences, read like a first-class film-script, complete with stage directions.

In this and other forthcoming sections of *Goodbye to Berlin*, the narrator picks out details, incidents and habits as if he were a roving camera lens, with a very sure-handed director behind him giving the orders. Isherwood was very much aware of this cinematographic link himself, stating it openly in the famous early passage of the section entitled 'A Berlin Diary' that begins: 'I am a camera with its shutter open, quite passive, recording, not thinking. Recording the man shaving at the window opposite and the woman in the kimono washing her hair. Some day this will be developed, carefully printed, fixed. . . .' So many critics have latched on to this passage as being the secret of Isherwood's success that it is worth pointing out that it has often been misinterpreted. As Isherwood told Robert Wennesten in an interview in the *Transatlantic Review* many years later:

> . . . what I really meant by saying 'I am a camera' was *not* I am a camera all the time, or that I'm *like* a camera. It was: I'm in the strangest mood at this particular moment, not the kind of mood I am usually in, a mood where I just sit and register impressions through the window – visual data as people say – in a quite blah sort of way without any reaction to it, like a camera. My usual mood would have been to rush downstairs

and get into the action. The idea that I was a person very divorced from what was going on around me is quite false. (Nos 42/43, p 19)

Towards the end of October, Stephen Spender arrived in Brussels with his latest boyfriend Tony Hyndman ('Jimmy Younger' in *World within World*). Tony was a cheery young working-class Welshman, with red hair, a ready smile and a good sense of discipline, inherited from a spell in the regular army. Christopher adored his zest and his use of phrases like 'yer silly thing!' and 'don't be so daft!' There was an immediate sexual attraction, although, under the circumstances, Christopher did not do anything about it for the time being. Tony had the added advantage, from both Stephen's and Christopher's point of view, of having a sincere interest in poetry.

As Stephen had decided he did wish to live the life of a literary exile after all, perhaps partly prompted by his inner confusion about which direction he wanted his private life to go, the four friends boarded a Brazilian boat at Antwerp on December 10 and set sail for Portugal. They started a group diary on-board ship and when they got to Lisbon decided to go to stay in the nearby hill-town of Sintra. Once they had discovered that it was easy and cheap to rent houses there, they took a five-bedroomed villa called Alecrim do Norte, and hired both a cook and a maid. Christopher bought some animals for Heinz to look after, while Tony Hyndman was put in charge of the household accounts. Tony also acted as secretary to Stephen, who was writing both the long political essay *Forward from Liberalism*, to be published in 1937 by Victor Gollancz, and the play *The Trial of a Judge*.

Toni Altmann was still in town, though Brian Howard had moved on. Toni was highly amused to see that Christopher had been taken up by a circle of expatriate English ladies, who dabbled in spiritualism. They loved to have this presentable young man over for tea. At the beginning of February, though, the inhabitants of the Villa Alecrim do Norte discovered a more expensive and addictive pastime: going down to the casino at Estoril. Heinz, in particular, became obsessed with the place. It was particularly sinister in the afternoon, when a smaller number of really dedicated gamblers were at the tables. The problem was, though, that the winter weather in Sintra was so bad that there was very little else for Heinz to do.

Meanwhile, Christopher was busy working on *Paul Is Alone*, and was distilling another novella for *New Writing* out of the mass of dormant material in *The Lost*. In January, he had written to John Lehmann half-apologetically that:

There is a section of *The Lost* ready – about an English girl who sings in a Berlin cabaret, but I hardly think it would suit the serious tone of

'New Writing'. It is rather like Anthony Hope's *The Dolly Dialogues*. It is an attempt to satirise the romance-of-prostitution racket. Good heter stuff.

It is hard to see why Isherwood felt that 'Sally Bowles' was any less serious than 'The Nowaks', but his fictionalisation of Jean Ross did give him many headaches. As early as July 1933, he had written to Olive Mangeot from Greece saying that he had written the Jean part of the novel. Yet nearly three years and countless revisions later, he was still not satisfied. A few weeks later, he wrote again to John Lehmann saying that he could not let him have 'Sally Bowles' in time for the next issue of *New Writing*, as there was still something radically wrong with it. Instead, he offered him about five thousand words from his Berlin diaries, 'only mildly (heter) dirty and chiefly about my landlady, fellow lodgers, pupils, etc'. Lehmann did want the diary extracts, but wished to settle the 'Sally Bowles' problem first, so the project was temporarily shelved.

On March 14, Stephen Spender and Tony Hyndman left for Spain, from which news of Republican outrages against churches and the offices of right-wing newspapers were filtering through. Stephen wanted to see the reality for himself. Two days later, Wystan Auden arrived, to start working on *The Ascent on F6*, which then had the working title of *The Summit*. Christopher sketched out the plot; then, they wrote up separate scenes. Wystan stayed indoors, hiding from the spring sun, while Christopher wrote out in the garden. Working intensively, they got the whole thing finished within a month. Their personal as well as professional relationship was still something very special, as Christopher noted in his diary:

> although I found myself glaring nervously whenever he shovelled food into his mouth while reading at meals; although I was often annoyed by his fussing and the mess he made – still I never for one moment was more than annoyed. I never felt opposed to him in my deepest being – as I sometimes feel opposed to almost everyone I know. We are, after all, of the same sort.

The theme of *The Ascent on F6* is motivation: the reasons behind a person's action are what makes them heroic or empty, lofty or base. However, it is not always easy to make the distinction between the two extremes. This concept of the theme might explain some of the confusion in the play, which is not as crisp as *The Dog Beneath the Skin*. The complexity of the characters may be truer to real life, but that does not necessarily make for better drama.

As Isherwood told the journalist W. I. Scobie in an interview for 'The Art of Fiction' (XLIX, 1975):

> We consciously thought of a subject, the study of a leader like Lawrence of Arabia, but translated into terms of mountain climbing – *The Ascent of F6*. We wanted to contrast mountain climbing for climbing's sake and mountain climbing for political ends, just as Lawrence went into the desert first because he loved it, and ended up being used politically.

During Wystan's time at Sintra they became friends with the German dramatist Ernst Toller, one of whose plays was translated and adapted by Auden as *No More Peace!*. Also a poet and a revolutionary, Toller was a handsome man with great charisma, and Christopher well understood how he had won the admiration of countless opponents of the Nazi regime. They met again several times in the 1930s, in London and New York, where Toller committed suicide in 1939. Christopher was to record his memories of the man in a piece which appeared in the first issue of *Encounter*, edited by Stephen Spender, in 1953. In it he confessed that at times he used to avoid Ernst Toller, because Toller had a direct and efficient way of enlisting friends and acquaintances to help his various causes.

Wystan left in mid-April, which enabled Christopher to get back to 'Sally Bowles'. The final draft was completed by June 21, by which time he had received Jean Ross's permission to use her real-life experiences in the story, including her abortion. Before forwarding the typescript to John Lehmann at *New Writing*, Christopher sent it off to Edward Upward for his imprimatur.

On June 25, the inevitable happened. The German consulate in Lisbon contacted Heinz telling him to report home for military service. Christopher went to see a lawyer about the possibility of Heinz being made a Portuguese citizen, but was told there was no chance. Depressed by this further setback, Christopher was only too pleased when William Robson-Scott arrived. William Robson-Scott had had to resign his post as a university lecturer in Berlin because of his opposition to the Nazis. He was reassuring and calm and sensible. And he also provided the practical service of finding a desirable couple to move into the villa, now that Stephen and Tony were gone: James and Tania Stern.

James Stern was a short-story writer who had led an exciting life. He'd had a number of humble professions, such as being a bank clerk in Germany and a cattle rancher in South Africa. A hypochondriac like Christopher, he was by nature a grumbler, but he could also be wildly funny. His wife Tania was German and beautiful and had been a teacher. Every day, Christopher, Heinz,

James and Tania would sit huddled round the radio, listening for every scrap of news of the Fascist rebellion in Spain. James maintained that newspapers were totally unreliable, being full of lies. For days on end, he would shut himself away in his room, seeing only Tania – especially if Christopher had any of his English ladies round for tea. James Stern loathed the social niceties, and found the overt support for Franco's forces among some of the British expatriate community in Portugal despicable. Christopher liked James for his crotchety ways, but it was Tania who became the better friend.

When Kathleen had been out on a visit to Sintra in June, Christopher warned her that the arrangements for Heinz's projected change of nationality would probably cost quite a bit of money. He was looking to her to provide it, as he did not have any capital of his own. Despite her own misgivings, Kathleen agreed to enter negotiations with a lawyer Gerald Hamilton knew in Brussels, who demanded a thousand pounds for the necessary expenses, with no guarantee of success. She called in her cousin Sir William Graham Greene, who worked in the Admiralty, for advice, and she concurred with him that the whole thing sounded very shady indeed. By this time civil war had broken out in Spain, disrupting the post, so Kathleen was reduced to sending telegrams to Christopher. She cabled him to come back to London to try to sort things out. He got there on August 21, after leaving Heinz safely in Ostend. After several days of hard persuasion, Kathleen did provide the thousand pounds for the lawyer. It was rather an expensive way of winning Christopher's gratitude, but she could see that the matter was of vital importance to him.

The main hope for Heinz's salvation now lay with the Mexican legation in Brussels. Christopher had set up his base in that city again by the middle of September and, a month later, took Heinz to the old-fashioned thermal resort at Spa, to recuperate from an operation on his nose, which was meant to ease his breathing. Heinz loathed Spa, with its lack of entertainments, but it was there that Christopher was able to sort out the fate of some of his entangled literary projects in his mind. In particular, he started writing the first draft of what was to become *Lions and Shadows*. Back in Brussels, he worked on a revision of *The Ascent on F6*. Published by Faber & Faber in September, the first edition of this received a rather hostile notice from Stephen Spender in the *Left Review*. But Stephen had an even bigger surprise in store: he was getting married. Properly.

According to his memoirs, *World within World*, Stephen had realised when he returned to London in the autumn of 1936 that his personal life was a failure. He decided he must separate from Tony Hyndman, and went off to live alone in a flat in Hammersmith. Very shortly afterwards, he was invited to speak at an 'Aid for Spain' meeting in Oxford. At a lunch party there, he

found himself sitting next to a very pretty girl student of poetry called Inez Pearn. She had been in Spain that summer, where she had had a rather tempestuous affair with a painter, and she was a member of the Spanish Aid Committee. Stephen invited her to attend his house-warming party a few days later. She came and was a success with the other guests. The next day, he proposed to her. Later Stephen admitted he was not quite sure why. But both of them seemed to see marriage as a solution to their own current personal problems. The wedding took place three weeks later. Christopher was present, but he had a blind spot about bisexuality, and found Stephen's transformation into a husband difficult to accept.

Meanwhile, John Lehmann was beset by doubts about the Sally Bowles story. He liked it immensely, but wondered if it was not too long for *New Writing*. More important, he was concerned about the abortion episode. He was not sure that the printers would agree to set it and asked if it could be removed. Christopher replied on January 2, 1937:

> About SALLY, you know, I'm doubtful, though quite open to conviction. It seems to me that Sally, without the abortion sequence, would be just a silly little capricious bitch. Besides, what would the whole thing lead up to? And down from? The whole idea of the story is to show that even the greatest disasters leave a person like Sally essentially unchanged.

In the end, Lehmann published some 'Berlin Diary' extracts in the third issue of *New Writing*, while *Sally Bowles* appeared as a separate little book, brought out by the Hogarth Press later that year. Lehmann had given up his attempt to persuade Christopher to cut the abortion episode. But a number of Jean Ross's friends – who had little difficulty recognising her as Sally – were shocked. Unlike Gerald Hamilton, Jean Ross made considerable efforts to avoid public identification with her fictional counterpart, as did her husband Claud Cockburn. She was by now deeply committed to the Communist cause, and it would have done her no good whatsoever had her political colleagues realised that she was the model of divine decadence in the Weimar Republic's closing years. Respecting her wishes, Isherwood did not divulge the identity of the real 'Sally Bowles' until after Jean's death in 1973. When some journalists did manage to track her down and invited her to see the stage-show *Cabaret*, she politely declined.

As Jean Ross herself faded into the background, the Sally Bowles character grew. In Isherwood's portrayal, she is a strong, unforgettable figure, but she subsequently took on a life of her own, transformed by each successive

representation on stage and screen. The ultimate accolade, perhaps, was the appearance of a whole book about her different manifestations, Linda Mizejewski's *Divine Decadence*.

The irony was, though, that as Sally Bowles was about to make her début in 1937 Britain, a large percentage of the country's left-wing intellectuals had focused their interest more on Spain. One after another, over Christmas and New Year 1936–1937, Christopher's friends announced that they were going either to fight with the International Brigade, to help fend off the Fascist challenge, or else to cover events for the Press. Tony Hyndman came through Brussels at Christmas, accompanied by Winston Churchill's nephew, Giles Romilly, though Tony became very quickly disillusioned with what he found in Spain when he got there. Stephen Spender, who had joined the Communist Party, wrote to say he was going to Spain for the *Daily Worker* with T. C. Worsley. And, on January 12, Christopher met up with Brian Howard in Paris to give Wystan Auden a drunken send-off.

At least for the first few months of the Civil War, it seemed to those on the left to be a clear-cut case between black and white. Spain became a rallying point for all those who despised the perverted values and behaviour of Fascism. Throughout the 1930s, poetry, drama and to a lesser extent prose had been full of the imagery of confrontation, of the battle between good and evil, young and old. Denied the opportunity of taking part in the Great War because of their age, the young writers of a slowly coalescing generation suddenly had a well-defined cause for which they could stand up and be counted. What's more, they had the chance to write literate propaganda in support of their beliefs: what Auden called 'parable art', which can 'teach man to unlearn hatred and learn love'. Christopher watched all this from the side-lines, wondering if he too would have been swept up in the tide of idealistic enthusiasm, had he not been bogged down in his own domestic drama of trying to hang on to Heinz.

At the beginning of February, Christopher went to London to sit in on the rehearsals of *The Ascent on F6*, which Rupert Doone was directing at the Mercury Theatre in Notting Hill. Rupert Doone's lover, Robert Medley, who was responsible for the sets, knew in advance that it was going to be a success when it opened to a full house (including Christopher and Kathleen) on February 26. But Medley also knew that, dramatically, the play was fatally flawed. In his Memoirs, *Drawn from the Life*, he passed a telling judgment on both the play and its authors:

Rupert's strength as a producer lay in his gift, developed in earlier years as a dancer . . . for creating atmosphere without cluttering the stage

with irrelevant detail. This gave the moral and poetic elements in the drama space to breathe. As designer I was acutely aware of the problems of presentation that were posed by *F6*. It was perfectly understood by Rupert that in the writing of the play the authors should not be inhibited by practical details. As producer it was his job to cope with such difficulties. Neither Wystan nor Christopher, however, seemed prepared to learn from those who as directors, designers and actors had the job of putting across on the stage what they had created on the page. They found it difficult . . . to subordinate themselves to the imperatives of co-operative production. All this goes to show that they were reluctant to learn their job as dramatists the hard way, in the theatre. It was simply another activity in their promotion of their own careers . . . (p 139)

Wystan and Christopher were in fact aware that the play was far from perfect, and that the ending was particularly weak. They even consulted Morgan Forster to see if he could come up with some solution, to no avail. And, in fact, Rupert Doone did manage to persuade Christopher to make a few changes while Wystan was out of the way. When Wystan returned from Spain and saw the play for the first time, in Christopher's company, on March 4, he greatly amused the audience by exclaiming in a very loud whisper: 'My dear, what have you *done* to it?'

Christopher returned to Belgium a fortnight later to find there was still no news from the Mexican legation. So, after three days, he travelled with Heinz to Paris, where James and Tania Stern were now living. Tania suggested sensibly that it would be a good idea if Heinz learnt a trade, and he was therefore apprenticed to a silversmith friend of hers. Cyril Connolly and his wife Jean were also in Paris, with their young friend Tony Bower, an amusing, impulsive, generous young man, who rather complicated matters by falling in love with Christopher.

On April Fools' Day, Christopher was back in London, where he went down with a seriously infected mouth. The doctor was puzzled, but Kathleen remained unflappable, looking after him with resignation. His friends flocked to his sick-bed, including Wystan Auden, Edward Upward and his wife Hilda, and Tony Bower. Wystan nobly agreed to go over to Paris to see if Heinz was all right, and phoned to say that unfortunately the young man had got into trouble with the police. He had lost his identity card in a street-fight, had been pointed out to the police as a rent-boy, and was accused of seducing a deaf-and-dumb chambermaid in the small hotel where he was staying. The net result of these various misdemeanours was that the police told him he would have to leave the country when his residence permit expired on April

15. Tony Bower, anxious to be of service, agreed to go back to Paris and escort Heinz to Luxembourg safely.

Ten days later, Christopher was well enough to rejoin his boyfriend. After a rough Channel crossing, he stopped off in Brussels for a dinner consultation with Gerald Hamilton. Christopher felt irrationally reassured, and went on to Luxembourg convinced that the Brussels lawyer would manage to get Heinz a Mexican passport very shortly. Gerald Hamilton joined them in the Grand Duchy during the first week of May to add substance to this report.

However, on May 12, the police arrived at the hotel in Luxembourg where Christopher and Heinz were staying and informed them that Heinz was to be expelled. Christopher phoned through to the lawyer in Brussels, who said that Heinz should go back to Germany. From there, a short-term visa for Belgium could be arranged. But when Heinz crossed the frontier into Germany, he was immediately arrested by Gestapo agents, on the grounds of being a draft-evader. In June he was convicted in court not only of that, but also of 'reciprocal onanism' with Christopher and was sentenced to six months prison, followed by a year's labour for the state, and three years' military service.

Christopher wept when he reflected on how things had turned out, realising that the chances of reunion were almost non-existent. He never knew whether he had been hoodwinked by Gerald Hamilton, or whether the Brussels lawyer had tipped the Gestapo off about Heinz's return. Or maybe it was just all bad luck. Whatever the truth, the prime motivation for the peripatetic existence Christopher had been leading as Europe drifted ever closer to war had gone. William Robson-Scott turned up in Brussels like some guardian angel to calm his distress. There was nothing for it, Christopher decided, but to buckle down to work.

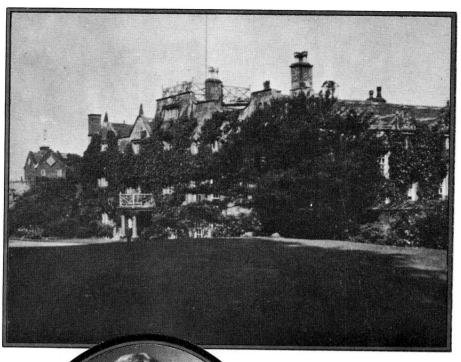

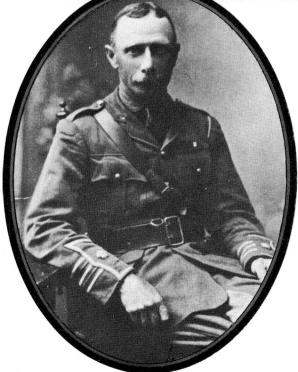

Above: Marple Hall.
Courtesy of Christopher Isherwood.

Left: Frank Isherwood, c1914. *Courtesy of Christopher Isherwood.*

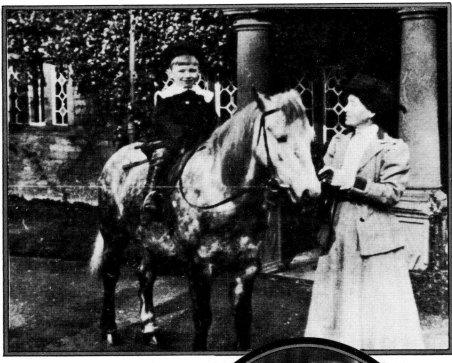

Above: Christopher and
Nurse Avis at Marple,
1909. *Courtesy of
Christopher Isherwood.*

Right: Kathleen,
Christopher and Richard,
1912. *Courtesy of
Christopher Isherwood.*

St. Edmund's School, c1916. Seated are Cyril and Rosamira Morgan-Brown.
Peering round her head is Christopher; seated at her feet is Wystan Auden.

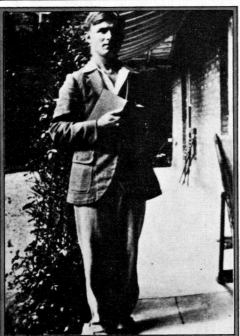

Left and above: Christopher on the Isle of Wight, 1928, the day an advance copy of *All the Conspirators* arrived.
Photographed by and courtesy of Edward Upward.
Below: Edward Upward, 1928.
Photographed by Christopher Isherwood; courtesy of Edward Upward.

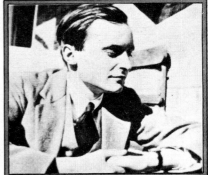

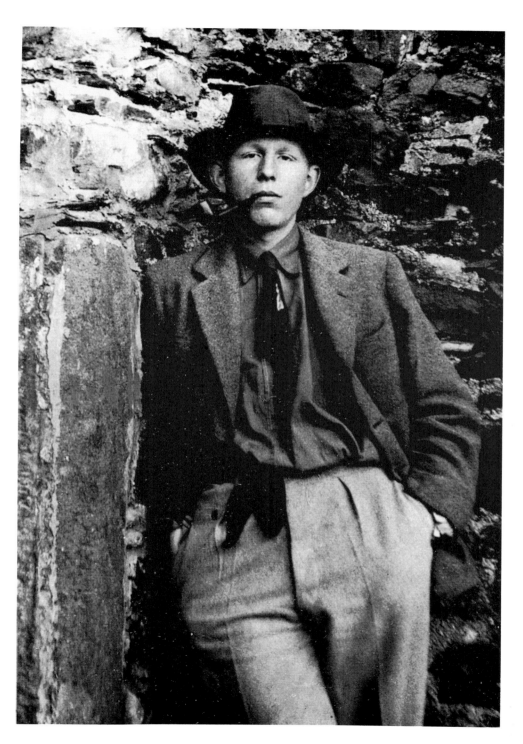

Wystan Auden, early 1930s.

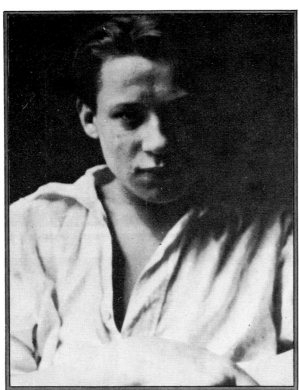

Left: 'Otto', c1931.
*Photographed by Stephen
Spender; courtesy of
Christopher Isherwood.*

Below: Christopher and
'Otto' on Ruegen Island,
c1931. *Photographed by
Stephen Spender; courtesy
of Christopher Isherwood.*

Above: Heinz, 1933.
Photographed by and courtesy of Humphrey Spender.

Left: Salka Viertel as a young woman.

Gottfried Reinhardt and Christopher viewing set for *Rage in Heaven*, c1940. *Courtesy of Gottfried Reinhardt.*

Dodie (Smith) and Alec Beesley, 1940s.

Left: Swami Prabhavananda and Christopher, 1942. *Photographed by and courtesy of Margaret Kiskadden.*

Below: Denny Fouts ('Paul'). *Courtesy of Christopher Isherwood.*

Overleaf: Bill Caskey and Christopher, c1949. *Photographed by and courtesy of William Caskey.*

Above: Christopher, Kathleen and Richard outside Wyberslegh Hall, c1947.
Courtesy of Christopher Isherwood.

Previous page: Christopher, 1946. *Photographed by and
courtesy of William Caskey.*

Christopher and Don Bachardy, 1953. *Courtesy of Christopher Isherwood.*

Wystan Auden, Stephen Spender and Christopher on Ruegen Island, 1931. *Photographed by and courtesy of Stephen Spender.*

Wystan Auden, Stephen Spender and Christopher on Fire Island, 1947. *Photographed by and courtesy of James Stern.*

8

1938–1939

In one of the displays of resilience which astonished some of his friends, Christopher closeted himself away in Brussels after losing Heinz, and finished the first draft of *Lions and Shadows* within a couple of weeks. In June, he accepted an invitation to go to a pro-Republican Writers Congress in Valencia. Because of the deteriorating security situation in Spain, however, the Foreign Office in London vetoed the journey, and Christopher did not go, unlike Stephen Spender who obtained a false Spanish travel document with the help of André Malraux, issued in the rather curious name of Ramos Ramos.

By July, Christopher was back in the world of cinema in London, working on the screenplay of a film based on a story by Carl Zuckmayer, directed by Ludwig Berger and produced by Alexander Korda. In fact, the film was never finished, which was to happen with rather a lot of the movie projects Isherwood got involved with over the coming years; but at least he always got paid.

In August, Wystan Auden and Christopher joined Morgan Forster in Dover, where he was spending a month's holiday. This curious choice was based on the presence of a large army barracks, some of whose soldiers had become used to entertaining gentlemen visiting from London. Such useful tips were passed around the clandestine homosexual community in those pre-Second World War days, as indeed were individual compliant soldiers, policemen, employees of London clubs and others who were 'adopted' by groups of friends. In a world where blackmail was always a nauseating possibility, this was safer, as well as more convenient, for everybody.

In Dover, Christopher and Wystan none the less managed to achieve their goal of finishing a draft of their third dramatic collaboration: *On the Frontier*. It is by far the weakest of their plays, with too many unconvincing, two-dimensional characters, and surprisingly little good verse. The theme

119

was meant to be the senselessness of war and the awfulness of kowtowing to nationalist leaders. Back in London, they showed the draft to Stephen Spender and several other friends, who made some helpful criticisms. Maynard Keynes expressed interest in funding a Group Theatre production of the play, providing there was a week's run in Cambridge prior to its opening in London. But these plans had to be postponed when Christopher and Wystan said they had to go off to China.

Earlier in 1937, they had accepted a commission from Auden's American publisher, Random House, to do a joint travel book on the Far East. China seemed the obvious choice, given the drama of the Japanese invasion; that way, Auden said, while everyone else was writing about Spain, they would have a war of their very own. They almost got diverted to Spain after all though, as another invitation to go there came through; Wystan accepted, and Christopher half-heartedly agreed to go along. But when the date for the Spanish visit was postponed, they thought they had better not put off the China trip any longer. In a frenzy of literary activity immediately before departure, Christopher finalised *Lions and Shadows* and wrote three sections of *Goodbye to Berlin*. As he told Stephen Spender, he might be killed in China and wanted to leave everything tidy.

Rupert Doone gave a farewell party for the two travellers on 18 January 1938, at Julian Trevelyan's studio in Chiswick. Morgan Forster, Brian Howard, Rose Macaulay and Benjamin Britten were among the guests and a great deal of drink was consumed. Somehow, they managed to get themselves the following day to the boat-train at Victoria station, where they posed for the assembled press cameras. Wystan was by now used to being one of the gossip columnists' darlings, and affected a nonchalant air. Christopher, by no means so well known to the public, grinned.

They travelled via Paris to Marseilles, where they boarded the French liner *Aramis*, whose final destination was the Japanese port of Kobe. During the voyage out, they wrote a joint diary, part of which was destined to appear in *Harper's Bazaar*. Needless to say, much was recorded in the diary which never appeared in print. Christopher was still addicted to jotting down overheard conversations, and their fellow passengers provided a rich source of curious anecdotes, being a mixture of colonial officials and plantation owners returning to Ceylon or South East Asia from home leave, plus a few idle tourists. As ever, Christopher had an ear for the absurd, the pompous and the scatological. They also continued work on revisions to *On the Frontier*, in the hope of getting it into presentable shape by their return.

The ship made stops in Egypt, Djibouti, Ceylon and Vietnam. Francis Turville-Petre met them on the quay at Port Said, and drove them for a quick

sight-seeing tour of Cairo, 'that immense and sinister Woolworth's, where everything is for sale', as Christopher described it in a piece reprinted in *Exhumations*. It was the last time they would see Francis, as he died in Egypt four years later. They picked up some dirty postcards from the local vendors in Port Said, but later had second thoughts about passing through Hong Kong's customs with obscene material in their luggage and lobbed them out of the porthole in mid-ocean. Unfortunately, the wind was blowing the wrong way and they were dismayed to see one of the postcards wafting down onto the deck below, where it was nabbed by a grateful sailor.

They arrived on February 16 in Hong Kong, where the harbour was disappointingly shrouded in chilly, drizzling fog. They stayed with the Vice-Chancellor of Hong Kong University and were fêted by the local expatriate dignitaries, including the Governor. As ever vulnerable to strange new food, Christopher went down with the local stomach-bug known as 'Hong Kong dog', while the more sturdy Wystan went into what Christopher described in a letter to John Lehmann as a 'Proust fit', relishing the lavish hospitality and outmoded gentility. The letter went on to say:

If I am killed in China, I'd like my name on the ['New Writing'] notepaper just the same, with a cute little black cross against it! Our plans are taking shape. Next Saturday, we cross for one night to Macao, the Portuguese colony which provides stolid Hong Kong with its nightlife; there are even special late boats, leaving there at three in the morning! On Sunday afternoon, we return here, pack and leave early on Monday for Canton by river-boat. There are no Jap troops around Canton, but the Jap planes bomb the railway every afternoon, and drop bombs all round the city. On the whole, people say, they've behaved well, in so far as they've stuck to military objectives and avoided actually slaughtering civilians. The chief danger is that they're very bad shots.

The letter is adequate testimony to the breathtaking ignorance with which Christopher and Wystan were about to enter the war zone. Preoccupied with their writing and events in Spain, neither of them seems to have done any serious reading about China before going there, despite the fact that the 1930s had seen a plethora of new books on Chinese history and civilisation, thanks partly to gifted enthusiasts like Arthur Waley. The two friends do not even seem to have taken appropriate reading material with them, preferring Trollope's *Framley Parsonage* and Scott's *Guy Mannering* instead. Few Chinese would have agreed with Christopher's statement that the 'Japs' had

behaved well. This was a bloody, brutal war – a flagrant example of colonial expansionism without any concern for the welfare of the Chinese civilian population. But Christopher was relying entirely on the comments and judgments of the expatriate population of Hong Kong, many of whom admired Japanese 'discipline'.

Besides, it was never Wystan and Christopher's intention to write an exposé of the Sino-Japanese War. From the start, they homed in on everything that was comic and absurd, so that at times the resultant travel book, *Journey to a War*, reads like a riotous school outing. Even though the two of them did indeed find much to laugh about, however, as their journey progressed they became increasingly aware of the horrible realities of war.

Their initiation was gradual. At the end of the month, they travelled without incident by river-boat to Canton, giggling at the sight of a British naval officer in white ducks who was practising golf-shots on the deck of a Royal Navy cruiser. Excitedly they spotted a Japanese gunboat. Approaching Canton itself, they could distinguish the various European 'factories', the trading houses which had the appropriate nation's flag or emblem painted clearly on the roof to show the Japanese bombers they were neutral territory. They were met at the dock by a car from the British Consulate-General and stayed in a missionary compound. Christopher blanched over tea and sultana cake while his hosts chatted politely as if oblivious to the air-raid that had just started.

The following morning, assuming their new role as war correspondents, Christopher and Wystan trotted off with their notebooks and pencils for the first of a long series of interviews with authoritative Chinese and expatriates, many of whom were extremely distinguished and knowledgeable, but whose names meant nothing to the two young visitors. As the chauffeured limousine, with the Union Jack fluttering from its bonnet, drove them to their first appointment, with the Mayor of Canton, it dawned on them that they had not the remotest idea what they should ask him. The resultant write-up in *Journey to a War* gives the impression that they covered up their embarrassment and ignorance by producing a patronising report, which smacks all too openly of the dismissive British attitude to foreigners prevalent at the time. Their version of the Mayor's comments reads:

We not wan' to fight Japan. Japan wan' to fight *us*! Japan velly foolish. First she wan' to be number *tree* power. Then number *two*. Then number *one*. Japan industrial country, you see. Suppose we go Japan, dlop bomb – woo-er, boom! Velly bad for Japanese, I think? Japanese come to China. China aglicultural country. Japanese dlop bomb – woo-er, boom! Only break up earth, make easier for Chinese plough land! Much people

122

is killed of course. Velly cruel. But we have lots more, yes? Ha, ha, ha, ha! (p 35)

The next day, they met the Governor of Guangdong Province and other leading political figures, but they were impatient to get up country, nearer the military action. They kitted themselves out for the journey ahead, buying collapsible camp-beds and mosquito nets. They had visiting-cards printed with their names rendered phonetically into Chinese characters, as Au Dong and Yi Xiaowu. Christopher togged himself out as a debonair war-reporter, with a polo-neck sweater, a Spanish beret and riding-boots. But Wystan rather spoiled the effect by donning a scruffy old overcoat, a woollen balaclava and soft bedroom slippers, which he said he needed because of his corns.

The journey by train to Hanzhou was long and potentially dangerous, but their main problem seems to have been keeping boredom at bay. Thanks to the influence of the Governor of Guangdong, they had been given the best possible accommodation: a two-berth cabin in the first-class coach. But the passing countryside and the people on board were not enough to entertain them for the two days and three nights of the journey. They wiled away the time reading aloud from their Victorian novels and screeching themselves into hysterics by singing opera arias in falsetto, to the consternation of other people on the train. As in their preparatory schooldays, they got embroiled in violent religious arguments. When Christopher teased Wystan for seemingly beginning to move back towards the Anglican Church, Wystan exclaimed prophetically: 'One of these days, my dear, you're going to have *such* a conversion!'

The Chinese Nationalist government, under Chiang Kai-shek, was then based in Hanzhou, which had become a centre of furious diplomatic and military activity. At the time, the Kuomintang and the Chinese Communist Party were just about on speaking terms, in the hope of forming a common front against Japanese aggression. Chou En-lai was in town, as well as a herd of pressmen, ambassadors, missionaries and spies of numerous nationalities. Christopher and Wystan camped down in a big, empty room in the British Consul's residence.

They visited the left-wing American churchman Bishop Roots, whose house in Hanzhou had been nicknamed the Moscow-Heaven Axis ever since the journalist and longtime pro-Communist Agnes Smedley had moved in. The Dutch documentary film-maker Joris Ivens was able to give them considerable information about Mao Tse-tung and the Eighth Route Army. But when one of Agnes Smedley's friends said it should be possible to go to see these Communist troops, Christopher turned the offer down on the grounds that too many Western journalists had already been.

In Hanzhou, they learned from the aide-de-camp of one of Chiang Kai-shek's military advisors, Baron Alexander von Falkenhausen, that German forces had moved into Austria. While they were reeling from the enormity of this news of the *Anschluss*, the young man showed them into General von Falkenhausen's presence, and they quickly had to compose themselves to ask intelligent questions about the military situation in China. Von Falkenhausen was recalled to Germany two months later, where he was approached unsuccessfully by Adam von Trott zu Solz to see if he would join one of the early assassination conspiracies against Hitler.

Wystan and Christopher were invited to tea by Mme Chiang Kai-shek (Mayling Soong), who quickly conquered Christopher with her exquisite, almost terrifying charm. She dazzled her visitors with her ability to switch roles in mid-conversation, at one moment the highly cultivated, US-educated woman with a broad knowledge of Western and Oriental literature and art, and, the next, a technical expert discussing aeroplane engines and machine guns. Christopher had heard that she could be ruthless and cold-blooded, but witnessed only her graciousness. She looked tired and rather ill, yet gave them a vigorous lecture on her New Life Movement, which she hoped would restore dignity and prosperity to an ailing China. On their way out, Christopher and Wystan ran into the Generalissimo himself, and persuaded him to pose for a photograph with his wife, for which he stiffened visibly, like a schoolboy on parade.

Next the two friends headed for Suzhou, moving nearer the front line. Indeed, the front line was moving nearer them. Refugees were on the move and they found missionaries bricking up the walls of their compound in preparation for the expected Japanese occupation. Wystan gazed in dismay at the depressing, muddy terrain and christened it 'The Bad Earth'.

They acquired the necessary passes to go up to the front, and on March 27 set off for battle in a rickshaw, later transferring to horses. In fact they saw no heavy action, just the odd exploding shell and a few Japanese planes flying overhead. A Chinese guide pointed out a position, saying: 'Over there are the lines to which we shall retreat', to which Wystan retorted imperiously: 'But you *mustn't* retreat!' Christopher noted with admiration that Wystan seemed totally without fear, though this seemed to be based on the illogical grounds that nothing could possibly happen to *him*. In contrast, at times Christopher felt scared.

In mid-April, they returned to Hanzhou, to find the capital transformed by the spring. Japanese air-raids had become more frequent, but the socialising continued unbated. They got on well with the British Ambassador, Sir Archibald Clark-Kerr, who was an artistic and amusing host, and a fan of

Sally Bowles. He introduced them to the journalist and traveller-extraordinary Peter Fleming, who was then in China as a correspondent for *The Times*. Christopher thought him a subtly comic figure, with his sleek good looks and *pukka sahib* air. But Christopher was aware that Fleming was a professional in a game in which Wystan and he were rank amateurs.

Fleming accompanied the two of them in May on the first leg of their journey to Shanghai. The route was complicated by the need to avoid Japanese-occupied territory. They marvelled at Fleming's ability to say and do exactly the right thing, thus ensuring maximum co-operation from the Chinese. To keep up their spirits, they recited passages from an imaginary book called *With Fleming to the Front*.

In the summer of 1938, the Japanese still respected the neutrality of the Foreign Settlements in Shanghai, where many of the diplomatic corps, traders and missionaries lived. A large number of Chinese had sought sanctuary there when the city itself was occupied by the Japanese. The Foreign Settlements offered everything the traveller could wish for, from Chinese opera to the latest American movies. Prostitution was rife and Shanghai was renowned throughout the Far East for its pretty rent-boys. Christopher and Wystan were staying with the British Ambassador, Sir Archibald, who had come up from Hanzhou to Shanghai, and they spent a lot of time photographing and documenting the abysmal poverty and working conditions of the local Chinese. But they none the less found the time to slip away on several occasions to bathhouses where they could enjoy the intimate massages given by willowy youths.

Now their stay in China was coming to an end, they had to make a decision about where to go next. They had deliberately not made specific plans. They decided to return to Europe via America, thus making a complete tour of the world since leaving England. However, they got a nasty shock when the American consulate in Shanghai refused their application for US entry visas. Fortunately, they were able to get Sir Archibald Clerk-Kerr to intervene on their behalf; had he not done so, the whole direction to Christopher's life might have been changed.

Christopher and Wystan crossed the Pacific on the *Empress of Asia*, which called at three Japanese ports en route. They were rather intimidated by this prospect, as both of them were by now sworn enemies of Imperial Japan. However, they decided to seize the opportunity of an overnight stay in Tokyo, where they ran into a delirious mob that was seeing a detachment of soldiers off to China. This so shook Wystan that he dropped and broke his only pair of glasses.

The Pacific crossing to Vancouver was uneventful, and they made no

significant stops on the train journey across North America, as they were keen to get to New York. There they were met at Penn Central Station by the writer and magazine editor George Davis, whom they had previously encountered in London. They were delighted when he immediately handed them wads of dollar bills: the earnings from the travel article they had sent to *Harper's Bazaar*.

New York was an exhilarating place for two young English writers now considered to be on the way up. They were interviewed and photographed and invited to parties, and George Davis gave them a whirlwind tour of the city in nine days. He showed them Manhattan, and Coney Island on the Fourth of July. The pair revelled in their popularity and the excitement of the city. But the thing which clinched Christopher's instant love-affair with America was George Davis's brilliance as a pimp. He offered to find both Wystan and Christopher a boy of their own specification. Christopher ordered an eighteen-year-old blond, with long, sexy legs. To his amazement, Davis produced exactly what he wanted.

As the youth's later life was far removed from that of a call-boy, I shall respect the use of his pseudonym 'Vernon'. Christopher was immediately attracted to him, not only because he was physically so appealing, but also because he seemed to embody the youth and vitality of America which Christopher was so keen to embrace. The myth of the German Blond had been replaced with the Myth of the American Blond, and Christopher spent most of his remaining brief visit to New York in Vernon's company.

On the voyage home across the Atlantic, though, Christopher's euphoria helped plunge Wystan into a bout of self-pitying depression. He cried, and moaned that Christopher always had the more exciting sexual adventures; he never had such luck. The strain of six months' travelling in each other's company was obviously beginning to tell. They had had their tiffs in China, with Wystan complaining that Christopher was a despot and too sulky, while Christopher had become irritated with Wystan's dogmatism. But the trans-atlantic voyage was a serious low in their relationship. Christopher even refused to have Wystan to stay for the night at Pembroke Gardens, when they reached London on July 17. Later he suspected this was mainly because he did not want to share the rapturous welcome he knew he would get from Kathleen, Richard and Nanny. That very same evening, though, Christopher went out to the theatre, to see his honorary sister Beatrix Lehmann perform.

While he had been away, *Lions and Shadows* had been published, to mixed reviews. Several critics noted that the book was hardly a flattering self-portrait; in fact, the narrator repeatedly exposes himself to ridicule. Evelyn Waugh, writing in *The Spectator*, thought that the fact that Isherwood seemed

to relish this exposure so much might mean that his transformation was not complete. Because the book is presented as autobiography, rather than as a memoir, Isherwood is centre-stage virtually the whole time. However, the reader must constantly wonder how much of the book is strictly true, especially considering that all but a few minor characters are given false names.

Christopher now began a period of constant movement and considerable promiscuity. He went to the Isle of Wight to see John Lehmann, who was able to brief him on what was happening in Germany, as he had recently revisited Berlin. John had even managed to see Heinz there, finding that the young man seemed to be coping fairly well with the situation, having resigned himself to what was happening. This news of Heinz was both reassuring and troubling, not least because Christopher's mind also kept returning to Vernon over the other side of the Atlantic. Meanwhile, London offered numerous temptations to a quite handsome young author just beginning to taste success. He began an affair with Stephen Spender's old boyfriend, Tony Hyndman, and took him on a holiday to Ostend. Then he joined Morgan Forster, Joe Ackerley, William Plomer and T. C. Worsley in Dover. Though these friends were quite interested to hear about Christopher's experiences in China, the storm-clouds gathering in Europe preoccupied their minds. War seemed inevitable. Christopher started a journal of the crisis, extracts of which he later used in *Down There on a Visit*.

The journal reflects Christopher's troubled spirit. His political position had never been as firm as that of friends like Edward Upward, Jean Ross or Olive Mangeot. But his intimate connections with Germany and his recent experience of war made his stance towards the growing crisis equivocal. None the less, under John Lehmann's steadying influence, he wrote to the Foreign Office, offering his services in propaganda work in the event of war. He reckoned that John and he could always share a flat together in London if the worst came to the worst. Then suddenly came a reprieve, in the form of Chamberlain's Munich agreement. Christopher was elated, and yet at the back of his mind he wondered whether in fact things had only been put off, not solved.

Wystan, just back from a holiday in Belgium, was much clearer about his own intentions. He too had been instantly won over by the United States and wanted to return for a lengthy period. Christopher agreed in principle to accompany him, but insisted that they must finish the China book first. This was a galling prospect, for although the journey was so recent, it all seemed so distant from their current concerns.

Meanwhile, literary life in London continued unabated. Christopher found

himself increasingly invited to fashionable parties and dinners. On one memorable occasion, he was summoned to the house of the great London hostess Lady Sybil Colefax. Virginia Woolf coincided with him on the doorstep, and although it was not the first time the two had met, she noted in her diary that night: 'He is a slip of a wild boy, with quicksilver eyes: nipped; jockeylike. "That young man," said W. Maugham, "holds the future of the English novel in his hands." ' This was not the first time Christopher had met Somerset Maugham either, but he would have been astonished to know how much this rather cantankerous and hugely popular novelist approved of him. In fact, he was quite sure Maugham must consider him a very wet fish as, slightly tipsy, Christopher had tried to tell a funny story at the Colefax party, which had fallen flat, causing him to flee the house in embarrassment.

Maynard Keynes meanwhile had gone ahead and sponsored *On the Frontier*, in which his wife, the Russian ballet-dancer Lydia Lopokova, played the female lead. It opened at the Arts Theatre in Cambridge on November 14, with the usual Group Theatre crowd: Rupert Doone directing, Robert Medley doing the sets and Benjamin Britten the music. The play was received kindly by the audience, but Christopher himself was aware that it really was not very good.

By this stage, Christopher had taken up with a new boyfriend, a 21-year-old working-class lad from Gateshead called Jack Hewit. 'Jackie', as he tended to be called, had fallen on both feet in London's gay sub-culture when he arrived in the city at the age of seventeen. He was a regular at the Sunday afternoon teas on the first floor of the Lyon's Corner House in Coventry Street, where homosexuals table-hopped until they found someone they fancied, and he frequented the theatres and cinemas where other contacts were made. Then, in 1937, he was picked up in a pub by a Hungarian diplomat, who invited him to accompany him to a gay party. At the party were Brian Howard and Rolf Katz, Anthony Blunt and Guy Burgess, who was then working for the Foreign Office. Burgess took Jackie home that night and they began a stormy affair. It was when Jackie was in Burgess's company at a cinema in Leicester Square that Christopher first met him. When Jackie found he could not cope with Burgess's drinking and compulsive promiscuity, he sought consolation with Anthony Blunt. But then Christopher ran into Jackie again towards the end of 1938, and invited him to go with him to Brussels for a short holiday. He was only too ready to accept.

Wystan came along as well, though he stayed in different lodgings from Christopher and Jackie's in the Square Marie-Louise. Jackie did the cooking

and the housework while Christopher corrected the proofs of *Goodbye to Berlin*. He functioned just like an office-worker, at his desk from nine to five, with a short break for lunch. Over fifty years later (in an interview with Duncan Fallowell in the *Sunday Times* magazine), Jack Hewit recalled that Christopher was sexually active in bed, but not adventurous. He did not like touching, and Hewit found he wasn't affectionate either. This may have been partly because being in Brussels had made Christopher once again aware of what kept him from Heinz. Another dampener was the realisation that he had caught the clap, for which treatment in those days was a painful business.

Wystan met a charming Belgian boy, which cheered him up considerably, and when he joined Christopher and Jackie for New Year's Eve, he produced a scurrilous poem to welcome in 1939. Each stanza was addressed to a particular friend, and the one dedicated to Christopher read:

Dear Christopher, always a sort of
 Conscience to which I'd confess
In the years before Hitler was thought of,
 Or the guinea-pig had a success;
Now reviewers are singing your praises,
 And lovers are scratching your back
But, O how unhappy your face is
 So I wish you the peace that you lack.

Christopher seized on Wystan's new mellowness to get him to make a quick trip on his behalf to Berlin to check on Heinz. They returned to England on January 9. By now Christopher had succumbed to Wystan's enthusiasm to get back to New York, and they had booked a passage for January 19 on a French ship, the *Champlain*. Jackie went in the taxi to Victoria Station to see them off, and pushed a champagne cork that he had kept from the New Year's Eve party in Brussels into Christopher's hand. A whole group had gathered to see Christopher and Wystan off, including Benjamin Britten and his comparatively recent lover Peter Pears, who invited Jackie home to try to console him afterwards – rather too warmly for Benjy's taste. John Lehmann, meanwhile, was scandalised that Christopher was going off to New York – where he knew Vernon was waiting for him – without making the situation plain to Jackie. But when I asked Hewit about this half a century later, he said he knew Christopher would not come back.

9

1939–1941

In the February 1940 issue of the magazine *Horizon*, Cyril Connolly described Auden and Isherwood's departure for America a year previously as 'the most important literary event since the outbreak of the Spanish Civil War'. Few people would consider it that significant today, except in terms of the effect it had on the two writers' personal careers. But, because of the enormous bitterness that their absence caused in some circles once war broke out, it is worthwhile analysing why they went. In Auden's case, there was a deep disenchantment with British literary life and a craving for a new beginning, which he believed he could find in New York. But Christopher's case was not so straightforward. In fact, it took him several months to work out exactly why he had gone. It was not just to escape Kathleen, with whom he was now anyway on better terms. Nor was the desire to be a wanderer really the answer. The truth was that he did not feel that he wished to be part of a Europe heading for war. But the reasons that slowly emerged were nothing as simple as cowardice.

As the *Champlain* entered New York harbour on the coldest day so far that winter, the news came through that Barcelona had fallen to Franco's forces, thereby effectively putting an end to the Republican dream. But Klaus and Erika Mann were on the quarantine launch to welcome the new arrivals and had no intention of letting the news from Europe spoil the day. Wystan and Christopher installed themselves in the George Washington Hotel at Lexington Avenue and 23rd Street, and Christopher took up where he had left off with Vernon.

Despite the boy's presence, Christopher felt a growing malaise. Daily, Wystan seemed to be more at home, especially after they moved into an apartment at 237 East 81st Street. But Christopher was not. It was not so much that New York had changed since the previous July, though he certainly

did not like its winter guise. Rather, he had changed, though he could not immediately work out how.

In the meantime, there was plenty to keep both friends busy. Though no longer the flavour of the month, as they had been during those nine glorious days the previous summer, they were still invited to many parties and introduced to new friends. The Manns gave them an entrée into the large German expatriate community and, through an introduction from Stephen Spender, they met the founder of the New York City Ballet, Lincoln Kirstein. Kirstein became a valued friend for several years until an incident, which both sides subsequently refused to talk about, forced an unbridgeable rift between him and Christopher. There were endless meetings to go to, at which Wystan and Christopher were asked to speak: on China, on Spain, or just on literature. That, Christopher began to realise, was part of the problem. As he sensed the ground swell of righteous indignation against the Fascist powers among his colleagues on such occasions, he felt alienated from it. He was getting less political, not more, and needed something much more personal and internal to give him a new sense of direction.

One of Christopher's first literary engagements was an invitation to a PEN Club dinner, to which he went unaware that he was expected to speak. Moreover, he was called on first. Off the cuff, he talked about cross-cultural misunderstandings, based on an old *Reader's Digest* joke about a foreigner who arrives in New York for the first time and sees a woman fall out of a high office-block window into a dustbin. 'America must be very wasteful', the foreigner exclaims. 'That woman was good for another ten years at least!' Christopher sat down, feeling rather pleased with himself, then noted that a senior member of the American literary establishment was glaring at him. 'Charming', the other writer said, icily. Only later did Christopher discover that the PEN Club dinner was a deadly serious anti-Fascist affair, a fact which seems to have been communicated to all the speakers but him.

It was at one of the public readings that he and Wystan gave that Wystan inadvertently found one thing he had been looking for: someone to love. As the poet Harold Norse recounted in his *Memoirs of a Bastard Angel*, at the end of March he heard that Auden and Isherwood, along with Louis MacNeice and Frederic Prokosch, were going to read from their work at the Keynote Club on West 52nd Street on April 6. Norse asked his eighteen-year-old Jewish friend Chester Kallman if he wanted to go, and the two boys hatched a plot to sit on the front row and wink at Auden and Isherwood, to see how they would react. Their first impression of Wystan was one of shock at his slovenly appearance, with his unironed shirt, socks tumbling down round his ankles and untied shoe laces falling over his shoes. 'Miss *Mess*,'

hissed Kallman, who thought that Christopher, in comparison, looked spruce and cute. As Christopher quickly noticed, the boys began flashing him winning smiles. Norse recalls:

> Auden's brisk Oxford-Yorkshire monotone was difficult to understand. With his sloppy clothes and awkward movements (not to mention his swift birdlike nods of the head) he was the star, the gauche comedian, the mad genius. He stole the show. Overcome by the situation, we stifled giggles and continued to flirt outrageously with Isherwood, winking and grinning, and he grinned back. (pp 62–63)

After the readings, the boys rushed backstage, where Christopher and Wystan were being besieged by young admirers. Christopher handed Harold Norse his visiting-card and asked him to get in touch. Later, Chester Kallman borrowed the card from him and went to see Wystan alone. When Wystan opened the door of their apartment, he exclaimed in disappointment: 'It's the wrong blond!' Apparently he had been hoping to see a young college-jock who had also come backstage on the night of the reading. But he invited Chester in and started to show some interest when the boy referred to the sixteenth-century metaphysical poet Thomas Rogers. On a second visit, Chester showed Wystan his body and Wystan fell head over heels in love.

Chester Kallman stayed with Wystan on and off for the rest of his life, though in later years they spent long periods apart. Christopher and Chester never really got on, and Wystan used sometimes to claim outrageously that this was because of Christopher's unconscious anti-Semitism. What is more likely is that Chester was jealous of the relationship Christopher had had with Wystan and saw him as some kind of threat. Wystan was unfailingly generous to Chester, whose character could be bitchy and selfish, especially in his middle age.

Chester's arrival on the scene coincided with Christopher's realisation that it would probably be a good idea for him to see less of Wystan, as he felt he was beginning to operate in Wystan's shadow. He recognised that Wystan was by far the greater intellect and artist and, of all the members of the Mutual Admiration Society, was the one with a real claim to genius. So, once they had reworked the ending of *The Ascent of F6* together in New York, Christopher felt it was best that they went their separate ways. They did honour one short commission, from *Vogue* magazine, to do a piece on ten young British authors who were on the way up. They chose George Orwell, Ralph Bates, Arthur Calder-Marshall, Graham Greene, Stephen

Spender, Rex Warner, Edward Upward, Henry Green, William Plomer and James Stern. Cecil Day Lewis and Louis MacNeice did not qualify because they had not written significant amounts of prose. However, Christopher and Wystan failed to write the joint travel book on America which John Lehmann had commissioned, under the provisional title *Address Not Known*.

On May 2, Christopher wrote to John, describing his inner torment, and his dissatisfaction with New York:

> Oh God, what a city! The nervous breakdown expressed in terms of architecture. The skyscrapers are all Father fixations. The police cars are fitted with air-raid sirens, specially designed to promote paranoia. The elevated railway is the circular madness. . . .
> I myself am in the most Goddamawful mess. I have discovered, what I didn't realise before, or what I wasn't till now, that I am a pacifist. And now I have to find out what that means, and what duties it implies. That's one reason why I am going to Hollywood, to talk to Gerald Heard and [Aldous] Huxley. Maybe I'll flatly disagree with them, but I have to hear their case, stated as expertly as possible. And I have to get ready to cope with the war situation, if or when it comes.

Christopher's recognition of his pacifism was no overnight affair. He had had long talks about it with a new friend, the American playwright John van Druten, and the two of them had drawn up a list of questions about the role of the pacifist in wartime, which they had then sent off to three prominent pacifists of the day living in England: Runham Brown, George Lansbury and Rudolph Messel. All three took the trouble to reply. Brown wrote that a pacifist should nevertheless try to be a useful member of society, while Lansbury stressed the nobility of passive resistance. Messel was the most militant of the three, urging pacifists to sabotage the war machine.

At this stage Christopher's pacifism was not based on any religious convictions. Instead, his thinking about the likelihood of war with Germany had confronted him with the possibility of pointing a gun at, or dropping a bomb on, Heinz. This he felt he could never do. But if he could not drop a bomb on Heinz, he reasoned, then he could not drop a bomb at all. Was not every German somebody's Heinz? Understanding this made Christopher reappraise his entire moral and political standpoint, as he explained in his 1963 pamphlet *An Approach to Vedanta*:

> . . . as I now began to realise, my whole political position, left-wing anti-fascist, had been based on the acceptance of armed force. All the

slogans I had been repeating and living by were essentially militaristic. Very well: throw them out. But what remained? I told myself that I should have to put my emotions back from a political on to a personal basis. I would be an individual again, with my own values, my own kind of integrity. This sounded challenging and exciting. But it raised a disconcerting question: what were the values to be?

Christopher hoped that Huxley and Heard would have the answer. Joking with friends about his journey to see these wise men, Christopher reminded them that a fortune-teller had mentioned to him that the letter 'H' would be important for his future. This was unlikely to be Heinz anymore, though it could be Vernon, whose real name began with 'H'. Or maybe it could be Huxley and Heard . . .

Gerald Heard, Christopher Wood, and Aldous Huxley and his Belgian wife Maria had all settled in the Los Angeles area of California in 1937. Rumours had filtered back to Christopher and his friends in London that Heard was studying yoga, and they had laughed at the thought of him dressed in a turban and levitating over the desert. However, even if Christopher was not then ready to admit the possibility of taking up such practices himself, he was convinced of Heard's intellectual integrity. He had corresponded with Heard, who whetted his appetite by writing that every pacifist should acquire medical knowledge, so that a team of psychologically sound, well-equipped healers could be formed. The idea of becoming a healer appealed to Christopher and he was hungry for more details. Accordingly, on May 6, Vernon and he set off by Greyhound bus on a three-week Odyssey to southern California that took them through Washington, New Orleans, El Paso, Houston, Albuquerque and the Grand Canyon.

They were fairly broke by the time they arrived in Los Angeles, so Christopher Wood lent Christopher two thousand dollars until he found work in the Hollywood film studios, as they all assumed he would. After all, his literary reputation was growing, especially with the appearance that year of *Goodbye to Berlin*. Although some critics in London found the narrator figure in the book too cold and detached, the general reception was good.

Chris Wood seem unchanged, but Gerald Heard had been transformed by his California existence. He had acquired a beard and abandoned his elegant suits for ragged, loose jackets and jeans. He had begun an intensive programme of spiritual self-preparation, which involved sitting for three two-hour periods of meditation every day. When Christopher quizzed him about his religious beliefs, Gerald spoke not of God but of 'This Thing'. His favourite pacifist gospel was the Taoist classic *Tao Te Ching* and, like its

author Lao Tze, Gerald had become enigmatic to the uninitiated. What Christopher did grasp, though, was Heard's concept of 'intentional living', in which each individual could become involved at a deeper level with every moment of his or her life. As Isherwood recalled in *My Guru and His Disciple*, this opened up the appealing prospect of heightening the significance of even the most ordinary day, and of abolishing boredom by turning one's life into an art form.

Aldous Huxley, whom Christopher met in July, was a far more sombre individual. Christopher found him nice but bookish, and inclined to be pontifical. He never lost his initial impression that Huxley and he were very different kinds of people, but that did not stop them becoming friends. Huxley was essentially a great intellect, while Christopher relied more on intuition. Christopher took very easily to Maria Huxley, small and chirruping at the side of her tall, rather solemn husband. Without being a calculating hostess, Maria created some memorable parties, and Christopher quickly adopted her as his first 'American' honorary sister.

After a brief stay in a grotty downtown hotel, Christopher and Vernon moved into a rented house in the Hollywood Hills, 7136 Sycamore Trail. From there Christopher wrote to John Lehmann about his new life, on July 7, 1939:

Here I am living very quietly, seeing hardly anyone and hoping vaguely that when Berthold [Viertel] arrives [from an assignment on the East Coast] he will get me a movie job. Life with [Vernon] reminds me very much of life with Heinz – except that he is even more serious, hates going out in the evenings, reads Suetonius, Wells and Freud and goes to Art School. If I were happier inside myself, I would be very happy. But I never cease worrying about Europe. My 'change of heart' about War, and the use of force generally, has only strengthened and been confirmed. I am sure this is how I will feel for the rest of my life. I'm afraid this will mean that I shall lose a lot of friends but, I hope, none of the real ones. I am often very homesick for London, and the Hogarth Press Office, Stephen's jokes about his psychoanalysis, walks with Morgan [Forster] near Abinger Hammer. Peggy's [Beatrix Lehmann's] imitations, rows with my Mother. When I think of my friends, I remember them all laughing. The Past appears entirely in terms of jokes. The driving-forces, which separate people, are so dull, really. Oh dear, why do we have bodies? By the time they've been satisfied, there is only half an hour a day left over for Talk. And talk is all that finally matters.

Christopher's growing feeling of self-disgust was not only a revolt against the demands of the flesh, or disenchantment caused by the divisive nature of politics. He had also turned against what he saw as his overpowering ego. He had become fertile ground in which to sow the seeds of Eastern religion.

Those seeds were planted by Gerald Heard, and soon afterwards Aldous Huxley, passing on what they had learnt of Vedanta. Vedanta is the philosophy preached in the most ancient of Hindu scriptures, the Vedas, and teaches human beings to recognise their true divine nature. The aim of a person's life is gradually to manifest that divinity, which resides within him or her, though it may perhaps be hidden. It is thus totally opposed to the dualism of some Christian sects. Vedantists believe that Truth is universal, so they are tolerant of other religions, saying that all beliefs can be valid routes to the knowledge of God, if engaged in sincerely with a pure heart.

In India, there was a renaissance of Vedanta in the nineteenth century, thanks to the life and teachings of the mystic Ramakrishna (1836–1886). Immediately after his death, several of Ramakrishna's disciples formed a group, led by two men, Vivekananda and Brahmananda, in order to carry on Sri Ramakrishna's work. In 1897, this group became an Order, which set up its headquarters at Belur Math near Calcutta.

Swami Vivekananda visited the United States in 1893, as an official delegate to the World Fair's parliament of religions in Chicago. His lectures, as he toured several cities, made a great impression on American audiences. Six years later, he returned to America and supervised the opening of several Vedanta centres, arranging for swamis from the Ramakrishna Order to come over from India to direct them. During this second tour of the United States Vivekananda became acquainted with three sisters in Pasadena, California. One of these was a widow, Carrie Mead Wyckoff, later known as Sister Lalita, who kept in touch with members of the Ramakrishna Order after Vivekananda went back to India, where he died in 1902.

In 1928, Sister Lalita met Swami Prabhavananda, who was then assistant head of the Vedanta Centre in San Francisco. The following year she invited him to Los Angeles, and put her own house in Ivar Avenue, Hollywood, as well as her income, at his disposal. Thus, the Vedanta Society of Southern California was formed. At first, it was very modest, but, around 1936, the congregation of devotees grew considerably. Enough money was raised to build a small onion-domed temple in the garden, which was dedicated in the summer of 1938. Both Aldous Huxley and Gerald Heard were intimately involved in the group, largely because they were attracted by the personal example of Swami Prabhavananda. Gerald Heard spoke often of the Swami

to Christopher during his first few weeks in California, but said Christopher needed to prepare himself before being taken to meet him.

Heard told Christopher that every individual has two selves: the apparent, outer self, and the invisible, inner self. Everyone is familiar with the outer self, but the inner self is secret, unchanging and immortal. It has no individuality, and because it is infinite by nature, it has access to the infinite, just as sea-water has access to the sea because it *is* the sea. One's personal quest, therefore, should be to gain an understanding of the inner self, to which end meditation is the normal means. Heard recommended that Christopher start meditating gradually, having little sits of ten or fifteen minutes at a time, letting his mind fall into calm, then reminding himself of what he was searching for and why. Christopher often thought Heard's way of talking about 'this thing' was very funny, but this was quite in keeping with the practice of the Ramakrishna Order, which believed that laughter was also a means of apprehending Truth.

By the end of July, Christopher felt he understood enough to ask for an interview with Swami Prabhavananda. Later he could recall nothing of this first meeting and wondered if it was because Gerald Heard, who accompanied him, had talked so brilliantly that everyone else present, including the Swami, had dimmed into insignificance. But this was not an unusual first reaction to the guru. Prabhavananda was remarkable as a teacher partly because he steadfastly refused to *appear* remarkable, making no effort whatsoever to make an immediate impact on people. His manner exuded humility, and at all times he insisted that he was directed not so much by his own ideas as by the example of the late Brahmananda, whose disciple he had been. Brahmananda had died back in 1922, yet Prabhavananda managed to convey the impression that his guru still directed the activities of the Vedanta Society.

Prabhavananda invited Christopher to return to the Centre a few days later, on August 4, when he received him alone, thus giving Christopher the opportunity of observing him properly. He thought him small and unobtrusive, impressive in his very mild authority, devoid of grandeur, ostentation or severity. He seemed to represent a higher attainment than the normal run of life, while at the same time displaying one blatant human weakness: chain-smoking. This habit unsettled many of the Swami's visitors, but Christopher, who also smoked heavily at this time, found him easier to accept as a role-model because of it, because he was not trying to present a false face of perfection to the world.

Christopher noted in his diary, when he wrote up his visit to the Swami that day, that he felt ill at ease in the guru's presence, like some rich, overdressed woman, full of her own vanity. Aware that everything he was

saying sounded artificial, Christopher started putting on a little act of false humility. When he told the Swami that he didn't think he would be able to handle all the meditation while continuing to live the sort of life he led, Prabhavananda advised him to be like a lotus on a pond, saying that the lotus leaf is never wet. And when Christopher wondered aloud whether he wouldn't be taking on too much, with all the risk of disappointment later, the Swami countered that there is no such thing as failure in the search for God, because every step in that search is a positive advance.

The Swami seemed to have an answer to everything. When Christopher admitted that he hated the word 'God', he declared that one could just as well use the terms 'The Self' or 'Nature'. But Christopher's discomfort wasn't only over terminology. He explained that he had always looked on yoga as silly superstitious nonsense. The Swami laughed out loud at this, saying: 'And now you have fallen into the trap?'

Prabhavananda recommended that Christopher first open himself up to feel the all-pervading Existence around him. Next, he should consciously emanate goodwill to people close to him, both those visibly near and those far off. He should think of his body as a temple, containing the inner self – the reality of infinite knowledge and infinite peace.

Christopher was worried by apparent contradictions in himself, which he discussed with Prabhavananda at a very early stage. How could the sort of work he was intending to take in the flashy movie-world be compatible with Vedanta practice? More important, how could such a religion be reconciled with an active homosexual life?

The first question was easily answered. One emulates the pure lotus living in the dirty pond. But the second question was more complex. The Swami had no objection to homosexuality *per se*; the object of sexual desire was irrelevant. What was important was the degree to which sexual and other animal desires ruled one's life. The Swami and a number of his devotees practised sexual abstinence, in the belief that sexual activity distracted from the energy and totality of the spiritual quest. It was up to Christopher to see how far he could go down that path.

Over the next few years, Christopher had to evolve his own standards in this matter. He had long discussions with Gerald Heard about the need for self-discipline, abstinence, release from the power of possessions, and the avoidance of pretension, especially at a later stage in one's quest for Truth, when one might begin to feel snug about one's spiritual superiority.

Christopher was proved correct when he predicted to John Lehmann in the letter cited above that his new attitude to life might bring ridicule from some quarters, or even lead to broken friendships. John himself became increas-

ingly concerned at what he felt was Christopher's withdrawal from reality, though he did not let this come between them. Morgan Forster, as the man who stated famously that if he had to chose between betraying his friend or his country, then he hoped he would have the courage to betray his country, had little difficulty in accepting Christopher's pacifism. But, as a humanist, he found Christopher's new religiosity hard to swallow. After Christopher had written to him declaring that in the Swami Prabhavananda's presence one *knew* that God exists, Forster wrote to William Plomer: 'How he does go on about God!', adding sweetly, 'I suppose it wouldn't matter in conversation.'

The most distressing opposition, however, came from Wystan Auden, who himself was increasingly finding solace in the pomp and circumstance of High Anglicanism. Wystan bluntly referred to Vedanta as mumbo-jumbo, and remained mercilessly critical of it. This did nothing to reduce the growing distance between the two of them, which was now far more than a matter of physical separation. For several years, they saw very little of each other and corresponded rarely.

The main objection from others to Vedanta was what they felt was its almost offensive irrelevance to the period. This feeling was succinctly expressed retrospectively by J. B. Priestley in his *Letter to a Returning Serviceman*, towards the end of the Second World War:

> . . . there are some brilliant literary acquaintances of ours who have pleasantly exiled themselves to southern California (the choice is significant), where they announce themselves as a kind of new Yogi men, meditating hard to enlarge or change human consciousness. I for one have no quarrel with them, and am prepared to consider all reports of progress they mail to us from Hollywood, but I believe they are on the wrong track, that the change of consciousness has already happened, and that the evidence for that change is best found in the heat and muck of social conflict from which they have fled.

On September 3, Britain and France declared war on Germany, following Hitler's invasion of Poland. And, a couple of months later, the first volley was fired in what was to turn into an anti-Auden and Isherwood campaign in the British media and Parliament. Christopher had written a chatty, rather indiscreet letter to Gerald Hamilton about some of the German refugees he had met in California. Tom Driberg, as 'William Hickey' of the *Daily Express*, saw this letter and printed parts of it in his column of November 27:

The studios are very eager about producing anything about the war, so I am working on a Chinese story [for Sam Goldwyn] and spend nearly all my time with [Berthold] Viertel (the director of *Little Friend*) and his family. [Aldous] Huxley lives in the same street [in Santa Monica Canyon; where Christopher and Vernon moved in mid-September]. I see him daily. Also Gerald Heard. I have got very absorbed in Yoga, but it is difficult to write about, so I won't. I have no intention of coming back to England. . . .

The refugees here are very militant, and already squabbling over the future German Government. God help Germany if some of them ever get into power. Others are interested, apparently, in reconquering the Romanisches Café, and will gladly sacrifice the entire British Army to make Berlin safe for night-life. So much silly hate. So much I-told-you-soing.

The article could hardly have struck a more unfortunate note at a time when Britons were bracing themselves patriotically for the conflict to come. It stoked the fires of those MPs and pundits who were looking for traitors at home and abroad. It also puzzled and hurt many of Christopher's German friends in California when, inevitably, it filtered back.

Berthold Viertel had indeed returned to California that summer, and it was largely through him and his wife Salka that Christopher met the by now well-established emigré German community. Throughout the 1930s, refugees flooded out of Germany and Austria, before and after the Nazis came to power. A high percentage of these refugees were Jews, though others were political opponents of the Hitler regime. Between 1933 and 1941, nearly 200,000 immigrants arrived in the United States from Germany and Austria. Others went to Mexico and South America, and about 7,000 found themselves stranded in Cuba. Many had had to leave all their possessions behind. It is worth recalling, though, that there was a much smaller but none the less significant movement in the opposite direction, as overseas Germans returned to the Fatherland in the belief that the Third Reich would see the realisation of a magnificent new German era.

Europe's loss was America's gain, in so far as many of those who chose to leave Germany and central Europe were men and women of talent: writers, artists, film-makers, scientists, doctors and other professionals. Hollywood naturally attracted much of the fresh talent, and a colony of emigré *literati* grew up in Christopher's new home neighbourhood of Santa Monica. Salka Viertel became a focal point for these exiles, running what was to all intents and purposes a *salon*. Thomas and Heinrich Mann were among the regulars,

as were Arnold Schoenberg, Otto Klemperer, Bruno Walter and Max Reinhardt. Frequent visitors who dropped by included Greta Garbo and Aldous Huxley.

Salka Viertel was the daughter of an artistic-legal family of Jews from Galicia, which at that time was part of Poland. She had had a sucessful acting career in Vienna and Berlin – including a stint under Max Reinhardt's direction – before going to America with Berthold. Her pianist brother Edward was one of the great interpreters of the music of Schoenberg, Berg and von Webern. In California, Salka Viertel became a close friend of Greta Garbo, and wrote scripts for her, including the original treatment for the 1933 classic *Queen Christina*, directed by Rouben Mamoulian for MGM. She was an active member of the Hollywood anti-Nazi League founded by Prince Hubert von und zu Lowenstein, Otto Katz (alias Breda) and others.

Hollywood took its politics seriously under the influence of a committed nucleus. The Viertels hosted a successful evening for André Malraux, when he went to America to speak about Spain, and fifteen Hollywood stars gave $15,000 each for medical aid when Ernest Hemingway and Joris Ivens toured with the film *Spanish Earth*.

Christopher arrived at Salka Viertel's Mabery Road home with a high recommendation from Berthold, who had written from London: 'Isherwood [is] one of the finest and most original writers. He observes very sharply, behind his mask of boyish charm. He lived in Berlin and speaks German. I find his *Berlin Diary* a stylistic masterpiece, the humour is quite devilish. You will like him.' Salka and Berthold had taken to living separate private lives, though Berthold stayed in Santa Monica on regular visits. Salka, who had acquired American citizenship in 1939, had her three sons Hans, Peter and Tommy with her, and Gottfried Reinhardt formed part of the household. Gottfried was the younger son of Max Reinhardt, whose Salzburg chateau Hermann Göring had expropriated. Gottfried was working for MGM and it was he who gave Christopher his first major US film assignment, in January 1940.

Gottfried Reinhardt was then the producer of a film based on James Hilton's novel *Rage of Heaven*. He thought Christopher would be ideal to work on the script, as he was familiar with the habits and speech-patterns of the sort of wealthy, upper-middle-class London characters in the story. Although Reinhardt had trouble persuading the boys in the front office at MGM, who had never heard of Isherwood, a contract was obtained. Christopher was mainly responsible for dialogue, while the story-line was written by Robert Thoeren. The young Ingrid Bergman was chosen to play the leading female role, co-starring with Robert Montgomery. W. S. van Dyke II directed the film.

When Robert Montgomery read the Thoeren–Isherwood script, he felt he

could contribute little or nothing to the role and was extremely unhappy when MGM refused to release him from his contract. For a while it seemed as though the film would never be made. When shooting began in late 1940, Mongomery thought van Dyke a studio workhorse, in that he pressed ahead with shooting the film without giving enough time for adequate rehearsals. Gottfried Reinhardt, on the other hand, had the impression that Montgomery was not co-operating, and MGM made an unofficial complaint to the Screen Actors' Guild that he was not giving a performance. Reinhardt thought the rushes looked so awful that it seemed as if drastic action might have to be taken, until Christopher suggested adding a prologue to the film in which a doctor explained that the principal character had been in a lunatic asylum and was suffering from a condition whose symptoms corresponded exactly to the way Montgomery was behaving. Montgomery was unaware of the changes brought about as a result of this bizarre arrangement, but he had the last laugh, as his interpretation was well received in many trade and popular papers. However, the film was not a great commercial success.

MGM none the less offered Christopher a one-year contract, though not on the same generous terms as they gave Aldous Huxley, who was paid $1500 a week. Huxley was a welcome support at this time, as both he and Christopher were living a life split between the film studios and Vedanta. Christopher, Aldous Huxley, Gerald Heard and the Swami Prabhavanada developed the habit of meeting for lunch on Thursdays, at the Farmers' Market, where they could eat health foods under the olive trees. Sundays were often spent with the Huxleys' friend Anita Loos, author of *Gentlemen Prefer Blondes*. On one memorable occasion, Anita Loos, Christopher and the Huxleys were joined by Charlie Chaplin and Greta Garbo – both in disguise to avoid being hassled by fans – and the Theosophist guru Krishnamurti. Chaplin brought caviar and champagne, while Garbo had her usual stock of raw carrots. Hardly had they settled down for a picnic in a nice spot than a sheriff arrived and threatened to arrest them for trespassing.

Meanwhile, the Auden–Isherwood controversy had exploded with full force in Britain. *Reynolds News* accused Huxley, Heard and Isherwood of having fled to California to contemplate their navels. But Christopher was more stung when Cyril Connolly wrote in the second issue of the new magazine *Horizon* (which he and Stephen Spender were running, with financial backing from Peter Watson, the heir to an oleomargarine fortune) that Auden and Isherwood were 'far-sighted and ambitious young men with a strong instinct for self-preservation, and an eye on the main chance'. Connolly apparently meant this as a kind of defence, but Christopher took it as a direct attack, which he felt violated the code of friendship. Throughout his life, Isherwood

would get extremely upset when he felt friends had been disloyal to him, and often would cut them off from any further contact. In this case, he wrote a strong letter of protest to Stephen Spender, who came less ambiguously to Wystan and Christopher's defence in the following issue.

By then, though, Harold Nicolson had entered the fray. In *The Spectator* he accused Auden, Isherwood, Huxley and Heard of having escaped to 'the gentler solitudes of the Wisdom of the East . . . when Western civilization is bursting into flame'. The politicians then weighed in. On June 13, Major Sir Jocelyn Lucas, the Conservative MP for Portsmouth South, asked of the Parliamentary Secretary to the Minister of Labour, at Question Time in the House of Commons, whether 'British citizens of military age, such as Mr W. H. Auden and Mr Christopher Isherwood, who have gone to the United States and expressed their determination not to return to this country until the war is over, will be summoned back for registration and calling up in view of the fact they are seeking refuge abroad?' The Government did not follow up this demand, but Sir Jocelyn's intervention prompted an even more vitriolic – and anonymous – attack in *The Spectator* on 'Certain Intellectuals Safe in America'. E. M. Forster responded to that, accusing the attackers of unconscious envy, and asking whether there could not now be a closed season on baiting absent intellectuals. The 'Enemy' had the final word, however. For, despite Evelyn Waugh's appreciation of Isherwood's fiction, he mercilessly caricatured Christopher and Wystan as the poets Parsnip and Pimpernell in his novel *Put out More Flags*.

In early July 1940, Christopher received the news of Uncle Henry's death. This meant that he would inherit the Bradshaw-Isherwood estate. However, he had no wish to get involved with his English past for the time being. Besides, the last thing he needed to help his spiritual enlightenment was a substantial estate. He believed that his mother Kathleen and brother Richard would benefit far more from the property, and so made everything over to his brother – including an income of several thousand pounds a year. He wrote in his diary:

I was fond of [Uncle Henry] and he of me. He always thought of me as being after his money – as indeed I was. But this seemed to him perfectly natural and proper. He had the eighteenth-century conception of the relation between uncle and heir.

I often used to wonder just when this would happen – and I always half knew that when it did, when Marple and all the money became mine, it would be too late. It is too late now – not merely because of the War but because the absurd boyhood dreams of riches is over

144

forever. It is too late to invite my friends to a banquet, to burn the Flemish tapestries and the Elizabethan beds, to turn the house into a brothel. I no longer want to be revenged on the Past.

Christopher does not seem to have realised to what extent Marple Hall had deteriorated structurally after years of neglect in Henry's absence. Richard had spent weekends there from time to time with the caretaker, but it was already largely uninhabitable and would have needed massive maintenance work to be restored. Richard meanwhile was doing his National Service as a farm-worker on a farm attached to Wyberslegh, subsequently being transferred to another, adjoining Marple Hall Park. As legal owner, Richard could now have let Kathleen go back to live in her beloved Wyberslegh, but only after finding alternative accommodation for the elderly lady tenant there. As it happened, a few months later Wyberslegh was hit by some small German incendiary bombs. Later, Kathleen did move in there with Nanny, and Richard joined them.

Christopher was not as detached from events in England as his critics imagined. He found his meditations were being flooded with thoughts of the War, especially after the German air-attacks on London began in earnest in August, and invasion seemed a real possibility. But he concentrated on a phrase from T. S. Eliot, 'to care and not to care', in an effort to achieve an inner peace while at the same time remaining conscious of other people's suffering. At the same time, he looked around for openings for some kind of non-military war work. He found the idea of the (Quaker) Friends' Ambulance Unit particularly appealing, because of the Society of Friends' pacifist stance, but as he had neither completed his medical studies, nor knew anything about the mechanics of motor-vehicles, he was not considered much potential use.

In August, an unexpected acquaintance from England arrived, Denham 'Denny' Fouts, whom Christopher later fictionalised in *Down There on a Visit* as 'the best-kept boy in the world'. They had first met in London in 1938. According to Truman Capote, who wrote at length about Denny Fouts in his racy but unreliable book *Answered Prayers*, the young man grew up in Florida, where he worked as a teenager in his father's bakery. When he was sixteen, he was swept off his feet by a passing cosmetics tycoon, and – on his own admission – began his career as a bisexual whore. He left his original benefactor in Capri, following a trail of aristocratic and wealthy connections of both sexes that took him at their expense to the more glamorous parts of the world. Shortly before the War he met Peter Watson, who insisted that he return to the safety of the United States, in the company of Jean Connolly ('Ruthie' in *Down There on a Visit*). To complete the

triumvirate of characters who appear in the novel, the Connollys' charming acolyte, Tony Bower ('Ronnie') had appeared in Los Angeles earlier in 1940 as well. Since Christopher had last seen him in Europe, Tony had exploited his natural talent as an amusing gossip to become the film correspondent of a New York paper. He was soon drafted into the US army.

To Christopher's astonishment and pleasure, Denny Fouts expressed a sincere interest in Vedanta. He said he had had a blinding flash of enlightenment when under the influence of drugs, and now wished to give up his life of sex, drink and pursuing the rich. This didn't actually turn Denny off alcohol; he would still get blind drunk at parties, but now he talked of religion all the time.

Inwardly, Christopher thought what a wonderful convert to Vedanta this wayward young man would be. So, after taking him to sit quietly in the temple in Ivar Avenue, he decided he should introduce Denny to Swami Prabhavananda. The meeting was a disaster. Denny spoke graphically of the depths of his own depravity. But, far from grasping this opportunity to reform a repentant sinner, the Swami told him that he ought to drive his insincere thoughts of becoming a devotee out of his mind, and go and get a proper job. Denny never forgave him. However, he did move in with Christopher briefly the following year, for a joint exercise in monastic living.

On November 8, 1940 Christopher was initiated by Swami Prabhavananda. After fifteen months of study at the Centre, Christopher felt that asking the Swami to become his guru was the most important decision of his life. The ceremony was held on the birthday of Ramakrishna's Holy Mother, and as Christopher recorded in *An Approach to Vedanta*:

> The initiation took place before breakfast, right after the first of the day's three meditation periods. Before going into the temple, I was provided by one of the women of the family with a small tray on which were arranged the flowers I was to offer: two red roses, a white rose and a large daisy. The Swami was waiting for me inside the shrine; its curtains had been drawn for privacy. First, he told me to offer the flowers: to the photographs of Ramakrishna and Holy Mother, to the icon of Christ, and to himself – because the guru must always receive at least a token of an initiation-gift. Next he taught me my mantra, making me repeat it several times until I was quite sure of it. Next he gave me a rosary and showed me how to use it.

In February 1941, Christopher and Vernon parted. Christopher still loved the young man, but they had begun to exasperate each other. Christopher

hoped Vernon would go back to New York, to make the separation more definitive, but he didn't. Christopher moved into a hotel, while Vernon rented rooms nearby. Christopher then plunged into a routine of long silent periods at the Vedanta Centre, trying to regain some inner calm. In March, he moved into an apartment alone, just around the corner from Gerald Heard and Chris Wood's house.

Christopher continued to work for MGM until his contract expired in May 1941. He collaborated on Victor Saville's *A Woman's Face*, starring Joan Crawford, and *Crossroads*, a remake of a French film about amnesia. One day, at the end of March, one of the trade gossip-columnists dropped by at Christopher's office at the studios and asked if he might use the phone. As Christopher carried on with his work, he heard the journalist shout down the phone: 'No, no, you dope. The name's Woolf – W-O-O-L-F – sure, I'm sure – sure, I've heard of her, you ignorant bastard – she was a great writer – British.' Thus Christopher learnt of Virgina Woolf's suicide by drowning. Klaus Mann asked him to write a memorial piece for a new magazine he had started, called *Destiny*, which duly appeared in May. Christopher recalled the occasions when he had sat at Virginia Woolf's feet, riveted by her talk. So much so, in fact, that on one occasion in London a few years previously he had gone round to the Woolfs for tea and stayed on for supper at Virginia's suggestion. He sat in rapt attention to the stream of literary anecdotes until about ten o'clock, when he suddenly remembered that he ought to have been at a hotel in Croydon with a young man he had recently met, and with whom he was meant to be flying off to Paris for a romantic weekend.

During the spring and summer of 1941, European refugees continued to arrive, swelling Santa Monica's emigré community. Salka Viertel's mother, Augusta Steuermann, turned up, sprightly but emaciated after a harrowing wait in Moscow and a long journey across the Trans-Siberian railway and the Pacific Ocean. Bertolt Brecht and his wife Helli arrived with their children in July. Brecht did a substantial amount of work for the film studios, though he despised them. As he said to Salka Viertel: 'Every morning to earn my bread I go to the market where they buy lies.'

Although Brecht understood English, he did not attempt to express himself in that language. He would talk with friends late into the night about the War, while Helli served tea and home-made cakes in their simple but spacious wooden bungalow. Christopher felt a degree of mutual antagonism with Brecht. Brecht took him to task over a translation he had made of some of the lyrics from the *Threepenny Opera*, and generally gave the impression of being a very uncomfortable person to have around: wary and tough, with an almost peasant cunning. Christopher was also deeply hostile to Brecht's

Stalinist political position, with its implicit acceptance of the unquestionable authority of the Communist state.

The doyen of the German expatriate writers was Thomas Mann, who was amused by Christopher and tended to call him 'the starry-eyed one'. They first met in California at a Mann family reunion, with Erika and Klaus. As a journalist was present, Thomas Mann introduced each of his family members in turn. 'And who is that?' asked the reporter, pointing to Christopher. 'Family pimp,' Mann replied, in a light-hearted reference to Christopher's role in fixing Erika's marriage to Wystan Auden.

Somerset Maugham passed through Los Angeles that summer and showed a far more sympathetic understanding of Vedanta than most of his compatriots. In fact, he told Christopher that he was intending to write a novel about India and Hindu mysticism that autumn – the book that was to appear as *The Razor's Edge*. Some critics have claimed that Isherwood was the model for the main character in that book, but Maugham denied it.

In July 1941, Christopher joined about twenty-five other people at La Verne, some thirty-five miles inland, for a month-long seminar run by Gerald Heard. The programme was divided up between meditation, discussion, physical labour and relaxation. A number of the participants were Vedantists or Quakers. Just before he left to go there, Christopher wrote to John Lehmann:

I think it should be interesting. God forbid that I should make any more rash promises, but *supposing* I were to write a short plain account of the doings and findings there, would you feel inclined to print it? I feel so terribly sorry about all the times I've let you down that I rack my brains to find any conceivable way of appeasing you.

Later plans are still very vague. I may go East to see Wystan [Auden had, like Isherwood, become an American citizen], but this depends on whether or not he has been conscripted: he had been ordered to report for duty on July 1, and I haven't heard from him since. Most probably they'll reject him because he's too old. Tony Bower, as Cuthbert [Worsley] will have told you, is already in the army.

This fall, I hope to get some fulltime job working with the [Society of] Friends, either on relief or refugees, and thence possibly to China next spring – but all that depends on circumstances outside my control.

The full-time employment with the Quakers did indeed materialise. It was natural that Christopher should find the Society of Friends the most sympathetic of the Christian sects. They preached pacifism and tolerance,

were usually free of religious dogmatism and bigotry, and believed in the Inner Light, or 'that of God' in every person – a concept similar to some Vedanta teachings. At La Verne, Christopher had long discussions with a Quaker named Harold Chance, who wrote to the headquarters of the American Friends Service Committee in Philadelphia about Christopher's wish to work in some Friendly concern:

> Up until recently he has been employed by one of the Hollywood movie companies as a scriptwriter and, I understand, at a salary of between $500 and $600 a week. . . . [giving him] enough savings to last him a year or so and since that has been rather closely associated with Gerald Heard and his group here in Southern California . . .
>
> I have found Christopher a most interesting person. He apparently has a rather brilliant mind, at least he expresses himself very well, though he is very much English in that expression . . . I might add that I do not think that he is ambitious in his desires as to the type of service, in fact, I think for a year or so he is quite eager to do some very humble chore if necessary.

Another Friend, Raymond Booth, sent a strong letter of support in favour of Christopher's application. Consequently, in October, Christopher left for Haverford, outside Philadelphia in Pennsylvania, to work at the Co-operative College Workshop. He had gone straight to the heart of American Quakerism.

10

1941–1948

For generations, the Quakers had dominated the area round Haverford. They had arrived originally in the seventeenth century with William Penn's vision of a Peaceable Kingdom in the New World, where the lamb could lie down with the lion. But, gradually, the Pennsylvania Quakers had adapted to many of the customs of society at large, as they had welcomed others into their community. Because of their integrity in handling affairs, many Friends had become successful businessmen, so that not all the leading figures in Haverford Quaker circles lived out the principle of simplicity that had always been a cornerstone of Friends' beliefs and practice. None the less, there were many men and women there when Christopher arrived in the autumn of 1941 who displayed considerable sincerity and goodness. And the town's Quaker-endowed College educated many upright youngsters who later contributed to the world of scholarship, notably in religious affairs.

The local Quaker Meeting had more than its fair share of 'weighty' or influential Friends. Most notable was Rufus Jones, the eminent theologian and historian, who was then nearing his eightieth birthday. Friends Meetings for Worship – at least in the brand of Quakerism found in Europe and the eastern seaboard of the United States – are based on silence, though anyone may get up and speak if he or she feels the Spirit moves them. Rufus Jones was so moved, often week after week, sometimes ministering at great length, after the manner of seventeenth-century Friends. Christopher quickly became familiar with this elderly but vigorous figure, with his white moustache and round, steel-rimmed glasses.

On some Sunday mornings, however, Christopher prefered to travel over to another Meeting, at Radnor, a few miles away, where ministry tended to be much briefer, though often many people spoke. One Quaker there, curious to learn the newcomer's impressions of the community, asked Christopher how he compared the two Meetings. Christopher replied in Hollywood jargon

151

that Haverford was a 'long serial' while Radnor was 'short subjects', a remark that became an 'in' joke among local Friends. Though rarely frivolous, Friends around Haverford were quite able to laugh at the world and themselves. None the less, Christopher sometimes caused eyebrows to be raised, especially after he got sexually involved with a young man with a boisterous sense of humour. Christopher himself was appalled but admiring one Sunday when the said youth came out of the Meeting, looked up at a rather stern portrait of the early nineteenth-century Quaker social reformer Elizabeth Fry and said very loudly: 'I never liked that picture of you, Chris!'

The Co-operative College Workshop, where Christopher was assigned, had been established to help incoming refugees from Europe adapt to the American way of life. Christopher taught English to Germans and Austrians, but the programme also entailed briefing new arrivals about basic American customs and institutions. A high percentage of the twenty-five or so refugees who tended to be there at any one time were intellectuals, who went on to teach in colleges themselves, or to hold other responsible positions. The Workshop wardens reported back to the American Friends Service Committee in Philadelphia that they found Christopher keen and always ready to pitch in with the washing-up. But they applied to him exactly the same adjective as Thomas Mann had done: starry-eyed.

While working with the Quakers, Christopher became close to a young lecturer in Spanish at Haverford College, René Blanc-Roos (who was the physical model for the character 'Leonard Dwight' in *Prater Violet*). Apart from his teaching duties, Blanc-Roos coached the college wrestling team, and had an occasionally pugnacious attitude which greatly appealed to Christopher as a contrast to all the worthy gentleness around. Blanc-Roos was a warm but critical admirer of Isherwood's work, and insisted that he should keep himself in form by writing something – anything – so as not to lose the habit.

The result was a story entitled 'Take It Or Leave It', which was published in the *New Yorker* in October 1942. Its construction is completely artificial, quite unlike anything else Isherwood wrote. In it, the writer appeals to the reader to write the story for him, providing the outline, but asking for the details to be fitted in. Even the characters are unnamed. If writing it was an attempt at a new direction, this was clearly not one that would lead anywhere. But Christopher was grateful to Blanc-Roos for getting him writing something other than film dialogue, and later dedicated *Prater Violet* to him.

Christopher and Blanc-Roos would have furious arguments about literature and sex, reading aloud from Rimbaud and drinking together. But, even so, at times he found Haverford confining. On such occasions he would go off

to visit the bars in Philadelphia. On at least one occasion, he travelled to New York. There he saw Benjamin Britten, who had been caught in America when war broke out. He was now suffering great mental anguish about being away from Britain, and eventually organised his passage home, in 1941.

While Christopher was at Haverford, the Japanese attacked Pearl Harbor and America joined the war. As Christopher had already taken out his first US citizenship papers, he suddenly found himself eligible for military service. However, the draft board in Pennsylvania was quite used to dealing with conscientious objectors and classified him as such. From the beginning, he said he was willing to serve in a medical corps, if he did not have to carry arms. It seemed more likely that he would be sent to a forestry camp, as Denny Fouts was. But, in the end, Christopher's age saved him from having to serve.

The Friends' programme for refugees at Haverford closed down in July, partly through a shortage of funds, and Christopher returned to California, expecting to be called up. Swami Prabhavananda urged him to get his classification changed, so he could be registered as a theology student – and come and live as a monk in the Vedanta Centre once a new wing for men had been completed. In the meantime, he wanted Christopher's immediate help on a literary project. Prabhavananda had done a rough translation of the great Hindu classic, the *Bhagavad-Gita*, which needed to be put into proper English. Christopher found it a satisfying task which made him think hard what each verse of the text really meant.

At first, Christopher combined work on the translation with a resumption of his past Hollywood life. He accepted an assignment at Paramount with Lesser Samuels, whom he had known in London in his Gaumont-British days, and who was now working on a Somerset Maugham story, *The Hour Before Dawn*. Christopher's contribution was mainly to a tribunal scene, as Paramount wanted someone who could accurately portray the feelings of a conscientious objector. The sudden call from Paramount put a temporary stop to a new novel Christopher had begun, *Prater Violets*. The final 's' was dropped in the end product. From the outset, the book was to be a study of Berthold Viertel and his partnership with Christopher in the making of *Little Friend*. In fact, the contract with Paramount proved to be a godsend for the book, as Lesser Samuels was able to advise Christopher on all the relevant technical jargon of the film world, much of which Christopher had forgotton.

The new accommodation for men at the Vedanta Centre was completed in early February and Christopher moved in. Berthold Viertel thoroughly disapproved and wondered whether his friends would see Christopher again. But Christopher had already got an assurance from the Swami that he would

not have to cut himself off from the world. What being at the Centre did provide, however, was an opportunity to try out different aspects of self-discipline, such as sexual abstinence, vegetarianism and much longer periods of silent meditation. His capacity to meditate was at times stretched to the limit, thanks to pent-up rage against a young Asian monk in the same building, who played his transistor radio at all times of the day and night. At Haverford, Christopher had had a little bedroom of his own, and he found the communal living in the Ivar Avenue lodgings difficult to accept. Presumably realising Christopher's discomfort, the Swami asked him to sleep in his own room in the main building when he had to make a short visit to a sick colleague on the East coast in June.

A few weeks later, Salka Viertel brought Greta Garbo to the Vedanta Centre for lunch. As the trainee nuns twittered round her excitedly, Garbo cooed about how wonderful it must be to devote oneself to a spiritual life, implying that all her fame was worthless. She turned all her charm on the Swami, who was now back in Los Angeles, telling him he had dark and wondrous eyes. He revelled in the flattery and after Garbo had gone, told Christopher that the next person he wanted him to arrange to come was the Duke of Windsor. Far from finding such worldliness disillusioning, Christopher felt it made him love the Swami even more.

Another, unannounced, visitor to the Centre at this time was the young writer Tennessee Williams, who had come to Hollywood to do some work for MGM. He had a letter of introduction to Christopher from Lincoln Kirstein, who loved putting people in touch. When Tennessee knocked on the door at the Vedanta Centre, someone opened it and put their finger to their lips, indicating that meditation was in process. Christopher was summoned and ushered his visitor in, inviting him to join the meditation. Tennessee thought this was a very unfortunate way to meet someone whose work he admired so much, and he could not concentrate at all. But a few days later, Christopher felt he needed a break from the monastery and looked up Tennessee in his squalid lodgings in Santa Monica. He found the young playwright sitting writing at a desk, surrounded by dirty coffee cups, crumpled bed-linen and unwashed clothes. They had supper at a restaurant on Santa Monica pier, drank a lot of beer and talked sex all evening. The coastal region had been put under a wartime blackout, and the park area on top of the cliffs had become a major cruising ground for servicemen and their admirers. After they left the restaurant, Christopher saw Tennessee off into the promising darkness but resisted the temptation to follow.

None the less, over the coming months, Christopher did find himself giving way to his sexual desires, in brief encounters on the beach, when snatching

hours away from the Vedanta Centre. Then in February 1944 he met up with a beautiful young man whom Denny Fouts had briefly introduced him to the previous year. They started seeing each other regularly, making Christopher realise that he would probably never be able to renounce sex. In the middle of April he made the decision not to pursue the vocation to be a monk. The Swami took the news with equanimity and said that even if Christopher moved out of the Vedanta Centre, he would be welcome to treat it as a second home.

That summer, Vernon returned to Los Angeles from travels in the eastern USA and announced that he wanted to study Vedanta too. The Swami arranged for him to stay at a new centre at Montecito, where Christopher began seeing him again. He felt that Vernon needed his support, and the Swami seemed to encourage their renewed link, exclaiming 'Who could help loving him?' As the weeks went by, however, it became clear that Vernon was not looking for sexual passion again so much as a brotherly relationship, and Christopher had to back off. Vernon abandoned his experiment with Vedanta towards the end of the year, but he and Christopher remained good friends. When Vernon married in later life, he named his son after Christopher (as, indeed, did Heinz).

Meanwhile, Christopher had been getting on with some writing. He collaborated with Aldous Huxley on an original screenplay about a faith-healer, to be called *Jacob's Hands*. As Huxley wrote to Frieda Lawrence in April: 'I hope we shall be able to sell it, as it will solve a lot of economic problems and will make it unnecessary to go into temporary slavery at one of the studios.' However, none of the studios would touch the script, which puzzled Aldous and Christopher until they learnt from a friend that the studios feared objections from the medical profession. Huxley wrote at great length to the doctors' association, telling them why they should have no grounds for complaint, but to no avail. The film was never commissioned, though an adaptation for radio was produced.

Christopher's main writing at that time was his journals, which form the core of his later autobiographical volume *My Guru and His Disciple*. But he did find some time to advance with *Prater Violet*. As he wrote to Gerald Hamilton on June 12:

The greatest problem at present is the time element. Owing to my habit of writing about things which happened ten years ago, I find myself in a totally different epoch; and somehow I have to *allow* for the war, without mentioning it. I'm afraid this may make the thing seem very old-fashioned. But there is virtue in that, too, if one can somehow present it as a period piece.

Prater Violet, which was finished at the end of 1944, is probably the most successful of Isherwood's 'dynamic portraits', finding exactly the right balance between the character in the limelight and the narrator. The book has a good sting in the tail, when the narrator reveals that he does have a sex-life – something which has been hidden all the way through. The narrator is none the less ambiguous about the gender of his partners; in Isherwood's view, it was not yet time to identify himself openly as a homosexual. The story is almost a straight account of events at Gaumont-British, though simplified and exaggerated. Not all of the characters in the book correspond to real people, or at least, not to people there at that time. The portrait of Berthold Viertel is endearing without being flattering. There are also some amusing vignettes of home-life in London with Kathleen and Richard.

Berthold Viertel okayed the manuscript before it was sent to the publishers at the end of the year. He quite liked the book, though he wrote rather wistfully that he was ending his life as a 'tragic Punch'. Graciously he added that he was pleased that the time Christopher and he had spent working on *Little Friend* had not been in vain.

In December, Denny Fouts suggested Christopher come and live with him in an apartment he had found near Santa Monica beach. Christopher did not take up the offer, but sometimes spent the night there when he had stayed out late. Denny's apartment was dominated by a large Picasso, which Peter Watson had given him. Since being expelled from forestry camp for homosexual activity, Denny had taken up several jobs. He worked in the evenings in a bookshop in Hollywood, while, in the daytime, he was a janitor. He was able to use his duty hours to study maths, English and German, in order to get a high school diploma, having missed out on a proper education during his world travels. This study paid off, as soon he was able to go to college. Christopher and he often used to swim at the beach on Saturdays.

Both Denny and Christopher became very fond of a couple of British expatriates whom Christopher first met through John van Druten: Dodie and Alec Beesley. Alec was also a conscientious objector, and worked as his wife's manager. Writing under the name Dodie Smith, she had an immense success as a novelist and scriptwriter. Christopher got into the custom of going to have lunch with the Beesleys and their dalmatian dogs on Sundays, up until 1952. Dodie looked on Chris, as she always called him, rather as an overgrown child, though she was not in the least amused when she came out of the house one day to discover that he had thrown all her garden furniture into the swimming-pool as a prank. Despite such setbacks, Christopher and Dodie adored each other, prompting John van Druten to remark: 'Well I thought you'd like each other, but not *that* much!'

At the end of February 1945, Christopher found work at Warner Brothers, collaborating on a series of projects over the next seven months. These included Somerset Maugham's *Up at the Villa,* and an adaption of Wilkie Collins's *The Woman in White.* The Swami seemed to view this renewed activity in the film world with benign amusement.

In August, when the Allies celebrated their victory over Japan, Christopher rang Dodie Beesley and asked if he could come over for dinner at their house on the beach at Las Tunas. He arrived bearing a bottle of champagne to celebrate the end of the war, but he could equally well have been marking the end of a period in his life. For he had decided now definitely to leave the Vedanta Centre. And he asked the Beesleys if he could come and live with them. He moved into a room that was attached to the house and was designed as quarters for a chauffeur. It had its own front door, and he could get down a staircase to the beach. Nonchalantly, he asked the Beesleys if they would mind if a friend came to stay with him there. The friend was in fact the real reason why Christopher decided it was time to move out of Ivar Avenue: a twenty-four-year old Irish American of part Cherokee-Indian extraction, Bill Caskey.

Christopher had been fascinated by Bill Caskey the first time he saw him washing dishes at Cafe J, one of the popular hangouts near the beach. Christopher had gone into the kitchen to help, so he could get to know the young man. Bill's family were Kentucky horse people, and for a while he had worked operating the photo-finish at a race-course. He was an attractive, dark-haired young man, with a disarmingly quick wit and an aggressive ability. His violent temper intrigued Christopher, who had never got into a relationship with anyone who stood up to him in the same way. Bill had seen a lot since he had left Kentucky and had acquired a number of rich and influential friends before choosing to go it alone in Santa Monica. He was a highly competent photographer and, over the next few years, took hundreds of excellent portraits of Christopher and his friends.

As this was the first time Christopher had lived with anyone on a more or less equal footing, he thought it necessary to draw up a set of rules which he believed would guarantee the enterprise's success. Caskey was rather dubious of the idea, but agreed to give it a try. Many of the rules were concerned with individual freedom and respect, and included one stating that neither of them should bring another sex-partner back to their place while the other one was in town. Caskey stuck to the rules for quite some time, until he realised that Christopher was incapable of doing so, so then he abandoned them too.

They started out with a sort of honeymoon, travelling down to Mexico for

three weeks in a car that Christopher bought from money he had saved from his film work. When they returned, they moved into Denny Fouts' flat, as Denny had returned to Europe. Christopher got to know the beaches north of Santa Monica that had become nocturnal meeting-places and the scene for orgies during the war and remained that way for several years. He particularly frequented a stretch of beach known as 'The Pits', stimulated by the hint of danger and the anonymity of outdoor sexual encounters. Back at the flat, he and Bill Caskey lived a drunken, noisy, busy life, often keeping very late hours. Bill liked to entertain and was a good cook.

Christopher was ill for part of the winter of 1945-1946 and had to be operated on for an infection of the prostate gland. He had hoped to visit England in the summer of 1946, but had to put the trip off for several months. In the meantime, he and Bill moved out of Denny's flat into a small apartment over the garage at Salka Viertel's house at 165 Mabery Road. She left a portrait of Christopher at this time in her autobiography *The Kindness of Strangers*:

> He still looked like an adolescent; one could detect the fine lines around his blue, wide-open eyes, only because they were lighter than his sunburnt face.
>
> In the morning, on his way for a swim, he would stop by for a cup of coffee and a chat. . . . The chat would transform itself into an absorbing discussion, which on my side tended to be rather emotional. At this time I was 'unbalanced' to say the least, but Christopher had unlimited patience and understanding. Then one of us would say something atrocious and hilarious, and suddenly we laughed and the world became bearable again.

The immediate post-war years were the most glittering period for Salka Viertel's *salon*, no matter how 'unbalanced' she may have felt. Charlie Chaplin, who had become the victim of a lot of irrational hatred, was an increasingly regular visitor. During the war he had made a famous speech urging help for America's ally, the Soviet Union. In the hysterical anti-Communist search for Reds under the beds that was whipped up at the time of Winston Churchill's Iron Curtain speech, Chaplin became a prime target. His 'Soviet' pronouncements were thrown in his face, and he found himself on trial in a blown-up paternity case that took on considerable political overtones. Eventually he was found not guilty, but the criticism continued - especially when he married Oona, the eighteen-year-old daughter of the playwright Eugene O'Neill, shortly after the trial.

Christopher saw quite a lot of the Chaplins, but they struck him as rather a stuffy couple. This impression may well have had something to do with an unfortunate occasion at the Chaplins' when Bill Caskey made one of his more spectacular outbursts. The two of them had been invited to dinner and Bill was looking for a place to sit down. He was called over by Nathalie Moffat, the daughter-in-law of Iris Tree, and a former *protégée* of Jean-Paul Sartre. Nathalie had quite a reputation as a wit; it was she who memorably described Simone de Beauvoir as 'an alarm clock inside a fridge'. Expansively, she called out to Bill: 'Oh, Billy, do come and sit here. I just *love* pansies.' Bristling, Caskey shot back: 'Nathalie, my dear, your slang is out of date. The correct word is "cock-suckers".' The gathering was scandalised. The Chaplins never invited Christopher and Bill over again, but that may also have been because someone told them that Christopher had peed into their sofa one night when he was paralytically drunk.

Greta Garbo was an almost daily visitor to Salka Viertel's home. She fended off admirers so effectively that she sometimes found herself in desperate need for company. Often she would call round at Salka's and cheerily ask if she could go out for a walk with her. If Salka was not at home, then Garbo would go round to the garage and dig out Christopher or Bill. Meeting Garbo had been one of Christopher's greatest dreams when he had come to the United States, but her unannounced visits were sometimes very inconvenient. On one occasion, when Christopher and Bill heard her outside their door, they hid under the table until she went away.

Then generally seen as the epitome of beauty, Garbo did everything she could to make herself as unattractive as possible in public. Presumably her intention was to escape recognition, but sometimes the very bizarreness of her drab clothing drew attention. Although Garbo hated to be contradicted or dictated to, Salka Viertel could be quite strict with her. When she was organising a birthday outing for Christopher that August, at which Garbo would be one of the guests, she insisted that Garbo wear a dress instead of her usual baggy slacks. To everyone's amazement, she did.

Hovering around California in the latter half of 1946 – more often than not as a moth around Garbo's flame – was the British photographer and stage-designer Cecil Beaton. He had spent the war years in various remote corners of the world as an official war photographer. Were it not for the poignancy of unrequited passion, Beaton's insistent courting of Garbo (whom he had known in pre-war days) would have been good material for a comedy. As they had several friends in common, Beaton looked up Christopher in California, but later seemed to put a dampener on the possibility of any closer friendship. Bill Caskey later wondered whether Beaton had merely wished

to use Christopher and himself as yet another link in the chain that could bind him to Garbo.

On January 12, 1947, equipped with his newly acquired American citizenship and passport, Christopher left, on his own, for England. Having a rather superstitious streak to his nature, he had deliberately chosen the date to coincide with the anniversary of the sailing of the *Aramis* to the Far East nine years before. He flew from New York to Gander, where the passengers disembarked for light refreshments and the plane refuelled for the transatlantic crossing. Christopher stayed awake through the dark and icy night, and watched the sunrise and the descent to Shannon in Ireland. His mind was full of the memories of his childhood there, as he noted the flag of the now independent state and the Gaelic announcements that came over the airport tannoy. Bad weather delayed the plane's onward departure until the afternoon, but soon he was coming in to land at Bovington, setting foot on English soil for the first time in eight years. Wartime joviality was clearly still in force. When the lady at the immigration controls learnt that Christopher had no vaccination certificate, she shrugged and said: 'Oh well, never mind. You've got a jolly good sunburn!'

On arrival in London, Christopher went straight to John Lehmann's flat, which had become one of the major gathering places of literary life. There he was reunited with many of his old friends. John Lehmann saw a big difference in him, noting in his autobiographical volume *The Ample Proposition*:

> Perhaps he didn't realise that his accent and some of his mannerisms had changed as much as we noticed at once. These changes did not, however, show themselves continuously. I had the impression, talking to him during the three months of his visit, that he was, in spirit, being pulled to and fro across the Atlantic all the time.

Christopher stayed at John Lehmann's for two days. Two things about London struck him: the shabbiness and the goodwill. He was startled also by a new acceptance of officialdom and regulations, and the readiness to queue. Next he travelled up to Cheshire, to stay with Kathleen and Richard at Wyberslegh. That winter was particularly severe, and there were coal shortages. Worn out by the demands of a war that was now over, the population moaned piteously about the weather. Nanny had become very frail, and Kathleen had reversed roles with her, as it was now she who waited on Nanny. Accustomed as he was to the material comforts of American life, Christopher was alarmed by the lack of basic household aids. When he

queried whether they ought not to have a refrigerator, Kathleen replied that the food kept cold enough in the larder, which was in the cellar next to the coal supply. When he offered to buy her a vaccum cleaner, she indignantly refused. He stared in dismay at pans caked in grease, and tried to be of service without appearing too fussy. Richard kept him supplied with endless cups of tea.

After such a long separation, Christopher had wondered how he would react to his family and the house. Despite the noticeable physical deterioration, they were essentially the same as when he had known them before; it was he who had radically altered. He now saw himself as a foreigner in England, in a metaphorical as well as a factual sense. He was even more aware of the family traits that had irritated and bored him in the past, yet he had learnt a new tolerance and patience that had been notably lacking in his youth. Plaintively he wrote to William Plomer on January 27:

> . . . my dear Nanny has suddenly turned into an aged crone who laughs toothlessly at mysterious private jokes. My Mother, at 78, is quite unchanged, and a miracle of energy. She does all the cooking; and presently we are going to trudge through a snowdrift to collect Nanny's old-age pension. It is cold beyond belief . . .
>
> I hope to emerge from this retirement around March 1st, for a *mad* fortnight in London, and am already counting the days and muttering 'February hath 28 alone'.

In March, he visited Edward and Hilda Upward, and then went to Cheltenham to see Olive Mangeot and Jean Ross, with Sarah, her young daughter by Claud Cockburn. He tried to get to Stratford-upon-Avon to see Beatrix Lehmann perform, but was prevented by floods. On returning to Wyberslegh he wrote to Edward Upward on March 22, announcing that the reviews of *Prater Violet* made him feel he needed to become an *emotional* writer, as most of the critics seemed to think he was incapable of Love. Two days later he continued:

> I've faithfully promised to write [a new novel provisionally entitled] *The School of Tragedy* this year, and I still don't know what it's about. I would like to produce something rather like a Huxley novel, with serious discussions; but, unlike Huxley, with convincing characters. Also there's going to be a LOVE scene, if it kills me. As usual, the really attractive relationship – the battle of two elderly Quaker spinsters for an elderly Austrian Jewish refugee – can't be described, because it

actually happened. It's heartbreaking. Why must people be so touchy? I would have loved it – the bitchery, the perms, the diets, the cyanide glances – and the wedding – with half the Quakers drunk on Californian port which I'd smuggled into a bedroom – George Moore would have swooned with pleasure.

Christopher left Southampton by ship for America on April 16, after a farewell party at John Lehmann's. There he met several artists including Keith Vaughan, whose work he liked so much that he took several examples of it back with him to the States. Bill Caskey was waiting in New York, as they had decided to try living there for a while. They took an apartment on 207 East 52nd Street, rented from James Stern. Christopher wrote to John Lehmann on April 28:

> Just to let you know that I arrived on Friday, after a bugger of a voyage, with strong head-gales. I avoided being sick by doggedly overeating and dosing myself with whisky. We were all vaccinated, which made me feel a bit sick after landing but I'm fine now. Jimmy's apartment is a dream (I even have a room to myself to work in) and Caskey is sweeter than ever, and I am very very happy. . . .
>
> In a few days I hope to start driving the plough over the terrain for my new novel. I have terrible stage-fright about this, but the only thing is to make a start. At all costs, I'm resolved, this time, not to be funny. I don't care how dreary and boring it is, as long as it isn't the kind of book anybody could possibly read for pleasure on a train. People like being amused more than anything, I've decided.

Christopher had great difficulty getting down to work on the book, partly because he found New York to be noisy, jittery and hot. He'd also accepted a commission from Random House to write a travel book about South America, and the conflicting demands on his mind to address both that and the prospect of a novel seem to have added to his feeling of being fussed. But as he wrote to Edward Upward at the end of July, he was also having great problems getting to grips with the new novel's central character, who would be quite different from the narrator figures of his three last novels:

> I am determined to write in the third person and abolish 'Christopher Isherwood', but this other character has to be such a lot of things which I am, and also am not. He has to be: my age, an orphan, rather rich, born in America of a wealthy Quaker Philadelphia family but educated

in England and having spent much of his life in Europe. In youth he was a bit of a Côte d'Azur playboy, was married and divorced: he has a bad conscience about the kind of life he led and has reverted to Quakerism, largely because of the social service involved. He doesn't really get on well with the Quakers, however, because they are such awful puritans, and he can't just write off art and sex and pleasure as being wicked in themselves. At the same time, he is 'religious' - i.e. he believes in the validity of mystical experience, to a degree which makes him a bit impatient with the super-intellectual liberal materialism of the Central European refugees.

Christopher continued discussions about the novel with Edward through the post for several months. Meanwhile Stephen Spender (now in a happy second marriage to the pianist Natasha Litvin) arrived from England, and he, Wystan Auden and Christopher posed together on Fire Island for a photograph recapturing the famous trio on Ruegen Island fifteen years before.

Worries about the novel were shelved when the time came to head for South America. Bill Caskey travelled with Christopher, to take the photographs that would illustrate the book. Christopher was peeved to hear that Ecuador had a revolution just as they were about to leave New York, as he would have enjoyed being there when it happened, or so he thought. On September 19, he wrote a quick note to Edward Upward: 'Just leaving. Usual jitters and misery. Why do I do these things? My dog and I are tired of roving . . .'

Bill Caskey was horrified when he saw Christopher putting several thousand dollars into an ordinary current account at the bank. Caskey argued that at least the money ought to be put in an interest-earning deposit account, or better still invested, but Christopher scoffed. The incident fitted in with Christopher's philosophy of not wishing to be weighed down with possessions and responsibilities. For the same reason, even at those times in the 1940s when his earnings from film work could have enabled him to buy a house, he didn't.

Christopher kept a detailed travel diary during the six months of wandering in South America with Bill Caskey, which forms the basis of the travel book itself, *The Condor and the Cows*. He used the diary not just for observations about the countries they were passing through, but also for lengthy ruminations on politics, religion and life in general, much of which had nothing to do with Latin America at all. In fact, over the coming months he was to ask himself repeatedly what on earth he was doing there. He felt no affinity towards it, in the way that he had to both continental Europe and the

States. Despite this, *The Condor and the Cows* is one of his most successful books.

They sailed from New York to Curaçao, in the Dutch Antilles, where Christopher installed himself with a beer on the balcony of a hotel in Wilhelmstad. There, rather typically, instead of analysing the habits of the local people, he dreamed up a new persona for himself as an expatriate on the island, living off the stimulation of the never-ending parade of transient visitors: Curaçao Chris. The idea is of course preposterous. He would have gone crazy in Curaçao within a week, and indeed there were many occasions on the South American trip when boredom set in most cruelly. Christopher never had the unflagging enthusiasm and curiosity of a real traveller; nor did he relish the discomforts of exploration in the more underdeveloped parts of the world. Where he could travel first-class, he did. Where he couldn't, he moaned. And he was usually most ready to accept hospitality on his travels when it was from someone who could offer the comforts of Europe or North America.

From Curaçao, the ship called at a couple of Venezuelan ports before docking at Cartagena in Colombia, where they disembarked. Most of their journey through Colombia was by river steamer. For nine days, they played deck-games and kept a desultory lookout for alligators. The last stage of their journey to Bogota was by a train which climbed a single-gauge track for more than eight thousand feet. They arrived in the city at the dead of night, and checked into the Hotel Astor, a rendezvous for bejewelled, bridge-playing ladies. Bogota itself struck them as being most undistinguished, though Christopher was impressed by the large number of bookshops, which seemed to confirm the Colombian capital's reputation as a place where even the shoeshine boys could quote Proust. On their third evening there, Christopher and Bill sought solace in a cinema where a Bob Hope movie was playing.

Things improved after Christopher checked in with the US Embassy and the British Cultural Institute, and was introduced to some of Colombia's intelligentsia. He particularly liked the novelist Eduardo Zalmea Borda, who took him to see the offices of the Liberal newspaper *El Espectador*. When the editor asked Christopher what his political beliefs were, he replied that he too was a Liberal. This was not entirely out of politeness. While Christopher enjoyed such discussions, however, Bill Caskey sat there 'looking like an unplugged lamp', so they both decided it would be better if he went off on his own and took his photographs.

One day they went to a bullfight, which Christopher found very exciting and not in the least disgusting. However, he hoped he would never have to see another one as he felt a hypocrite watching a spectacle which he knew

he would be too terrified to take part in himself. As usual on travels, his digestion then gave way.

A long, winding journey by mail-car took the two of them up to the Colombia–Ecuador frontier, for a connection on to Quito. Christopher's lack of appropriate wonderment is graphically reflected in the relevant passage from *The Condor and the Cows*:

> That is the irony of travel. You spend your boyhood dreaming of the magic, impossibly distant day when you will cross the equator, when your eyes will behold Quito. And then, in the slow prosaic process of life, that day undramatically dawns – and finds you sleepy, hungry and dull. The equator is just another valley; you aren't sure which and you don't care. Quito is just another railroad-station, with fuss about baggage and taxis and tips. And the only comforting reality, amidst all this picturesque noisy strangeness, is to find a clean pension run by Czech refugees and sit down in a cosy Central European parlour to a lunch of well-cooked Wiener Schnitzel.

Underwhelmed by Quito, the pair moved on, mainly by truck, to Peru, arriving in Lima on December 14. Their spirits perked up when they collected their mail, which included the manuscript of a novel, *The City and the Pillar*, by a young American named Gore Vidal. The diaries of their mutual acquaintance Anaïs Nin record that Vidal had expressed an interest in meeting Christopher Isherwood the year before, as he felt their writing was so similar. Vidal told her he would have liked to have written *Prater Violet*. But, in fact, *The City and the Pillar* was a far more daring novel than anything Isherwood had produced, being quite open about the theme of homosexuality. Christopher liked it a lot, especially because the young lovers in Vidal's book were depicted as clean-cut, all-American boys, rather than the usual neurotic gay inadequates in so much fiction.

Christmas was spent among American expatriates, though Christopher felt the festivities were blunted by the grinding poverty of the local people. The prospect of travelling sixty hours in local buses to reach the southern town of Arequipa was too daunting, so Christopher and Bill cheated and took a plane instead. At Arequipa, they stayed in a comfortable establishment run by the legendary Tina Bates. Then in her eighties, she had entertained the Duke of Windsor and Noël Coward, and reputedly received hundreds of letters from admirers, friends and grateful guests around the world. Christopher noted wrily that she seemed to reserve her greatest favours for young US soldiers and airline pilots.

Later in the week, they went up to the 12,000-foot-high plateau round Lake Titicaca, where the scenery struck Christopher as looking like how he imagined Tibet – the only one of his 'dream-places' that he never managed to visit. Indian culture was far more noticeable here. A detour to Cuzco brought new insights into the Spanish colonial heritage, but also landed them amongst hordes of tourists. But this did not stop them enjoying the wonders of the Inca remains at Machu Picchu.

A confrontation with a Protestant, who enraged the Catholic Bill Caskey with his lurid stories of the venality of Catholic priests, led Christopher to reflect on his own attitude to the Christian churches:

Even if you discount fifty per cent of all criticism, it can't be denied that the Church in South America is a disgrace to Catholicism, and that the conditions in some parishes are bad enough to satisfy the producer of a Russian anti-religious movie. But I loathe the prudery of the average Protestant, who judges nothing but external behaviour, refusing to see that the Catholics, even at their worst, have much more to teach him about the value of sacraments and the psychology of prayer. And how dare a comfortably married minister sneer at the backslidings of would-be celibates? He simply doesn't have their temptations. As for the militant atheists of the Left Wing, their smug stupidity appals me. It is all very well to brand certain cults and legends as superstitious, and to attack the political crimes of the historic sects, but have they never stopped to ask themselves what religion is *for*? How in the world do they imagine they can make their free democratic community function when they have removed the whole spiritual basis of consent?

The passage shows how Christopher's experience with the Quakers, Gerald Heard and the Vedanta Society had fundamentally changed his attitude to organised religion and spirituality. Ten years previously, it would have been unimaginable for Isherwood to have expressed views like that.

Bill and Christopher crossed Lake Titicaca into Bolivia, where, in early February 1948, Christopher began to show signs of altitude sickness. He was therefore unable to accompany Bill on a trip to photograph the Oruro Carnival and the Diablada Festival. Christopher used his time to make non-tiring social calls on some members of the large European refugee colony in La Paz, including the Austrian dramatist Georg von Terramare. He told Christopher that so many Austrians had settled in the city that he had been able to assemble both a cast and an audience for a play he had written in Viennese dialect.

A long and dusty train journey took Bill and Christopher into Argentina. Berthold Szczesny ('Bubi'), Christopher's first Berlin boyfriend, was at the station in Buenos Aires to meet them. Since Christopher last saw him before the war in England, Bubi had worked as a stoker on a German boat along the west coast of Africa, before being arrested by the Gestapo. He had decided to settle in South America and had become part-owner of a small factory. But he was still the same energetic, amusing soul, anxious to please. Christopher was touched to see that Bubi had copies of his novels on the shelves in the comfortable living-room of his surburban house, even though he still did not understand enough English to read them. He acted as the visitor's guide in Buenos Aires, which struck Christopher as being the most international city in the world, with its British banks, German restaurants and Parisian-style boulevards.

Victoria Ocampo, a friend of Wystan Auden's, also lived in Buenos Aires. She edited a famous literary magazine called *Sur* (South). Christopher found her to be an unashamed aristocrat – fearless, generous, commanding, demanding and not giving a damn about fashion. She was a woman of impulse, with the necessary strength of character and quantity of money to give free rein to her desires. Christopher, Bill and Bubi went to stay with her at the seaside resort of Mar del Plata, all three of them losing heavily at the local casino. Since Victoria Ocampo was a strict teetotaller who refused even to serve alcohol to her guests, the three men had brought a secret provision of whisky so they could gather in a room before dinner for a tipple. They were caught out the first evening by their hostess when she walked in unannounced. Instead of creating a scene, though, she sat down calmly and asked them to explain their addiction.

Most of March was spent back in Buenos Aires on a social whirl, which meant that Christopher only managed to write a few lines in his travel diary each day. One of his visits was to Jorge Luis Borges, the short-story writer and librarian, who dazzled him with his knowledge of classical and modern English literature. Christopher also managed to go twice to the Ramakrishna Mission at Bela Vista.

Originally, Christopher's idea had been to return to New York from Argentina, but he and Bill decided to go to Europe instead. They caught a French ship from Buenos Aires on March 27, which called at Montevideo, Rio de Janeiro and Dakar on its voyage to Le Havre. They travelled second-class and had to share a cabin with an elderly man who infuriated Bill by using a chamber pot in the cabin each night. Bill found this routine so disgusting that one day he threw the offending vessel out of the porthole. Another irritating passenger was a young Jewish intellectual who was

fascinated to discover that his new acquaintances knew leading members of the British literary scene. Each time he approached them, he would ask Christopher a question like 'And do you know E. M. Forster?' They had to laugh, though, when he came up to them and asked: 'And do you know Christopher Isherwood?'

They spent a few days in Paris where, one evening, Bill Caskey went alone to Pigalle and was slipped a Mickey Finn. He woke up the next morning in a cage in a police station, robbed of all his money and traveller's cheques, which sent Christopher into quite a state. A more pleasant surprise occurred when they were sitting at a café in St Germain des Prés and they were approached by a young man who introduced himself as Gore Vidal. Christopher thought him wildly attractive, and the three of them went sightseeing together. Vidal annoyed Bill at Versailles by running down a list of historical figures and deciding which of them were gay. But the friendship between Isherwood and Vidal developed and they saw each other on a number of occasions over the coming years. Isherwood dedicated *A Single Man* to Vidal, and Vidal returned the compliment with *Myra Breckinridge*.

Bill Caskey persuaded Christopher that they ought to go to see Denny Fouts, who was living in Peter Watson's flat in the Rue du Bac. By then, Denny was using dangerous quantities of heroin, opium and cocaine, declaring 'If it's good enough for Cocteau it's good enough for me'. When he couldn't afford to buy a fresh supply, he would prepare an infusion of the drugs from his opium pipe, which gave him a little lift, but also violent stomach cramps. Despite his addictions, though, he managed to retain a degree of elegance. He was smartly dressed when he joined Christopher and Bill in a restaurant for dinner, but ate nothing, looking on while the others devoured their meal as if they were the ones who were doing something strange. Denny died of a heart attack in Rome that December.

Another day in Paris, Christopher and Bill ran into Wystan Auden and Chester Kallman, who were on their way to the Italian island of Ischia. Caskey announced that as a Catholic he really ought to go to see Rome, which Christopher had never visited either. But he could not persuade Christopher to delay any longer their departure for England, where he was impatient to show Caskey off to some of his friends. They went up to Wyberslegh for a few days, where Kathleen alarmed Bill with her habit of hitching up her dress in front of the fire to warm herself. Christopher noted that wallpaper which had curled off the wall because of the damp had been rather unskilfully stuck back down again. Nanny's health had deteriorated even further and, later that year, she died.

Christopher and Bill returned to London in June, which gave them about

a month before sailing to New York. During that time, Christopher received an offer from MGM to work on a new film *The Great Sinner*, based on Dostoevsky's novel *The Gambler*. This meant that he would have three major projects to juggle in his head when he got back to the United States: the South America travel book, the novel and the film. But at least he knew that the MGM commission meant he would be able to settle back in sunny California.

11

1948–1952

C hristopher left Bill Caskey in New York when they arrived back from England in mid-July 1948. He then paid a brief visit to Alec and Dodie Beesley, who were staying in Pennsylvania, and flew on to California. He found a place to stay in Ocean Park and compensated for Bill's absence, as well as recovering from long hours at MGM, by drinking heavily at parties and going out on the town. When Bill joined him in October, he found the two of them a house at 333 East Rustic Road in Santa Monica, which was reputed to be haunted. As Christopher wrote to John Lehmann on November 6:

> My life, since I reached California, has been divided into two phases. The first, before Caskey joined me, was work at the studio, on the Dostoevsky picture, which is now being shot. (Called *The Great Sinner* – did you know he actually meditated writing a book of that name, the old ham!?) It is not Dostoevsky, but it's somewhat magnificent, owing to $3,000,000 worth of sets, costumes and high-powered talent. Anyhow, I disclaim all responsibility – unless, of course, you like it! This first phase also included a lot of whisky drinking and a good deal of running around town during which I lost nearly ten pounds and a good deal of sleep. Then Caskey arrived and found this house, which we hope to stay in for a couple of years. It is very nice, and really quite rustic, under some sycamores near the Ocean. . . .
>
> Caskey paints, carpenters, sews and cooks untiringly, and so far we have had only *one* wild party! I am churning out a travel-book, which is going to be my longest and worst work, I fear. I just can't do straight journalism, and the truth is that South America *bored* me, and I'm ashamed that it bored me, and I hate it for making me ashamed.

However, I am determined to go through with it and then get on to the novel, which at least will be an *honourable* failure.

The Great Sinner turned out to be one of the most satisfying film projects Isherwood worked on. Gottfried Reinhardt was again the director, and the film had a particularly strong cast, including Gregory Peck, Ava Gardner and Walter Huston. It got some very favourable reviews when it was released the following year.

Undoubtedly, one of the reasons why work on the novel was going so slowly during this period was Christopher's fairly degenerate existence, which sapped his creative energy. Frequently he would wake up in the morning with a hangover, and to clear his head he would do the washing-up from the night before. On the better days, he did manage to write his diary, standing upright for an hour or so to work on it, often chewing on his knuckle while he thought.

Christopher had a room in the house where he kept his most precious papers and books, and he would lock it if people were coming round for a party. He was known to fly into a rage if anyone so much as touched his typewriter. In marked contrast to the calm of his later years, Christopher at this time would often get worked up, and he and Bill had some quite spectacular rows in public, which secretly both of them enjoyed.

Neither of them had been able to vote in the 1948 presidential election that swept Harry Truman back into the White House, but they followed American politics closely, particularly during what William Manchester so aptly dubbed the Age of Suspicion. Indeed, the house into which they had moved had formerly been inhabited by the wife of one of the Hollywood Ten. While Christopher and Bill had been away in South America and Europe, the witch-hunt of Communists had been pursuing its gruesome course. A good many of Christopher's friends became directly or indirectly involved. Congressmen Thomas, Rankin and Stripling fought the 'Reds' in the guise of the US Congressional Committee Regarding the Communists' Infiltration of the Motion Picture Industry. Jack Warner and L. B. Mayer were obliged to defend their reasons for making films such as *Mission to Moscow* and *Song of Russia*. More than 500 prominent Americans signed a petition protesting against the hearings, and a Committee for the First Amendment was formed by those forces in Hollywood who saw the affair for the ignominy that it was.

Thomas Mann was cheered when he addressed a meeting called to denounce what was going on. Christopher was proud of Mann's peroration, which included the passage:

I have the honour to expose myself as a hostile witness. I testify that I am very much interested in the moving picture industry and that since my arrival in the United States nine years ago, I have seen a great many Hollywood films. If communist propaganda has been smuggled into them it must have been most thoroughly buried. I, for one, never noticed anything of the sort. . . . As an American citizen of German birth I finally testify that I am painfully familiar with certain political trends. Spiritual intolerance, political inquisitions, and declining legal security, and all this in the name of an alleged 'state of emergency' . . . That is how it started in Germany.

Unfortunately, not everybody had the common sense and courage of Thomas Mann, nor the moral integrity of Lillian Hellman, who wrote a letter that was a landmark of the McCarthy era, refusing to testify about any of her friends or their beliefs.

Nineteen people were originally summoned from California to Washington to explain themselves. Eight of them were dropped from the list of the Un-American Activities Committee. Bertolt Brecht, who figured among the remaining eleven, went through the interrogation, then immediately left on a plane for Switzerland, later moving to East Berlin. Helli Brecht sold the house in Santa Monica, then followed with the children. The remaining 'suspects' became the Hollywood Ten. But the witch-hunt did not stop with them. Salka Viertel, who had arranged an amicable divorce from Berthold during Christopher's absence in South America, found herself accused of being a Communist. She was refused an exit visa when she tried to go to visit Berthold in 1953, though a skilled lawyer managed to obtain a permit for her in the end.

Over in England, meanwhile, Edward Upward had left the Communist Party and Christopher felt free to express his relief, in a letter dated 9 February 1949:

I can't help feeling glad about the ending of your political activities. Just as I imagine you were glad when I stopped living with the Vedanta people. But I don't want to underline this, or I shall say something stupid not knowing the circumstances. I know the break must have been painful for both of you, but it is sure to make your writing easier. And your writing is your real job, your real debt to any kind of social order. We need you more than ever. The very fact that you've saved up your powers all these years is an advantage.

Edward Upward charted the course of his relationship with the Communist Party in his unjustly neglected trilogy of novels *The Spiral Ascent*, in which Christopher appears as the poet 'Richard'. Christopher remained one of the greatest believers in Upward's literary talent and repeatedly showered Upward's work with praise. After much discussion and soul-searching, Upward had finally agreed to have *The Railway Accident* published, and Christopher wrote a foreword to it.

However, Christopher had by no means severed links with the Vedanta Centre, which Bill Caskey used to refer to sarcastically as 'Heaven'. Despite eschewing nearly all the practices he had learnt under Swami Prabhavananda's wing, Christopher still went to see him regularly. Moreover, almost as a penance, he was working on a translation of Patanjali's yoga aphorisms, finally published in 1953 under the tital *How To Know God*. The possibility of a visit to India was mooted, but nothing came of it for the time being.

In May, Christopher was expecting Stephen Spender over on one of his many post-war visits to America, where he held a series of teaching positions. Having just seen his portrait in Spender's frank article about some of his friends in the *Partisan Review*, Christopher wrote to Edward Upward saying he was lucky not to have been included. 'I shall be embarrassed ever to show my face in New York again,' Christopher wrote. 'It is like being featured in the Kinsey Report [on the sexual habits of Americans].'

One of Christopher's closest friendships during this difficult period was with the Russian composer Igor Stravinsky, who lived with his wife Vera in Santa Monica. Christopher considered Stravinsky to be one of the three most remarkable men in his life, the others being Morgan Forster and Swami Prabhavananda. In the winter of 1948–1949, Stravinsky was working on the opera *The Rake's Progress*. But he was also travelling enormously both inside and outside the United States, conducting, composing and leading a glittering social life. He was fond of Christopher and was amused by him, and thought Bill Caskey a riot. Often they would team up with Aldous and Maria Huxley, and go off together to the Farmers' Market, where Aldous could get the sunflower seeds which he was then eating in vast quantities, in the hope of improving his eyesight. Not that he missed much even with his poor eyes. To Christopher and Bill's great delight one time, when they were lunching at the Market with the Huxleys and the Stravinskys, Aldous spotted two young queens sashaying across the forecourt and sighed: 'Ah! Boys *will* be girls!'

The Stravinskys were usually accompanied by Igor's shadow and biographer Robert Craft, who penned a portrait of Christopher at one of the Farmers' Market lunches in his diary entry for August 10, 1949:

His manner is casual, vagabondish, lovelorn. One does not readily imagine him in a fit of anger or behaving precipitately or enduring extended states of great commotion. At moments he might be thinking of things beyond and remote, from which the conversation brusquely summons him back to earth. But he's a listener and an observer – he has the observer's habit of staring – rather than a propounder and expatiator, and his tracelike eyes will see more deeply through, and record more essential matter about, us than this verbosity is doing about him. . . .

Isherwood brings greetings to All-deuce (as he pronounces it) from a Swami. The voice, both in pitch and volume, is somewhat too high, and the words are too deliberated. Aldous, replying, digresses to make room for a ribald story, which Isherwood follows like an eager schoolboy, exclaiming 'Oh boy!' once, and rubbing his knees in anticipation of the outcome. He also says 'heck!', 'swell!', 'by golly!', 'gosh!' and 'gee-whizz!'

Talking of Igor Stravinsky twenty-five years later to the British journalist W. I. Scobie, in an interview in *The Art of Fiction*, Christopher said he thought of him in a very physical way:

He was physically adorable; he was cuddly – he was so little, and you wanted to protect him. He was very demonstrative, a person who – I suppose it was his Russian-ness – was full of kisses and embraces. He had great warmth. He could be fearfully hostile and snub people and attack his critics and so forth, but personally, he was a person of immense joy and warmth. The first time I came to his house he said to me: 'Would you like to hear my Mass before we get drunk?'

And drink they did, on many occasions. Stravinsky was fond of one particularly lethal liqueur called Marc de Borgogne, which usually made Christopher (who anyway had a very low level of alcohol endurance) tiddly in a very short time. Once Christopher passed out on Stravinsky's floor, and came round to see Aldous Huxley towering above him, talking French to their host. Huxley looked down rather curiously at Christopher lying prostrate on the floor, as if to say, 'Aren't you going a little far?'

It took Christopher a long time to appreciate Stravinsky's music, though; indeed, one of the things that endeared Isherwood to the composer was that he once fell asleep to it. But then Christopher was never notably musical. This did not prevent his making good friends within the tight-knit

world of musicians, including Virgil Thompson and, of course, Benjamin Britten.

Christopher was seeing Aldous Huxley professionally as well as socially at this time as they had started working on yet another ill-fated joint movie-project. This one was to be set in South America, with a sort of Hungarian Mr Norris in it – an idea which made Christopher wonder whether he ought not to write a sequel to *Mr Norris Changes Trains* anyway, set in South America. Christopher did manage to pick up a few bits and pieces of film work with MGM during 1949, but for the first time since his earliest Californian days, money became a problem. Bill Caskey supplemented the household income by working as a gardener.

The Condor and the Cows came out at the end of 1949 to a far warmer reception than Christopher was expecting. The book did particularly well in Britain, where it was chosen as the Book of the Month by the *Evening Standard*. In later life, Isherwood came to look on it with far greater affection.

At the beginning of December 1949, Christopher and Bill rented a new house, at 31152 Monterey Street, Coast Royal, South Laguna, about sixty miles down the coast from Santa Monica, in a deliberate attempt to break the pattern of unproductive slovenliness into which they had settled. As Christopher wrote to Edward Upward:

> This is by means of an attempt at a New Period – goodbye Hollywood, *allons* to serious writing, retirement, art, and no more parties and telephone calls. Actually, I don't know what we are going to use for money; and I'll probably come scampering back if I get the least sniff of a job . . .
>
> My novel is alive again and I'm determined to finish it, even as an interesting failure. I am feeling my way towards an Anglo-American style, and this is itself very hard. It *ought* theoretically to be wonderful and funny to be a detached mongrel, talking a bastard jargon, but I fear this will only come with more practice.

Bill Caskey's personal finances were eased considerably when his father died, and he inherited some money, but the death also meant that he had to go back to Kentucky for several months in the first part of 1950, to help look after the family business. Christopher hoped himself to travel, both to England and India, but simply couldn't afford it. As Swami Prabhavananda's own trip to India in the late spring coincided with Gerald Heard's absence in New York, Christopher found himself having to take the Sunday morning lecture sessions himself. Not wishing to take on the role of a minister, he

gave readings (including Edward Upward's prize-winning undergraduate poem 'Buddha') instead.

Despite his dislike of reviewing, Christopher accepted an offer to review books for the American magazine *Tomorrow*. He had his own code of ethics in that he refused to review anything he did not like, on the grounds that it was a waste of the readers' time to describe poor books when there were so many good ones clamouring for recognition. He also did not like to hurt other writers' feelings, and was always pained when his own books got bad reviews – particularly if these were written by friends. One of the books that was sent to him was Stephen Spender's autobiography *World within World*, which he told Edward Upward he found extremely interesting, though there was something in it to enrage everybody, including both of them.

New Year 1951 saw Christopher still grappling with his 'Anglo-American' novel. As he wrote to Edward Upward:

I simply haven't the slightest idea what is going to happen in it, or if it is the least bit good. It is becoming much more like Freudian analysis, and I'm far more interested to see what I can discover about myself than to see how it will develop as an artwork. However, the practical result is the same: I have to go on writing it and I will.

One of the more constructive distractions from working on the book was his role as a member of the board of the Huntington Hartford Foundation. This had been started in 1949 by a multi-millionaire who had built a centre on 135 acres in Rustic Canyon where writers, musicians and artists could have three months free board and lodging, as well as the use of a studio, so they could get on with their work free from practical worries. There were several small houses on the Huntington Hartford property, though Christopher himself was given the use of a studio apartment over the stables. He alternated between there and the house at South Laguna. Sometimes he alarmed Bill by swerving back from the Foundation at night in his little old Ford, in a state of semi-inebriation. But Bill was himself not in much of a position to protest, as he had been hauled up before the magistrates for driving under the influence.

Christopher's job for the Foundation was to vet manuscripts from young writers applying for scholarships. Other advisory board members included Robert Penn Warren and a young novelist from Louisiana, Speed Lamkin. Speed Lamkin had turned up in Hollywood in January 1951, doing research for a novel about old movie stars, *The Easter Egg Hunt*. Christopher appears in it, thinly disguised as the character Sebastian Saunders. Lamkin was a

great fan of Isherwood's work and began a collaboration with him and Lesser Samuels to try to dramatise *Sally Bowles*. It did not look as though they would get it off the ground, though, so Alec and Dodie Beesley hatched a plot which they hoped would ease Christopher's finanical position.

Driving past Palm Springs on their way to visit John van Druten at his desert ranch, Alec Beesley suddenly asked Dodie whether she did not think that if John van Druten dramatised *Sally Bowles*, then there should be little problem in getting sufficient backing for a production. Dodie agreed, but doubted whether van Druten would accept if the proposition were put to him straight. Accordingly, they arranged a little scene. When Alec popped his head out of John van Druten's swimming-pool and said, 'John, why don't you turn *Sally Bowles* into a play?' Dodie instantly responded: 'It couldn't be done.' This prompted John van Druten to speculate on just how it *could* be done. By the time the Beesleys left the ranch, they knew they had him hooked.

Van Druten got to work almost immediately, constructing *I Am a Camera* mainly out of *Sally Bowles*, but with bits of Isherwood's other Berlin stories added in. He even created a few extra things of his own, such as a mother for Sally. By June 1951 he had finished the play and by September had the necessary backing to put it on.

Neither the Beesleys nor Christopher were wildly enthusiastic about the play in script, but it was quite a different matter on stage, as Christopher discovered when he went to New York in October to watch rehearsals. Julie Harris was given the lead role and it was she who made the play. As Isherwood recalled in a piece in the *Saturday Review* twenty-five years later:

> I first set eyes on Julie at the studio of a New York photographer, where she and I were to enact meetings, for publicity purposes. Julie entered in costume as Sally Bowles. Since we had not been formally introduced I decided to treat her as Sally. Hugging my lost companion, I exclaimed reproachfully that she had stayed the same age while I had grown twenty years older. My scene of improvised whimsy was played to conceal a certain dismay, a disconcerting sense of strangeness. This was not just an actress dressed up as one of my characters. Here was something other, an independent presence, which Julie, under John's direction, had mediumatically produced. Oh yes, it was *like* Sally Bowles, but it wasn't my creation. It had a life of its own.

I Am a Camera opened at Hartford, Connecticut on November 8, 1951, and transferred to the Empire Theatre in New York at the end of the month.

Celebrities were out in force on the first night. Christopher and John van Druten paced back and forth across the back of the auditorium, trying to get a feel of the audience. During the interval, Christopher went into the lobby, where Stravinsky rushed up to him, embraced him and murmured: 'Inferior to the novel!' Marlene Dietrich then approached Stravinsky with a wild 'Cher Maitre!', but Stravinsky did not introduce her, so Christopher stood around feeling very foolish.

At the end of the show, Christopher walked back to the house where he was staying near the docks, absorbed in an account of the love-life of a friend of his. He completely forgot about the play until the notices appeared in the morning's papers. A few critics, like Brooks Atkinson in the *New York Times*, had reservations about it, but it soon became obvious that it was a great hit. A British production, starring Dorothy Tutin, was also successful. As the Beesleys had hoped, Christopher did well out of it financially, though there was some bitterness caused when John van Druten (then a relatively wealthy man) insisted on a 60:40 split of royalties in his favour, rather than the more usual 50:50.

As Bill Caskey had decided to take advantage of the Korean War to go off and see some more of the world in the navy, Christopher travelled alone from New York on the *Queen Elizabeth* to spend Christmas with Kathleen and Richard at a hotel in London. John Lehmann fixed him up to do a broadcast on the BBC on up-and-coming American writers, and he also gave a reading from his work in progress at the Institute of Contemporary Arts. But his most important commission was from *The Observer* – to go back to Berlin and report on what he found.

On his two previous post-war visits to Europe, Christopher had studiously avoided going to Germany, being unsure of how he would react to Berlin *après le deluge*. As he wrote in the newspaper article, he dreaded meeting the people he had known, and began to feel quite ill on the plane going out. He had not warned Fräulein Thurau, his old landlady, that he would be coming. When he arrived at her door she let out a Wagnerian scream of joy that must have been heard throughout the block. She knew about her fictional alter ego, Fräulein Schroeder, but did not seem disturbed by it, though she told Christopher she was annoyed that he had said that she 'waddled'. She made him laugh by showing him how she had made herself look really unattractive when the Russian soldiers arrived in Berlin, to make sure she did not get raped. She told him that Otto had been round recently, looking very well-dressed but still a spiv; he had wanted to buy her carpets. Heinz too was in good form. Christopher visited him and his wife and son, and felt guilty that he had not been over to see them before.

Christopher stayed barely a week in London on his return, before boarding the *Queen Elizabeth* again for New York. Though he had enjoyed his trip over to Europe, he was homesick for California and told Gerald Hamilton that he wept when he saw the Statue of Liberty as the liner pulled into New York. However, he did not head home immediately, but instead went on a short holiday to Bermuda with a young Irish-Minnesotan, who miraculously got him to stop drinking for a while. Christopher then travelled by train from New York to San Francisco, where he joined up with Bill Caskey who was on shore leave. They went on a short mountain trip together, before Christopher returned alone to Los Angeles. He had nowhere fixed to live, and no boyfriend waiting for him there. But he was determined to shake off the mental block that seemed to be preventing him getting his life in order, let alone completing his novel.

12

1952–1961

When Christopher and Bill Caskey parted in San Francisco, both of them recognised that their lovers' relationship was over. They would still remain good friends and correspondents, but the fire and passion had gone. Moreover, Christopher was aware of his need to re-establish a stronger form of self-discipline. First he went to the Huntington Hartford Foundation, but instead of offering peace and quiet, the place was in an uproar over the suitability of its Director.

He then sought greater tranquillity at Trabuco, the monastic college which Gerald Heard and some friends had built in the 1940s in a deserted location in southern California and which had been handed over to the Vedanta Society. Young devotees were busy with the demanding tasks of keeping both the buildings and the very extensive grounds maintained, while Christopher did lighter voluntary tasks like pulling weeds out from between the vines. In May 1952, he finished the Patanjali translation with Swami Prabhavananda there, as well as the first part of the novel that was shaping up as *The World in the Evening*. But he knew that he was not cut out for spending long periods at Trabuco, as he quickly got bored with the silence. He therefore started dividing his time between there and the more stimulating Los Angeles.

In the big city, he had become good friends with a remarkable psychologist, Evelyn Hooker, who was married to a professor of English literature at UCLA (University of California, Los Angeles). Dr Hooker was engaged in a comprehensive study of homosexuality, which was still frowned upon in conservative California. She worked from the assumption that homosexuals are not necessarily sick people – as the conventional wisdom had it – but should instead be viewed objectively as a group phenomenon, which was an ideal subject for social-psychological research. She interviewed hundreds of homosexual men of all kinds, and became a familiar and loved figure in the

gay bars of Hollywood at a time when these felt like the outposts of a threatened minority. Christopher's relationship with her began out of a professional interest, but turned into a close friendship.

When Christopher mentioned to Evelyn Hooker that he was having problems finding somewhere to live in Los Angeles, she half-jokingly said he could always move into the summer-house at the bottom of her garden. To her surprise and amusement, he leapt at the suggestion, and commissioned a friend of his, the architect and writer Jim Charlton, to refurbish it. This new base at 400 South Saltair Avenue enabled him to keep in touch with both the gay scene and the film world in Los Angeles, and to enjoy the company of short-term visitors to Hollywood like Julie Harris and John Gielgud.

Bill Caskey reappeared in the autumn of 1952, back from the Orient. In November, he and Christopher went off on a second trip to Mexico, driving down the west coast in a new Sunbeam Talbot which Christopher had treated himself to out of the proceeds of *I Am a Camera*. He wrote to William Plomer from Hermsillo that Mexico was full of Hemingway characters who had lost control of their dialogue. Obviously, both he and Bill enjoyed it, as they were back south of the border again briefly at Christmas, staying at Ensenada. Christopher had got his drinking under control and, in January 1953, he finished a first complete draft of *The World in the Evening*. He made disparaging comments about it to several of his friends, describing it in a letter to Dodie and Alec Beesley as 'a curiously trivial story, told in considerable detail, with a certain amount of squalor'. In his diary, he confessed that it was the toughest of all his literary experiences. Its production was no doubt made even more painful by the fact that he had given up smoking.

He was still going to parties, however, and became friendly with two appealing brothers, Ted and Don Bachardy. Years later, Don told an interviewer from the gay periodical *The Advocate* that his first meeting with Christopher took place at a St Valentine's Day party, in other words, on February 14, 1953. According to this charmingly romanticised account, Don approached Christopher, who was standing by an open window. Both of them had had several drinks, and toppled out of the window onto the ground below. Soon afterwards they teamed up and stayed together until Christopher's death over thirty years later.

In fact, this central relationship of Christopher's life developed much more slowly. Christopher found the two boys fun, and as they were both crazy about films, was more than happy to share his Hollywood anecdotes. They came from a rather conventional family of modest means and their father

was around Christopher's age. At first Christopher's attitude to the boys was a little ambivalent and, at times, positively paternal. But gradually he became aware that he had fallen in love with Don. However, Christopher was by now forty-eight years old, while Don was only eighteen. Indeed, with his bright, enthusiastic eyes and cute gap-toothed grin, the boy often looked even younger. Don moved into the little summer house with Christopher but, as California was not Ancient Greece, several of Christopher's friends looked askance at this new liaison, and said so. They were never forgiven.

Evelyn Hooker found herself in a difficult position. She sympathised totally with Christopher's feelings, but was alarmed that someone might instigate legal proceedings against him. She felt her husband Edward – who was then working on a definitive critical edition of the seventeenth-century English poet John Dryden – would not be able to cope with any scandal. She therefore gently asked Christopher to find somewhere else to live. She continued to keep a lively interest in their relationship, however, and remained a good friend.

Bill Caskey received an anonymous poison-pen letter urging him to report Christopher and Don to the police but, of course, he did no such thing. Bill never settled into a permanent relationship of his own and eventually made his base in Athens (with frequent trips to Egypt). There he would sit in a café and peruse the financial columns of the *International Herald Tribune*, to see how his modest investments were doing. Despite his earlier promise as a photographer, he never achieved success either in that field, or in his hobby of constructing nightmarish *objets trouvés* out of flotsam and junk. He died in Athens in 1981, a sad and rather embittered man.

Christopher and Don's problem was solved in the first instance by Speed Lamkin's sister Marguerite. She was then the young bride of Harry Brown, the author of the best-seller *A Walk in the Sun*. Speed had once joked that he knew something terrible would happen if he ever introduced Christopher to Marguerite; but they got on very well. She and Don quickly became firm friends. Don moved in with her and Harry Brown, while Christopher rented a place conveniently close. He kept the summer house in the Hookers' garden as an office to do his writing in.

That summer Christopher worked on a television story with a friend Gus Field, using a writer hero loosely based on Somerset Maugham. But his main energies were channeled into knocking *The World in the Evening* into shape. He had written to Edward Upward earlier in the year that the novel was 'vulgar, reactionary pornographic trash' and, after Don had helped him type the final draft at the beginning of August, he sent it to Alec and Dodie Beesley for their verdict. Though Dodie did suggest a few small changes, she told him it

was far from bad. Accordingly, he sent copies off to his American and British publishers. When he got back from a short holiday in San Francisco with Don, Christopher found essentially positive reactions from both. Methuens said encouragingly that they thought it was his best novel yet, but Random House wanted a few minor alterations. In particular, they questioned the wisdom of having *two* homosexual relationships in the book, wondering whether one would not be enough. Christopher rejected that suggestion, but he did agree to other revisions. These were finished by the end of November; then, he took Don off to New York for Christmas to celebrate.

The World in the Evening is Isherwood's longest novel and by far his least successful. It traces the fortunes of Stephen Monk, a wealthy lapsed Quaker in his mid-thirties. He sets out on a voyage of personal reappraisal at the beginning of the Second World War, after discovering his second wife (allegedly based on Bill Caskey!) making love to another man in a large doll's house in the garden at a friend's party in Santa Monica. Stephen Monk flees California and seeks refuge with a saintly Quaker honorary aunt in Pennsylvania, who had taken in an intelligent young German woman refugee. There Stephen recalls his first marriage to a famous writer (an amalgam of Katherine Mansfield and Virginia Woolf) much older than himself.

Stephen is given the ideal opportunity to reflect when he half-deliberately gets run over by a lorry and is forced to convalesce. He thinks back to a relationship he had with a younger man, whom he had used dishonestly. The doctor who looks after him in Pennsylvania is gay, and bantering scenes with the doctor's lively young lover allow Isherwood to explore the differences between 'high' and 'low' camp – one of the few genuinely original things in the book. After his recovery, Stephen obtains a divorce from his second wife. Each is destined to lead a new and more noble life, Stephen as an ambulance-driver in North Africa.

Many people felt that *The World in the Evening* confirmed their worst fears about the effect of Hollywood on good novelists. There is little of the old Isherwood sparkle in the book, and some passages read like the dialogue from a poor 'B' movie. Of course, many people in real life do speak as if they are in a 'B' movie, but one feels that the individuals in this novel ought to be capable of much more. The real problem with the book is the central character Stephen Monk. The device of using him as a first-person narrator does not work at all. For part of the time, he is a recognisable Christopher derivative, doing Christopher-type things. But at others he is totally different and becomes a stereotype of the sort of unscrupulous bisexual Christopher so loathed. The reader is thus left confused about the attitude he or she should take towards the main character. And the enigma is not intriguing enough to warrant any

great effort on the reader's part. Isherwood fails to convey the heterosexual lust which Stephen is meant to feel for his attractive second wife, while his portrait of the relationship between the homosexual doctor and his young lover is squirmingly twee.

Christopher was only too aware of the book's shortcomings. He wrote to Edward Upward on August 31:

> It is terribly slipshod and sentimental at times in a Hollywoodish way, and there is a great deal of sex, including some homosexual scenes which will shock many people, I dare say, worse than anything I've written, though not in the least pornographic. . . . All of it has been rewritten three times, if not more.

Edward confirmed Christopher's doubts about the book. But for once Christopher had deliberately sent him the manuscript *after* delivering it to the publishers, not before, so it was too late to do anything about it. When the book was published, in June 1954, the vast majority of the critics were hostile. One exception was Thom Gunn in *The London Magazine*. And the public obviously shared Gunn's view that *The World in the Evening* was worthwhile. For a couple of weeks the novel crept into the bottom of the best-seller lists in the States. But most of Christopher's friends shared the verdict of Somerset Maugham, who wrote to a friend: 'Perhaps I shouldn't have felt so let down if I had not so greatly admired and cherished the Christopher of twenty years ago. What damage Gerald Heard did to our English literature when he induced . . . these talented writers to desert their native country for America!'

America meant money, though, which was an important consideration for a novelist who no longer had a private income to help him survive. In January 1954, Edwin Knopf at MGM got in touch with Christopher and commissioned him to write an original story for a film based on the life of Diane de Poitiers. As for once he had a relatively free hand, Christopher got considerable satisfaction from the project, spending many hours delving into the novels of Honoré de Balzac and Alexandre Dumas for background. Gore Vidal, who was in Hollywood trying to drum up some film work himself, visited Christopher at the studios when the story-line of *Diane* was finished and casting was underway. Lana Turner was to play Diane de Poitiers, and when Vidal laughed at this, Christopher replied grimly 'Lana can do it!' He then tried to persuade Vidal not 'to become a hack like me'. But Vidal was convinced that Christopher's apparent melancholy was itself only a form of play-acting.

But Christopher was unhappy about the casting of *Diane*. In that proprietorial way that many writers feel about films for which they do scripts, he had early on enrolled actors for the film in his mind. He wanted a European cast, with Ingrid Bergman in the lead role, and Julie Harris as Catherine de Medici, wife of King Henry II of France. The studio declared that Ingrid Bergman was quite out of the question, and when Julie Harris went for a screen test she was turned down. Marisa Pavan was given the role of Catherine instead. Christopher later admitted that this casting turned out well, though he was uneasy about the American 'twang' in such a very European costume drama.

Work on *Diane* meant that Christopher was unable to accept an offer from Henry Cornelius to do the screenplay for a filmed version of *I Am a Camera*. This was a double pity, as Christopher would have liked to have control of the material, and the job would almost certainly have given him the chance of spending some time in England. However, that in itself would have presented problems as he would not have wanted to go to Britain without Don, who was then in the middle of studying at college, as well as being threatened with being called up to do military service. John Collier did the screenplay for *I Am a Camera* instead.

Julie Harris – at that time working on a film version of John Steinbeck's *East of Eden* and seeing a lot of Christopher and Don – accepted the screen role as Sally Bowles, whom she had already immortalised on stage. Laurence Harvey played Christopher and Shelley Winters was the rather curious choice for Natalia Landauer. Henry Cornelius had been in Berlin with Max Rheinhardt in the 1930s, so was familiar with the terrain. However, he decided that the relationship between Christopher and Sally in the book was not plausible on film. A wholesome American audience, he argued, would never buy two young, healthy people of the opposite sex going through a whole film as *friends*, so in his version, they get married at the end.

The film was well received by the public, but some of the reviews were scathing. Alan Brien, writing in the *Evening Standard*, declared uncompromisingly: 'It has a distinct and unforgettable taste like a caviar sandwich dipped in sugar and cream.' Harold Conway in the *Daily Sketch* rapped Cornelius and Collier over the knuckles for the liberties they had taken with the original story-line. 'The screen version exchanges subtlety for horseplay, an awkwardly-contrived happy ending for the astringent charm of the original', he wrote. Christopher was even more dismissive, telling John Lehmann in a letter that John van Druten and he thought it 'disgusting, ooh-la-la near pornographic trash'.

In November 1954, Christopher and Don flew to Key West in Florida,

where Tennessee Williams was working on the film version of his play *The Rose Tattoo*, starring Burt Lancaster and Anna Magnani. Christopher was persuaded to play a bit part, and marvelled at the skill and speed with which Tennessee was able to make alterations to dialogue on set. In December Christopher and Don were off on their travels again, this time to Mexico, driving down through Tijuana to Mexico City with two friends called Ben and Jo Masselink. The holiday started well and Christopher was elated to see an iguana. However, disaster struck in Mexico City in the form of Montezuma's Revenge, a stomach bug which laid both Chris and Don out. When they were finally fit enough to leave the city, Christopher shook his fist at it and shouted 'Good-bye, Death Valley!'

Out of this trip to Mexico grew the idea of a new novel, as Christopher wrote to Edward Upward, in May 1955:

> Very dimly but with increasing excitement I receive adumbrations of a quite different sort of novel – a fantasy: realistic throughout but nevertheless queer (I don't mean *queer*). I shall tell you more of this later. It has some relation to my recent trip to Mexico. A journey which is not a journey. Something of [Dante's] *Inferno*, something of [your] *Journey to the Border*, and of course Kafka, but more cheerful, even hilarious – hilarious hideous, maybe. Very suggestive . . .

The novel was to be called *Down There on a Visit*, a title that refers to Huysmans' *Là-Bas*. The *Inferno* would be translated into the purgatory of a trip to Mexico City. The cast of 'damned' characters would include Basil Fry (Christopher's Vice-Consul relative in pre-war Bremen), Francis Turville-Petre, the inmates of a refugee hostel in America, and Denny Fouts. Several of those characters did indeed appear in Isherwood's novel of the same name, seven years later, by which time the whole framework and style of the book had changed.

During the winter of 1954–1955, Christopher and Don had moved into an apartment together. They still saw a lot of Marguerite (Lamkin) Brown, meeting several times a week, often over a splendid dinner. She meticulously kept the menus of those meals, but later cursed herself for not noting down the conversations as well. On January 22, she gave a large party for Tennessee Williams and, a fortnight later, travelled with him to New York to work on a production of *Cat on a Hot Tin Roof*. Christopher and Don flew to Philadelphia in March to see the play. Back in Los Angeles, the slap-up meals continued, and Christopher decided it was time he started exercising, to keep himself in shape.

While the shooting of *Diane* progressed, Christopher was working on a screenplay of the life of Buddha. An original script had been written by Robert Hardy Andrews, which Christopher used as a basis to fabricate his own highly inventive version. He took several liberties with the Buddhist legend, in order to make the story more workable dramatically. He introduced a pretender to the throne that the future Buddha was meant to inherit, someone who had every reason to try to fulfil the prophecy that the young crown prince would renounce his heritage and become a monk. Despite these flights of fancy, the film was intended to be fairly authentic, and was expected to be shot in India with Asian actors. But like so many other cinema projects, it fell though.

That summer, Christopher and Don took a temporary lease on a house on the beach at Malibu: 29938 Pacific Coast Highway. Then, in October, they left for a leisurely tour of Europe, which would be Don's first encounter with the Old World. They boarded an Italian boat in New York, which took them to Tangiers. There they called on Paul Bowles, who had made that still-wicked port his home.

Bowles had not seen Christopher since before the war and noticed how American he had become. It was a stormy night and Bowles's servant Ahmed gave Christopher a rather large dose of *majoun* before sending the visitors out into the gale. Christopher found himself totally disoriented and had an extremely unpleasant 'trip', having the impression that time had come to a stop. This gave him the idea of an ending for the original version of *Down There on a Visit*, in which the character Dante would be given the drug by a figure based on Aleister Crowley, and would then come to realise the difference between good and evil. Elements of this can be found in Isherwood's story 'A Visit to Anselm Oakes', reprinted in *Exhumations*.

For the first time in his life, Christopher next visited Italy which, until then, he had studiously avoided as the place that all the English loved. Italy was enjoying a marvellous Indian summer that November. Christopher and Don hired a car and drove through Tuscany. In Milan, they met up with King Vidor, who was making his epic version of *War and Peace*. They visited the set and made a home movie of it. To Vidor's annoyance, and his guests' delight, the Italian extras hired for the big crowd-scenes failed to take their work seriously, falling off bridges, fooling around and roaring with laughter. Later, Christopher and Don moved on to Venice, arriving in thick fog. They stayed in a vast suite in a grand hotel. When Christopher went to the window in the morning and looked out on the canal in the glorious pale sunlight, he burst into tears.

After quick stops in France and the Rhineland, they arrived in England in

January 1956. Don had to submit to the scrutiny of Christopher's London friends, but generally created an excellent impression. Apparently undeterred by his experience with *majoun* in Tangiers, Christopher decided to follow Aldous Huxley's famous example and try some mescalin. The pharmacist he went to had never heard of it, but was able to order some without a prescription. When Huxley had taken the drug, under impeccably scientific conditions, he had recorded its effects on his perception in minute detail. But Christopher took the mescalin in a much more slap-dash way and the result was disappointing. Under its influence, he walked into Westminster Abbey to see if God was there, but decided he wasn't. Subsequently, Christopher steered clear of hard and medium drugs, though in the 1960s and 1970s he did fall into the fashionable Californian habit of sharing a joint of hash after dinner.

He took Don up to Cheshire to meet his family. Kathleen was still going strong at eighty-seven. Richard – now a Rosicrucian – had become odder than ever, but was kept busy in a losing battle against damp and dirt at Wyberslegh Hall. He took Christopher over for a last, horrifying glimpse of Marple Hall. It looked like a gutted ruin, with its walls stripped of the ivy, and the windows staring black and empy. As the main staircase was now unsafe, Richard led him up round the back. They climbed over a bath-tub lying on the floor, and walked along a bare corridor to the drawing room, where a pink fireplace, brought back from Italy by Uncle Henry, was, remarkably, intact. But not even that was salvaged. Soon afterwards, Richard was advised to hand over ownership of Marple Hall to the local council, in case someone had an accident on the site for which he would be liable. The building continued to deteriorate and in 1959 was demolished.

Kathleen and Richard accompanied Christopher and Don down to London in March, where Kathleen suddenly became her old, animated, sociable self, despite her massively increased bulk and various illnesses. It was to be her last sight of the metropolis.

Back in California the following month, Christopher went house-hunting. Now he had the responsibility of a lover thirty years his junior, he decided it was about time he invested in some property, to give Don some long-term security. In May he found what he wanted: a small house at 434 Sycamore Road, Santa Monica, which had a front patio and a terraced garden on the hillside behind, stocked with sub-tropical plants, a banana tree, a magnolia and a Spanish bayonet. The street was at the bottom of the Canyon, near the beach. The Canyon had changed dramatically since the wartime era, as many members of the old European emigré community had returned home or died, or simply moved out of the area. Their replacements were mainly young

families who were looking for a comfortable life in the sun – politically conservative and intellectually mediocre. Christopher and Don stayed there only three years, before fleeing up the hill to get away from the noise of squealing children.

Unfortunately, Don came down with hepatitis when they were meant to be moving into Sycamore Road, and had to go into hospital. Christopher then developed symptoms as well, though mildly. This meant they were both forbidden alcohol for a year. Christopher was not too ill to get on with some work, however. Swami Prabhanavanda had been urging him for some time to write a biography of Ramakrishna. The idea did not enthral him, but he had promised the Swami three years earlier at Trabuco that he would take the project seriously once *The World in the Evening* was finished. He now started to get down to the research on Ramakrishna, mainly as a labour of his love for the Swami. Parallel to this he edited an anthology of English short stories for the American publishers Dell, and grappled once more with his 'Mexican' novel.

Don, in the meantime, signed up at art school, having given up an earlier aspiration to train to be an actor. Don's burgeoning artistic talent and dedication delighted Christopher and helped him to establish his own identity and some degree of parity within the relationship in the eyes of the outside world. As he told a Gay Pride gathering many years later, it was not always easy, especially in the early years, to be viewed by people as Mrs Christopher Isherwood.

The first draft of Christopher's Mexican novel was finished in November, by which time he was re-immersed in the film world. Jerry Wald at Twentieth Century Fox hired him to work on an adaption of Romain Rolland's vast novel sequence *Jean-Christophe*. While engaged on the project, Chistopher was introduced by Ivan Moffat to another writer working for Wald, Gavin Lambert, who was doing a script based on D. H. Lawrence's *Sons and Lovers*. Lambert was a great fan of Isherwood's and was working on a novel himself. They quickly became firm friends and would seek each other's advice. The bond was made even stronger when Gavin Lambert became interested in the teachings of Krishnamurti. He was a compact young man, with rather bird-like features. He did not give himself easily in conversation with strangers, but could be very amusing when relaxing with friends. Lambert lived in the Canyon until the 1960s, and became its most successful chronicler in the book *The Slide Area*. Another novel of his, *Inside Daisy Clover*, enjoyed success both as a book and as a film. Later, Lambert moved to Tangiers, joining the extraordinary literary colony there that included not only Paul and Jane Bowles, but William Burroughs and Alec Waugh. Lambert still visited

California from time to time, however, and Christopher appointed him to be his literary executor, in the event of Don and he dying simultaneously.

Natasha Spender, Stephen's second wife, was then in Southern California, staying for part of the time with Evelyn and Edward Hooker. One evening, the Hookers invited Christopher there for dinner with her and the novelist Raymond Chandler, with whom Natasha Spender had developed a close friendship. Chandler later wrote that he liked Christopher and felt at ease with him, but Christopher found the evening very tense. He had the impression that Chandler was anti-gay and this put him on edge. Normally affable and sociable, Christopher could bristle when he was with someone whose political or moral stance he found antagonistic. He was especially sensitive about homosexuality and personal loyalty. Although his temper had calmed since he started living with Don, he could still sometimes lose control. On one occasion he hit out at an underground film-maker, who sued him, though the case was settled out of court. Usually, when people offended Christopher's code of behaviour, he 'excommunicated' them instead.

In 1957, Dell brought out Christopher's anthology *Great English Short Stories*. This contained work by thirteen writers: Joseph Conrad, G. K. Chesterton, George Moore, H. G. Wells, E. M. Forster, Rudyard Kipling, D. H. Lawrence, Katherine Mansfield, Ethel Mayne, Robert Graves, Somerset Maugham, W. S. Pritchett and William Plomer. Originally, there were meant to be two more. But Christopher refused to agree to the conditions set by Conan Doyle's estate, which insisted on approving any comments Christopher made about the author's story. And the executors of Dylan Thomas refused permission to reprint his story, despite the fact that Christopher had helped escort the poet on a rollicking tour of Hollywood in April 1950. Christopher's London literary agents Curtis Brown tried to place the book in England, but all the publishers approached rejected it, on the grounds that the selection was too predictable.

On October 8, 1957, Christopher and Don left on a three-month trip that would take them right round the world. Initially, the idea had been to do a kind of pilgrimage to places associated with Paul Gauguin, Katherine Mansfield and D. H. Lawrence, which would have meant a sweep across the southern Pacific, taking in Tahiti, New Zealand and Australia. However, they modified this plan, perhaps partly because Christopher had had a health scare earlier in the year when a tumour had suddenly appeared on the side of his lower abdomen. This proved to be benign, but it gave him a shocking intimation of his mortality and reminded him how the age difference with Don would almost inevitably mean that he would have to leave him many years on his own.

They flew first to Hawaii and then on to Japan, where they spent a couple of weeks sight-seeing. From there they progressed to Hong Kong, which was so picturesque that Christopher wondered how on earth he could have been so dismissive about the place nearly twenty years before. A boat then took them on to Singapore and to Bali, where they doubled back to Singapore for a connection to the stunning Khmer temples at Angkor Wat in Cambodia, before moving on to Bangkok. On November 30, they flew from Bangkok to Calcutta, which for Christopher was rather like going to his spiritual home. Unfortunately, he had such bad stomach problems from a bug picked up in Bangkok that he had to restrict his wanderings there to the area directly associated with Ramakrishna. After a few days in a grand but grubby hotel, they were invited to stay at the simple, clean Vedanta guesthouse at Belur Math. Christopher was struck by the contrast between the squalor of the Indian environment, and the purity of the monastery itself.

This stay was extremely brief, however, as they left by plane for London on December 9. They spent Christmas and saw in the New Year 1958 in England in a mad whirl of parties and more intimate meals with friends like John and Beatrix Lehmann, before leaving for New York on January 12. By the end of the month, they were back in Santa Monica.

In April, Christopher learnt that Kathleen had had a stroke. There seemed no urgent need to go back to England as the doctor said her life was in no immediate danger. Besides, he was anxious to get on with the Ramakrishna biography, after his recent Indian experience. He began it with a long dissertation on how he had personally become involved with Vedanta, before rejecting this as far too egotistical an approach for a biography. The material was not wasted, however, as it was subsequently published as a separate booklet in 1963, under the title *An Approach to Vedanta*.

Christopher had hoped that a travel book might emerge from the round-the-world trip, for which Don could do the illustrations. As well as going to art school, Don was now taking private lessons from Christopher's former lover Vernon, who had established a career as an artist. And, in 1958, Don sold his first portrait, to Gerald Heard. But Christopher realised that they had not really done much more than be tourists in places that were well on the beaten track, with the exception of their brief experience of the Ramakrishna community, so the travel book project was scrapped. However, he was very keen to collaborate with Don, so together they dramatised *The World in the Evening* (which Christopher had started to refer to disrespectfully to friends as 'Whirled in the Evenink'). They showed the end result to Alec and Dodie Beesley, who were not impressed, and the script was put away in a drawer.

Christopher earned a little money by working with David Selznick on an abortive project on Mary Magdalene, but his mind was far more focused on trying to make some sense of his 'Mexican' novel. As he wrote to Edward Upward in mid-September:

> I have rewritten 72 pages to date. I think the detail of it is good in places and will amuse you, and there is far less sawdust than in World. My motto has been 'best trust the hate-filled moments', to paraphrase Masefield. But I am still sick with fear that [it] isn't really about anything at all. Just oddity for oddity's sake. I long to send you what I have written but I mustn't.

By December, the work seemed to be breaking up into two separate books, one largely autobiographical and the other mainly fantasy. Christopher realised that the only sensible way out was to jettison the fantasy and to concentrate on the more autobiographical approach, which he knew he could handle competently. Thus what was to become the novel finally published as *Down There on a Visit* began to take shape. It was to be in four parts, dealing with four clear-cut periods in Christopher's life, from 1928 to 1952. During the spring of 1959, he worked on the first episode, 'Mr Lancaster', based on his visit to Basil Fry in Bremen. He sent this to the *New Yorker* to see if the magazine would take it as a separate piece, but without success. John Lehmann in London was more enthusiastic, and published it in the October edition of the *London Magazine*, which he was now running. By then, Christopher was already well into the second section, 'Ambrose', largely based on his stay with Francis Turville-Petre on the Greek island of St Nikolas in 1932.

This didn't prevent him following a number of other avenues for collaborative work in 1959. Inspired by the success of *I Am a Camera*, he was convinced that there was money to be made from other spin-offs of his earlier works. Accordingly, he had been to New York in mid-April, to see if Wystan Auden and Chester Kallman – who were establishing quite a reputation as librettists – could help him do a muscial version of the Berlin stories. No backer was found, so the idea fizzled out.

Christopher put part of his new burst of creative energy down to the stimulating presence of Don. By now, Don was working on a fashion magazine and was showing what Christopher termed a kind of 'comic-glamorous' feeling for women which he was able to convey in his work. But it was portraiture that was fast becoming Don's artistic forte. Over the coming years, he produced a long series of line drawings of writers, artists and others,

which he ingeniously got signed by the sitter, rather than signing them himself. These included numerous studies of Christopher, as well as justly famous portraits of friends such as Wystan Auden and Joe Ackerley. One particularly successful drawing was of the actress Bette Davis, emphasising her ferocious mouth; she exclaimed, on seeing it: 'Oh yes! That's the old bag!'

That summer Christopher felt he really ought to go to see Kathleen, and took Don with him. She was now not only paralysed in one arm as a result of the stroke, but also blind in one eye, having refused to have a cataract removed. But her will remained indomitable. She asked Christopher if Vedantists believed in an after-life, to which he answered at least half-truthfully: yes. She said she was looking forward to seeking Frank again. There just had to be an after-life, she said, otherwise it was all just too *monstrously* unfair. Christopher thought to himself that he would never see her alive again and, indeed, she died in June the following year, telling Richard: 'Try not to mind too much.'

At the beginning of September 1959, after their visit to England, Christopher and Don spent a few days with Somerset Maugham at Cap Ferrat in the South of France. But Christopher was keen to get back to California, to finalise the purchase of a new house at 145 Adelaide Drive, Santa Monica, which was to be his home with Don for the rest of his life. This was an attractive bungalow of modest size, with a sun-deck overlooking the Canyon. Christopher had a study in the bedroom area, and a studio was later built onto the garage for Don. They decorated the house with pictures by their growing circle of artist friends, as well as some watercolours by Christopher's parents.

Christopher settled down into a fairly domestic existence which varied little for the next twenty years. Methodical and ordered, he would usually rise early for breakfast. This was a light meal, but sometimes featured health items like Tiger's Milk. Then he would write, or work on his diaries, before going for a late-morning swim down on the beach, returning in time for lunch. Quite often he would go to the local gym for a work-out, taking pleasure in the camaraderie and mixture of age-groups and types he found there. In the evenings, he and Don would often go out to the cinema, or to dinner at friends'. Small dinner parties were usually preferred to big affairs, because of their more intimate and brilliant conversation.

Unable to find lucrative work at the film studios, Christopher took the first of a number of short lectureships, on this occasion in the English department of the California State College. He gave twice-weekly lectures during term-time from September 1959 to May 1960, and concentrated on the output of his literary friends. He believed his role was to amuse rather than to

instruct, and he appreciated the irony of ending up as a college lecturer despite his flunking Cambridge University himself.

At the end of March 1960, he finished the 'Ambrose' section of *Down There on a Visit*, and sent it off to Stephen Spender who was then editing the magazine *Encounter* in London. Stephen cabled back that he thought it was marvellous, but then he procrastinated, sending a letter to the effect that he would not be able to publish it after all. Christopher was rather hurt and puzzled by this rejection and wondered whether someone at the *Encounter* office had been shocked by the story's explicit homosexuality. None the less, he was able to complete the third section, 'Waldemar', by the early summer.

In September 1960, Christopher took over from Aldous Huxley as Visiting Professor at the University of California at Santa Barbara, giving a series of lectures entitled 'A Writer and His World'. He found the experience rewarding. Many of the students held full-time jobs to finance their studies and were eager to learn and join in discussions. He was pleasantly surprised that there seemed to be no restrictions on freedom of speech. Even in the classroom the topics of conversation were wide and Christopher enthusiastically kept up with the burning political issues of the day. These included arguing the case against capital punishment.

During 1960, Christopher saw a lot of his next-door neighbours in Adelaide Drive, Charles Laughton and his wife Elsa Lanchester. Christopher had met Laughton the year before, and he and Don managed to see him play King Lear at Stratford-upon-Avon on their 1959 trip to England. Charles Laughton and Elsa Lanchester made an odd couple. She was so alert and alive and ever-ready to puncture pomposity, whereas he was slow, awkward and painfully self-conscious of his physical unattractiveness. To complicate matters, he had realised rather late in life that he was gay. The marriage survived this revelation, though he and Elsa began to lead increasingly separate lives. Laughton would surround himself with handsome young men, almost as if he hoped some of their good looks would rub off on him. Happily, he found a charming and loving young companion.

Christopher and Charles Laughton decided to write a play together, based on Plato's version of the life of Socrates. Laughton saw this as a testament to beauty, in which he would star. He had translated an Italian play on the same subject, but that proved to be of little use. They were searching for a more informal, improvised format. Initially, Laughton proved to be a poor sight-reader of the material Christopher was producing, but soon he had it under control. They laughed a great deal and frequently broke off from their serious work to indulge in comic readings and buffoonery. On one occasion, Laughton read from the Book of Job, in which he made God sound like a

Nazi Gauleiter and Job a stage Jew. Sometimes, however, there were clashes. As Christopher told Laughton's biographer Charles Highman:

> Elsa, in the kindness of her heart, used to try and warn me not to be victimised by Charles, and I always replied that, after all, I'm a monster, and quite able to take care of myself with other monsters – such as Charles undoubtedly was. And as I told her, monsters are very loyal to each other in their own peculiar way. And she wasn't to be afraid that either was going to eat the other.

Unfortunately, Laughton was struck down first by a gall-bladder problem and then a heart attack. The illnesses, growing despair and a trip to the Far East prevented him finishing the project with Christopher.

The Ramakrishna biography had started appearing in instalments in the Vedanta Society magazine in 1959, and was to do so for the next five years. Already by 1960, Christopher was weary of it, as he told friends like Alec and Dodie Beesley. He got infinitely more pleasure out of the novel *Down There on a Visit*. Just before Christmas 1960, he was able to write to John Lehmann that the book was largely finished, though he still had some revision to do on the last section, 'Paul': 'I can only tell you that I feel far fewer misgivings than I did about *Whirled in the Evenink*. This, for better or worse, is me.'

In January 1961, Don left to take up a six-month scholarship at the Slade School of Fine Arts in London. There he studied under Sir William Coldstream, an old friend of Christopher's. He lodged at Richard Burton's home, while the actor was away in New York. Christopher had to stay in California until early April, lecturing and reworking 'Paul'; then, he joined Don in England, staying till October. He took part in a number of radio and television programmes, including an interview by Edward Upward for the BBC. He also travelled up to Cambridge to see Morgan Forster, who was now living a quiet and rather secluded life in University rooms in Cambridge. Forster was now eighty-two and feeling tired of life. He told Christopher pathetically that he now felt out of things and could not work, and hoped that he would 'pop off quickly'.

Christopher hoped to find some work in London. One suggestion was a film script of his cousin Graham Greene's *England Made Me*. But the project fell through, as did Tony Richardson's idea of staging the mooted Auden-Kallman musical of Christopher's Berlin stories at the Royal Court Theatre. Instead, Christopher found himself having to concentrate on the 'Paul' episode of his novel again, as his American publishers Simon and Schuster

had written to him in July saying they felt it hung together less well than the other three sections. Initially, he refused to make substantial changes, but he had a change of heart in October, removing the part dealing with the narrator's visit to 'Anselm Oakes'.

The novel as finished was the swan-song of Isherwood's affair with his dummy narrator. Finding the right tone for the Christopher Isherwood figure in the book had proved to be his greatest problem, but he had resolved it triumphantly. 'Christopher' is no longer a mere observer, though he maintains a brilliant faculty to sum up people in a few astute and often damning phrases. He is a full participator in the action, playing off the other characters against each other while, at the same time, revealing many facets of himself, as he develops over the years. The book is not all factual by any means, but then Isherwood never believed that only fact is true. In the opening pages of 'Mr Lancaster', he summarised his current perspective on the old Christopher:

> . . . before I slip into the convention of calling this young man 'I', let me consider him as a separate being, a stranger almost, setting out on this adventure in a taxi to the docks. For, of course, he *is* almost a stranger to me. I have revised his opinions, changed his accent and his mannerisms, unlearned or exaggerated his prejudices and his habits. We still share the same skeleton, but its outer covering has altered so much that I doubt if he would recognise me on the street. We have in common the label of our name, and a continuity of consciousness; there has been no break in the sequence of daily statements that I am I. But *what* I am has refashioned itself throughout the days and years, until now almost all that remains constant is the mere awareness of being conscious. (pp 13–14)

The Christopher of 'Mr Lancaster' is a self-conscious young rebel, fuming against the older generation, and in particular Mr Lancaster himself. By the time he reaches the island of St Gregory in 'Ambrose', Christopher has sunk into torpor and indecision, drowning his uncertainty in alcohol and sunshine. In 'Waldemar', he has gained a new hardness and a self-avowed calculation:

> How do I appear to my friends and acquaintances? To judge from the jokes they make about me, they see a rather complex creature, part despot, part diplomat. I'm told that I hold myself like a drill sergeant or a strict landlady; I am supposed to have an overpowering will. [Wystan Auden] compared it once to a fire hose before which everybody has to retreat. Then again they say I'm so sly; I pretend to be nobody in

particular, just one of the gang, when all the time I have the arrogance of Lawrence of Arabia and the subtlety of Talleyrand. Oh, yes – and I'm utterly ruthless and completely cynical. But I do make them laugh. (p 152)

The reader should be very wary about accepting such self-portraits at face value. Because there are so many familiar landmarks taken from Isherwood's life in *Down There on a Visit*, it is easy to be seduced into thinking that it is all autobiographical, lightly dressed as fiction. But even at this stage, Isherwood was not being honest about Christopher's involvement – especially sexual – with the other characters. The 'Waldemar' section is the most misleading of all. Although it draws heavily on Christopher's experiences with both Otto and Heinz, the character Waldemar is neither of them, and his fiancée is a pure invention.

The Christopher of the 'Paul' episode is suddenly much older, full of responsibilities and groping awkwardly towards spirituality. As in reality, America shows itself to have been the major turning-point of the narrator Christopher's life. The section's inclusion gives the whole book the flavour of a portrait of transition, which accounts for much of its fascination. When *Down There on a Visit* was finally published as a complete novel in 1962, several critics commented on what they considered to be its preoccupation with sex. But this is a mistaken emphasis, as the novel is not about sexual deviation any more than any other Isherwood books are. What it is is a study of a maturing individual moving through a world of people who are unable to communicate with each other. The theme is profoundly sad, but the treatment is often very funny. Of all the reviews, perhaps that by Stuart Hampshire in *Encounter* was the most perceptive:

> The hero's defensive tactics – and the substance of his heroism – have been evasion; he keeps on the move; for he is perpetually on a visit, and has never stayed long enough to compromise, and to settle down with the enemy. He recounts four of his visits here; for the hero is always a writer before he is anything else.

What Stuart Hampshire could not know – and probably Christopher himself did not yet fully realise – was that the appearance of *Down There on a Visit* marked the end of his life of visits. Even though he travelled quite widely during the remainder of his life, to all intents and purposes he had now settled down. What's more, he had enough experiences under his belt to provide material for the rest of his literary days.

13

1961–1966

C hristopher had suggested to the University of California at Santa
Barbara that he ought to include American authors, as well as British
ones, in his contemporary literature classes, but they insisted he stick
to what they considered to be his home ground. Despite his American
citizenship, and his having been made a member of the US National Institute
for Arts and Letters back in 1949, he was still viewed by the American
literary establishment as a British writer. Accordingly, his syllabus embraced
Kingsley Amis's *Lucky Jim*, William Golding's *Lord of the Flies*, Shelagh
Delaney's *A Taste of Honey* and John Osborne's *Look Back in Anger*.

In the Christmas break from the courses, he flew to New York to join
Don, who was back from England. They stayed with Julie Harris. An
exhibition of Don's portraits opened in the New Year and was such a success
that he decided to stay on in New York for a while, to complete new
commissions that arose from the show. Christopher returned alone to Santa
Monica, where the germ of a new novel began to stir. The central focus was
to be on a father–son relationship, which had always interested him greatly,
even though he had no wish to have children of his own. He often declared
that he *felt* like a father to some of the boys with whom he had been involved.
The fact that these relationships were sexual was not a problem, as the concept
of homosexual incest appealed. In fact, nothing materialised from his
ruminations about the father–son book, but Christopher did continue mulling
over the literary possibilities of an incestuous brotherly relationship.

By late spring 1962, he was thinking more in terms of a short novel,
provisionally entitled *An Englishwoman*. In it, the character 'Christopher
Isherwood' would be a teacher on a California University campus. He meets
the heroine Charlotte (the eponymous Englishwoman) through her son, who
is in one of his classes. She is a GI bride whose husband has left her, and
her son tries to get 'Christopher Isherwood' to persuade her that his own

wish to go off and live with a girl is not another form of desertion. After only three months of work on the book, Christopher was having grave doubts about it, though he thought it might give birth to something else.

In the meantime, he was thrilled when Don announced one day in June that he wanted the Swami to give him a mantra. Don had been looking into Vedanta for some time, but Christopher was determined not to be seen to be pushing him towards it. The Swami liked Don and agreed to give him a provisional mantra. Don discussed this with Christopher on July 9, at Los Angeles airport, while waiting for a plane to take him to New York for another exhibition. Don wondered whether this would lead him into the life of a devotee, and Christopher was not sure whether to be delighted or miserable. Having already had a rather mixed experience with Vernon and Vedanta, he wondered whether this would bring Don closer to him or drive them apart. In the end his anxiety proved groundless. Don was initiated by the Swami in December, receiving his 'permanent' mantra then, but he kept his feet firmly in the material world of his art and his relationship with Christopher.

Throughout that summer Christopher experienced bouts of depression, partly due to the realisation of his own advancing age. A fortnight after his fifty-eighth birthday, he wrote to Edward Upward:

Melancholia is the occupational disease of us oldies. Senile melancholia is quite different from the romantic melancholia of the young. I am rather lucky, in that a doctor told me long ago that I suffer from pyloric spasm, a flap in the vagus nerve at the entrance to the stomach; so, whenever I find myself thinking 'what's the use?' I firmly remind myself of the physical cause. Or I try to. It is very insidious. The Hindu concept of dharma helps: one employs one's talents because one has them, not in obedience to some external Power but because of the obligation which the talents impose. I find I can make this argument stick, most of the time. Though it is dangerously apt to turn into a sort of stoic masochism: *fais énergiquement ta longue et lourde tâche. Tâche* suggests a taskmaster, so you become a groaning slave; whereas dharma can only be obeyed by an act of free will. It does seem to me too that all occupations are symbolic, or rather that their fruits are quite other than they appear to be. It isn't really the finished novel that matters but something that happens to [you] while you are writing it.

Christopher's musings about the significance of life and death were heightened by a visit on November 29 to the Cedars of Lebanon Hospital,

where Charles Laughton was dying of cancer. Laughton was sleepy and in evident pain, and asked his visitor: 'The preoccupation is with death, isn't it?' Christopher held Laughton's hand as he kept dozing off, and prayed to Ramakrishna to help him through his suffering. 'Do it for Brahmananda's sake,' Christopher prayed, 'for Vivekenanda's sake, for Prabhavananda's sake.' And then he realised with a jolt that his ego was telling him how wonderful it would be if Laughton died peacefully at that moment in his presence.

The following months, the 'baby' of *An Englishwoman* began to take sudden shape. Christopher himself would become the central figure, though transmuted into a different person, 'George'. Excitedly, through 1963, Christopher realised that the book was turning into the best thing he had ever written. George is no longer the narrator of the novel, as in the original concept, but is closely observed through a single day in his life. He is Christopher's age, an English expatriate lecturer, living in Santa Monica, and is homosexual. He is seen going through the deliberate, everyday activities of a man on the borderline of old age, staring at himself in the mirror, sitting on the loo, and painfully recalling the death of his lover, with whom he shared the house that he still inhabits.

George lives out Mortmerish aggression fantasies as he drives at a furious pace along the freeway to his college. He is a charming, soggy liberal, quietly militant about homosexual rights in thought if not in word. He is probably considered an amusing and harmless old thing by his students, whose youth and beauty gently stir his desire and make his day more enjoyable. George prides himself on being in better shape than his peers when he has a work-out at the gym, and is capable of a bit of spontaneous fun by going for a late-night swim when one of his students turns up in a gay bar. But he ends his day alone in bed, drunk and with no consolation but a handkerchief into which to masturbate, and the knowledge that one night, perhaps that night, he will die.

A Single Man (for which Don suggested the title) is indeed Isherwood's masterpiece, though it has never enjoyed the wide popularity of his Berlin novels. Inevitably, when it was published the following year much of the attention it gained was because of its homosexual theme. Yet it is not a novel *about* homosexuality. Rather, it is the story of a solitary individual with one foot in the grave. It is a study of a form of survival – the playing at life by a man who has lost, both his youth and the one person who could give him true happiness. By chance, this individual the reader follows belongs to the homosexual minority. But, equally importantly, George belongs to other minorities as well. He is one of the living, as opposed to the dead. He is an

educated man in a philistine world. And he is still rooted in his English past, in contrast to the overwhelmingly American Americans around him, whatever their names or ethnic origins.

George is aware of the political significance of minorities, but he is not blinded to their true nature by sentimentality or guilt. As he tells his students in class one day:

> Now . . . people with freckles aren't thought of as a minority by the non-freckled. They aren't a minority in the sense we're talking about. And why aren't they? Because a minority is only thought of as a minority when it constitutes some kind of threat to the majority, real or imaginary. And no threat is ever *quite* imaginary . . . Minorities are people; *people*, not angels. Sure, they're like us – but not exactly like us, that's the all-too-familiar state of liberal hysteria, in which you begin to kid yourself you honestly cannot see any difference between a Negro and a Swede . . . So, let's face it, minorities are people who probably look and act and think differently from us, and have faults that we don't have. We may dislike the way they look and act, and we may hate their faults. And it's *better* if we admit to disliking and hating them, than if we try to smear our feelings over with pseudo-sentimentality. If we are frank about our feelings, we have a safety valve, we're actually less likely to start persecuting.

During the war, the minority with which Christopher was most directly concerned was the community of exiled European Jews. Yet even though he identified with their suffering, and had been called an 'Honorary Jew' himself, he could never *be* a Jew. Since then, the all-important minority for him had been the homosexual one. From the 1960s on, he identified himself increasingly publicly with it. He was particularly pleased gay men *are* a minority, and stated repeatedly that were homosexuals ever to become the majority, he would become heterosexual. However psychologically unconvincing that might sound, the intention behind it was sincere. Interestingly, it echoes Graham Greene's affirmation that in a capitalist society he (Greene) would be a Communist, and in a Communist one a capitalist.

A Single Man gives only the minimum necessary description of the local gay subculture, as that forms only a small part of George's current life. Christopher himself, though, was by no means unfamiliar with the haunts of gay Los Angeles, or with the development of homosexual literature. In the summer of 1963, when the first draft of *A Single Man* was ready, he was reading William Burroughs's *The Naked Lunch*, and he had been instrumental

in getting John Rechy's novel of LA hustlers, *City of Night*, published. John Rechy had become a good friend in the process, though relations later soured temporarily over what some people considered to be his tasteless portrait of Christopher and Don in a later, lesser novel called *Numbers*. However, Rechy considered himself to be Isherwood's protégé, and retained a great admiration both for the man and for his work.

Christopher's teaching duties were of course helpful in providing substance to the college scenes in *A Single Man*. In April and May 1963, he gave three significant lectures at the University of California at Berkeley, entitled 'The Autobiography of My Books'. Originally there were just going to be two talks, but so little ground had been covered by the end of the first that an extra one was scheduled. Students were invited to join him in the faculty office afterwards, if they wanted to carry on a probing discussion. The lectures gave Christopher the opportunity to try out on a young and critical audience something which had become an increasingly attractive prospect for him: a deeply researched reappraisal of his own experience and its relationship to his published work. This was to be the major task of the rest of his life.

During the summer of 1963, he had a car accident, which nearly brought things to an abrupt end. His little Volkswagen collided with several large American automobiles, resulting in a broken rib and a huge repair bill. A few months later, Christopher was picked up by the police for drunken driving but, fortunately for his mobility, he did not lose his licence.

At the beginning of November, Christopher was back at the Cedars of Lebanon Hospital, visiting another friend dying of cancer: Aldous Huxley. Huxley had turned into a withered old man, grey-faced and with dull black eyes. His low, hoarse voice was hard to understand. But unlike Charles Laughton, Huxley did not want to talk of death. Instead he commented perceptively on the wide variety of subjects that Christopher brought up in order to break the silence. As Isherwood recalled later in *My Guru and His Disciple*, Huxley gave him the impression of a great noble ship sinking quietly into the deep, all its lights still shining. Huxley passed away on November 22, the same day that President Kennedy was assassinated. In accordance with his wishes, there was no funeral ceremony as such; the day after his body had been cremated, Christopher joined family and intimate friends for a walk along Huxley's favourite route round the Hollywood Reservoir. Christopher later contributed to a memorial volume, edited by Julian Huxley.

Shortly before Christmas, Christopher flew with Swami Prabhanavanda via Tokyo to Calcutta, to take part in the centenary celebrations of Vivekananda's birth. They stayed at Belur Math, which seemed more delightful than Christopher remembered it, possibly because for once on long travels, his

digestion did not collapse. The grounds of the monastery were crowded with visitors, and the celebrations lasted a whole year. Christopher was interviewed in the local press and attended the Parliament of Religions in Calcutta. There he made a speech to a large assembly, wondering how much of it the local people could actually understand. He also had talks about his nearly-completed Ramakrishna biography with Vedantist leaders, whose attempts at chapter-by-chapter censorship he deeply resented.

On January 7, 1964, Christopher boarded an overnight flight from Calcutta to Rome. There was a party of loud Australians on board, which made it hard for him to sleep. But anyway his mind was busy evaluating this second visit to India, and he realised the seed for a new novel had been sown. It dawned on him that he could resurrect some of the abandoned Mexican material from the original draft of *Down There on a Visit*, and transfer it to India. In particular, he was thinking of a dialogue and confrontation between two people, which would now be linked to the decision of a Westerner to become a Vedantist monk. This would enable him to retain his earlier intention of portraying a meeting of two worlds, rather like Jesus and Satan's encounter in the wilderness. A line from Byron's 'The Vision of Judgement' had stuck in his mind: 'Between His Darkness and His Brightness there passed a mutual glance of great politeness'. From this, the novel *A Meeting by the River* would grow.

Christopher visited Gore Vidal in Rome but, by January 24, was back home in California. He was looking out for film work again, and had high hopes of his friend Tony Richardson, who had had an enormous success with *Tom Jones* the previous year. In the meantime, Christopher polished the final sections of the Ramakrishna biography. And he was prompted, by an admirer's suggestion that a book of his uncollected articles and stories would be a good idea to undertake, into editing such a volume himself. This enabled him to engage in another exercise in straight autobiography, by writing linking passages explaining the context of each piece. With tongue in cheek, he called the resultant book *Exhumations*.

In March, Tony Richardson came up trumps. He had agreed to direct *The Loved One*, a film version of Evelyn Waugh's mordant study of death, California-style. Originally, Jessica Mitford, author of *The American Way of Death*, had been approached to write the script, but she had turned it down. Christopher and Terry Southern were then signed up to do the script and were asked to be on the set during the shooting of the film, for last-minute dialogue changes. Terry Southern was in fact responsible for the lion's share of the screenplay, though Christopher wrote the scene in the chapel, where a wedding is transformed into a funeral. He did not particularly like Waugh's

novel, feeling it betrayed a British snobbishness about life in California. And he considered the hero a boring heel. But he enjoyed being involved in the making of the film enormously. The cast included John Gielgud, Rod Steiger, Dana Andrews and James Coburn. Christopher himself can be glimpsed fleetingly in the film, as one of the mourners at the funeral of the character played by John Gielgud. The finished film itself was quite a laugh, though many critics panned it as a travesty of Evelyn Waugh's book.

That spring saw the beginning of an important new friendship for both Christopher and Don. A mutual friend introduced them to the young British artist David Hockney, who had arrived in Los Angeles thrilled and frightened. He rented a room overlooking the sea, at Venice, next to Santa Monica. The rapport Hockney felt with Christopher and Don was instant. They would invite him round to Adelaide Drive or take him out to dinner. As Hockney later told his literary collaborator Nikos Stangos, early on in the friendship Christopher exclaimed excitedly: 'Oh David, we've so much in common! We love California, we love American boys, and we're both from the North of England!' Hockney wondered wrily what a working-class lad from Bradford had in common with the scion of a rather grand family from the other side of the Pennines. But Christopher was the first writer he admired whom he had ever met, and Hockney thought he was lovely.

In July, Christopher was hard at work on another script for Tony Richardson, based on Carson McCullers' *Reflection in a Golden Eye*. The novel is itself very visual, so he was able to follow the original closely, and had the whole thing finished by September. However, Richardson then decided not to direct the film after all. John Huston took over the project – most successfully – but commissioned a different script.

In October, Christopher took on a third commission from Tony Richardson, to do the screenplay for *The Sailor from Gibraltar*, based on a novel by Marguerite Duras. Jeanne Moreau had persuaded Richardson to do the film, with her in the leading female role. Her co-stars included Venessa Redgrave and Orson Welles, but even they could not save the film from being a flop. Christopher spent about four months working on the script, which was then polished by Don Magner. But it was not something to remember with pride.

While Christopher was busy with these films, Don Bachardy prepared and held new exhibitions in both San Francisco and New York. They went together to New Mexico for Christmas, and early in 1965 Don made a trip to Egypt. Christopher could not accompany him, as he had taken on a new academic appointment as Regent's Professor of English at UCLA, from February through to early summer. The lectures he prepared were an expansion of his talks at Berkeley, and laid the foundations for the first

volume of what to all intents and purposes were to be his memoirs, *Kathleen and Frank*.

Ramakrishna and His Disciples was published that spring, being greeted by a chorus of puzzlement and derision. As one reviewer put it: 'It is still a bit difficult to regard Herr Issyvoo as guru-fancier.' Used to Isherwood's ironic touch, the critics found the straightforward credulity with which he described the exploits of Ramakrishna and his followers both boring and colourless. Several took the opportunity to take another swipe at sunbelt swamis.

Angry but unbowed, Christopher pressed on with *A Meeting by the River*, the second draft of which was finished by the summer. Christopher described the plot to an East Coast correspondent, Marshall Bean, with whom he had a lengthy exchange of letters, mainly about spirituality and death:

> Basically, there are two brothers – Patrick and Oliver. Patrick is very successful and a rather unusually imaginative and intelligent business man. Oliver is a social worker, admirable, energetic, capable and a bit of a puritan, who has spent his life in the Red Cross, the Friends Service Committee and suchlike. Suddenly Oliver meets a Hindu monk, goes to India, joins a monastery there and prepares to take his final vows. Patrick visits him. It now develops that the brothers have a strong emotional relationship, much love, much hate, and, in addition, Oliver as the younger brother can't help depending on Patrick's approval. He *wants* Patrick to tell him that it's all right for him to become a monk, and of course Patrick disapproves, and tells him so. And then Oliver tells Patrick that Patrick's way of life fills him with horror. Neither one will back down. Yet at the end, when Oliver has taken the final vows, the brothers are reconciled, because their love turns out to be stronger than their prejudices. They part again, agreeing, as it were, to think each other wrong, ridiculous and lovable.

Christopher was still not satisfied, however, and started on another draft. He was still working on it in the spring of 1966, by which time he had begun teaching at the Riverside campus of the University of California. There he was perturbed by the militancy of some of the students in their campaigning against the Vietnam war. Though he approved of their stand, Christopher was upset by the violence of the confrontations with police and national guardsmen. The atmosphere was hardly conducive to injecting serenity into his novel. In the meantime, he agreed to follow Edward Upward's suggestion to heighten the tension between the two brothers in the book. Trying to ignore

the arthritis which had now begun to plague him, Christopher finished the third and final draft of the novel in June. He sent a copy to John Yale, one of two young Americans who had become monks during Christopher's last visit to India. Yale was now living at the Vedanta Centre outside Paris, under the name Swami Vidyatmananda, and he gave Christopher useful information and criticism. Edward Upward also made some further suggestions. Christopher's publishers were happy with the book when he sent the amended typescript on to them.

The novel is in the form of a series of extracts from the diary kept by Oliver, (who is just about to become a swami in an Indian monastic order), interspersed with letters from his brother Patrick to their mother, his wife and his young male lover Tom. A crisis is reached when Tom telephones hysterically to the monastery, and Patrick confesses his homosexual affair to Oliver. Patrick expects and hopes that Oliver will tell him to remember his duty as a family man, and turn his back on the clearly infatuated youth. Instead, Oliver says that he believes it would be more honest if Patrick were to honour his duty to his wife by leaving her, but providing her with generous alimony, and then by following his heart by starting a new life with Tom. Patrick, being a Truly Weak Man, instead goes back to his forgiving wife and family and ditches the young man. Oliver meanwhile passes through a moment of last-minute spiritual doubt. But because of his belief in, and love for, his deceased guru, he is able to go through with his final vows. The two brothers part lovingly.

The relationship between the two brothers and their inevitable confrontation are the core elements of the book. Both of them are aware of the emotional and physical possibilities of an intense brotherly love, though neither of them would admit it. In his diary, Oliver confesses that in what he calls his Freudian phase, he wondered if he wasn't actually in love with Patrick, romantically and physically. Patrick subconsciously flirts with Oliver, through his brilliant smiles and by unashamedly exhibiting his powerful, well-endowed body to him. But his incestuous longings are directed more towards his temporary boyish lovers, of whom Tom is not the first nor, the reader feels, the last. A telling letter from Patrick to Tom includes a passage that seems to come straight from Isherwood's own heart:

Tommy . . . I'm certain that *you* could be my brother – the kind of brother I now know I've been searching for all these years, without even quite daring to admit to myself what it was that I wanted. I suppose I was frightened off by the taboos which surround the idea of brotherhood in the family sense – oh yes, they encourage you to love

your brother, but only as far as the limits they've set – beyond that, it's a deadly sin and a horror. What I want is a life beyond their taboos, in which two men learn to trust each other so completely that there's no fear and they experience and share everything together in the flesh and in the spirit. I don't believe such closeness is possible between a man and a woman – deep down they are natural enemies – and how many men ever find it together? Only a very few even glimpse the possibility of it, and only a very few out of that few dare to try to find it. (p 109)

In a letter to the present writer, Isherwood said that he was far more Patrick than Oliver, though he understood Oliver more than Patrick did. Like Patrick, Christopher focused his 'incestuous' desires not on his real brother, Richard, but on 'adopted' younger brothers, of whom Don was the supreme example. For Christopher *was* one of the very few out of the few who understood the possibilities of 'brotherly' closeness who dared to search – and found it.

It is tempting to see *A Meeting by the River* as an allegory of the conflict between sexuality and spirituality. Symbolically, neither side is the victor, nor the vanquished. Both must continue to exist and can learn something from each other. Yet if the novel was really intended to deal with what the French would call a *grand sujet*, then its length and depth are insufficient. The characters, both as people and as symbols, are not exhaustively portrayed, which helps to give the book a delightfully worked but unavoidable slightness. This left many critics intrigued but dissatisfied. However, Christopher received the accolade which meant more to him than good reviews. He had been worried how Swami Prabhavananda would react to the sexuality in this novel, the last that he would write. But the Swami phoned him when he had finished reading it and told him the last scene had left him with two tears running down his cheeks.

14

1966–1986

In July 1966, soon after completing the final draft of *A Meeting by the River*, Christopher received the first offer to work for television, from a director friend of his, Daniel Mann. The assignment was to script part of a Christmas Special, dealing with the early nineteenth-century origins of the carol 'Silent Night'. It was the sort of commercial project which raised John Lehmann's eyebrows, as he wondered just what Christopher would agree to do next. But Christopher took it very seriously. It involved a short trip to Austria in September, where the TV film was shot, enabling him to look up Gottfried Rheinhardt, who had settled near Salzburg. From there he went to London, staying with Stephen Spender, before joining Richard at Wyberslegh.

Christopher suggested they go over to the site of Marple Hall, but Richard thought the idea too upsetting. So Christopher hired a taxi on his own. The entrance gates to the park had gone and new houses had been built near the main road. Where the old Hall had stood, there was now a modern grammar school, surrounded by playing-fields. As the taxi-driver waited impatiently, Christopher wandered round looking for some sign from the past. Eventually he came across the headstone from the doorway, inscribed 'H.B. 1658', lying in the grass. As he recalled in *Kathleen and Frank*:

> There was no grimness or sadness today. Christopher felt wonderfully joyful. For him this certainly wasn't the end of an ancient enemy but it did seem to be the lifting of a curse. Whatever here had exercised an evil power seemed appeased now and buried.

Part of that 'evil power' comprised the responsibilities and expectations of Christopher as heir of Marple Hall, which he had so emphatically rejected. Paradoxically, now that the ghosts were laid to rest and the physical evidence

of his weighty ancestral history was obliterated, he was able to turn to the past and review it afresh, largely as an exercise in understanding himself.

Christopher returned to California on November 2, and completed his script for *Silent Night*. In the finished programme, very little of what he wrote remained, and the director had added a sickly coda of Kirk Douglas standing outside the United Nations building in New York with children of different races, singing the carol. Christopher tried, unsuccessfully, to get his name removed from the credits.

Even more irritating was the opening that month in New York of Hal Prince's musical version of *I Am a Camera*, starring Joel Gray and Lotte Lenya. Christopher had no control over the show or input into it, and friends who saw it urged him to stay away. Not only was Sally Bowles made pregnant by the 'Christopher' in the show, but Fraulein Schneider had acquired a Jewish lover. The tiny percentage of the proceeds which Christopher received as royalties nowhere near made up for his frustration and anger. A later English stage version, starring Judi Dench, was equally far from the original source material and again his friends begged Christopher to keep well clear. As Edward Upward wrote pungently: 'It's an ill bird that fouls the nest where the golden eggs are laid. Especially when the nest is anyhow made entirely of sawdust and shit.'

Christopher drowned his sorrows over Christmas 1966 at boisterous parties given by Tony Richardson and Vanessa Redgrave (whose marriage was shortly to be dissolved). Then he buckled down to the new book. The original concept was rather different from the published version of *Kathleen and Frank*. It was to be written entirely in the present tense, skipping backwards and forwards in time, showing the influence of various characters and acts by his parents on Richard and himself. The book was to open with an extract from a letter which Frank had written to Kathleen in 1902, telling her about his researches into esoteric Buddhism. As Christopher explained in a letter to Marshall Bean, dated January 19, 1967:

Then, after quoting this, I jump to the Fall of last year, when I am visiting my Brother in England and we are sitting reading through this and other old letters. And my Brother Richard remarks that they make him see our Father in a quite different light – he has always felt rather hostile to him but now begins to realise that he was a very sympathetic person!

This method of revelation proved unsatisfactory, however, so Christopher switched to a more conventional chronological approach, albeit still using

some flash-backs and references to his own later life. He told another correspondent, Alan Clodd, that he had thought of calling the autobiographical project 'Hero Father, Demon Mother', and that it would be a Jungian study of the main characters in his own mythology.

He completed a first draft that spring, but then realised that he needed to return to England to get his mother's side of the story, as recorded in her diary and letters. This fitted in quite neatly, as he wanted to be in London anyway for the launch of *A Meeting by the River*. Publication of the novel was originally scheduled for April, but was then put off to June 1. Christopher arrived there early in May, and gave an interview to the *Evening Standard*. In it he spoke of the new work in progress and reaffirmed his intention of staying in America, unlike Wystan Auden, who was spending increasingly long periods in Europe. Interestingly, Christopher referred to America as the only home he had ever had. He also said that America needed him more than England, because of his interest in civil liberties. He managed to see several old friends while he was there, including Morgan Forster and Joe Ackerley; the latter died while Christopher was still in England.

Up at Wyberslegh, he found huge quantities of archive material about his parents and arranged for it to be transported over to California. He then spent over a year laboriously working through Kathleen and Frank's diaries and papers, acquiring an entirely new understanding of his mother in the process. He realised that the focus of the book would have to change, being less on himself, and more on her. In the process, Kathleen was transformed from a monster to a rather noble being – full of faults, certainly, but brave and creative and loyal.

Christopher was able to share some of the excitement of this reappraisal with Wysten Auden, who came to stay at the house in Adelaide Drive in February. Wystan had complained bitterly to John Lehmann that he had felt neglected by Christopher over the past few years, partly because Christopher was getting less conscientious about keeping up correspondence with old friends. But face-to-face they got on famously again. Though just sixty, Wystan had taken on a monumental appearance, in keeping with the enormous literary standing he had acquired. Christopher thought his face looked so ancient, with its extraordinary deep, expressive lines, that it really belonged in the British Museum. Wystan himself said it looked like a wedding-cake left out in the rain. He was dressed even more shabbily than ever, slopped food and drink down his clothes and had become obsessive about getting to bed early.

In August, Christopher and Don went to see Gerald Heard, who had joined the disquietingly long list of friends suffering unpleasant deaths. He had had

a stroke the previous year, followed by others, and when Christopher and Don saw him he was very weak. Their presence seemed to cheer Gerald up, however, and he started laughing weirdly but rather wonderfully. He made Christopher think of Ramakrishna, joyfully describing a vision he had had. But he noted in his diary that day: 'What awful *toil* dying so gradually must be'. It was another four years – after over thirty strokes – before Gerald finally passed away.

As a counterbalance to his elderly and departing friends, Christopher was getting more and more integrated into a network of far younger men, many of whom were artists. This was largely due to Don, but also reflected his growing status as a sort of guru-uncle to a new generation of artistic and literary homosexuals. Many were introduced by mutual friends. Others wrote to him, and some simply phoned up out of the blue. Christopher deliberately made himself accessible by keeping his telephone number listed in the Los Angeles directory and he was extraordinarily generous with his time.

One of those younger pals, David Hockney, celebrated both their friendship and Christopher's special relationship with Don in a justly famous joint portrait, painted in the first half of 1968. Don was away for much of this time, so Hockney had to do his side of the portrait largely from photographs. Christopher would drop by at Hockney's studio and complain how much he was missing Don, though he was determined not to prevent him leading his own life. The finished portrait is a stunning achievement, and was acquired by Marguerite Lamkin (now remarried), who gave it pride of place in her house in London. Hockney was then living with the beautiful young Peter Schlesinger in Santa Monica, and was seeing a lot of his fellow artist Ron Kitaj, who was teaching at Berkeley, near San Francisco. When Kitaj said he was a fan of Christopher Isherwood's, Hockney arranged for them to meet over dinner at his place. Kitaj – an avid book collector – arrived bearing a pile of Isherwood first editions for Christopher to sign, including a copy of *Lions and Shadows*. Looking at the photograph in it of Christopher aged twenty-one, Hockney was struck by how little he had changed.

Anxious to work together with Don on a successful project, Christopher suggested they turn *A Meeting by the River* into a play. As he wrote to Edward Upward on November 30:

It is very interesting work, turning a novel into a play; I'm learning all over again those truths we used to preach about the dangers of describing your efforts instead of creating them. And then one falls in love with a bit of literary dialogue and has to admit painfully that it isn't dramatic dialogue. I think we shall at least get it a try out here

and I believe it may reach England in due course. The great difficulty here is that it demands two really good young English actors.

Several of Christopher's friends who read the script thought the play was a great improvement on the novel. And for a while it looked as if it might get its first production in England, in the autumn of 1969, at the Royal Court in London, thanks to that theatre's connection with Tony Richardson. The dancer Christopher Gable agreed to take on the role of Oliver; Christopher and Don had been keen to use him after seeing him in a televised version of the life of Delius. But the production never happened. Far more successful was a version Christopher did of Bernard Shaw's *The Adventures of a Black Girl in Search of God*, which was staged by the young writer and director James Bridges at the Mark Taper Forum in Los Angeles that year.

In the summer of 1969, Christopher finally realised his adolescent dream of visiting the South Pacific. Tony Richardson was in Australia making a film about the boy outlaw Ned Kelly, with Mick Jagger in the title role. Christopher and Don flew out in July to join him, travelling via Tahiti, Bora-Bora, Samoa and Auckland, New Zealand. In Tahiti Christopher tried to imagine Gauguin's days, and in Samoa the two lovers made their long-planned pilgrimage to Robert Louis Stevenson's grave. They were highly amused by the local guides, who had them clambering up and down hillsides and made rude jokes about them.

Their arrival in Australia was inauspicious. The airline lost the passengers' baggage, whereupon one impatient traveller declared loudly: 'fucking inefficiency!' An airline official reprimanded him: 'Don't you use that kind of language in this country – we have ways of dealing with people who do!' Christopher thought this was very sinister, and wondered whether they were entering a semi-Fascist state. He readily believed the press rumours that the Australian police were just waiting for the opportunity to catch Mick Jagger in possession of drugs, so they could throw him out of the country. Christopher instinctively adopted a protective air to the young pop star, and was enchanted by Mick Jagger's tenderness when his girlfriend Marianne Faithful arrived on the scene in an emotional state. Christopher wrote to John Lehmann that Jagger was a man of great style, the perfect balance of extrovert and introvert, capable of being both funny and serious, 'a "gentleman" according to my mother's rating, almost entirely without affectation and, it seems, vanity'.

The main purpose of joining up with Tony Richardson was to discuss a possible screenplay for the director's next film project, based on Robert Graves's two novels *I Claudius* and *Claudius the God*. Within weeks

Christopher and Don were back in Santa Monica, working hard on the script together. This was despatched to Tony Richardson in November, but it was the old, familiar story; though they were paid for their work, the script was shelved.

In February 1970, Christopher and Don went to London, to revise the play *A Meeting by the River*, at the request of the producer Clifford Williams. Don had to return to Los Angeles in mid-February for an exhibition, but Christopher hung on till the end of April, until it became clear that the play would not be staged after all. He went to see Morgan Forster at Cambridge, which was a rather depressing experience, as Forster did not even recognise him when he first came in. He died the following year.

Much more entertaining was a short trip to the south of France with David Hockney and Peter Schlesinger. Hockney had a taste for what he called 'whizz-tours' – rapid visits to desirable places, where he would rush around snapping photographs of everyone. It was unseasonably cold when they visited the Spenders' French hideaway, and Natasha Spender charmed her shivering guests by throwing one of her chairs onto the open fire. They returned to London in time for the opening of David Hockney's retrospective exhibition at the Whitechapel Gallery, then Christopher flew back to America.

From May to November, he worked on the second half of *Kathleen and Frank*. He had typed out over a million words from his parents' letters and diaries, and even after he had cut these down to a tenth of their length, his British agents Curtis Brown judged the book far too long. The final revision was sent off in January 1971, and the book was published in England in October. The American edition came out three months later.

The reception given to *Kathleen and Frank* was very mixed. Glenway Westcott considered it a 'masterpiece of head and heart', but others thought it was simply boring. Several critics were irritated by Christopher's referring to himself in the third person throughout; Frederick Raphael said it made him sound like 'a self-effacing Caesar'. Others complained that the book did not have an index. This was a deliberate decision, as Christopher did not want the book to be seen as a straight biography of his parents, though perversely he did include a number of charming photographs of his family and their homes, as if it were just that.

In an interview with *The National Observer*, in February 1972, Christopher explained: 'I tried to see my parents as people in a novel, and it helped me tremendously – not just in the writing, but it made them interesting to me as people in a new way. . . . Just in being able to call them Kathleen and Frank, and not mother and father, I discovered a tremendous psychological release.' In the Afterword to the book, he had written that he had found he

was far more closely interwoven with Kathleen and Frank than he had liked to believe. But Stephen Spender, who could be quite an astringent critic of his friend's work, expressed the opinion that in his painful effort to be nice about his mother in *Kathleen and Frank*, Isherwood had actually made himself less sympathetic than when he was being nasty about her in the novel *The Memorial*.

Christopher and Don saw quite a lot of John Lehmann at this time, as he had accepted a whole series of invitations to give lectures at colleges and societies in the United States. John was in Austin, Texas, on February 10, 1971, when a sizeable earthquake shook southern California. He managed to get Christopher on the phone and learned that although he and Don were perfectly all right, the whole house had rocked and shaken. Pots and pans had come crashing down onto the floor in the kitchen. Within hours, police cars were cruising the streets to try to stop people looting damaged buildings. The earthquake was still a major topic of conversation a month later, when John came to spend the night with them, as he was giving a lecture at UCLA. After the meal, Christopher and Don retired to the study, where John could hear Don typing as Christopher dictated part of a new, joint, TV film treatment of Mary Shelley's *Frankenstein*.

The commission for this came from the Universal Television Studios, which said that the couple would have a free hand in writing what they wanted. Accordingly, they made considerable alterations to Mary Shelley's classic tale, stressing its potential as a Gothic romantic melodrama by making the 'monster' beautiful at first, so that his creator half falls in love with him. As Christopher wrote to Alec and Dodie Beesley, this was a touching relationship, and the screenplay was 'really a fable about birth control and the generation gap'. The substantial script was finished by September, but in the event was subject to considerable cuts and revisions before the film was made, nearly eighteen months later, under Jack Smight's direction.

In the meantime, Christopher and Don accepted another film commission from Universal which kept them busy from January to September 1972, writing a thriller set in Egypt, called 'The Lady from the Land of the Dead'. They completed the work, but the film was never made. However, the year was not all disappointment, as at last their play of *A Meeting by the River* was staged, in April, by James Bridges at the Mark Taper Forum. The play was a two-acter, in which the confrontation between the two brothers was more dramatically intense than in the book. The peripheral characters in the book are brought on-stage, and are given a sharper reality. The mother becomes a forceful, bitter woman, tired of her sons' antics. Tom and Patrick are shown embracing, and Patrick is made more blatantly flamboyant and

irrepressible. His wife appears and accuses him of wanting an incestuous relationship with *her*, 'a brother and sister who share every thought, who read each other's moods and who go to bed together . . .' But the finale is one of hope. All the characters, from the mother to the swamis, join together in a crazy dance. Asked by the San Francisco *Sunday Examiner and Chronicle* to explain the new tone of the plot, Christopher replied:

> *A Meeting by the River* is a secret little book, but when I write for the stage I immediately become bold and want broad effects. My instinct is, if there's music, it ought to be louder! It's rather like painting with a broom.

Sally Bowles's final transmutation, in the film *Cabaret*, also appeared in 1972. Three years earlier, Christopher had been approached to do a screenplay for the movie, but the original producers ran out of money and sold on the rights; the new producers then hired someone else to do the script. Bob Fosse was the director, and Christopher saw the film at a private screening in New York in February, while there for the launch of the American edition of *Kathleen and Frank*. He had been thrilled by the casting of Michael York as the Isherwood-based character, telling the *Evening Standard* that 'they've even brushed his hair across his forehead like mine. And we've both got broken noses. He's a good-looking version of what I looked like.' Liza Minnelli as 'Sally' got excellent publicity for the film, appearing on the cover of both *Time* and *Newsweek*. But Christopher was disappointed and angry at the film's portrayal of the relationship between the two leading characters. He told friends that the Issyvoo character's encounters with men were shown as temporary, immature aberrations, like bed-wetting. Christopher was quite offensive to Bob Fosse about it when he ran into him at a party.

It was in New York on this occasion that Christopher first 'came out' openly as gay on television. All of his close friends were of course aware of his sexual orientation, as would be many of the readers of his books. In *Kathleen and Frank* he had made his sexuality obvious. But as he approached his twilight years, Christopher decided it was time to make a public stand. He was hardly the first famous writer or artist to make such a declaration, but he was considered an important 'catch' for the cause of gay liberation. He loathed the word 'gay', usually employing the term 'queer', but once he had joined the gay-libbers' march, he led firmly from the middle. When Winston Leyland, editor of the magazine *Gay Sunshine* came to interview him in Santa Monica a few months later, Christopher commented that most

homosexuals would probably react to his coming out by saying 'So what?' Unlike many of them, he did not risk losing a job, or being sent to prison, or being run out of town:

> Society can afford to overlook the deviant behaviour of an elderly, otherwise respectable literary man who has sufficient savings in the bank. It may be that what I have done will inject a little courage into the souls of a few timid brothers. If so, good. If not, also good, because I at least feel a certain satisfaction.

When Christopher and Don flew to England in February 1973 to be present at the shooting of the TV film *Frankenstein: The True Story* they discovered just how much had been altered. To make matters worse, the Screenwriters' Guild to which they belonged called a strike, so they felt obliged to stop working altogether. They fled to the continent, where Gore Vidal restored their spirits in Rome with an impromptu champagne party to celebrate their twenty years of living together. Back in the States, they got their own back on Universal Studios by getting their original screenplay of *Frankenstein: the True Story* published by Avon Books. The film that was actually made was four hours long, and had a star-studded line-up, including John Gielgud, James Mason, Ralph Richardson and Agnes Moorhead. It won the prize for the best scenario at the 1976 International Festival of Fantastic and Science Fiction Films in Paris.

On September 29, 1973, Christopher was distressed by the news of Wystan Auden's death. As he wrote to Edward Upward ten days later:

> I was absolutely incredulous at first. It was one of those shocks which one had neglected to prepare oneself for – I'd always taken it for granted that he'd survive to write all our epitaphs. It seemed curiously sad that he never got the Nobel Prize, because I think he had set his heart on it. Needless to say, the news reached me from the media – Reuters and the BBC. The latter, after a respectful pause of 10 seconds, so I could indulge in private grief, asked for a 'comment' – 'how would you place him as a writer?' They really are grotesque.

Christopher was not informed about the moving memorial service which was held for Wystan at Westminster Abbey. He wondered if Chester Kallman had been responsible for this in a moment of ill-timed spite. As Bill Caskey witnessed, Kallman degenerated horribly in the remaining few months of his own life, mostly spent in Greece, before following Wystan quickly to the

grave. Christopher re-read Wystan's poetry as a form of personal tribute, then turned his mind back to work, as Wystan would have wished.

His main professional preoccupation at this time was how to turn his massive 300,000 word diary for the period 1939–1945 into a book about his early years in America. But as he progressed with the project he realised that too many things needed explaining. This meant he would have to start the book much earlier, filling in the decade between the end of *Lions and Shadows* (1929) and his move to the United States (1939). As he had destroyed some of his diaries for the period in question, it would mean reviewing the portrayal of some of those years in his novels with a new subjective memory: that of a fairly militant queer. He made this glaringly obvious in the early pages of the resultant book, *Christopher and His Kind* (for which, once again, Don came up with the title), when he stated that for Christopher, Berlin meant boys.

In December 1974, Christopher travelled with Don to New York, to talk about gay literature at a convention of college teachers. Being such a self-evidently civilised speaker, witty yet non-camp, he had become a popular spokesman for the cause. Yet the moderation of his manner masked the radical nature of some of his beliefs. He was, for example, an eloquent defender of promiscuity. Even in the pre-AIDS day, critics of homosexuals lambasted them for sleeping around and for spreading venereal disease. Christopher took the bull by the horns in defending promiscuity, even in situations such as his relationship with Don. In fact, he claimed that a true loving relationship could only be proved if it had been tested by – and survived – sexual peccadilloes by either or both partners. He also defended the validity of one-night stands, believing that some of man's greatest sexual experiences come in brief encounters, which need not necessarily be sordid or even anonymous.

This candid public stance openly implied to the world many things about his relationship with Don. Initially, it had looked to some to be merely a replay of earlier affairs, based essentially on a physical obsession for an attractive youth. But over the years it became obvious that it was something quite different. Christopher watched lovingly over Don's artistic and character development, encouraging and helping where he could, but without crushing Don's sensibility with his own forceful personality and his standing as a writer. Don found his own branch of creativity, but in the latter years, worked increasingly in collaboration with Christopher on literary projects. He too kept a journal and would become the guardian not only of the ageing Christopher, but also of the Isherwood legacy.

Christopher's efforts to complete *Christopher and His Kind* in 1975 were

hampered by an otherwise welcome commission from NBC Television to do a joint script with Don based on Scott Fitzgerald's *The Beautiful and the Damned* – yet another project which never got onto the screen. This meant that his autobiographic volume was not finished until May 1976. Earlier plans to cover the entire period from 1929 to almost the end of the Second World War had been scrapped; his 'wandering years' of the 1930s would now stand on their own. Besides, the 1930s had come back into vogue. In June that year, there was an impressive exhibition at the National Portrait Gallery in London, on the Writers of the Thirties, for which Christopher and Don travelled over.

While he was in England, Christopher received the news of Swami Prabhavananda's death. It was not a great surprise, as the Swami had been ill for some time. Besides, Christopher had prepared himself for his guru's physical departure from this world knowing that his spiritual presence would remain. When he said the mantra Prabhavananda had given him, he could still feel the Swami's love and inner being. The mantra, he felt, was all he needed.

None the less, the Swami's death crystalised Christopher's thoughts about what he should do next. Rather than distilling another book of autobiography out of his diaries from the early American years, he would produce a book which would use the relevant parts of all his American diaries to explore his relationship with Prabhavananda. The rest could be used in a further volume – in the event never written – which would particularly stress his film work in Hollywood. The research and writing of *My Guru and His Disciple* would be Christopher's main occupation for the next three years.

Christopher and His Kind came out in America in November 1976, and in Britain the following March. It briefly appeared at the bottom of the British hardback bestsellers list, and won Christopher many new fans among young gays. Older critics, who were familiar with Isherwood's earlier work, were divided in their opinions of its worth. Dame Rebecca West declared memorably in the *Sunday Telegraph* that it was 'one long symphony of squalor'. Francis King, who had earlier published his own extensive critique of the Isherwood *oeuvre*, found his use of the 1930s Christopher as a separate persona from the Christopher writing in the 1970s whimsical. Peter Conrad, in *The Spectator*, threw down the gauntlet by declaring provocatively that the semi-fictional nature of the book only went to show that Isherwood was incapable of writing autobiography at all. In defence, Isherwood could have replied that he had not really tried to. This time, there was not even any photographs.

Yet as *My Guru and His Disciple* shaped up, it showed that Isherwood

could write a very convincing volume of autobiography when he had to share the focus of attention with the guru he admired and loved. What is more, because the material in the book was fresh – unlike his reworked Berlin reminiscences in *Christopher and His Kind* – he felt under no obligation to set the record straight, or make amends. The fact that the book did not sell better doubtless reflected what many people saw as its esoteric theme. But it remains a central aid to understanding Isherwood's complete personality.

Christopher and Don were over in England on a visit in 1980, the year *My Guru and His Disciple* came out, and at the beginning of July went to dinner with Stephen Spender at his daughter Lizzie's. They had champagne first at Spender's own home in Loudoun Road, and Stephen thought Christopher looked hardly changed since he had first known him. Christopher got drunk, which made him even more noisy in his conversation, punctuating his comments with exclamations like 'Oh yeah!' and 'Gee!' He spoke of the Americans as 'us' (though other friends noticed that his accent was becoming less American and more mid-Atlantic). And at the end of the evening, he rushed up to everyone there, flapping his arms like a bird, and giving them a big kiss on the cheek.

This exuberance did not last long. The following year, a medical check-up showed that Christopher had cancer of the prostate. Having seen several friends die unpleasantly from various forms of cancer, he became deeply depressed and discouraged. Although he kept up his diary entries for another two years, he knew the chances of another book were slight. Don did help him put together a volume, *October*, comprising his journal for the month October 1979, with illustrations by Don. This was published in 1983. Unaware of Christopher's medical condition, some critics wondered sadly why nothing more substantial had emerged. Many of the diary entries struck reviewers as inconsequential and unprofound. And Paul Binding in the *New Statesman* was not the only critic to ask how anyone of Isherwood's sensitivity could include a superficially crass record of a phone conversation with a semi-hustler friend, who was writing a sado-masochistic fantasy of a Jew having a relationship with a Nazi guard in a concentration camp, and who wanted to know how to say 'I love you' in German. *October* – published in Christopher and Don's joint names – is Isherwood's least known book, and at the time of writing is out of print.

By the time *October* was published, Christopher had become almost entirely dependent on Don, though a number of loyal friends – Stephen Spender, Gore Vidal and Julie Harris – kept in frequent touch. Although Christopher had to go to hospital for radiation treatment and chemotherapy as the illness advanced, Don was determined to keep him at home. He nursed

him, fed him and bathed him, even when, at times, Christopher's emaciated, pain-wracked frame physically revolted him. And Don drew. Day after day, often several portraits each day, tracking Christopher's agony and disintegration. Sometimes Christopher would shout out at him as if the cancer were his fault, and call him 'the torturer'; at others, there would be the odd glimpse of the old spark and humour. On December 2, 1985, when it was obvious that the end was getting near, Christopher was watching Don drawing out of the corner of his eye while Don thought he was napping, and startled him by saying suddenly: 'I like the ones of him dying!'

The extraordinarily forceful book which Don subsequently produced, *The Last Drawings of Christopher Isherwood*, is an agonising record not only of those terrible last months of pain, but also of the bond that united subject and artist. When Christopher died on the night of January 3-4, 1986, Don kept on drawing for hours as the corpse grew cold, until the doctor called at nine in the morning, and the skin and the bones that were no longer Christopher were taken away.

His friends mourned, glad for his release, but sad for the talent that had died. Stephen Spender, as the last of that famous trio on Ruegen Island beach, was called on to give many a tribute. In *The Observer* he recalled the occasion when he had remarked to Christopher that the members of their literary generation had, on the whole, had happy lives. 'Gee!' Christopher burst out. 'That's true. We've had the happiest! We've been the luckiest!'

The major works of Christopher Isherwood

Novels
All the Conspirators, Jonathan Cape, 1928.
The Memorial, the Hogarth Press, 1932.
Mr Norris Changes Trains, the Hograth Press, 1935.
Goodbye to Berlin, the Hogarth Press, 1939.
Prater Violet, Methuen, 1946.
The World in the Evening, Methuen, 1954.
Down There on a Visit, Methuen, 1962
A Single Man, Methuen, 1964.
A Meeting by the River, Methuen, 1967.

Plays (with W. H. Auden)
The Dog Beneath the Skin, Faber and Faber, 1935.
The Ascent of F6, Faber and Faber, 1936.
On the Frontier, Faber and Faber, 1938.

Travel
Journey to a War (with W. H. Auden), Faber and Faber, 1939).
The Condor and the Cows, Methuen, 1949.

Autobiography
Lions and Shadows, the Hogarth Press, 1938.
Kathleen and Frank, Methuen, 1971.
Christopher and His Kind, Methuen, 1977.
My Guru and His Disciple, Eyre Methuen, 1980.
October, Methuen, 1983.

Biography
Ramakrishna and His Disciples, Methuen, 1965.

Philosophy
Vedanta for the Western World, the Marcel Road Co., Hollywood, 1945.
Vedanta for Modern Man, Harper and Bros., New York, 1951.
An Approach to Vedanta, Vedanta Press, Hollywood, 1963.
Essentials of Vedanta, Vedanta Press, Hollywood, 1969.

Index

CI in the index stands for Christopher Isherwood. His writings are indexed under the entry for Isherwood himself.

INDEX